Worthy

Bobbie Smith

CreateSpace Independent
Publishing Platform

To The Northshore Wordsmiths, in particular,
Norma and Jim Shephard, Diana Walsh,
Sylvia Mertins and Anne Gwaza

Dear Cynthia,
I am so pleased
that you will be
reading my work!
Enjoy!
All the best
Bobbie
Nov. 2015

Part 1.

"The burden of guilt dropped on me and started days of such remorse that I thought of ending my life. It was not fear, I think, nor even the teachings of the church, that kept me from such action, but the terrible tiredness that made any decision seem impossible."
From Random Passage, by: Bernice Morgan, p.213

Chapter 1

Sarah Marsh was hanging out the clothes when she felt it: a quiet but present tumble in her stomach. A serious urge lingered at the base of her throat. She pulled the one wooden clothespin from her mouth and took a deep breath. The dishtowel in her other hand flapped senselessly in the northeastern wind. Across the clothesline, saltwater crests rolled into Fox Harbour.

This should not be happening. This was not happening to her. She firmly clipped another towel and then a shirt to the line when the wave rose higher. If she didn't make a run for it now, she would regurgitate her entire breakfast: a slice of white homemade bread with butter and bakeapple jam, and a cup of tea.

She dropped everything and instinctively covered her mouth with her apron. She looked around frantically. Earlier, she had seen her father outside. He was close. Her stomach rolled again. The wind blew her hair out of control, blond tentacles smothering her tiny face.

She stumbled over the lumpy ground and ran around the back to the outhouse. She ached for privacy. If only she could sneak inside the house and use the indoor toilet. No, she couldn't risk it. Sarah would get a bawling out from her mother. Imagine having the nerve to take advantage on a fine day in August, her mother would say.

She could still remember the day they got their toilet. They had been too poor to buy one. They had no cash, only fish her father caught. The general store tracked how many goods and supplies each family could take home, based on how much fish the men took in each year.

It was a day in April last year when her father arrived home carrying the dirty rickety porcelain bowl he'd picked up from a builder at the Base in nearby Argentia. The town's coastal location drew the Americans to their outport near the beginning of the War, but Sarah figured the entire island of Newfoundland fell into that

category. With the Base came an influx of American supplies, goods, flags and soldiers. It meant Fox Harbour, Ship Harbour, Dunville, Placentia and all the surrounding outports quickly had access to weaker alcohol, stronger cigarettes and new and strange things like indoor toilets. It was already summer in 1942 and except for the Base, Sarah didn't feel like Newfoundland was at war at all – all she felt was the bile now rising to the base of her throat.

She knew the moment she got near the hole above the stinking pit, her gag reflex would kick in, but she had no time to be discreet. She'd have to risk exposing herself instead of going over the hill out of sight. She prayed it was early enough to do something about the smell before anyone suspected anything. She counted on the other smells to mask her shame.

The scratchy, wooden outhouse door shut out the August gale with a stomp, until the retching drowned out any brief silence.

When she was done, her head hung limp. Her arms held her slight weight, elbows trembling as she hovered over the pit. The recent cool temperatures in the harbour had hardly tamed the stench below her chin and allowed her to stay on her feet. On empty, but determined to pull it together, she hauled herself up to her full five feet. In slow motion, her pale hands, delicate against the soiled planks, pushed her shaky frame upward. Awkwardly, she removed the short-length cotton apron from her waist, and used it to wipe her mouth. She waited a moment to see if her body was done with rejection, then she dabbed at the sweat beading on her forehead.

Another wave washed over her: not nausea, but anguish and helplessness. Her situation was bitter with no sweet to be found. A dead end of misery and shame. She was marked for life and doomed to hell; that's how Father William would surely see it. He spent his days warning them in Mass about the hellish inferno that awaited the sinners, urging them to heed his words. Nothing could possibly save her and she knew it.

She pictured her father's huge chest swelled with anger, could imagine his blows to her body, could hear her mother's wailing tears as she grieved in the bedroom, could feel herself disintegrating in her

sister's scowl of condemnation. Her loving sister Elizabeth would turn on her. She just knew it. Faith, love and trust; all were mercies closed to her now.

Through the tiny vent hole, she could see the neighbours' houses, colourful saltbox shapes lodged into the hills, painted bright blues, greens and reds to cheer up the gloomy winter that droned on past spring. The houses had small windows; the bigger the windows, the more the heat escaped. Better to be warm in the dark than freeze in the light. She could feel all their eyes staring right through her thin cotton dress. Exaggerated voices laughed inside her head, mocking her sinful stupidity.

She imagined herself, bloated belly and stringy unwashed hair walking into the kitchen at her Uncle Johnny's and seeing Aunt Marg pointing at her and chanting the Lord's name, her head rocking back in slow motion in judgment, disgusted, while the others just glared and shook their heads.

She saw them pointing at the door and shouting obscenities, words she'd heard her whole life that were not hers to repeat as a young respectable female. Now, they would use them on her. Her cheeks flushed with shame. She placed a clammy hand on her forehead to calm her anxiety. What could she say to them? What was she going to do with this sin? How could she explain it? She could only hide it for so long. Sarah shook her head like a five-year-old not wanting to go to bed, wanting it all to go away, starting with getting to hell out of this outhouse.

A buzzing fly knocked against her ear, startling her. She squealed and flung the door open, crashing it loudly against the side.

"Sarah?"

Her head jolted up. Her father was walking toward her, the handle of his axe resting on the meat of his right shoulder.

"Daddy!"

He stopped at the sight of her tangled hair, apron all balled up in her fist and fright in her eyes.

"Did you call out?"

"I'm fine, Daddy," she said, struggling to smile. She tipped her head so a thick flap of her hair covered her troubled face in the wind. "It was a stupid blue-arse fly buzzing in my ear. Frightened the life out of me."

His eyes tightened. Her skin paled in response.

"What are you up to, child?"

"Nothing, Daddy, just needed to go." Gratitude swept through her as she realized she'd already wiped her mouth. She couldn't look up at him.

"Go on, then," he said, surrendering with a vague wave of his hand as he walked off toward the woodpile.

She ran off clutching her crumpled apron in her white hand.

Edward Marsh sighed deeply. He had three women in his life: Sarah, his older daughter Elizabeth, and his wife Mary. He had a few sisters, too, but they were tomboys. He had learned a long time ago that sometimes women acted strangely. There was crying and running off to the hills or silence amid company, and there was lots of hiding either themselves in another room for a time or hiding what they really wanted instead of what they said. This was another day he would never understand the women in his life, so he gave up trying. Ed walked back to the woodpile around the corner of the house, shaking his head.

"Everything all right?" Frankie Healey halted his wood chopping for his father-in-law to reply. He was helping Ed cut a cord of wood they would split between the two households.

"Women," said Ed under his breath and slammed his axe into another piece of wood.

Sarah ran inside the house to rinse her mouth out and her apron in the sink. Peeking outside the kitchen window, she tried to see if her father was coming in, but she couldn't see him. She let out the air held tightly in her chest and shuddered. She put him out of her mind and wrung out the apron, cold water splashing on her housedress. Rinsing her mouth of the sour taste, she drank straight from her cupped hands.

"Sarah?" Her mother Mary called from her sewing spot tucked beneath the stairs. Most women stitched, knit and darned by the stove, no matter what the season. In winter, it was to keep warm; in summer, it was habit. Her momma had no need to stitch by the stove. She never got cold. She preferred the cool air around her as she worked and August in Newfoundland didn't disappoint.

"Yes, Momma?"

"Come here, please."

"What do you want?" Sarah stalled. She wasn't ready to face her sharp-eyed mother yet.

"I don't wanna hear none of that sauce. Just come here, young lady."

Sarah closed her eyes briefly as she took a deep breath that smelled of woodstove, baked goods and tobacco.

"Coming."

She left her apron in the basket of dirty washcloths kept near the stove.

She stopped near the boxy armchair that sat on guard, unsmiling in the living room. Leaning around the corner, she kept her body hidden, showing only her head and shoulders to her mother who was sitting, mending a skirt.

"Here, honey, let me see this up next to you. You and Elizabeth are almost the same size now, though I can hardly believe it myself."

Sarah reluctantly moved away from the wall, resisting the impulse to protect her belly with her right hand. She moved around the chair and squeezed through the narrow space leading to her mother's breeding nest of fabrics and materials under the stairs, her father's solution to women's work. Her mother tended to pile scraps of rag all around her in a swell of colour and thread that followed her wherever she worked, until one day her father couldn't find a spot to sit in the kitchen.

"Jesus, Mary, do you think you could fling this stuff any further?" said her daddy, clutching a tangle of multi-coloured fabrics cut in different shapes from clothes they had all worn before. "Christ, I can't move and I'm trippin' all over women's work."

"You give me a spot to work, sir, and you won't ever see it. Mark my words."

Exasperated, he had flicked the material in a spray on the daybed and stormed out. Behind him lay pieces of their lives, a section of Mary's old grey and white housedress, a corner of Sarah's faded green plaid flannel nightgown and a sleeve from his own red and blue cotton shirt. By the end of the week, he had come up with an idea: a half-closet under the stairs. It was missing a door and a meaningful purpose – till now. He yanked out bits of junk, a baby's highchair, a couple of broken toys, a few dusty canning jars and cleared a cubby-hole big enough for his wife to sit and mend. He placed an old dresser against one short wall so she could store scraps and bits in the drawers, and he lodged a small crate beneath the slanted wall under the stairs so she could sit. Finally, he jammed a couple of nails into the wall, a crude row of hangers. Her daddy himself couldn't stand up to his full height in the space, but to him, it didn't matter. He had his own workshop outside where he often spent hours whittling away at something by candlelight.

Sarah brushed away an imaginary crumb from her skirt. Her mother wasn't looking at her. She was eyeing the skirt hem with the look of a surgeon. She placed it over her slim daughter's stomach and nodded her head in satisfaction, then reached for a pin.

"Yes," she said. "That'll do just fine."

Sarah stilled, holding her breath, looking down at her mother sitting and sewing, wondering how she might tell her. Her lips opened halfway, but nothing came out – only tense hot air. Her heart fluttered.

Her mother was fixated on her hem. She was already back to her needle and thread, her fingers nimbly working through the stitches. Without looking up, she asked her daughter if she'd eaten yet.

"Toast," said Sarah, now looking over the armchair and through the window at her father's axe appearing, then disappearing, the muted rhythm of woodcutting reaching her. It was safer than catching her mother's eyes straight on.

"I was getting the clothes out," she said, crossing the creaky floor to get a closer look. Through the window, her father chopped, his expression intense. The axe blade was buried in the top of a birch junk. The strength in his arms and the weight of the junk attached to the blade made it look as if he were heaving a swollen sledgehammer over his head, crashing it down on the cutting bench below with a boom. She jumped. The two sides of the junk, now split, fell away from each other to the soft grass, making no sound through the window, only a vibration. She swallowed.

"Good girl, you are. Would you mind, love, bringing me a tea? I need a few minutes on this hem now."

"Sure, Momma."

She returned to the stove where a pewter-polished kettle sat permanently boiled. It only left the confines of the black iron stove when it needed to be refilled with water. Pouring the steaming water, she watched the tea bag drown and suffocate under the intense weight of gushing liquid. Then it floated on the surface, like a grey jellyfish. She grabbed a spoon so when the tea was rusty brown and tart on the taste buds, her mother could fish it out later. She added a thin, solid stream of Carnation milk and a teaspoon of sugar and stirred delicately. Her father yelled at her when she scraped.

Her hand was unsteady holding the tiny rattling cup as she moved through the cool house, cold enough to see her breath in small puffs

of fog brushing by her in short bursts. Relieved the tea hadn't spilled, Sarah laid it on the low dresser and rewrapped her worn cardigan around her tiny frame as she turned to leave.

"Thanks, honey. Go on now and finish the clothes." Her mother's eyes hadn't left the line of stitches.

Sarah walked through the kitchen, out the door and back into the garden to her basket of damp laundry. She buttoned her sweater to the top. Though it was August, the wind coming across the water was sharp, carrying the raw scent of brine and a force angry enough for fall.

The chopping hammered on. She picked up the threadbare dishtowel and small wooden pegs she had dropped earlier – soldiers scattered on the grass. Suddenly, lukewarm tears poured over tense cheeks too young to wrinkle and too old to be caught crying over nothing. The steel grey water slopped against the jagged shore. Fox Harbour had been her home for all of her years, but suddenly those years were crumbling to dust. These hills that once hugged her, now closed in on her, entrapping her indefinitely. She knew she had to leave.

She could never go back to that house. She was too terrified. She couldn't go through it again. She needed to talk to Elizabeth, but for the first time in her life, she could not turn to her sister. Her father would beat her, without a doubt. She'd once overheard her father talk about when Sally Foley from over the road got pregnant. Her old man hit her over and over again with a two-inch thick stick that had been kicking around from the old fence out back until she was bleeding on the ground.

"Proper thing," Sarah's father had said. "That was the right thing to do," he'd said. "She should know better than that at 16 years old. He should have thrown her out."

"Ed! Jesus, b'y."

"No, Mary, it's only right. The likes of her shouldn't be at that stuff. What was she thinking? It's shameful, that's what it is."

"Yes, t'is shameful but there's no need to beat up the poor thing."

"No, Mary, y're too soft, I'm sure it was in the heat of the moment, but sure, t'is only proper. Young Catholic girl like that will go straight to hell, she will."

Sarah shuddered to herself, thinking of a stick striking poor Sally. Sally never did have that baby. Sarah clipped another wooden peg to the wire line they used to hang their clothes out to dry, struggling against the wind. She and Sally weren't close friends but close enough. They'd shared their lunch once or twice at school when one of them had nothing much to eat. They'd been in the same class for four or five years in primary and elementary school but the last time they talked was when they were 11 or 12. They certainly didn't ever talk about what went on in each other's houses, especially anything sinful. They'd get whipped on the backside if anyone caught wind of them exposing the family sores. Nor did they talk about the stuff that went on with boys. That was shameful. It was easier to pretend it didn't matter. So they talked about the safest thing: everybody else's wrongdoings. And whatever they didn't know for sure, they guessed.

There was no changing Newfoundland, she figured, or people's minds about what was right. It was a really wet and damp place for hanging out clothes, too, but people did it anyway, out of necessity, stubbornness and habit. She didn't mind putting clothes out on the line but she did mind being judged for something she didn't cause. She wished she could save herself some other way. Getting pregnant meant you had to get married right away…or else.

She could not marry him. Impossible. He already had a wife.

"Oh God," she thought. Fear gripped her heart. She wished again she could tell Elizabeth. Her older sister was always her oasis of calm, her unerring guide when something was bothering her and her confidant who was always ready to absorb every single, private detail. Not this time.

No one can ever know about him, ever, she decided firmly, shaking a damp shirt from her basket and adding it to the organized

flapping row of shapes along her line. She rushed through the rest of her clothes and grabbed the empty basket.

Instead, what if she went to confession? Mass was tomorrow morning. What if Father Williams told her parents about her big sin? No. She couldn't chance it. She would privately ask the Almighty Father for His forgiveness, protection and guidance. He was all-knowing and all-loving. He would understand.

Chapter 2

Kneeling on a folded cloth on the kitchen floor, Elizabeth wiped a stray hair from her face with her wrist. She sighed, dropped her damp, cleaning cloth into the grey pail and watched it flounder as she pushed it to the bottom, drowning it in hot, soapy liquid. She wrung out the old cloth before slapping it on the hard floor again.

Washing and scrubbing helped her push away the frustration that bit at her patience. Washing floors, counters, shelves and corners allowed her to cleanse intruding specks of dust and dirt brought in by his muddy boots or the bitter winds that howled through all the seasons. Scrubbing hard gave her power, wet brush on solid surfaces, pressure on spots or spaces that held their ground but didn't fight back, clean or not.

Her house had never been cleaner these last couple of years.

She had tried so hard not to be silly about marriage, expecting a man to fawn over her, bring her flowers and write her poems like they seemed to do in the stories and books they studied at school. Characters in a book were no match for the men around here with their gruff talk, their love of the drink and their disdain for anything remotely romantic. Elizabeth knew that as well as anybody, but somewhere in her mind, somehow she had deluded herself into thinking you would still have love. Not anything very visible or strong but a quiet feeling of warmth, one that warded off loneliness; that's all she'd longed for.

Frankie wasn't mean, not too mean, anyway. He was pre-occupied, is all. Thinking about things like fishin' and rum and the Base and his buddies and not her. Or if he did think about her, it was to demand she make him a son. The first year, he was friendly and would hold her hand from time to time. That was about as romantic as he got, but Elizabeth hadn't ever seen her parents do as much as that. She hadn't seen love in her household, except in the form of hot

meals, kind tasks done without asking or spending time in the same room. That was all the love she'd ever seen. That would be good enough for her, too.

By the second year, when it was clear she wasn't getting pregnant, he started getting testy.

"Frankie, I think we should go to a doctor and get checked out," said Elizabeth as she cleared the breakfast dishes off the kitchen table.

"What do you mean 'we'?" said Frankie, looking up from his newspaper.

"Well," Elizabeth looked away, took her dishes to the counter and started unpacking them to rinse. "I mean, I think we should both go in and get checked, you know, to see why we can't..." Her voice trailed off.

"Yeah, you should go in and find out why you can't make me a son," said Frankie, looking straight at her. "Good idea." He returned to his paper.

"Frankie, it takes two people to make a child, honey."

"Don't 'honey' me. You're not the one being ridiculed all over this fuckin place."

"What do you mean?"

"I can't turn around without someone taunting my ability to perform, and my manhood...and all because YOU can't get pregnant. That's what I mean."

"Well, I'm sorry, but maybe it is your manhood."

Frankie slapped his hand across the table sending the tea mugs crashing to the floor, startling her, his eyes still glaring by the time she had steeled herself to look at him.

"You go to that doctor and come back with an answer," he said, pointing at her. "And don't dare talk about my manhood like that ever again."

Elizabeth did go to the doctor a number of times but they couldn't find anything wrong with her. Frankie refused to go, much like most of the men in Fox Harbour. They saw sickness as a sign of weakness and going to the doctor was as good as admitting it.

Still, three years later, all she could give him was a clean house, home-cooked meals and half of her bed; that wasn't enough.

No news from Frankie again. He'd been gone since about 1 o'clock in the afternoon; soon be time for supper. Continuing to rub her washing cloth over new spots of floor, dirty or not, she knew she could fix a dirty house and cook as good as her momma, but she couldn't make a child nor could she make her husband happy. But she kept trying. She longed to talk to Sarah, ask her what to do, but her little sister was too young, too innocent for such conversations.

"I'm home. Haven't ya got supper started yet?" Frankie stumbled into the kitchen, banging the door against the wall with his weight regained his balance.

"I said,"

"I heard you. It won't be long coming."

Chapter 3

Sunday morning, Elizabeth watched as the uphill stream of parishioners slowly climbed the grey mound of gravel toward the Sacred Heart of Mary Church. Though the people in her small community didn't have much, they always gave to the collection, even if it was their last dime. The generosity, or perhaps fear of hell, she suspected, made Sacred Heart the most freshly painted place of worship in Fox Harbour. Her Catholic community was proud of their church, which could be seen from anywhere in Placentia Bay.

Elizabeth never cared much for fashion but in her contemplative moments, she liked watching people. She casually absorbed the women's clothing with quiet indifference. They wore modest homemade skirts in the greens, greys, blues and browns of the rugged landscape. Cloaked in light coats and hats in decades-gone styles, they clustered together to cut the wind. She knew they were all preparing themselves for the appropriate state of holiness required for Mass. Their searching eyes counted heads and faces like schoolteachers keeping attendance, or sergeants looking for deserters. They compared their findings in hushed indignant tones. She noticed the men lingering momentarily on the wooden steps outside in their salt-and-pepper wool hats and baggy trousers, finishing their American-brand Winston cigarettes and chatting to each other. She couldn't understand the affection for the bloody things. They stank and only led to more drink.

She heard the hens clucking again.

"I don't see the Foleys from over the eastside lane, do you?" asked one Martha Kelly, her nose tipped in the air, higher than her hat as she monitored the flow of churchgoers.

"Oh no, girl. They never comes, that crowd," said April Donavon. "You knows what they're like." She nodded at the Davises from the west side as they walked by.

"Good to see you."

"Indeed, ladies, indeed."

Sherry-Lynn Martin waved her hand in the direction of the Marshes. "There come the Marshes. Wave now."

Elizabeth froze. They didn't realize she was within earshot. Such known gossipers, what would they say? Elizabeth watched them wave until her momma and sister caught sight of the group and shyly waved back. Her young sister blushed as they made their way up the hill.

"Don't say much, do they, Sherry-Lynn?" asked Martha.

"No, girl, but they're lovely." Sherry-Lynn paused. "Except for Mister. He's as crooked as they comes. Never cracks a smile, he don't."

Elizabeth slowly let out the breath she'd been holding in and smiled knowingly to herself. Her daddy was crooked! She chuckled to herself. She wouldn't have him any other way.

Behind her momma and Sarah, her daddy trudged along quiet and distant, looking past the women as they walked up the steps of the church. He headed directly toward the men.

Elizabeth had snuck into the church and waited for them inside the 10-foot-tall narrow doors. She was alone. She rarely engaged with the clucking hens out front. They made her feel even lonelier. Nice enough but she never knew how to find their centre. It was as if they hadn't one or as if it kept moving so much, she'd never hitch onto it.

It had become the same with her husband. She remembered when they had first married, she'd felt special, even though her wedding hadn't been anything fancy and Frankie was not exactly a prince. She'd worn a floor-length gown of nylon lace and Frankie had worn a suit from his buddy who'd been in the military and could afford a nice one. He was nothing like the kind, but dashing heroes she'd read about in books and dreamed about as a young girl. But she also

19

had resigned herself to reality; this was Fox Harbour, Newfoundland. Where would she find kind and dashing creatures here? She and Frankie liked each other, he had a good income from fishing and his own house, and he wanted kids.

"You are the prettiest girl in this harbour, you know that?"

"Frankie, I'm not." Elizabeth would smile with equal amounts of pleasure and embarrassment.

"Well, I'm tellin you, you are." Then he'd kiss her on the lips, the sweet scent of rum on his breath, softly at first and then more passionately until they ended up in their creaky, second-hand, handmade bed with iron springs. They never striped down; it seemed too dirty. She opened her dress on top and then he would sneak himself into her underneath. After a couple of minutes it would be over and she would finally get to the good part: cuddling at the end; then he would fall asleep.

After the wedding, they spent time creating a home for themselves down the lane from her parents. She had thought it would give them a sense of community and love. She wanted to walk through the tall grass fields at sunset and dig for mussels in the summer. Over time, Frankie spent more and more time at the Base playing the slots and drinking rum. At first his excuses were reasonable, "Maybe later on," or "I need to get down to the wharf to help Tom with his boat." They were real, genuine reasons she could accept, though she'd wished they could have put the world on pause and go anyway. Reasonable gave way to truth as their marriage progressed. The excuses hardened and became, "I really don't feel like going for a walk in the grass right now," until he could no longer contain his bitterness and truth, "I don't want to go for a fuckin walk in the grass, woman. What would I want to do that for?"

"I don't know, I guess, I thought it would be nice to walk," then Elizabeth would look down at her lonely hands that ached to be held. She silently scolded them for making her want them connected to someone, to him. It made her angry with herself.

"Never mind."

How did things turn so quickly yet so gradually? She hadn't really noticed and suddenly she saw the change in him, so raw and exposed, it prompted her to look away when he spoke to her with such venom. His hostility made her not want to talk to anyone or do anything. She preferred staying close to her family, the women especially, so that's what she did. Maybe in time, he would come around again, like he once was.

She opened the door to see how close they all were. Her father Ed and husband Frankie were outside smoking with the men, their backs to her.

"Ready for another session with the Lord, I s'pose," Frankie asked Ed.

"Oh, you knows, b'y. Waits for it every week, I do," he said taking a long draw on a non-filtered cigarette. "If only I could smoke in there." Ed nodded towards the church. Elizabeth backed away from the door. She could hear Frankie still laughing when her mother opened the church doors.

"Good morning, child."

Sarah smiled, said hi and quickly lifted one eyebrow, telling her sister they needed to talk. Elizabeth nodded her head slightly, and led them into the main room in the church. Droning organ music played as parishioners huddled uncomfortably on solid wooden pews. Mary and her daughters knelt in prayer for a few minutes before taking their seats. Sarah's eyes were shut tight. In Mass, she could imagine herself outside of her body looking down on the congregation and on her life, an angel taking special care of all things. It was how she prayed. It made her feel next to God, closer to Him. Suddenly, she had an urge to connect, too, with what was growing inside her. Without thinking she put her hand on her belly for a moment. Instinctively, she opened her eyes and saw her mother looking at her. She took her hand immediately away, but it was too late. Nothing got past that woman. Watching shock, anger and pity cascade over her mother's eyes, Sarah looked past her mother to ask

Elizabeth for help, but only got her profile; she was looking straight ahead.

Moments later, Elizabeth turned and looked at them. Sarah watched her sister notice their mother's stiff composure. Her momma clenched her jaw in self-control. Elizabeth's eyebrows crinkled, signaling she knew something was up, but wasn't sure what it was. She leaned forward to her mother's ear and said something. Her mother replied. Elizabeth shook her head vigorously but then anxiously leaned forward to read Sarah's familiar face for answers, clarity, denial, anything but what their momma must have told her.

Sarah and her sister had always had an ability to read each other. They each knew what the other was thinking without speaking. Sometimes, they could predict what the other would say. But this time, Sarah had no idea what response to expect. Shame and fear had completely shut down her ability to predict Elizabeth's reaction. Elizabeth's head dropped. Sarah looked away, her momma still stiff as a board beside her.

The music started. Sarah gripped the back of the pew in front of her, a cold bar of rounded and varnished wood. She pulled herself upright, yanking her from this frightening moment, one she had dreaded for much too short a time. She wasn't ready to cope with the rejection yet. She still needed to work this through on her own. But it was too late. She dared not turn her head to the left. She could feel the accusatory heat radiating from her mother and sister as they, too, clung to the same, dead-still wooden support, hand-built by men in the community.

Elizabeth had only four years on her younger sister but suddenly she felt decades older and very far away. Her baby sister could not be pregnant. It was only the hussies that ran loose like that, not Sarah. The organ rumbled through staunch chords, numbing her eardrums. It couldn't be true yet it was her own mother who told her in Mass. Her mother would never lie in the house of the Lord.

Elizabeth's mind toppled over the faces and names of whatever young males she could think of in Fox Harbour and who it might be. She fought to remember details of events over the past few months,

thinking she might recall a moment shared between Sarah and a boy that had meant nothing at the time, but everything now. Was it the garden party in June when all the community came together to sell turkey teas to make money for the church? Sarah was with them in the kitchen assembling the dinners with cold turkey, savoury dressing and cold salads. Maybe something happened in the night when no one was around? But how would she have known? How could she not have known? She thought she knew her sister, but suddenly she didn't.

As the priest's entourage led him up the aisle, Ed, Frankie and the other men gradually began to file into the pews beside and behind the women. The three Marsh women stood firmly and still, continuing to absorb the news and hide the emotional tidal waves that flooded their minds. Like tiny birds, their mouths chirped in rhythm with the hymns and chants of the Mass, but their backs were straight and their heads held stiffly high and pious.

Father William repeated the Mass in Latin with enthusiasm but his homily was in English. Latin was no way to reach a community with a real message, he'd always said. He wanted to be understood. His teachings were lost on Sarah, Elizabeth and Mary that day. They were held hostage by the crude reality of Sarah's shameful state.

The congregation carried the load and cloaked them in silence until the end.

"Go in peace to serve the Lord."

"Amen."

The priest led his group outdoors with the parishioners strolling lazily behind them. Once the majority of people were outside in front of the church, Mary turned abruptly to both girls, grabbing one arm each. Under her breath, she hissed at them.

"Not a word, you hear me?"

They both nodded.

"Fine," she said, looking at people as they passed by and forcing a compassionate smile. "Meet me in the ladies' area in a few moments while I send your father away."

They watched her scurry away.

Sarah started to shake, a sob emanating from her chest. Elizabeth hastily put her arm over her sister's shoulder and looked around to see who might be looking. No one, only old Mrs. Sampson crowned in her fuzzy beehive of cotton white hair. She was harmless. The old woman loved to know what was going on but unlike half the town, she never participated in the town gossip mills. She looked discreetly away.

Elizabeth had her arm around Sarah and walked her out of the crowd toward the ladies' area where they could talk in peace. Sarah leaned into her sister, trembling uncontrollably now.

"Omigod, Sarah, what happened?"

Sarah couldn't look at her sister and those searching eyes. She was so ashamed. All she wanted to do was wrap herself into a ball and be buried alive, deep in the rich, dark earth below ground where she could just close her eyes and fall asleep forever. She shook her head violently, tears flying out.

"How could this happen?" Elizabeth looked at her sister in shock, unable to read her hidden eyes. Sarah wrapped her thin coat around her body, rubbing her arms to stay warm and kept her eyes diverted.

"Aren't you going to tell me?"

"I can't."

"What do you mean you can't? I'm your sister, your best friend!"

Elizabeth quickly looked back toward the church for her mother. She saw she was on her way, as if she were coming to put out a fire.

"You don't understand. I can't."

"Sarah, honey, Momma is coming back. Hurry up and tell me. Who is he? Who did this to you? Come on, Sarah, I can help you."

Sarah shook her head, trying to wriggle out of Elizabeth's grip. Her sister couldn't help her; no one could.

"You're not going anywhere until you tell me." Elizabeth's pity was quickly shifting to anger at this betrayal.

Sarah looked up at her sister, shocked at the strength of her grip. She tried to pry her sister's fingers off her arm but Elizabeth would not let up.

"I can't. I won't." She ripped away and ran as fast as she could on wobbly legs with blurred vision, wet from shame.

Elizabeth's arms went up in the air before she ran after her younger sister. Their mother picked up her own skirts and followed suit. Sarah tripped past a shed on the other side and landed with a thud. In her mind, she had given up. She was ruined with tears, dirt and seed. She had no future, could expect no life here and could do not a single thing about it. The women each took an arm, pulled her up and took her to a log where they could all sit down.

"Sarah. What happened? When? How did this happen?"

"God, Sarah, how could you?" said Elizabeth.

Her mother and sister looked at Sarah as if she'd robbed them blind and would never repay them. She put her face in her hands.

"I...."

"What? Say it! Who? Who is he?"

"I tried asking her, Momma. She refuses say. I can't believe the nerve."

Mary ignored Elizabeth and leaned her face closer to Sarah, one arm held straight out, the other palm facing upward in frustration.

"Did you think this would be okay?"

"No," she cried, wiping the hurt from her eyes to clear them but they kept refilling, overflowing. "I-it wasn't my fault. He just....he just did it." It had only been a whisper but it made her face burn. She looked down at her hands. "Without my permission."

"Oh dear Jesus."

Her mother did the sign of the cross on herself and Sarah.

"Who is the bastard? Tell me. Was it Mikey over in Freshwater?"

"No!"

"What about them Walsh boys? Was it one of them? Was it Jack Davis?"

"Momma!"

"Well who was it, Sarah?"

"I can't say."

"You have to say. I'm your mother. Now who was it?"

"Wait," Elizabeth said. She had thought of something. "It was one of the American guys on the Base, wasn't it?"

"I can't tell you."

"See, Momma? I bet that's who it was."

"Look, I'm not going to say anyway because..."

"Because what?"

"Because he said no one would believe me and...."

"And what?" Sarah could see her momma was running out of patience.

"...and he said he'd kill me."

"Sarah, no one is going to kill you; this is ridiculous. Tell your mother who did this to you."

"I can't, Momma. I don't want people to know, and he's right."

She looked up at both women, eyes ragged pink around the rims, nose worn from rubbing it in her sleeve.

"No one will believe me."

Elizabeth looked at her mother's tightened face.

"What are we going to do with her, Momma? Even if it is one of the boys from the Base, they probably won't marry her and he could be long gone. Another load of them left the other day."

Sarah looked at their faces, dazed with disbelief. She wanted to float away, and watch from above.

"We're going to have to get her away from here for a while."

"What?"

Sarah knew they would want to hide this and send her away somewhere, but she wasn't ready to deal with this yet. She first wanted time to think this all through. She couldn't just go away. And where could she go? The only people she'd ever known were here.

"The moment you start showing, you have to be out of this place."

"But where?"

"Anywhere," said Mary. "Maybe St. John's. Aunt Grace is there. She could help if need be. We could all three go in to visit her. Then maybe she can get you into the convent there."

Sarah looked up, her eyes glassy but frozen.

"Convent?"

"The Sisters can look out for you until you have the baby."

"But it's so far away, Momma. Isn't there somewhere else? Somewhere closer?"

"Not a soul in St. John's knows you. Not like here."

"You'd send me away to St. John's of all places? I thought you said it was a terrible place."

"It is. But right now, you don't have a choice, my dear. None of us would live down the shame."

"But I didn't do anything wrong."

"Sarah, honey, that doesn't matter. People talk. It's just better for everybody if you're out...if you're able to take care of this in private."

"But a convent? Why a convent? Isn't that the last place I should go?"

"Oh, no. It's the best place to hide your condition and the safest. Only women are allowed in and it's protected from the public. You're not the first, let me tell you. And, besides, at the convent, it's free. We couldn't afford anything else."

"Momma, I couldn't."

"You must. You can stay with the Sisters while you carry to term in private, and then they will take care of the adoption."

"I can't have this baby," Sarah was shaking her head. "There is no way I can do this. I can't. It's disgusting."

Her mother's eyes narrowed and burrowed right through her.

"You will," she said.

Sarah opened her mouth again to say something and changed her mind. She caught her sister Elizabeth lifting her hand in truce, asking Sarah not to push further...and to let her big sister handle it. Don't do it, Elizabeth's face said. Don't push her.

"Momma, I can get Sarah ready at my house for the trip." Elizabeth and Frankie lived in a small saltbox-shaped house down the lane from them. In Fox Harbour, everybody lived down one lane

28

or another. Sarah wasn't sure what would be next. She looked up anxiously waiting for her mother's reply.

"No, Elizabeth. I want her at the house. Let's aim for the fall. She probably won't show until October."

Mary Marsh turned to face the church. Sarah could barely breathe, thinking about what might be going through her mother's mind as the tired, old, yet strong woman watched parishioners slowly make their way down the hill to their homes. Her momma looked at both of them again.

"Nothing about this to your father, you hear me? Not a word."

They nodded.

Chapter 4

Captain Pierce Murphy was running over his coordinates when he felt it: A quiet but present rumble in the pit of his stomach. A serious urge lingered at the base of his throat.

The *SS Rose Castle* was driving its way along the Grand Banks, a gust fighting with the red, white and blue flag that flapped behind the pole just above the crow's nest. As the Union Jack hung on, whipping and snapping furiously, the ship scored the waters and bobbed from time to time despite its bulk and size. There seemed to be no end of supply needed across an ocean of heightened danger. The Germans weren't fighting only in Europe. They were here, too, in these very waters.

Fortunately, Murphy had his own radar, one that rarely let him and his men down. He sensed danger when it skulked close by. He didn't have to see it or smell it to know. The skin on his forearms would tingle and raise quick bumps. He never needed to speak of it; he simply acted on it. Then normally, seconds later, the red dots would blip on the ship's radar screens, a knowing science of underwater viewing that saved as many soldiers as it killed.

"Boys, quick. Haul back, now, haul back. Do ya here me? Haul back, I said!" Captain Murphy stomped over to the eyeglass on the map and took it up to inspect these waters he'd known his whole life. His eye socket hugged the top of the spy scope and scanned the line barely separating the blue of sky from the blue water. Nothing visible. Nothing at all. But his skin was crawling.

"Williams, anything to report?" asked Murphy.

Officer Roger Williams cocked an eyebrow. "Nothing, sir. We've checked the radios and all the equipment. We don't think they're here, sir, and we're supposed to be over there to Bell Island in well under an hour. It'll be the usual load of iron ore from the mine."

"Ay," said the Captain. "Getting a bad feeling, is all, Williams. It's nothing, I s'pose."

"Yes, sir. Understood."

Officer Williams called back to the men who could send a message to the engineers. "Yes, yes, let's slow things down a little, boys. Not too much, now –just a little. See if the Captain is onto something."

The SS Rose Castle was one of a fleet of British ships manned by much-too-young Newfoundlanders who escorted other ships carrying goods back and forth from the mother country to the colony. The vast area of sea between Europe and the Dominion of Newfoundland was a frightening expanse of many lesser-known hiding spots. But the shipping lanes were well marked in many nautical minds and maps. Though the horizon looked empty, the threat of U-Boats remained ever-present below the surface. Stories deep, these corrupt submarines penetrated the unseen depths of liquid most often avoided by surface ships.

Captain Murphy felt the boat slowing down by a few knots an hour and took a deeper breath. He hadn't realized he'd been holding his breath for so long. He let out the air. It was a beautiful day but the wind was angry and on a mission to chop, turning its tops to white and surface to grey. His own flecks of grey hair were beginning to show since taking on this active ship. Turning 36 in two weeks, he was young for his profession. Fighting for respect had become part of everything he did. It became his survival among his white-haired peers who wore decades more wrinkled skin and hard-learned mistakes. They'd made their mistakes honestly, along a dangerous and threatening route with lots of back up and years to massage them over. He was in a faster lane, speeding ahead. He didn't have time to mess up. Men older than him, more arrogant than him, less talented than him choked in his exhaust and burned with resentment. Not only would he lose his footing, if he slipped up, he'd be thrown too many miles back. He had to be on top and stay on top.

His eyes never rested on the horizon; they surveyed, always alert. But even when he wasn't watching, his radar rarely let him down. Even when working, watching the unpredictable yet rhythmic ripples of ocean surface eased his mind and let him wander in and out of quick vignettes in his memory. The smell of her golden hair would always be there no matter what part he replayed in his mind. She was forbidden fruit, and much too young. He had a daughter only seven years younger, but he couldn't release this young woman from his mind. Relishing the smell of her, he added his own images and then he was with her, taking her, only sometimes willingly, breaking her, breathing her in until he was full and the nubile pleasure took over his pelvis until he shivered internally.

Officer Williams re-entered the deck with papers in hand.

"Sir, we're almost there."

Murphy felt a chill as the heat evaporated from his body.

"Engines are ready. The *SS Lord Strathcona* and *SS Saganaga* should soon be coming into view."

Murphy nodded slowly and jammed his thoughts back into the same ugly corner from which he knew they'd eventually bubble out again. One day he'd have to find release for his urges, but not today. Today, they had things to do, military things that throbbed with great importance and kept him in the speeding lane. He needed to retain his focus. The Allies counted on ships like his to get supplies back to Europe. There were no luxuries, no delicacies, no caviar, no American trinkets or custom fashions. They carted the necessities of war and peace, and like the Tolstoy novel, his cargo was massive: ammunitions, woollen blankets, tin rations, cigarettes, and the mail, too. Today, they were headed to St. John's, the *Rose Castle*, *Lord Strathcona* and the *Saganaga*, stopping in for a very brief visit and checkpoint before the last dip of the journey. They were heading to Boston the next night to refill with supplies, have a night on the town and go back overseas.

Murphy longed for Boston. Something about the productive, salt air in that Northeastern city with its steeped tea history and tainted

Irish brogue drew him into a never-never land. Still, he loved his Canadian home, the navy-port of Kingston; and he especially loved stopping in at Argentia. He got pretty close with the Marshes, thanks to running into Ed and Frankie at the Base on many occasions. He hadn't been sure about them at first, a little gruff around the edges but as he got to know them, he realized there was much more behind the tough talk than he'd initially realized.

"Now, Murphy, c'mon, b'y, have another one," said Ed. "No need to be such a Yank, wha?"

"All right, Ed, that's the last one, sir, or you'll have me dead."

"Don't listen to him, Captain," said Frankie. "He'll keep ya goin all night, sir."

"Wouldn't he!" said Murphy, grinning at the pair of them.

"You're a seaman, aren't ya?" Growled Ed.

Murphy sighed and nodded his head and threw back his last shot. That was all he remembered until he was rolling over on a daybed and saw a young blond-haired girl standing over him and staring at him, as if he were a stray creature who'd suddenly appeared on her porch.

"Who are you?" she'd asked, clear as a bell.

Murphy cleared his raw throat and tried to speak but had left his vocal chords in his last shot of rum. He squawked out his last name.

"What's that, sir?" She leaned in, her beautiful face only inches from his. He'd wanted to touch her face. Almost had, then Ed appeared suddenly in the doorway.

"Sarah, what are ya doin' to the poor man? Leave him alone, would ya? He's beat up with the drink, girl. Go make a cup of tea, sure."

"Okay, Daddy. But who is it?"

"It's Captain Murphy."

"Captain?" Her eyebrows lifted as she carried the kettle to the sink. "Of a boat?"

"Yes, ma'am, of a boat," was all Murphy could scrape out. He flopped back down, his head throbbing with the very loudly ticking clock.

"I daresay it's a boat, girl," said Ed. "It's one of those shipping boats, getting stuff back and forth from the war, my dear. A very important job, ya know!"

"Well," said Murphy.

"Well, it is, I tell ya," said Ed.

"Oh my!" The girl Sarah was intrigued. "When do you sail again?"

"Oh, later today," he said. "Not much of a break most days. Hard work, you see."

She nodded her head and poured hot water into porcelain cups. "Tea, sir, I mean, Captain?"

He nodded, taking the hot liquid and waving off milk or sugar. He tried to sip it without burning his lip. It never worked. He seemed to have a permanent scar in the peak of his top lip from tea. He could drink rum every night, no problem, but bloody tea tore his lips into bits.

"Nice to meet you, Sarah." She smiled. His heart warmed. She was so beautiful, so young. So young. He thought of his own sweet child at home and felt slightly sick with himself for immediately wanting this petite girl. He felt Ed's eyes burning holes through his skull.

"Well, I'd best be getting going. Thanks again, Ed, for the hospitality, sir. Must be on my way. Give my best to Frankie."

Then suddenly he heard it, felt it, saw it all at once and still didn't believe it. Off in the distance, twin bursts of scarred orange fires and angry, black debris shot into space, lighting air and sky. The explosions consumed both ships before Murphy and Williams' eyes. Neither man made a sound, though other men hurried around in a state of emergency all over the ship. A nightmare had unfolded in front of them and there was nothing either of them could do except get the hell out of there.

"About!" Captain Murphy let the call rip through the ship and men scurried to their stations to move the ship in another direction as fast as possible before the U-boat detected them. When they pulled into port, Bell Island was a shapeless bulk in the mist. On the opposite side of the explosion, they stopped to admire the work of the Germans. Shaking his head in distaste, Murphy sat down quickly. Boston would have to wait.

The northeastern morning was like any other in September. Flustered wind swiped the sides of the hills, pushing blunt trees in a practiced direction. Stubborn, stagnant fog clung to the dawn and insulated the harbour from sound. A few shrieks from the kittiwakes pierced the mist, marking a normal Fox Harbour soundscape.

Sarah rose early enough to dump her night pot outside before her sister and mother started fussing over it, as if she were five years old all over again. She probably should be relieved they were still talking to her, but fawning over her; this, she had not expected. She wasn't sure why she preferred to deal with her night pot privately; this first morning chore churned her insides and emptied her body of energy. She carried the small white crock made of thin porcelain on her hip, keeping her arm across the top and her head and nose as far from its rank maw as she could stretch. Once at the washroom, she dumped it, not staying to watch it flush itself down the old Government Issue toilet. As she slowly climbed back up the narrow stairs to her bedroom, she was struck by how significantly her body had changed: plump, tender breasts, a much rounder stomach, and limbs empty of energy. The thought of how she got here nauseated

her. She so often felt unclean, tainted, spoiled. She lamented often about this cruel situation. Life was not fair.

Wiped out, she sat back against her rag-stuffed pillow. Her bedclothes were rolled back lopsided, forming a compact sausage of thick patchwork quilts. The walls showed their age in pasty life-size patches of matted plaster, spider-vein cracks crawled into corners and intersected from multiple beginnings—making her think of maps—Paris, New York, Toronto, cities that were words in a story, places she'd never see. Even Boston where Captain Murphy lived was not within reach for a girl as poor as she was and especially an unwed pregnant girl.

In the schoolroom, Miss Geraldine made them study the big cities and their landmarks just like they studied the planets, sun and moon. She knew they were all out there: the Eiffel Tower, Mercury, the Statue of Liberty, Mars, and she could spell them out. It would be impossible to go see them. One was as far away as the others. Instead, she was trapped, strapped to this wretched island, to this raw shore until she was buried in the ground, smothered by acidic deserted soil.

More and more, she found herself sleeping past dawn, the grey morning light coating her. She'd wake up abruptly in a sweat of shock and fright, hoisting the bulk of blankets off her drenched body. Then when she realized how late it was, embarrassment for her laziness roasted her cheeks.

How did she sleep and not hear her father's clumsy amble through her parents' bedroom? The thick-muted clunk of his sock drawer, the dead stomp of his rubber boots, and the bark of his curses echoed as he readied himself for the North Atlantic? How did she miss the clanking of the steel poker against the iron stove as her mother wrestled with the fire? How did she miss the exquisite and yeasty aromas from her mother's lovingly kneaded home-baked bread as it sat on grates, the rounded bums stuck in the air, cooling in the dining room?

At least, this morning, she was alert. She rose from her bed and swung her rail-thin legs round to the floor. These cozy scents had

violently turned against her as the vapours clogged her throat and assaulted her delicate insides with nothing but watery drool to spew. She wiped her mouth and face, threw on a button-up housedress that still fit and joined her mother in the kitchen.

"Here, child," said Mary, handing her a lukewarm concoction of Newfoundland Pineapple Weed, water and honey. The easy-to-find weed had a calming effect similar to chamomile and dotted fields of tall grass all over the island.

"This will calm your stomach."

"But Momma, I can't."

"Drink."

Sarah had little force left to challenge and took the potion in careful sips, eventually relaxing into the stiff wooden chair when she realized thankfully that the remedy would stay down.

"I've been thinking..." Sarah's eyes slowly rolled up without lifting her head, ready to acknowledge her mother. Mary didn't look up. She continued to stir her pot of steamy clay-coloured porridge peppered with scrawny shriveled raisins. "I've been thinkin' about your father, and what we should tell him, now that we're in this mess." Sarah waited, sipping her cup of calm, breathing evenly. "You want to join the convent."

Sarah's cup jerked back from her lips, slopping warm drops of tea into her lap.

"Momma!"

Mary's dark eyes narrowed.

"Now, you listen to me, child." Mary's wooden spoon struggled to loosen the near-cement gruel on the stove as she spoke.

"The Lord's work is a worthy cause, mind."

Sarah brushed her fingers across the rough surface at the bottom of her mug, afraid to take her eyes off her mother.

"And I'm sure your father would only be so pleased that his little girl would be considerin' such a holy path."

Sarah could not speak.

"Yes, my dear," said Mary. "I think you'd make a lovely Sister, don't you, Elizabeth?"

Elizabeth had just finished wiping her black rubber boots in the rag mat in the main porch before entering the kitchen.

"What's going on in here?" she asked, as she removed her nutmeg-coloured woollen shawl from her lean shoulders. She eyed them both critically. "Yes, sure, she's a grand sister. I just wish she would tell us the truth about who did this to her."

Sarah sat up against the straight back of her chair, stone silent.

"Momma, look at her." Elizabeth gestured toward Sarah before facing her. Elizabeth stood tall at the table, her arms crossed and shut like locked gates. Her eyes searched her younger sister's face.

"I am your sister. We have shared every thought, every secret, every sigh together since the day you were born. You get pregnant and suddenly, I'm not worthy. You won't tell me anything."

"It's not that simple, Lizzy."

"Can't you just say who did this?"

"I told you, I can't."

"Why not? What do you think we're going to do, Sarah? Lord above, girl! He deserves to go to jail. He must go to jail." Elizabeth started pacing up and down the old linoleum floor.

"I'm going upstairs." Sarah stood.

"No, Sarah," said Elizabeth. "This is serious. Look, we're not going to go all over town telling people. When did you stop trusting me?"

Silence.

"My God, I can't believe it. Of all people, you can't tell your only sister, your best friend who this monster is?" Elizabeth searched out her sister's eyes. "You'd rather protect him than open up to me? You have some nerve, my dear." Elizabeth crossed her arms and looked away, hoping the shame would guilt Sarah into telling.

"Listen to your sister, Sarah." Mary's impatient tone resonated in Sarah's chest, freezing her to her spot. "You've told us the worst part, Sarah. All you have to do is tell us who he is and it's over."

"Over?" Sarah looked at her mother and then her sister. "Over? It'll never be over!" She felt the tears of shame and lost all access to words. In silent protest, she forced herself out of her chair and escaped to her room.

"Honey," Mary cried out after her, hoping to bring her back. But nothing could bring her little girl back—they were at a point of no return—the seed was planted. Now, her little girl was a woman enslaved by the Lord's mysterious wish for her to carry a child. Why this could be, Mary did not know. None of them knew; nor could they stop it. No one could halt the Lord's plan once put in motion. They could only accept it and all the changes that came with the arrival of this unexpected child.

"What do we do with her?" asked Elizabeth, shaking her head, still pacing back and forth. "It makes no sense to me."

"I know, child, I know."

"I'm starting to think that it's not one of the Yankees, that it might be someone we know." Elizabeth pushed stray strands of hair from her clear complexion. "Why else would she hide it?"

"She doesn't want to deal with it yet, girl, I suppose," said Mary. "Still in disbelief, maybe." Mary stopped stirring. She stared for a moment at the crucifix above the main door and slid into her own trance. She, too, was in denial. She sighed deeply. "I keep waking up every morning," said Mary out loud, "praying this is all a bad dream

and that my little girl is still a little girl—unharmed by some wretched devil."

"But what devil and why is she protecting him?" Elizabeth fought her anger. "Can't she see that she's helping him? We don't know who he is, if he doesn't pay for what he's done..."

"I am not helping him! How can you even begin to suggest that?"

Sarah's reddened eyes and shaky body appeared in the doorway. Elizabeth and Mary turned.

"Don't you think I'd love to make him pay?" Sarah spit the words on the floor.

"Sarah."

"Don't 'Sarah' me, Elizabeth. You didn't live through it. You have no right to tell me what to do." Sarah wiped the water from her eyes. "I would love to make him writhe in pain for the rest of his life, but there's nothing I can do without all of Fox Harbour knowing. I have to trust in the Lord. And when judgment day comes, he'll pay."

Frankie walked in and stood frozen, a fish splitter in one hand and guts on his coveralls.

"Did you hear?" he said. "A bunch of ships just exploded off the Coast of Bell Island."

"Dear God in Heaven," Mary stopped stirring her spoon, let go of the handle leaving it standing in the pot and hurried over to the radio to hear the news. She turned the dial and it hissed into action spitting out the announcer's words in mid-sentence.

"...also known as Dangerous Waters by the navies of the world who make regular trips along these vital trans-Atlantic convoy routes. Allied ships navigate these paths to bring vital supplies to Britain. Newfoundland is particularly vulnerable to threats as there are roving packs of German U-boats that lurk in these waters..."

The girls all breathed in audibly.

"Shhhh," Mary said, waving her hands frantically.

"The heroic efforts of these merchant ships are outweighed by nothing, only the acute dangers they face. Today, two such ships fell victim to this known threat. Both the *SS Lord Strathcona* and the *SS Saganaga* exploded off the Coast of Bell Island on their way to pick up additional supplies in Boston before heading back to Britain. It is believed that a German U-boat torpedo hit the ships killing 29 men onboard the *Saganaga*. The *SS Rose Castle*, a third merchant ship was in the area but was far enough from the blast to escape safely. We'll have more on our 6 o'clock report…"

"Captain Murphy!" said Elizabeth. "He was on the *Rose Castle*, wasn't he Momma?"

"He's one lucky son-of-a-gun," said Frankie, shaking his head before he turned and walked out the door.

Without another word, Sarah approached the daybed, lifted the thick bumpy quilt and slid her body underneath. She shivered slightly, turning her back to the world as she recalled Captain Murphy and how handsome he was. He had spoken so kindly to her every time she'd met him, like she were a princess or a lady from a distant land. He was always such a gentleman, unlike any man she'd ever met. He treated her as if she were a grown woman with thoughts and ideas and a presence. She remembered his eyes, sparkling, inviting and the colour of clear ocean water. She sighed and closed her eyes, dreaming of being older than she was, waltzing and swaying with him while he held his strong and warm arms around her. Within minutes she was asleep.

"I need a strong cup of tea," said Mary.

Chapter 5

Jack Davis Junior was sick as a dog. It was all he could do to keep himself upright on his boat. Never seasick in his life, he could never before understand why boats turned poor souls green around the gills, forcing them to hang over the side. He was hung over the side all right, but it was entirely the old black rum that done him in.

He wasn't just raised on this boat, riding with his father, the late Jack Davis; he was literally born on it. Fishing had involved the whole family when his father was alive. His mother Martha's water broke while they were to-ing and fro-ing out in the middle of the ocean just past the bay when out he came, right onto the deck, with only a towel protecting him from the fish guts.

Today, he struggled worse than any other time in all his three and a half decades of life. He cut the motor, leaned over the edge and braced himself before the side of his dory banged stiffly against the wharf, throwing his heaving stomach into a lurch. Out came the rest of his stomach's contents.

"Whoa, Jack, buddy!" Frankie jogged down the wharf in his coveralls, the mid-section glazed in fish slime and muck. "Did you hear about the explosions?"

Jack looked up in alarm.

"Two ships just blew up off Bell Island and Captain Murphy was on a third ship and managed to escape alive. Can you believe it?"

"How did…?" he paused.

"The German subs, b'y."

"Jesus."

"You all right, Jack, buddy?"

Jack, pale-faced and making no eye contact, heaved again but nothing else came out, so he climbed out of his boat and sat on the wharf, his legs dangling over the side, holding his head in one hand and bracing himself with the other hand.

"I'm just gettin' old, b'y," said Jack, wiping his mouth on his sleeve.

"Go on, Jack. Too much at the Base, man?" Frankie laughed through his question. Then he stopped himself, remembering Jack spent a lot of time coping with a dying wife and taking care of two girls. That's what he might have been doing last night rather than celebrating at the Base. Frankie looked away briefly.

"Look, sorry, Jack, I know you're looking after..."

Jack sighed heavily. "Naw, forget it. I think I'll be givin' it up."

"No, b'y, you aren't serious."

"I am."

"Sure, you'll be the finest kind tomorrow."

"Yes, I will." He started to push himself up. "Cause I'll be stayin' clear of the sauce, sir. Guaranteed."

Ed's boat was pulling into the harbour as Jack checked his own, seeing it was safely stored. Frankie wanted to ask him about Kate but figured it was best not to. No news was probably good news.

"Girls are good, are they Jack?"

"God, yes, they're doing great. Look, Frankie, I'm going to go now. Tell Ed I'll have to talk to him later. Can't do it, b'y."

"Take care of yourself, sir and maybe we'll see you at the Base." Frankie grinned at him but Jack was already walking away, shaking his head.

"She's coming to life," said Elizabeth. "Do you think she has come to her senses?"

Sarah groaned and rolled over, covering her mess of blond hair with the quilt. Stray wisps of hair like straw poked out from behind the cotton covering.

"So you're thinking about becoming a nun, Sarah?" Elizabeth said, not expecting an answer. She was sad for her sister and this new situation but she was getting tired of asking questions and having her sister refuse to answer them. She felt betrayed, alienated and rejected. The hurt burned and hardened her. "Daddy will be so pleased." Elizabeth smiled but her eyes scowled.

Sarah lifted the bedclothes off her body and sat up, rubbing her eyes.

Mary placed three bowls of steaming hot porridge on the table, trying to ignore the conversation.

Sarah stood mute. She straightened her skirt, taking her time to flatten out the wrinkles. Then she grabbed a piece of string from her pocket to tie up her hair.

"Going to stay with the nuns for a few months should be helpful—give you a chance to see what it's like before you leap in forever, I s'pose."

"I imagine so," said Sarah, her voice void of emotion. She refused to take the bait; instead she took her seat at the table.

"I'm told you need to live at the convent for six to eight months before making the decision to take the vows."

"I won't be taking no vows."

"Poverty won't be so hard. We're all used to that. Not so sure about obedience and well, chastity won't do much good now, will it?"

Sarah kept quiet, unsure of what chastity really meant.

"Momma, I think we're ready for some porridge," said Elizabeth.

"You can have it all." Sarah folded her arms over her middle.

"Oh no, my child," said Mary in a cross voice. "You're having something. This is no longer about you," she said, eyeing her daughter's stomach.

"Fine, but no milk, please."

Sarah could see Elizabeth eyeing her for a sign, an indication, something that would tell her the truth. Sarah getting pregnant was upsetting enough, but the secrecy had slapped her hard. They'd always had a trust between them that meant they felt they could tell each other anything. This sudden drop in trust was hard for Elizabeth to stomach but Sarah could not bring herself to divulge anything. This time was different. Sarah had expected disapproval, shock and sadness but not this bitterness. Still she wasn't about to ruin her sister's life with the truth. Her own life was already ruined. That was enough.

Reaching for her spoon, Sarah realized she was more worried about what her father was going to think. What if he didn't believe that she was considering the convent? Would he see her as pious enough to consider the convent or would he suspect something? She thought back to her own behaviour over the past few months or more. Would he have seen her praying? Had he noticed that she rarely missed Mass? Would he know if she went to confession every week like a good Catholic girl? More importantly, had he noticed the few times when she hadn't gone? She couldn't say. He'd never mentioned anything about that. It was usually her mother who was on them about going to church, praying to God and going to Confession. All her father concerned himself with was fishing, cutting wood and going to the Base.

45

"The only reason them young girls are wanting to go to that Base," said Ed one night at supper, "is to find themselves a soldier to marry."

Everyone around the table kept eating, knowing there was more to come. The sermon had just begun.

"Yes, sir. That's the only reason." He lifted a hefty forkful of mashed potato to his mouth. "And I can tell you," he said, pointing his fork at his audience, "that's the last thing them soldiers are thinking about is marriage. All they're thinking about is getting under all them skirts."

Frankie laughed out loud.

"Edward!" Mary stood immediately and crossed her arms. "Mind yourself, b'y."

"Now, Mary, sit down, woman. You knows yourself that's what they're after, aren't they, Frankie?"

"Yes, b'y, I s'pose," said Frankie, smirking while Mary hurriedly dumped more mashed potato onto plates, even ones that didn't need any.

"Yes, that's all they minds," said Ed. "Skirts!"

The two daughters struggled to smother their giggles, twisting their smiles into fake frowns. Still trying not to laugh, Elizabeth watched her plate as she spoke.

"I hear a number of girls do have Basemen as boyfriends, Daddy."

"Yes, now," said Ed, his white hair standing straight on end, his pink face colouring. "Well that just makes them all no good for nothin'," he roared, jamming more potato into his mouth and chewing vigorously.

"Daddy, Captain Murphy is at the Base, too. Is he like that?"

Sarah's blue eyes were wide with discovery and curiosity. Ed cleared his throat. Elizabeth raised one eyebrow at her.

"Oh, no my honey," said Ed. "Captain Murphy is a fine man, he is. He's very respectable and very married. No, I'm talkin' about them young fellas down the road and them Americans. They are the ones you wants to mind out for."

"Ed, none of our daughters have ever been near the Base unattended, nor will they ever be, so quit your foolishness, b'y."

"Go on, woman. Give us some of that moose meat there, luh."

Inwardly, Sarah sighed, her dreams of the handsome Captain Murphy somewhat intact, until Elizabeth kicked her quietly under the table. Sarah kicked her back.

Always grateful to get busy, Mary fetched the steaming bowl of game meat in dark brown gravy and slopped a heap of it onto her husband's plate. She eyed him with her right eyebrow cocked and ready to fire.

"Our girls are too good for any of them anyway," he said before plugging an over-sized chunk of stringy chocolate-coloured meat into his clean-shaven maw.

Ed chewed and nodded his head, signalling the end of his speech.

Frankie stood on the wharf exposed to the chilly winds, watching Ed's boat chug toward shore. A fine drizzle moved in, coating everything in a ever-present mist. Communicating through nods and winks, the two men shored Ed's boat, hauled the fish out, and brought their haul inside to be gutted.

Between the two of them, they whipped through a thousand pounds of fish in an afternoon. They were pleased, and so would be the merchants. In no time, they'd be ready for winter at this rate of prosperity. They cleared the guts, blood and oily films from the main cutting surfaces and hosed them down, the pressure pushing the

organic substances in motion down the drain and back into the harbour.

"Come on down to the house now after you gets cleaned up," said Ed. "Mary will make us a bite to eat."

Frankie followed his father-in-law up the road toward their lane from behind. He sized up the familiar outline of Ed in his fishing gear: a strong back, muscular shoulders—the kind that had mass, not definition—and hands like baseball catcher mitts. He took a deep breath at the thought of what this brute of a man could do to someone who crossed him. It sent electric waves of fright down his spine and through his heart. Death would be more appealing. Frankie caught up with Ed and gave him the news of the ships getting hit by the enemy.

Elizabeth was alone in the kitchen setting bowls of cooked turnip, carrots and cabbage on the table when the men walked in.

"Mary?"

"Just me, Daddy. Momma's out back for a minute." She paused to greet her husband. "Hi, Frankie."

Frankie nodded without making eye contact. Elizabeth was thankful her father didn't notice.

"That's somethin' about the torpedoes, wha?" Ed was shaking his head.

"Yes and thank heavens Captain Murphy made it out safely," said Elizabeth continuing to set out food and dishes.

"She got enough on for Frankie?" asked Ed, nodding in the direction of the table.

"Oh yes, Daddy," said Elizabeth without looking up.

Frankie nodded again.

"I'm going home to get cleaned up. Be right back."

Outside, Ed shed his oilskins and dropped them over a barrel to dry. He needed to wash them down and hang them in the store, the small shed-like building where he kept all his tools, fishing equipment and extra supplies. He splashed a bucket of water over the skins and left them on hooks for the next day. He walked back to the house and stuck his head in the door.

"Elizabeth," he barked. "Tell me when yer mother comes in. I'll be on the porch with me pipe."

The bottom step in front of the house was triple the height of the others and made for a comfortable stone bench for sitting outside. He sat leaning forward, his pipe in his right hand, his left hand on his knee. The air beyond his pipe no longer had the warm sultry smell of summer. Instead, the chilly and crisp air of fall carried with it the pungent smell of root cellars and decaying grasses. Mingled with earthy, tobacco smoke, the apple scent of fall. Reminded him of pie. Ed had trouble remembering the last time they'd had apple pie – the baking priority was always the staples: bread and buns, anything you could dip into gravy. Only on special occasions did Mary make the extra effort like on Thanksgiving or Christmas or for a bake sale at Sacred Heart Parish.

Puffing quietly, Ed's eyelids began to feel heavy. He fought the desire to skip supper and go straight to bed. Getting up at three am to fish was finally wearing him down after four decades. He was tired a lot these days. Going on 60 shouldn't be this rough, should it? He surely wasn't telling Mary anything or she'd hound him to 'go get checked' at the doctor's and he'd have no part of that. He didn't want no young feller out of school poking around his parts.

In his younger years, he'd unload a boat, get home and split a cord of wood without much more than a few drops of sweat on his forehead. Now, he struggled to stay awake by the time supper came. He didn't notice any of his buddies wearing down quite so quick as that; though, like him, they'd be too damn proud to let it show. Then he thought of Murphy.

"Jesus, he was a lucky bastard," muttered Ed.

"Ed, time for supper."

"Ed!" Mary shook him with all her might but he was still fighting it.

"Ed, for Christ's sake and ours, will you wake up?!"

Sarah had heard the racket and came to the hall, blond hair in a tangle.

"What, what is it, woman?"

"What's going on Momma?"

"It's Kate, Jack's wife. She needs to get to the hospital. Can you bring her?"

"I'll get dressed to watch the girls," said Sarah and raced back to her room.

Ed was sitting upright now, shaking the sleep out of his head. "Jesus, yes. Where's Jack?"

"He's on the porch waiting."

"Tell him to come in."

"He wouldn't. Hurry, Ed; he said she's going fast."

Mary ran out to the porch. "He's coming, Jack, in one minute."

Jack nodded, and proceeded to pace back and forth on the gravel, rubbing his hands together. The porch had been too still for him.

"We'll go down and see to your girls."

He nodded furiously again, keeping his eyes focused on the ground. He couldn't look at anything for fear the floodgates would burst. He paced.

"Come on, Jack. We'll go get her and she'll be grand," said Ed, grabbing his jacket and jumping into the car. The men drove off and left Mary on the porch making a sign of the cross.

"Sarah!"

"I'm here."

"Let's go see those poor little girls."

Sarah had fallen asleep on the bed next to six-year-old Maddy, who clung to her care-worn handmade stuffed bunny. Mary came into the room and unfolded one of the quilts piled on a chair near the child's small bed. Sarah was so tiny; she fit snuggly beside the little child. They almost looked like sisters with the blond hair and the quiet rhythmic breathing under heavy quilts. Mary covered her daughter with the blanket and kissed her on the cheek, then quietly closed the bedroom door behind her. She grabbed her shawl from around her waist and put it back over her shoulders. She should check on the fire again before the men got back with Kate. The poor woman would need all the heat and help she could get to feel better. That cough she had sounded deep.

Mary walked quietly down the stairs, trying not to wake anyone. She looked in on four-year-old Ellen who was in the room beside the stairs. She wanted to make sure the child was still asleep. Only Maddy knew her mommy had gone to the hospital. The little one hadn't woken up yet. Mary prayed mommy would come home soon and well. She lovingly stroked the soft light brown hair out of the child's face.

She thought of her unborn grandchild. She longed to have her daughter's child in their lives. It wasn't the child's fault how it came to be. The thought of such violence was horrible but she still wanted her grandchild, if only it could be done without shame to the whole family. She knew that was impossible. She wished she could turn back time and fix what had broken. But nothing like that could be fixed. She heard the door creak. She adjusted Ellen's blanket and walked to the kitchen, her heart full of dread. In the same way that

nothing could undo Sarah's situation, nothing could undo Kate's untimely death. Jack stood in the door, weeping. Ed sat in the car.

Mary guided Jack to the daybed, sat him down and let him cry his heart away. Once the first big wave had crashed, she stood without a word, removed his coat and hung it up. He kicked off his boots and lay down with his back to the kitchen, his expanse of shoulders shaking involuntarily from time to time. Mary got busy, boiling water for tea and making an herbal mix for bringing on sleep. She added a spoon of sugar and a good helping of rum and brought it to him. He waved it off.

"It'll help you sleep," she said. "Your girls are going to need you to be strong in the morning. Drink."

He sat up against the wall. There weren't too many people who said 'no' to Mary.

Though she'd already gone back to the stove, he thanked her for the hot tin and the cloth underneath to keep from burning his hands. While he sipped, Mary went about her business as if it were her own kitchen. She chopped carrots, onions and potatoes that she threw in a pot of boiling water and covered. She sliced meat and made sandwiches cut into portions and wrapped in cloth. She made a big pot of tea, with lots of sugar, water and ice for the girls in the morning. By then, Jack had finished his drink and had slid back under the covers. Ed was finally inside, sitting at the table, nursing a glass of dark rum. In a matter of minutes Jack passed out.

"Sarah and I are going to stay the night. He's in no shape to be on his own yet." Mary nodded to the daybed as she spoke. "I can do a bunch of cooking so he and the girls have plenty to eat while they try to piece it all together. God have mercy, she was so young."

Ed just shook his head and took a big swig of his drink.

"Sarah can take care of the girls for the day and we'll see what happens one day at a time, I guess."

"Not much else you can do than that, Mare."

"Finish your drink and walk home, Ed. It's bad enough that those girls have lost their momma. I don't want them waking up to a drunk old man."

"Go on, I'm not drunk."

"Ed, go home."

"I'm goin."

* * *

Chapter 6

Sounds of the morning outcast of boats in the harbour found their way back to Frankie's kitchen. It was five am and already men were on the water checking nets, jigging and working to feed their families for the year. Frankie was no different. If he could jam enough cod into his boat by late September, he and the Missus could use that stock to sell and barter for all kinds of necessities: flour, tea, salt, hard tack, yeast, sugar, molasses, salt pork, fabric, yarn, some meat, eggs and butter, and rum, beer and cigarettes.

Sometimes, the lucky fishermen might have a bit extra at the end for a train trip to St. John's or a ride to visit other family on the island. Others would go to the Base for a few runs at the slot machines. The Missus liked to get extra fabric sometimes for a new dress or for a baby quilt for a newborn that didn't exist.

It pissed him off how the boys kept giving him a hard time about it. Lord knows he'd tried to make her with child but nothing seemed to work. And yet girls all over the harbour seemed to have no problem at all. The Missus was so tense now—a piece of wood and unresponsive. She'd never been relaxed – most women probably didn't enjoy it the way men do anyway. Although what did he know? He had a bit of experience but he was no expert on figuring out women.

A few times when he was younger, he snatched a feel here and there like any normal fellow, and he would get a squeal or a shove, but that was what they were supposed to do, he figured. Most fellows probably wouldn't marry someone who wanted it all the time or they'd have something to worry about. Like that Lorraine Foley up on the hill. Now that one would take whatever she could get until she got driven out of the harbour for being such a whore. Shockin'.

Frankie took a hot gulp of his tea, slurping loudly. He chewed on the toutons the Missus made for him. He wondered if the Missus would be helping out over at the Davises now that Kate was gone.

Perhaps since she was going to be busy anyway, he might go gallivanting with Mikey later on down to the Base.

Slot machines. Yes, that's what Frankie enjoyed the most. He wasn't hooked on them like Billy Duke from across the harbour or Ron Smith down in Dunville, pouring their nickels in the slots instead of giving the money to their wives to feed their snotty-nosed youngsters. Those Smith kids were always filthy and saucy as a cracky. Their mutt dog was more polite than those youngsters. He'd like to give that young Jack a smack up the side of the head some day to straighten him out.

It seemed like ages since he'd been at the Base, but really it had only been three months ago...

The air that night was smoky and dry but palettes were thirsty at the Base. Frankie and his buddy Mikey were making their rounds on the machines, hoping to score at least one jackpot. The Missus knew he was there. She didn't realize he had a small sweet pot of coin on the side that he kept for this very purpose so she never really knew how much he had, but she knew he was there. That was the main thing. Didn't want to piss off her old man. Ed would kill Frankie with his bare hands if he messed with his daughter.

Tonight, he had 12 dollars and was on fire. He looked over at a slim girl standing three machines to his left next to her soldier boy, squirming shyly in her pretty dress. Her hair was piled high with golden curls bubbling around her smooth face. Her figure was curved, but firm. His Adam's apple bulged as he swallowed his desire all the way down to his pants. He looked away. His machine was doing okay and then, yes, b'y! Ten dollars in nickels poured into the pan clinking with sounds of success and prowess. A bunch of people clapped and hooted. Mikey came to pat him on the back.

"Nice one, Frankie! Well done. Let's get another drink." Frankie couldn't remember how many drinks he'd had but he didn't care. He and Mikey were on the go.

Another few rounds of drinks later, the Base flicked the lights. Frankie and Mikey jumped in the old beater car they shared and drove home. He parked diagonally for badness. Mikey took off down the lane, swerving dangerously on foot.

Frankie chuckled to himself. Feeling like a man in charge of his world, he pulled himself out of the driver's seat of his car. His booze-infused swagger matched his mood of defiance, recklessness and power. Frankie had no idea what time it was but it was definitely after midnight. He'd lost track of time. He clambered up the steps and suddenly got quiet. He didn't want to deal with Elizabeth right now. That would ruin his night. So he crept quietly into the front porch, cursing himself for not oiling the outside door – the Missus had ragged on him about it already, a few times. He held his breath for movement. Nothing. Good. He took off his jacket, swaying only minimally and flung it on the small footstool. He had a hard-on the size of an oilcan, drumming in his head, banging until he couldn't see or hear anything anymore. Then he saw her shape on the daybed.

The horizon of a female silhouette lay outstretched, waiting for him, calling for him. Frankie answered with movement. He unceremoniously grabbed the corner of the wool blanket and pulled it down. It was dark but the light from the moon shone on her face. The shock turned him on even more as her supple, youthful breast sat heaving with breath, partially exposed, waiting to be taken by him. A small voice in the back of his head asked a question. He looked up to listen for sounds and heard nothing. With all the thirst and pain of longing, his hand dove deep into her nightgown and clutched the warm white breast, while undoing his belt with his other hand. Then she started moving slightly.

He undid himself faster and moved his left hand over her half-open mouth instead. He reached down, made room in the pinned V-form of her legs underneath him and overcome with bursting pulses, tormented anticipation and the agony of his intoxicated pleasure, and shot into her softness, relishing the waves of release that followed. He panted wolfishly and finally done looked up. Her eyes were scrunched closed and locked tight. She fought underneath him until she stopped and sobbed.

He grabbed his belt buckle as held it up to her face.

"Open your eyes," he hissed.

Her face held trapped eyes of blood-red hate and bone-white fear. They followed the thick metal buckle he held it close to her face, pushing the corner into her delicate neck.

"One word about this and I'll fucking kill you, do you hear me?" His whispers were the loudest words she'd ever heard in her life.

She nodded frantically.

"No one. Got it?" She nodded again quickly.

Slowly he began to lift his left hand off her mouth while he held his right hand up to his mouth in a shush sign. Sarah grabbed the wool blanket and ran to the bathroom. Frankie felt sated, kind of stoned and exhausted. He'd been a bit pent up with Elizabeth holding back on him. He reluctantly smirked to himself; there was no way she was going to say anything. Satisfied, he walked up the stairs and fell asleep with his boots still on next to his Missus.

The day after, he rubbed his cleanly-shaven face, pondering. He had a pounding headache, his missus was giving him hell for being out so late and Sarah was nowhere in sight. The daybed in the corner was exposed but empty of emotion. It was as if nothing had happened. A hollow feeling in his gut pulled at him. He felt like shit about it but it was done now. There wasn't anything he could do to fix it. He had to try and forget about it or he might want more, and that would be too complicated and too messy.

No. He wasn't goin down that track. No. He got lucky and it made sense to walk away. He'd try again with his own wife and see where he got to. He hoped to God Sarah didn't go to his Missus or her old man. If she talked, Frankie would need to leave town. He drank his last drop of tea and headed out the door. He was pretty sure she wouldn't say a thing, and for the time being, he had fishing to do.

Sarah sobbed, but no sound came out. She sat down and cried as his seed dripped warm and sticky ran down the insides of her legs. There was blood, too. She'd heard if you stayed upright and didn't lie down; there was a chance you might not get pregnant. She started rocking back and forth, unable to stop the horrid scene from playing over again in her mind.

She had been soundly asleep so she hadn't heard anything until she felt the weight of him on top of her. Her eyes flipped open as her brain raced to understand the clamp on her breast and the hefty weight of a man's body trapping her to the day bed. She blinked in disbelief as it dawned on her who it was. How could it be Frankie, her own sister's husband? How?

The horror that struck her heart raged more violently than the actual pained that gripped her nipple. She watched in fright as he suddenly let go of her sore breast, undid himself hurriedly and moved his left hand over her half-open mouth, not stopping for a second to look at her. To him, she wasn't there. She was simply a female carcass for his evil need. Even if her mouth had been freed and wide open, she could not have uttered any sound louder than a whimper.

He reached down towards her most intimate parts and she realized he wanted much more than she could possibly allow. She fought to release her arms and hands from underneath him. As she pushed her shoulders upwards against him to throw him off, she felt his fingers probing underneath her cotton nightgown. He ripped her panties down and jabbed himself hard against her. She tried to pull back but she had nowhere to go. He tore at her muscles, going into delicate places, too tight to respond without sharp pains. Her mind cried out as he continued to jab over and over again for an eternal minute, sending deeper pains to all her nerve centres. Then he stopped, shrank and slipped out, leaving a wet path between her legs.

Now, her hands shook as she pulled a cloth along the trail of liquids from his body and hers, as she tried to erase the filth he had so violently injected into her. She couldn't touch herself to see what had become of her. The shame was too thick, the humiliation too deep. She gently cleaned herself without looking. She could no

longer bear it. Her heart heaved with agony. Why would he do such a thing? How could he be so cruel?

She now wished she'd stayed at her parents' house up the lane. How stupid of her to come here instead? She knew she couldn't have known but it seemed easier to beat herself up under the guise of wishful thinking than to think about what had really happened.

Then she thought of Elizabeth and slid to the floor of the bathroom, cloth still in her hand. Elizabeth could never know. Ever. Oh dear God, this would ruin her. Sarah's throat tightened at the thought of her older sister learning about such a painful betrayal. Deep, new sobs gripped her lungs and pushed their way up through her larynx. She coughed and choked on each wave, scrambling to catch her breath. She drew her limbs into her chest, slid further onto the floor, laying her head on the cold linoleum, forming a fetal position.

An involuntary shaking began as she thought to herself: her life was ruined. No one would want to marry her now. And what if she got pregnant? She couldn't believe that this had really happened. There was no way she could be with child and especially keep it. What would she do? How would she get passed this? There was no immediate way out that came to mind. She had to assume that she was not pregnant. No other possibility could exist. It was as simple as that.

She refused to be pregnant. Her parents would be so ashamed. The whole harbour would talk about her and what a tramp she was. And because of Elizabeth, there was no way she could reveal who did this to her. She tried to take stock of herself and failed miserably. Exhaustion hit her mind and limbs and bullied her to full weakness. She would need to try again in the morning. She shook until finally, she fell asleep on the bathroom floor.

Sarah heard a banging in her head. She rolled over on the hard, cold floor.

"Sarah, are you in there?" Elizabeth pounded on the bathroom door. Sarah bolted up onto her feet, blanket left on the floor in a tangle. She cleared her throat, not having spoken since she had been violated. A new wave of sadness overcame her.

"Sarah?" Elizabeth called again, concern etched in her voice?

"Yes, I'm here," Sarah managed quickly. "I'm fine. I...I'm coming." Sarah looked at herself in the blurry rounded mirror. Dark bags sagged under her eyes. Her hair had tangled itself into a nest and her cheeks had pink wrinkles from having slept on the blanket.

She opened the door and walked quickly passed her sister, going straight to where she kept her dress and shoes. She needed to get home this minute.

"Sarah?" Her older sister watched Sarah get dressed quickly and hardly got another word in before Sarah raced out the door.

"Are you...?" Elizabeth stopped. Her sister could no longer answer if she had left. "How odd," she commented to herself.

Outside in the lane, Sarah stood numbly in the middle. She wandered up behind the shed and flopped down on the hay, leaning back against the ancient wood, not caring if she got slivers in her head. Her head and her heart weighed so heavily on her, she wondered if she might ever be able to get up again. She struggled to push out the memory of his tearing into her, of pinning her down, of tearing out her very soul. Her body ached all over. She stretched out her arms and legs to see if they carried visible wounds. She prayed no one would notice how damaged she felt. Her internal wounds clawed at her constantly but they couldn't compare to the damage to her mind. She had to be strong and show a happy and normal front.

If anyone saw the depth of her true pain, she would kill herself. She wanted to take her Daddy's axe and cut into her muscles and tissues and break apart her bones to distract from her shame. Nothing would fix this. Nothing could. She would have to pretend until she could find the right time to end her suffering.

She thought about her poor mother and tears came like the rains. Her momma would never understand the agony that needed to end. Her Daddy would probably want to kill her anyway. She worried less about him and more about the women in her family. Still, she couldn't bear the humiliation of them knowing anything. Somehow, she needed to find the strength to pull herself together and survive until she could figure this out. And she would never be able to go to Elizabeth's house ever again. How would she pull that off? Elizabeth was her only sister. It seemed impossible to accomplish. She would have to make up very good excuses.

Time to go home. Sarah pulled herself up from the grass and walked to her house. Her momma called out to her from inside the front room. Sarah walked quickly by, flicking her hand up in a quick wave.

"Hi Momma, I am going to take a rest. I didn't sleep well at Elizabeth's," and before Mary could answer, Sarah was bounding up the stairs, two at a time.

Sarah slept fitfully for a few hours until her mother came to wake her.

"Sarah, child," said Mary, gently shaking her. "Honey, you are sweating!" Mary touched her daughter's heated forehead. "Child, you must be sick. You will get changed out of those clothes and into a clean nightgown and get back into bed."

Trance-like, Sarah rose and let her mother help her out of her clothes and into a clean shift. Without a word she climbed back into her bed and clung to her blankets, her back to her mother. She couldn't let her mother see into her soul. Not until she had mastered hiding her pain. She could barely contain it this first day. She prayed it would be easier soon.

"Poor girl," Mary cooed. "I'll get you some cool milk and a cold cloth for your head." She didn't mind that her daughter didn't turn to look at her. Clearly, the poor little thing was not well. Mary would see to a quick recovery for Sarah and headed downstairs.

When Sarah knew her mother was safely in the kitchen, she let a few quiet sobs escape. If she didn't, she feared she might explode. She forced the disgusting pictures out of her mind, though they clambered to return to her mind's eye. She worked to calm herself for her mother's return to the bedroom. Soon she would have the privacy of her room once her mother had tended to her a little.

After a few days, Sarah's fever broke and she found herself sitting up when her mother came to see her.

"Hello, child," said Mary. "Looks like you're coming around. Let's get you into fresh clothes." Mary pulled her daughter's nightdress over her head and stopped suddenly.

"Sarah, honey, what are those marks on ya?"

Sarah instinctively covered her exposed breasts.

"Oh, I can't say, Momma," said Sarah, turning her back on her mother to take a peek at her chest. There on her skin were dark marks of bruising, like small purple fingerprints left by Frankie. She fought the tears and shook her head. "It's too embarrassing to tell you what I was doing." She grabbed another dress and pulled it on.

"Okay, child. I hope nothing is wrong."

"Oh no, Momma, everything's fine."

It had been several days since the girls found out their momma was away in Heaven where God would protect her and make her feel much better. "She was always so sick when she lived with us anyway," said Maddy over and over again.

"But Daddy said she misses us."

"Oh she does, honey, she does," Sarah would say.

She stayed as many nights as she could so she could be there when the girls woke up and called for their momma. It broke her heart to hear them cry out. She couldn't bear to leave them for very

long. When she heard the girls cry, she touched her stomach, without thinking. It repulsed her to think of Frankie's evil seed growing inside her and yet that seed was forming a little child not much different from the two girls to which she'd grown extremely attached. How could she continue to hate her very own child almost as much as she loved these girls. She gave her head a shake. She couldn't make sense of that yet. Maybe some day she could love the child--a child--her very own child. A swell of anxiety caught her breath. She put her thoughts on this aside. She have live children in front of her who needed care-taking. She would focus on that for now.

Jack got up and went to work to take advantage of the last good month of fishing and was in no shape to take care of them right now. He was emotionally drained, himself, and she'd even heard him cry out in the night, too. She couldn't save them all but if she could at least give the girls some support, it made her feel a bit better and gave her own life a temporary focus. She could think about helping them instead of moping over her own future. They were so little. She couldn't leave them. But, the day came when she finally had to.

"Sarry, no go." Ellen folded her arms and pouted. "No! Go!"

"I'm sorry, Ellen, but I have to go for a trip."

"When you come back?" asked Maddy, equally unimpressed.

"I'll be back in the spring to see you again, okay? You need to be big girls for me, promise?"

"No promise!" Ellen ran to her room. Maddy hugged Sarah and whispered to her. "I promise. I big girl."

"Thanks so much for everything, Sarah," said Jack. "Make sure you write."

Smiling helped keep the tears at bay. Sarah waved quickly at Jack, said nothing more and ran out the door.

When she got outside, she put her hands to her face and sobbed. She stood there on the gravel driveway sobbing for the girls, for Jack, for Kate, for herself, and she couldn't stop.

"Sarah."

She couldn't turn around. It was Jack calling from his front step.

"Look, if…" he paused and spoke softly. "If you change your mind about the convent, you always have somewhere to go, okay?"

Imperceptibly, she nodded her head, then took off running home.

October came without warning.

Three small bags made from leftover house dresses and kitchen curtains in faded floral patterns sat idle out on the porch, waiting to be loaded into the car. The mist was already crawling its way in through the carefully sewn seams. These precious bags housed the very few garments that belonged to Mary, Elizabeth and Sarah that could pass as acceptable in public in St. John's City. They were harbour women. They were not destitute, no. But they were frugal and there was rarely any money for extras like new clothes or traveling bags. They were lucky enough to get their train tickets all the way to St. John's and back. They lived and worked every day in pitiable housedresses sewn by their own hands. Even their underwear was a product of second hand cotton. Almost nothing went in the garbage, especially not the flour bags.

The Robin Hood Company sold flour in giant, strong, 50-pound bags of white premium cotton which Newfoundlanders bought at the general stores and trading posts across the island and up in Labrador. Away from the men's questioning eyes, and once the family had consumed a bag of Robin Hood, harbour women quietly cut the windfall fabric into petticoats, undergarments and diapers for the children. They sometimes kept the scraps for cleaning cloths and other feminine needs. After a few washes, the cotton fell soft and eased snuggly into its new shapes and sizes.

If the women were able to collect a few bags in especially decent shape and without too many rips, the windfall meant sheets. The women would take giant metal scissors and slice down two outer seams, down one side and across the bottom; then they'd do the same with another and another. They sewed the giant pieces together using a flat seam and made sturdy bed sheets whose fibers softened comfortably with age.

Elizabeth stood on the porch and watched her mother buzzing around the kitchen making tea before their trip. It still stung that Sarah would not reveal the father to her. She deserved to know. She had looked after Sarah for as long as she could remember. She had helped Sarah learn how to darn socks without leaving a hard lump in the wool; she had taught Sarah how to read and tell stories about fairies and wolves meeting in the woods. She'd stood by her little sister when kids picked on her for being a frail little thing. They'd even had a few words about what it was like to kiss a boy—which really meant Frankie as he was the only boy Elizabeth ever kissed. They'd often struggled to contain themselves with bubbling but nervous laughter, afraid of waking their parents.

Elizabeth's eyes closed. Against her will, she couldn't stop imagining her sister's attack, trying to imagine what it must have been like for her, how scared she must have been and wondering how different it might have been had Elizabeth been there to stop it. Images forced their way into her inexperienced mind—pictures of Sarah, her clothes tossed, a dark male figure pinning her arms above her head as she cried out in silence. Elizabeth shook her head as if to knock the sin out of her skull. She suddenly felt a sickly dip in her abdomen. It was hard to shake the image that violated her young sister, innocent golden hair scattered around her precious head as the dark monster refused to stop the terror or to let his satanic face be seen. Elizabeth covered her face, near the edge of vomiting over the railing. One hand over her mouth, the other holding the railing, she opened her eyes and looked straight into Sarah's clear blue ones.

"Are you okay?"

Elizabeth took her hand away from her mouth, buried her anger and nausea and walked down the steps to her curious sister. Without

a word, she linked her arm through Sarah's and silently escorted her to the car, making sure to carry the bags.

"In your condition," said Elizabeth, "you should be careful."

Sarah blushed profusely and looked shyly away. Elizabeth was still angry about Sarah's secret but now and then couldn't help letting her big-sister kindness slip through. It signalled to Sarah that her sister was still the same old girl she'd always been. It would take some time to bring her back, was all.

Elizabeth opened the car door to the backseat and helped her sister inside. Sarah must have hated the process of getting pregnant. Elizabeth thought back to her wedding night and often wondered why anyone would want to have babies if it meant doing such a thing? She was both horrified and mystified. And yet, over time, she came to like it. She hoped Sarah would arrive at the same place but it was going to take some time and it would take the right guy, someone very kind. When Sarah shuddered, Elizabeth assumed her younger sister was simply chilled in the October dampness. She took a shawl from one of the bags, placed it over Sarah's tiny shoulders and waited patiently for their father and mother.

Ed climbed into the driver's seat, started the old Ford and turned on the radio. It usually took half the trip to even get the thing going.

"Stop fussin' with that old radio and drive, Ed." Mary had no patience for anything with buttons or dials.

"Now, Mary. Don't know if you knows but there's a war goin' on and I intends to find out what's happening." He jiggled the dials for a bit longer. Then a sizzle of voice began hissing in and out until finally it came into range enough to hear a tune. Mary's eyebrows crinkled, the tops of her cheeks lifted to narrow the shape of her eyes but she said nothing and sat back in her seat. Satisfied, Ed put the car in reverse and started down the lumpy lane.

Before they made it to the bottom of the lane, the broadcast of Glenn Miller's *In the Mood* was interrupted to bring them a report on some breaking news.

"A submarine hit has taken down another ship in Newfoundland. This time, civilians have been killed."

Mary covered her mouth.

"Oh, no children, I hope."

"The U-boat fired at the ferry, hitting it and killing 136 people, including 10 children."

"Oh, Lord have mercy," Mary said, doing the sign of the cross.

"Quiet," barked Ed.

"The *SS Caribou* left North Sydney at 9:30 last night to ferry passengers to Port aux Basques. On board were civilians, including 11 children, military personnel and crew. Military personnel who survived the Captain did their very best to prepare all passengers for possible U-boat attacks. More on this story later."

Ed turned off the radio and the Marshes stayed quiet until they arrived at the train station, secretly relieved at their choice of transport.

Chapter 7

October came without warning, and so did the torpedoes.

Captain Pierce Murphy was not easily rattled by the work he did, or by the most recent news from earlier about the *Caribou* going down. He carried himself like a military man and ran his steamship in much the same way. Though the attacks were happening more frequently, it didn't change his approach to the job. His courage and resolve remained intact, but he was starting to wonder what the hell was going on.

"Sir, they've confirmed that 49 of them were civilians," said Officer Williams, shaking his head as he re-read the message he held in his hand.

"Yes, Williams. Not sure what they'll accomplish with this tactic other than enrage their enemies into retaliation. All right," said Murphy. "Let's move out. I want to get us out of the way and closer to shore as soon as possi"—Murphy's words were interrupted by an enormous boom, shake and a tremor. Murphy and Williams were thrown to the side and both of their shoulders hit the deck with a clunk.

"We've been hit!" The men scrambled to their feet expecting an instant explosion. They stilled themselves for a handful of seconds and tentatively looked around. Williams was about to pull the horn and put everyone on emergency alert but Murphy stopped him by placing his huge hand on Williams' shoulder.

"Sir!"

"It was a dud."

"Sir?"

"It was a dud, Williams. They hit us with a torpedo but it bounced off us without exploding."

"We need to do something. We could have a hole in our side."

"Tell them to turn us toward the direction of the hit."

"What? Sir, they'll try again!"

"By the time they figure out that we're fine, we'll have hit them. They may still be close to the surface, go."

Williams ran out and signalled to the crew to not put anything on the radio that might be picked up by the Germans. They'd been trained to assume the worst.

Murphy collected himself and once they were ready, they fired into the depths at their invisible enemy lurking in Newfoundland waters.

When Sarah, Elizabeth and her mother were finally seated on the train at Main Branch Station, the tension began to leave their bodies. They stowed their tiny, soft bags at their feet, sat back against the red-upholstered seats and breathed deeply. Away from the questioning eyes of neighbours, they didn't need to shield Sarah from a potentially unwanted conversation.

"Oh my, Sarah. You're surely not putting on weight, are ya? A small thing like you?"

Maybe she's pregnant, they'd whisper, or worse: their eyes would look her over, like a scorned hag, they'd purse their lips as if to spit on her, and then they'd walk away.

And then there was their father. If he found out, he'd lose all patience. If she were lucky enough to get away before he put his hands on her, she'd feel grateful never coming home ever again. Sarah couldn't imagine what he'd do, and not knowing frightened her more. He had never laid a hand on her or her sister and she had never seen him hit another soul, but people were wary of him and his potential wrath. The opinionated outrage seething beneath the surface of his broad shoulders and massive square hands was enough

to make anyone think twice about crossing him. His pent up energy, the way he talked about people and their wrongdoings, the spit that flew out of his mouth when he disapproved, all of it was enough to make both girls live in fear of making him angry.

Mary fell asleep instantly, giving the two sisters some time to talk privately, something they didn't do often. Living in a small outport house with walls thin enough to allow both sound and wind to whistle through, anything they said was common knowledge in the household unless they talked at a bare whisper. To compensate, they had learned other ways of communicating their thoughts to each other while still avoiding detection. They spent hours practicing reading lips, using their own made-up sign language and paying attention to each other's facial movements and eyebrow signals. One raised eyebrow meant that they needed to talk at the soonest opportunity. Both eyebrows arched signalled disbelief and a need for more proof or information. Sometimes, blinking purposefully was enough to say, "See what I mean?" It made keeping secrets that much harder to do.

"Lizzy?" Sarah hadn't called her that name since she'd been a very little sister.

"Yes, Sarah."

"I know I don't have much choice but...I don't know if I can give this baby away." It had been the first time she'd admitted this possible truth to herself, the first time she'd spoken the words out loud.

"I'm sure it will be very hard."

Through the train-car window, the barren land spun by. Scraped and pockmarked from the ice age when glaciers pushed every stone forward and squat every tuft of moss into a flattened matt, this ragged silhouette of divots and lumps took its time unfolding across an entire wilderness. This unforgiving countryside harboured dirt that was as lacking in nutrients as the island's inhabitants and too acidic to grow much more than lichens, small root vegetables and

stunted, exposed evergreens sparingly dotting the hills, slanted by the unyielding wind.

"What if I could take care of it? I..." said Elizabeth, looking down at her hands, coping while she searched for the right words to soothe her sister and save this baby.

Sarah cringed in the silence.

"I could love it as my own and you could, too," continued Elizabeth. "We could say I was the mother, then you'd be the baby's aunt. That way she won't be sent away for adoption."

Sarah put her hand over her mouth. She didn't want to cry anymore, but bit by bit, the potential loss of this child inside her started to overwhelm her disgust for it. Then, she straightened up.

"You said 'she'."

"Yes, don't you think so?"

Sarah's reply wasn't audible.

"I feel like she's real already. Though I'm horrified by how she has come to us"

Sarah simply nodded. She knew Elizabeth was right. She knew they couldn't let this child slip away to unknown horrors. But to deal with the devil she knew was equally horrible. This solution would have been perfect had the father been anyone but Frankie. Sarah could handle giving her child to Elizabeth; she would stay close to her real family and Sarah could be there as she grew up. But give her child to her violator? She wasn't sure she could do that.

The train's rhythm and sway rocked their bodies gently from side to side. Their mother started to wake. They both watched her turning her head to one side, then turning back to rest. They waited until they knew she was back to sleep.

"So what did you have in mind exactly?" Sarah had finally managed to speak.

"I could pretend to go through the motions of being pregnant. I would tell Frankie. He'll be…well, he'll be Frankie: indifferent."

"What would you tell Frankie?" Sarah's eyes grew slightly wider at the idea of him knowing anything.

"That I'm pregnant."

"You wouldn't tell him that you're just pretending and that really it's me who is?"

"No, it's easier if he doesn't know."

Sarah experienced instant relief and sorrow in equal measure.

"When the key times come around, I'll make sure I have a belly. The only problem would be if anyone tries to reach out and touch my stomach, like Mrs. Wilson or Nanny Ferguson. You know what they're like. Oh come here and let me see you up close. Oh my, you look grand. Then without another word, they'd slide their nosy hands over your stomach in a blink, saying, Oh I think I feel it kicking."

Sarah was silent.

"Or," said Elizabeth, "maybe I could stay at the convent with you? After all, I would need to be on bed rest until I had the baby, right?"

Sarah blinked in disbelief. Elizabeth really wanted to go through with this.

"Oh, Jesus, Mary and Joseph, tell me you're not in that way, too, are ya?"

Mary had abruptly awakened and was now crossing herself again and again.

Elizabeth gently grabbed her elbow.

"No, Momma, I'm not pregnant, but I could act like I am and take care of Sarah's baby as my own. You know, raise her in mine and Frankie's house. No one would know any different."

Mary didn't know what to say. She knew her oldest daughter had been married for three years now and hadn't been able to have a child. Some people in the harbour were talking about it, her friend Geraldine had said. Mary, too, would love to have a beautiful grandchild.

"I don't know." Mary's hand reached up to her face where her fingers rubbed her bottom lip while she pondered this scenario."Oh please, Momma. This baby will disappear into some awful situation and we'll never see her again. Sarah and I can do this. You know Frankie can't make babies."

Sarah closed her eyes to trap the tears. She knew how untrue this was.

"Elizabeth, watch your trashy mouth, mind," said Mary, her face crumpled in disbelief and disapproval.

Elizabeth lowered her head before she spoke again.

"I'm sorry, I forgot myself."

Mary nodded her acknowledgement. Sarah remained focused on her hands, avoiding eye contact with her sister.

"We won't ever tell anyone it's Sarah's?" Elizabeth let the silent, expectant air hang between them.

Mary's lips formed a determined line in an uncertain situation. Her daughters returned to their own thoughts, knowing their mother's door to discussion was shut…for now.

The train pulled into Whitbourne station. Most of the travelers in and out of here were soldiers or Newfoundland Rangers going back and forth from St. John's to various outport communities, waiting in huddles to go home for the weekend or into St. John's for a few nights on the town.

The women looked away from the men's wandering eyes and kept quiet until all the soldiers were seated in the next car. The conductor was collecting tickets and announcing something in the

car before them. The women looked up expectedly but until he got closer, they couldn't tell what was happening. They could hear the buzz of reaction and gasping from the next car.

"I bet it's another U-boat hit," said an older man to his wife. They sat across the aisle from the Marsh women. The wife hugged her arms and muttered to herself. "Those poor sailors," she said.

"Tickets, tickets, please, ladies and gentlemen," called the conductor. "Good news and bad news. We just got word of another hit but everyone is safe. A U-boat hit the *SS Rose Castle* but thankfully, it was a dud and no one was hurt. Tickets, tickets please, ladies and gentlemen…"

The three Marsh women instinctively blessed themselves.

"My, I hope Captain Murphy gets home safe soon." Mary was shaking her head. "How many times has that been? He's running out of lives."

The bantering voices on the train eventually toned down into a dull hum as the train pulled out again, lulling the Marsh women back to their own thoughts.

Chapter 8

Serene hymnal music played quietly behind the white plaster walls of Mother Anne Martin's dark wood-paneled office. Slowly she worked her way through letters addressed to the Sisters of Mercy Motherhouse, Mercy Convent on Military Road in St. John's, Newfoundland. Even without the street number, the letters always managed to find her.

She purposefully situated her work area near the choir room to ensure her ongoing musical connection to God. It not only strengthened her faith to hear the girls singing, it forced the young sisters to buckle up and pay attention to their progress during rehearsals knowing the Mother General was always listening. The unpolished voices soothed her while she worked.

The entire world was a raw unvarnished land compared to the beauty of the Lord Almighty's Kingdom. This Earth would never reach such holy proportions; it was nothing more than a simple wooden table that lay bare, impressionable and full of potential. It gave her comfort to play a part in carving its destiny, bringing this piece of craftsmanship to a greater height of art through her service and that of her community of Sisters.

Sister Ella Gaulton tapped on the door and waited.

"Good evening, Sister Ella. God never rests, and nor will I. Come in."

"Yes, Mother." Sister Ella carefully entered the sacred office of her dear Mother General, gently easing the door closed behind her, hoping not to make a sound – though the choir could still be heard through the walls and halls.

"What is it, Sister? Mother Martin was still looking down at her work waiting for an answer."

"Dear Mother, I'm sorry to disturb you but…"

Sister Ella Gaulton's hands were clasped together, one inside the other, but she couldn't keep them still. Her hands changed places, circling over and over each other until she was ready to share her message. Interrupting Mother Martin always forced her to re-think every word before speaking…

"But what? Spit it out then."

Mother Martin lifted her head and glared at Sister Ella for a moment. She continued vigorously slicing her envelopes with a knife, freeing letters that spilled into her lap.

"Well, there is a family of Marshes at the door, Mother."

Sister Ella's cheeks still burned wild rose pink from the conversation she'd had with the bedraggled women on the front stairs before swinging the thick wooden doors wide open to let them in.

"And?"

"And, that is, there is a young woman named Sarah Marsh, accompanied here by her mother and her older sister from Fox Harbour, who needs somewhere to stay…during her-her term, Mother."

Mother Martin looked up at Sister Ella's cheeks. The young sister's eyes darted from the knotted spruce floor to the mahogany shelves where they kept the bibles and textbooks, back to the floor again, hands circling each other, holding each other, circling.

"I see."

Mother Martin sighed briefly. Her young sisters had trouble discussing such sinful predicaments, and truthfully, they hadn't had one of those cases in quite a while – almost two years. She nodded.

"Fine, then. See them into the main room and I'll be right out."

"Sure, Mother."

"That's 'Yes, Mother,'" Sister Ella. "Please mind your manners."

"Yes, Mother."

Sister Ella scuttled out before hurrying down the hall.

Mother Martin shook her head. What was she going to do with that girl? Born under a rock, she was. Oh well, one day at a time, she supposed. Now, Sarah Marsh…her eyes followed her right index finger down the page in front of her as she ran through the messages she'd received over the last four to five months. Nothing in the name of Marsh. She sighed heavily. With no additional money coming in this fall, things were not looking very good for unexpected dependents. As her own poor mother reminded her many times, the Lord's work was never easy and certainly never done.

She pulled together the letters in her lap, stood straightening her long white skirts with her free hand and then laid her pile of correspondence on a side table near her reading chair for later. She had visitors to attend to.

In the main room, a frail young woman with wisps of golden hair sat staring at her shoes, looking for penance. Soon enough, thought Mother Martin, she'd have to face the wrath of the Lord.

Beside her, the mother sat politely with hands folded in her lap. Either unaccustomed to waiting in formal situations or unsure about her daughter's new fate, the mother's fingers opened and closed, reaching for something, or perhaps trying hard to let go. Her black wool coat, pilled and ragged with years of harsh-winter use, housed a woman, ravaged with poverty but strengthened by survival. It was late October, and since Newfoundland inhabitants never knew what kind of gale-force winds they'd encounter on their journeys, or what temperatures they'd run into, this poor woman had worn her winter rag.

Mother Martin sighed in pity for these outport women. She shook her head quietly when suddenly the third young woman who had been standing now unintentionally sank to her knees.

"Oh dear," said Mother Martin as she moved toward the young woman to help her. "Sister Ella, run and get salts and a cold cloth. Quickly!"

She touched the woman's forehead with her icy-cold hand. Elizabeth lifted her head gingerly but couldn't lift anything more and lay back on the cold wooden-plank flooring with some effort.

"Here, Mother Martin. Oh my!" Sister Ella stood back, silent, frozen, her hand cupped over her tiny mouth.

"It's okay, everyone. I think she'll be fine. She's had a spell. Sister Ella, please help us get Ms. Marsh to a bed on the second floor, if you could."

"Her name is Elizabeth Healey, please," said Mary. "And thank you so kindly. I believe she's tired from the trip. I'm Mrs. Mary Marsh, her mother."

Mary didn't dare extend her hand. She simply nodded, her lips drawn tight.

"Yes, likewise. You can call me Mother Martin," she said, as they helped Elizabeth up the stairs.

Sarah's only interactions with people of the cloth were with men. Her encounters with them were very specific. She sat in her pew during Mass while they pontificated about the Lord's Kingdom and how unworthy the congregation was; or she kneeled in a stuffy wooden box with a screen between her and Father William where he expected her to tell him about dark secrets and poisonous behaviours. Sweat trickled down her neck underneath her dress collar at the mere thought of that caged-in prisoner's box. His homilies warned them against the evils of sin, yet weekly he expected her confessions of sin and evil during their one-on-one trial. She wondered if women of the cloth also had to go to confession as the Sisters clustered in their pristine white robes to shuffle Elizabeth up the old dark-wood staircase, and if they did, to

whom did they confess? Sarah wasn't sure if she should stay put or follow them.

Mother Martin looked back at Mary, one of Elizabeth's arms draped over her shoulder.

"Mrs. Marsh, this is Sister Ella. The others are in the chapel at the moment but since you'll be staying for dinner, you can meet them at 5:30 in the dining room."

Mother Martin paused. "Please don't be late."

Visibly pleased and mildly embarrassed, Mary smiled tentatively, and with great effort. Sarah climbed the stairs behind them, finally joining them. "Yes, of course. We'll be there."

Sarah surveyed the small room. A washstand sat in one corner, a simple chair in another. Elizabeth lay on the single bed with a cold cloth on her head. Was she already pretending to be pregnant, Sarah wondered. This was hardly necessary; they only just arrived, for heaven's sake. She frowned and moved their bags out of the entrance where one of the Sisters had left them and closed the door. Mary sat at the foot of the bed, absently caressing Elizabeth's leg while she stared at one of the walls. Sarah wished she hadn't put her mother through this but they were here now and would have to move on. That didn't stop her from pacing.

At dinnertime, Sister Ella came to Elizabeth's room to call the Marshes to join them for dinner. They were all sitting quietly with their hands in their laps, waiting, including Elizabeth.

"Dear Elizabeth, are you well enough to join us for supper?"

Elizabeth nodded.

"Good. This way, please."

Sister Ella showed them down the stairs, through a narrow hallway and into a carpet-muted room. Around the long table were several women of the cloth.

"Ah come in, come in, Mrs. Marsh, please. Bring your daughters. Have a seat. We're about to begin. Let us bow our heads and pray."

One of the Sisters near Sarah automatically grabbed her hand. Startled, Sarah drew back, hesitant. The Sister didn't dare look up, her hand held frozen, waiting. Sarah watched women in white reaching out for hands that linked them one-by-one in unity. She grasped the chilly, bony hand to her right, her mother's warm, rough hand to the left. She lowered her head. After a few seconds, she rolled her eyes upward again to look at the scene, taking in the sisters. At a glance, they all looked the same, equal and yet behind each habit sat an individual. She surveyed the multiple white veils covering the tops of their bowed heads, no faces or distinguishing features to be seen.

"Praise to you, oh Lord, for these Thy gifts which we are about to receive from Thy bounty through Christ our Lord, Amen."

Sarah dropped her eyes quickly.

"Amen."

The Sisters passed the bowls of food while Mother Martin talked.

"Delighted you could join us for dinner, Mrs. Marsh," said Mother Martin.

Mary nodded. "Please," she said. "Call me Mary, if you don't mind."

"Tell me, Mary, what's the latest in Fox Harbour?"

Mary's eyes widened a little. The latest? Sarah and Elizabeth took quick sidelong glances at each other. Their mother had no trouble speaking her mind when it came time to do so, but when anyone belonged to the church, she often froze up like a mussel trapped shut.

"Is Father Pomeroy still there?" asked Mother Martin.

"Oh," said Mary, breathing a little more freely and smiling slightly. Both her daughters' shoulders relaxed in unison. "No, no."

Mary was careful to omit any scandalous details with so many sacred people in one room, but Father Pomeroy had long gone away under hushed circumstances. Nothing had ever been proven, but lots of folks whispered a web of details with plenty of holes that eventually stuck. Instead she told the Sisters he'd moved on to the Burin Peninsula to take up the Lord's work. The Sisters tittered as she speculated how the biting winds and bountiful snowfalls in that region would likely push him to question his vows to the Lord. Encouraged, Mary chatted her way through the latest rash of births, including a couple of sets of twins, and the not-so-sudden deaths of a few older souls who had passed away in the long nights of summer. Mother Martin listened intently as she slowly plugged respectable-sized mouthfuls of bland but filling food into her mouth. The other Sisters ate quietly without utterances, even of acknowledgement. They were spectators looking for glimmers of entertainment or invitation to join in. Until then, the conversation was between two people and two people only.

The two senior women talked easily through the entire meal not once addressing the Marshes' reason for being there, until the meal was finished.

"So, I understand that one of you might be staying with us for a little while?"

Mary's mouth opened in shock. She would never have dared to talk about such an intimate subject so publicly and with a full table of members of a religious order.

Mother Martin smiled. True, she usually discouraged secrets and she never considered her convent Sisters as a public audience, but she knew there wasn't a prayer in Heaven that these young things would ever suspect one of the girls to be pregnant. They would assume she's joining the convent.

"Actually, if it would be okay," said Elizabeth, "both of us would like to remain together for mutual support."

81

The Sisters whispered urgently to each other, aghast at how bold this young woman was and how directly she spoke to their Mother General.

Mother Martin still wasn't sure which girl was pregnant. Clearly, Sarah was frail and had her mother's attentions. However, Elizabeth was the one who swooned. Mother Martin would have to get the story later that night.

"Sisters, please." Mother Martin eyed them sharply before she continued. Simmering down, the circle of white heads lowered, contrite.

"Very well," she said, looking around the table. "Does this mean you both are considering joining the convent then?"

Elizabeth cleared her throat before speaking. "Yes, Mother Martin."

The Sisters slowly nodded their heads, smiles on their lips.

"And so I assume you, too, Sarah will consider?" Asked Mother Martin, thinking she might be able to get a bit more funding if she had some new recruits. "We are always looking for young women to join us in our efforts to do the Lord's work."

Sarah's eyes stared silently at her mother's face and nodded quickly. Mary watched the Mother General.

Elizabeth chose to stare straight ahead. The other heads draped in white veils dared not look up in the heavy and growing silence that hung.

"Lots of time to think about it, of course."

The ladies around the table nodded their heads in quiet relief and earnest agreement.

"On another note," said Mother Martin, "I have some mail you can take back to the area post office for me, Mary, if you wouldn't mind."

"I would be happy to help," said Mary, ignoring her youngest daughter's pleading look. "Thank you for taking both daughters at the same time."

"As long as you both can share the same room, I see no problem with that."

Mary smiled more warmly.

"So, ladies, you know what to do. Guests, we'll say our final dinner prayer and then we'll chat privately in the Great Room."

Chapter 9

When Mother Martin met with priests, bishops or other important clergy or visitors, she received them in the Great Room of St. Francis of Assisi. It was a special room to the side of the main hallway behind closed austere doors, bound with burgundy leather padding that prevented sound from travelling beyond its sacred and enclosed confines. So guarded was the privacy of the Great Room that young Sisters were not permitted to enter until they had graduated and finalized their vows.

"Sister Ella, please check on the Great Room for us. Without question, we're going to need it for the upcoming delicate conversation that must be had," she insisted, watching the young Sister blush again.

Wide-eyed, Sister Ella nodded her response and left the dining room. She arrived only moments ahead of the others. By the time the tall and lanky Sister Marguerite Mullins escorted the Marshes into the Great Room, Sister Ella had placed a tray with hot tea, cold biscuits and cream and sugar on the beautifully polished mahogany table in the middle. Surrounding the refreshments were comfortable, leather-bound armchairs placed in a private circle. Off to the side stood another matching table surrounded by stately wooden chairs, facing inward as if meeting about an important matter.

"Please be seated."

Mother Martin waited until everyone was seated before she sat in the leather chair at the back of the room, straightening her long white robes in practiced flourishes.

"So, tell me the situation, Mrs. Marsh."

"My daughter Sarah is 15." In the brief silence that followed, Mary struggled to continue.

Mother Martin maintained a neutral, unmoving facial expression as she processed the news. It was worse than she had thought. At 15, there was no hope for this girl unless she joined the convent. Her mind was made up.

Mary couldn't take her eyes off her own calloused hands, feeling sudden shame in the presence of this woman of the cloth as Mary worked up the words to keep on. "I'm afraid, Mother, she was, um, forced into pregnancy by a man in the community."

"I see," said Mother Martin, touching the varnished wooden cross hanging around her neck as if to ward off the evil such knowledge inspired.

Mary covered her mouth and fought the cruel exposure of burning tears yet to be released. "I'm sorry, Mother. It's a terrible thing to hear, I know. We are ashamed of this mess."

The Mother General watched young Sarah rub her forehead, pressing in repeatedly as if trying to wash out the stained hideous black mark her mother seemed to carelessly plant on the girl. The older sister calmly placed her hand on the back of Sarah's neck and tried to whisper to her, perhaps words of encouragement or comfort. Just as swiftly, Sarah jerked away, rejecting her sister, a shadow blocking the intended warmth. This child will be a handful when she doesn't get her way, thought Mother Martin. She watched Elizabeth's pained expression and wondered how long before they would stop speaking to each other. No sound was heard inside or outside the room in those 15 seconds of penance. She allowed the silence to do its work

"I understand, Mary. Please go on." Mother Martin handed her several tissues.

"We do not know who he is," said Mary, pausing to glare at Sarah's averted eyes, "and she refuses to tell us. I didn't know what else to do with her, only bring her here."

She refuses? Mother Martin's eyebrows lifted in mild disbelief—it was worse than she thought. A 15-year-old refusing to provide vital information in an impossible situation where she had no

options. She leaned forward, suddenly eager to engage now that the challenge was visible. She would fix this girl, if not for her family, but for the Lord Almighty, for she lacked the humility, respect and honour of a good Catholic if she carried on this way with her own dear mother and that would not be tolerated. She saw Mary lean forward in response, visibly eager to continue.

"Fine," said Mother Martin. "We'll come back to that later."

As she quietly drank her tea, it occurred to her that from the outside, this could have been the most ordinary conversation between civilized women of society, yet it wasn't.

"I know she cannot have her baby in Fox Harbour," said Mary. "So I thought perhaps you might be able to help. Word of your good work has made its way around the bay, Mother Martin."

"I'm glad to hear that we have reached communities in some small way, Mary. Now, to do this for free would be quite the request, as you must know. So I will assume that both of you will help with the chores and other duties that may need doing until, Sarah, you are no longer able to?"

"Yes, Mother Martin," they both tentatively responded.

"Lovely, then. Mrs. Marsh, you are free to stay a few nights, before you say goodbye to your daughters. Then we'll move the girls into the Sisters' living quarters. You both can stay until April or such time as the baby is born. So, let's discuss what happens to the baby."

"Yes, well, I was thinking…" Elizabeth hesitated, as they hadn't really had time to confirm the entire plan with their mother.

"Yes?"

Elizabeth paused again and looked at Sarah's bowed head. "I was thinking of keeping Sarah's baby and raising her as my own."

Mary and Sarah remained motionless.

"I have been married these past three years to Frankie Healey. We've not been able to conceive yet and I thought…" she paused.

Mother Martin curiously eyed Sarah visibly cringing, her shoulders lifting involuntarily as her neck and head sunk further to a hung position.

"You are in your childbearing years," said Mother Martin eyes darting back and forth, searching for signals, "and so it should seem quite natural for you to finally have a child."

Elizabeth looked down at Mother Martin's pure white hands during the silence. The woman's nails were clipped in straight lines.

"Have I understood correctly, Elizabeth?" asked Mother Martin, wanting to understand every detail, no matter how seemingly insignificant or intimate.

"Yes." Elizabeth stared at the floor for fear of seeming too eager. Her heart pounded impatiently at how dangerously close she was to the possibility of possessing a child she could call her very own. It would mean acting as if she were my baby and as if Sarah were her Aunt.

"I see, yes."

Sarah held her breath.

"Sarah, do you think there is any chance the father may come looking for the right to his child?"

The hot air in the room was too thick to breathe, clogging Sarah's throat. She coughed before she spoke.

"Are you okay, dear? Have some water." Mother Martin poured water into a teacup and offered the lukewarm liquid, her sacred eyes ice blue as they examined Sarah. She shuddered at the thought of being alone with that razor-sharp glare as the tepid water wet the top of her throat. Then, she shook her head.

"He wouldn't. There's no chance. He doesn't even know…" said Sarah, not bothering to finish her sentence.

"I see," said Mother Martin. "I think in this case the Lord would find it in His heart to forgive you all this transgression for the child's sake."

Mother Martin looked at Mary's anxious face, and wondered what she might accept. She might have been without income, but she was rich in pride and concern over her daughters. Mother Martin's eyes reluctantly conveyed a glimmer of admiration.

"Are you comfortable with this plan, Mary?"

They watched Mary's face. Worry settled into her drawn and wrinkled cheeks. Finally, resignation rose high across her cheekbones. She stood quietly and walked toward the empty meeting table, trying to imagine bishops and priests sitting around, deciding the parishes' fate. Why couldn't her granddaughter be brought into a world of stability and contentment? Instead, it would be filled with secrecy and shame and she would never know her own mother. Mary's timeworn hand covered her heart.

"Mary?" Mother Martin stood slowly.

A tear fell from Mary's eye but she deftly cleared her face, a grey slate by the time she turned to face them again. She nodded her head. "If you think this is what's best for my grandchild, then it will be done."

"It really is for the best." Mother Martin walked around to the back of her own chair, put her hands on the soft back and leaned forward, looking straight into Mary's eyes.

"And are you prepared for your own daughter to never live in Fox Harbour again, Mary?"

Sarah's face flushed urgently. "What do you mean?"

"Sarah, child!" Mary scolded her daughter's outburst.

Energy boiled in Sarah's tiny ribcage. She looked ready to explode through her burning cheeks.

Her mother turned apologetically to Mother Martin, who calmly asked for order with her raised hand. Mary glared at the two girls, silencing them.

"Dear Mother Martin, you have been so kind. I apologize for my daughter rudeness. Please tell us what you propose."

"I have seen this situation before, Mary, and it can confuse the child if you all live in such proximity to one another. Sarah, as the biological mother, won't be able to let the child alone."

"But I will!"

"Sarah." Mary was losing patience.

Mother Martin smiled, acknowledging the young girl's innocence, but her eyes remained cold and determined to beat the resistance out of her.

"You know not what you are doing, my child. The pull of motherhood knows no boundaries when unleashed. You won't be able to help yourself and I won't let you interfere with what is best for this child."

"But…"

"And the closer you are to your child, the more likely the truth will be exposed." Mother Martin looked at Mary as she continued. "Mary, I see you with your daughters. Wouldn't you do anything for them?"

Reluctantly, Mary nodded her head slowly, not meeting Sarah's eyes.

"With us, Sarah has options. She could study to be a Sister of Mercy and perhaps teach, if it suited her. If not, she could learn to cook and clean. We could send her to the mainland to work in the rich homes in Toronto in Upper Canada. There are many fine Catholic families who are always looking for someone dependable. Since we have some connections there, it wouldn't take long for her

to get set up. She'd have a decent job with regular pay and a safe and clean place to live."

"Toronto?" Sarah struggled to close her mouth.

"That might be better," Mary said, ignoring Sarah's previous outburst and her own pain. She had figured it was the grandchild who would disappear somehow, into the fog as quickly as it had appeared. Now that they may have found a solution for the baby, she'd have to give up her own daughter?

"Now if you wish to have some more time to discuss it with your daughters, Mrs. Marsh, we can talk again in the morning."

"No need, Mother Martin. We agree to your plan."

Sarah gasped.

Mother Martin and Sister Ella rose, said goodnight and retired, leaving Mary to deal with her daughters who were still seated in shock.

"But, Momma, I can't go to Toronto. I don't know a soul!" Sarah was now in tears.

"Sarah, keep it down. We don't have much of a choice, do we?" Mary's teeth ground together as she spoke.

Without another word, Sarah left the room and headed upstairs.

"Momma, I am not so sure about this," said Elizabeth in a lower tone. She crossed her arms and walked toward the small, circular window in the far wall. She could see nothing but grey, wet rain landing in spurts.

"We didn't want them to send the baby away; why would we allow it for Sarah?"

Mary sat very still on the chair, staring at nothing.

"I simply can't imagine being away from her forever, Momma."

Mary shook her head and turned to her eldest with her palms facing the ceiling. "What else can we do?" she asked. Her voice broke. She cleared her throat and closed the conversation for the night. "We'll go with this for now until we see if there's some other way, Elizabeth, but tonight I don't want to hear no more about it."

By the time Mary and Elizabeth climbed into their makeshift beds, they presumed Sarah was asleep. She was wide-awake, still wrangling with her options. Her soul was torn between the horror of separating from her sister and family and a tiny baby she knew she'd love and the instinctual need to protect the child she would bring into this world. She felt great relief knowing she'd never have to see *him* again. The idea of being physically near him or pretending to act normal in his presence was both horrifying and exhausting.

Sarah longed to expose him for his hateful behaviour, but what could she do? She would love to give her baby to Elizabeth to raise; it made so much sense. But she couldn't bear the notion of the baby living in the same house as her attacker. How could she let that happen in good conscience? And yet, she couldn't tell Elizabeth. It was an impossible situation that kept getting worse. She had to come up with a way to escape and perhaps save the baby from Frankie. But where would they go? How would they live?

She craved her sister's consolation and reassurance that everything would work out, but how could that comfort ever come? Her sister would never understand. Her relationship with Elizabeth and her sister's marriage, too, would be ruined if Sarah told the truth. Frankie had threatened to kill her if she talked. Would he do it? What if Lizzy sided with him? That might be easier than admitting she'd married a monster. The tears fell onto strange blankets. Sarah could never tell anyone. Ever.

Elizabeth crawled into bed with her sister, taking care to keep a passage of space between their bodies. The narrow pocket of air felt like a chasm. She was inches from Sarah and had never felt further away as she lay in a safe straight line, trying to figure out how they got here. A part of her was on the verge of pure joy that she might get closer to the gift of motherhood she'd longed for her whole life. But the price she had to pay was not something she was sure she

could afford. Who would she share the triumphs and challenges of motherhood with if not with her sister? How could she possibly enjoy the experience of raising a child, knowing she'd stolen her from her dearest friend and only sister who was to be banished to another country? Would she never see Sarah or talk to her ever again once this was over? Elizabeth wasn't ready to let go. No matter what happened to Sarah, this was the best thing for this child. She felt Sarah squirm slightly next to her but they didn't make contact. They stayed oceans apart in a single bed with miles to go before morning.

Chapter 10

Sarah sat up in the creaky, lumpy bed. The noise made Elizabeth turn and look briefly before returning to her papers at the small table placed flush against the wall. Sarah couldn't believe this was happening. She could see Lizzy's pleasure from clear across the room.

"I can't believe it. You don't even care what happens to me as long as you get to keep my baby."

Sarah's accusation slapped Elizabeth and wrenched her out of her letter writing. She stared at the wall straight ahead of her, as if the answer lay printed on the eggshell plaster. After a brief pause, she finished folding the letter in her hand and turned, red-faced to speak to Sarah.

"How can you say that?"

"Because I know it's true."

Elizabeth put down her pen and licked another envelope. "Sarah, I do care, more than anything, but listen to me. Someone needs to save and protect this child."

"So now you're the saviour, is it?"

"I am not going to let this baby disappear into some strange place and never know any of her family."

Sarah burned inside with a hot angry feeling she couldn't control as she watched her sister glowing in the anticipation of becoming an expecting mother.

"The only one you're saving is…" Sarah stopped herself before she uttered Frankie's name. "You don't care who the father is anymore because what if you had to give the baby over to him?"

"My dear, you have some kind of nerve, saying the likes of that!"

Sarah couldn't stop herself. "You're probably hoping it's one of the American soldiers. Wouldn't that be perfect? Then you'd know for sure you could keep her."

Sarah turned her back and grit her teeth. Hard bile in the pit of her stomach smoldered. This was so unfair. She should have pushed harder to fight Frankie off of her that night. Maybe she should have screamed. But he had frightened her motionless. All she had managed to do was crawl away and hide in the bathroom.

Elizabeth didn't speak. Her sister was right. Secretly thrilled for her own good fortune, Elizabeth would finally have a child of her own. She could barely contain her increasing excitement as she wrote her letters to send back home with her news. Yes, finally, she was 'with child.' She would stay in St. John's until her term was through, due to unforeseen health circumstances, not to be discussed, of course. She had Sarah with her for moral support and Aunt Grace was close by, but because they had the room at the convent, it made sense to stay on Military Road.

Elizabeth was unable to mask her joy. Her personal thrill was no longer a secret. Her sister could see the pink glow on her older sister's cheeks. Breathing deeply, she even felt a slight fluttering deep in her ribcage.

"Sarah, I feel terrible about this whole thing and I am going to miss you so much but what else can we do?"

Sarah had her back to Elizabeth and was not planning to turn around anytime soon.

"You won't tell us anything about the father, and yes, if he is a soldier, does he...?"

"No, Lizzy, he doesn't know I'm pregnant." Sarah caught herself from going any further. Maybe that was a way to end the litany of questions, pretend he was a Yankee. She needed more time to think all this through. "He's long gone anyway."

"So he *is* from The Base! I knew it. Oh, Sarah, I'm so sorry."

Sarah shook her head and held up her hand. "Stop it."

"We could figure this out together," said Elizabeth. "Maybe we can make him pay something: money, jail time…"

Sarah let out an insincere laugh. "Just drop it."

"Girls!" Mother Martin called to them. "Come, down please. Your mother is ready to leave."

Relieved, Elizabeth pulled together her papers and envelopes. And Frankie would be so pleased to learn this news. He didn't need to know this wasn't his baby. And because she was going to be the baby's aunt, there might even be some resemblance. This was what they needed in their home to revive their marriage - a baby.

Reluctant and brooding, the girls treaded softly down the ancient stairs.

Mary stood waiting at the bottom.

Without a word, Elizabeth handed the letters to her mother, gave her a quick embrace and backed away.

Arms by her sides in protest, Sarah approached her mother. Mary hugged her youngest, arms and body as one. Then Sarah sheepishly handed her a few letters for the Davises'. She'd written a safe letter to the whole family in case her mother decided to read it before giving it to Jack. She had also included a drawing with a special note written at the bottom for each of the girls. She was going to miss them so much. It crushed her heart to think of them.

Mary nodded her silent goodbye to Sister Marguerite, Sister Ella and Mother Martin and left for the train back to Fox Harbour.

Chapter 11

Sister Marguerite stood tall, holding out dark-grey piles of woollen fabric to the girls.

"We Sisters typically wear these garments to clean house. Sorry," said Sister Marguerite, smiling broadly. "This is all we have. We can't let you wander around in civilian clothes, you understand. It's starting to get colder now so we switch to wool for winter."

"Yes, Sisters, now that you are here," said Mother Martin, "you are part of the convent, no matter what the reason for your stay. I trust you will do your best to fit in and act the part of a young woman learning what it takes to be a Sister of Mercy. This method is for the best. You don't want to raise the suspicions of the others, so they will call you Sister Sarah and Sister Elizabeth at all times. Equally, you must address all Sisters here in the same fashion: Sister Marguerite, Sister Ella, and so on. To start, please change into your habits and meet Sister Marguerite in the dining room. The polishing will be waiting for you."

Sister Marguerite bent her lanky frame to whisper loudly and close to their faces, "Mother Martin is big on polishing."

"Sister Marguerite, need I remind you of how rude it is to whisper." Mother Martin crossed her arms and waited for some acknowledgement from her most playful novice. Sister Marguerite grinned and held out the folds of grey to them, saying, "yes, Mother Martin. I mean, no, Mother Martin."

The Mother General frowned.

"I have work to do but I do intend to keep an eye on you two young ladies. You'll need to pull your weight around here. Is that clear?"

Only Elizabeth answered. "Yes Mother Martin."

"Sarah, is that clear?"

"Yes, ma'am."

Mother Martin slammed a short but stinging blow to Sarah's delicate cheek. Both girls were shocked into silence as Sarah grabbed her burning face.

Through gritted teeth, her hard face uncomfortably close to both girls, Mother Martin spit her words at them in a wet spray of distaste. "Do not address me unless you say, 'yes, Mother Martin.' Is *that* clear?"

Sarah nodded her head quickly, her eyes glued to the floor. Elizabeth froze, stunned by the sudden switch.

"Oh, and one more thing," Sister Marguerite said cheerfully, as if nothing had happened. She leaned down so both girls could hear her. In a hushed tone, as if Mother Martin were no longer there, she said, "you need to work silently."

Only the girls' eyes moved back and forth between the unaffected Sister and the unpredictable Mother General. Mother Martin stood staring at them while Sister Marguerite continued to talk in a happy, child-like manner, oblivious to any tension.

"Mother Martin tells us to think of God in our hearts as we work. He must always be present, you see. You can pray to Him or count goats in your head, for all I care. But don't be loud about it, all right?"

"Sister."

"Kidding, Mother, just kidding."

The girls' eyes widened. Elizabeth wondered if Sister Marguerite would get slapped, too. Mother Martin waved her off, turned in a business-like manner and walked away. The girls looked at each other, eyebrows gingerly questioning what had just happened, and grabbed the clothes. They pulled the awkward robes over their heads

and followed Sister Marguerite, draped in sleeves too long for their arms and material too scratchy for their skin.

"You Sisters are all set," chirped Sister Marguerite."

Sarah and Elizabeth quietly made eye contact.

"Now," she said, "here is the silverware. It needs to shine like the risen Lord," she said, singing the word 'shine'. "You can expect Mother Martin to drop by at any time to inspect. Let me show you."

Sister Marguerite took the soft cloth and wet it with metal polish. She showed them how to coat and polish a stick of silver, wipe away the milky residue and then vigorously rub it with a dryer cloth to make it shine like a thin sliver of mirror.

"There. I've got to get moving. I'm on bedroom duty, which means lots of sheets, pillowcases and washing to do before Chapel. See you then."

Perplexed, Elizabeth and Sarah surveyed the multiple rectangular trays of cutlery laid out like train cars in a rail yard waiting for transport. There was nowhere to sit, not even a hard un-sanded bench. There was only the oblong table and long hours' worth of silver utensils to buff meticulously. Sarah sighed, wet her cloth and started on her first fork.

Home, they stored a collection of mismatched forks and knives in plain drinking glasses their mother set on the dinner table during meals. They never required shining. Wearily she took in the detailed curly decorations on the fork handles, which meant more scrubbing before the shining could even begin. After several minutes had passed, Sarah looked up at her sister mindlessly working her way through the knives and had to break the silence.

"I'm surprised they left us alone with all this silverware."

"Not sure where we'd go with it," said Elizabeth looking up only briefly.

Sarah sighed.

98

"Do you think we're going to be able to handle all this," Sarah asked, her palms facing heavenward.

Elizabeth kept polishing.

"I mean, home, we pray every night before bed and we go to Mass on Sundays, but this? How many times a day will we have to pray?"

"The praying will be the least of our worries," said Elizabeth as she laid another butter knife in the wooden tray and started on the spoons for a change.

"I'm not sure who was scarier, seven-foot tall Sister Margie or that mean Mother General."

"Sarah." Elizabeth turned to her sister. "When are you going to get serious?" She shook her head, polishing away.

"Oh for God's sake, Lizzy, how can I be serious? I'm in a no-win trap!"

"Shhh, are you crazy?" Elizabeth checked around for anyone who might have heard her sister. "Mind your mouth. Here, of all places!"

Sarah sighed. "Never mind," she said, and grabbed a fork.

Several hours had passed when Sarah carelessly flicked a half-polished fork into a tray. "I'm not sure how I'm supposed to get in between those fork spikes. Besides, where would nuns get silver like this? I thought they were supposed to make a vow of poverty."

"We inherited that silverware," started Mother Martin.

Caught. They froze as she continued her sentence, walking toward them.

"Yes, it came to us from the late Father Ryan." Mother Martin walked over to the old wooden box and fished out a freshly-polished butter knife.

"Bless his soul. He got it from the diocese, if you must know." She turned the knife over slowly, staring at it as she talked, then she suddenly grabbed the front of Sarah's robe with her free hand and pulled the grey wool into a clustered knot. Sarah was trapped within inches of Mother Martin's pointed nose, a seething channel of indignation. The stench of rotting teeth hovered near Sarah's shocked face, churning her insides as she stubbornly fought every urge to resist. She longed to escape the rank, unwashed air, but refused to submit or allow weakness to show.

"See to it that you reserve your judgment, young lady, and keep that saucy mouth of yours shut," said Mother Martin, pointing the blunt and harmless knife at her target as she spoke launching a spray of spit with every syllable. Mother Martin moved her head back slightly and looked down the slope of her sharp, direct nose. Before she let go of her handle on Sarah's chest, she smeared leftover polish from the knife onto Sarah's sleeve. Instinctively, Sarah pulled back. Elizabeth's hand covered her mouth. "And that knife could use a bit more shine." She pushed Sarah back, knocking her against the thick, unshakeable hutch. Sarah winced as the lip of rounded wood dug into her back across her shoulder blades before she slide down to the stone-cold floor.

"Oh, and by the way," Mother Martin said, flicking the knife into the closest tray, "when you're done with this, you can start in on the rest of the silverware in there." She pointed to the furniture against which Sarah had just landed. "There is always more work to do, especially for a harlot like you. Now get to work – silently."

Mouths open, the girls couldn't even nod.

"Did you hear me?" she demanded, waiting for acknowledgement.

"Yes," they said in barely a whisper.

"'Yes, Mother Martin,'" Mother Martin said louder. "You will address me properly or face the consequences."

"Yes, Mother Martin." It was Elizabeth who couldn't make a sound this time, though her lips had moved.

When they were left alone, the humiliation, pain and helplessness struck Sarah with a rush of longing to run. Tears waited wet in her eyes for permission to roll.

Both of Elizabeth's hands were pressing the old table hard, holding herself up, her head hanging forward while she waited for her breathing to slow back to normal. "You all right?" asked Elizabeth quietly, without looking up at Sarah.

"More or less," said Sarah, not sure she could say anything more without falling victim to emotion and melting into a puddle of defeat. She fervently rubbed at her itchy grey sleeve to remove the silver polish, her mark of sin. She grabbed her cloth, covering the polish can before violently shaking it and spewing oily liquid into her already-stained cloth. She clutched another handful of forks, loudly clattering them to the table and started scrubbing every speck of tarnish and sin off each one until darkness fell.

At 5 AM sharp the chapel bell rang, waking the lead Sisters who woke the dawdlers. Sarah thought their 6:30 AM wake-up call back home was early; that was now like sleeping in. The convent routine this past week made memories of Fox Harbour seem like distant luxuries from an untouchable land.

"Come, Sister Sarah! Sister Elizabeth! Awake to receive the Holy Mother of God into your hearts," said Sister Jane Elson. She opened the curtains in a dramatic flourish to unveil the marble statue of the Virgin Mary outside their window, her head lowered in sadness at the loss of her only Son.

"Amen," said Sarah, yawning, sitting up and wiping her eyes. Her hands and forearms called for constant scratching from all the cleaning and scrubbing in lye soap. Some of the marks had begun to bleed and sting when immersed in hot or cold cleaning liquid. Seeing Elizabeth still lying motionless, she clambered out of her cot, shivering in the November chill and shook her sister's shoulder.

"Lizzy, come on. We cannot be late for this one or Mother Martin will give us penance– again."

"Coming," said Elizabeth's muffled voice below the blankets as she, too, scratched her arms.

The hallways came alive with the hum of sleepy Sisters moving steadily across dull, waxed floors. The young nuns pulled long grey woollen gowns over their bloomers and nightdresses and joined the corridors of Sisters flapping grey wings to stay warm, no longer able to wear their white cotton habits of summer.

After the girls had waddled their way down two flights of stairs and arrived closer to the breakfast room, they snapped into complete silence. Mother Martin expected them to ready their souls for pre-Mass meditation at 6 AM in the chapel.

"Just a reminder, everyone," Mother Martin tapped the teapot to get their attention. "I expect you to pray when in sessions such as meditation and Mass. Remember, you must always live in the presence of God. Peace be with you, Sisters."

"And also with you, Mother Martin," they murmured in return.

No one spoke as they drank lukewarm tea and ate dry, plain biscuits. Each of them in turn got up for the 4 AM shift to make the tea and bake the biscuits. Sister Aggie's biscuits were always the worst – dried crusts of breading that crumbled like dust and tasted like nothing. Sarah opened her mouth to make a quip but caught Mother Martin's stare and shoved the last of Sister Aggie's dry clump into her mouth. Sarah immediately looked down. She chewed on the mercilessly hard chaw until she drank her last drool of tea, now chilled, forcing the reluctant wad of dough down her throat.

The bell rang again, signaling it was time to walk to the chapel. The flock of Sisters in clusters of grey slowly migrated into solemn lines, inching toward the chapel entrance. Flooding the pews one at a time, the Sisters of Mercy settled down, and softly whispered blessings to open their hearts to prayer. Their meditation and stillness on their knees lasted 45 minutes. Sarah's restlessness started to show in her inability to remain still toward the last few minutes. She leaned and creaked a couple of times, drawing spontaneous side-glances and "ahems" from Sisters around her. Sarah finally caught a

heated glare from Sister Helen, a few seats over, and forced herself to stay painfully still while her shoulder blades and haunches screamed with tension. Mercifully, the bell rang again. Mass would begin in 15 minutes.

Chapter 12

Sarah rustled her older sister's arm and shoulder with both hands. Elizabeth was not a light sleeper. "Come on, Lizzy, I have to go again."

Lizzy groaned and pushed herself up onto her elbows.

"Sorry." Sarah had woken Lizzy twice already that night to go to the outhouse. She wished she could go alone. Lizzy herself said Sarah shouldn't go on her own in her condition, in case she fell, or something happened to her, but that wasn't enough to stop her. It was too spooky out there, especially with all the drones and horns of the various floating war ships docked in the harbour.

"Lizzy!" Sarah called violently under her breath.

"I'm coming," she hissed back and flipped her bedclothes back against the wall. "Let's go."

The girls walked quietly out to the hall, careful to shut the door without a sound before hurrying out the back door. The moon was at half-light, giving them enough visibility to find the tall, skinny box that perched at the base of a small hill. Sarah led the way, arms folded around her body for warmth, with Lizzy lagging behind on heavy, tired feet. Fortunately, because of the bitter wind cooling the box, Sarah didn't suffer from the toxic fumes once inside. Nevertheless, out of habit, she held her breath until she was done.

"Thanks, Lizzy, let's go now, quick. It's creepy out here." Lizzy nodded, turned and followed Sarah, hardly awake until Sarah stopped abruptly at their room door.

'Cleansing Ceremony for Sister Elizabeth and Sister Sarah at 7 AM', was all the note said. Sarah pulled the piece of handwritten paper from their room door and turned it over to see what other explanation might appear on the back. A blank slate of pure white stared back, empty of guidance or knowledge.

"What does it say?" Elizabeth walked past her into their room. Sister Jane was already up and dressed.

"We have a Cleansing Ceremony?" asked Sarah, shrugging her shoulders. She longed to crawl back into bed and sleep some more.

"Ah, yes," said Sister Jane. "That." Sister Jane wandered over to Sarah's bed to tidy it properly.

"What it is?" asked Sarah.

"Don't worry, Sister Jane, dear," said Mother Martin, briskly entering the tiny room where the Sisters slept. "You go ahead and start your chores," said Mother Martin, nodding at Sister Jane. "I can explain everything."

Sarah inadvertently recoiled a few feet, quietly bumping up against one of the roughly-made beds.

"Yes, Mother Martin."

After Sister Jane was gone, Sarah noticed Sister Marguerite beside the door with two well-worn cloth bags with drawstrings at the tops, the faded Robin Hood insignia barely visible.

"Sisters, time to cleanse your minds, bodies, souls and your world. Please bow your heads in prayer."

Reluctantly, the two sisters bowed their heads.

"In the name of the Father, and of the Son, and of the Holy Spirit," started Mother Martin, with the others joining in on the word "Father", blessing themselves by touching their foreheads, their abdomens, their left shoulders and then finally their right shoulder on the word "Amen".

"We ask you Lord to bless these two young lives Sister Elizabeth and Sister Sarah with your love, your patience and your mercy. They are sinners and must repent in your name. To begin, Lord, they will cleanse themselves this morning as we do with all our new Sisters and then proceed to start the day's chores. Lord, in your mercy, grant us the will to remain true to you in all things. Amen."

"Amen," said Sarah, Elizabeth and the four other Sisters who had since quietly joined Sister Marguerite outside the door. They carried pails, cloths and big chunks of vomit-coloured lye soap and laid them on the floor beside Mother Martin. Their long grey sleeves rolled up to their elbows. Sarah and Elizabeth started sidestepping slowly toward each other, as Mother Martin's stare made them reach for their middles like twins, as if to stop the drop of their stomachs.

"Let's begin," called Mother Martin. The four sisters flocked around the two frightened girls in a clucking fashion, lifting their habits up to their armpits and yanking them off. Two Sisters each knocked the girls over onto their hard mattresses and removed their petticoats and their bloomers. At the sight of the naked breasts, the Sisters averted as they threw the clothes to the ground. Both girls cried out in protest and indignation. Sarah's mind launched back into her attack as the rough Sisters held her arms and legs while one scrubbed her nude body from neck to toes, including very near her private places.

"No," cried Sarah, "don't!" She could feel *him* drumming into her again, her insides being pushed apart again, though nothing entered her. It was the humiliation of having no clothes on and being restrained. Not even her mother had seen her naked for nearly a decade.

Elizabeth simply fought their restraints, saying repeatedly, "Please, Sisters, I can do this myself. There is no need to do this, please. No."

"Oh yes," said Mother Martin. "There is much need. No one skips this ceremony. You cannot be ready for God without it."

Through gritted teeth, Elizabeth lashed out. "But I am not getting ready for God." All the Sisters froze, waiting for Mother Martin to say the word, even the ones working on Sarah.

"As long as you are in this convent, you will follow our rules. You BOTH are here with us until April, therefore, you are both getting ready for God. Otherwise, I will need to send a telegram to the Doyle radio announcements show explaining publicly why you

and your delicate little sister are here and why I've kicked you out," said Mother Martin, watching Sarah's face. "I can see your poor mother's reaction now. She's a tough woman, that Mary, but I'm not so sure she'd like to hear that all over the Island, would she?"

Elizabeth's mouth opened for a split second and then immediately closed as she fought the tears in her throat that rose to her eyes.

"Is that clear Sister Elizabeth?"

Elizabeth could only nod.

"Very well, Sisters. Let's finish the bodies and dress them."

Like mechanical dolls, the Sisters splashed the final wet wipes of cold water on the shivering girls and brusquely wiped them dry with clean cloths that had been blessed in the Chapel. While the Sisters dressed them, Sister Marguerite brought in her white sacks. Sarah hugged her body, her teeth chattering, wondering what would be the next round of ridicule.

"Good morning, Sisters," said Sister Marguerite. "It's time to rid yourselves of your filth. Start dumping your stuff in here, or we'll do it for you." Her broad clown smile made her eyes shine like an eerie marionette ready to knock off the heads of the other puppets. "Go ahead," she urged them. "Start throwing the stuff in."

"What are you talking about?" asked Sarah.

"Whatever you own," said Sister Marguerite, not a quiver in her circus smile, her head jauntily tipped to one side.

"As long as you Sisters are in the convent and preparing yourselves for God, you must be stripped of all possessions." Mother Martin's hands dropped moved to a pose of control as she tented her fingers.

"Why?" asked Elizabeth, then she quickly backed off. "I mean, sorry, Mother Martin. I didn't mean to be rude. I am interested in the reason why. I beg your pardon."

Sarah looked at her sister as if she were a traitor, but saw Mother Martin suddenly smiling.

"Sister Elizabeth, yes, I believe you are learning. When Sisters prepare for the Lord, they must focus on nothing else. You focus entirely on serving Him, learning about Him and how you can do better to share His Good Word and His Good Works." Mother Martin started to walk around the room. Suddenly, she was a lecturer in theology, imparting knowledge to her eager students.

"Nothing comes without sacrifice, she said. "As a Sister, you own nothing. Not your time, not your privacy, not your pride, not your individuality, nothing."

Sarah was shaking her head slightly.

"Oh yes, my dear," said Mother Martin. "You see, Christ said: 'If thou wilt be my disciple, deny thyself.' It means you must give up all you have or you will never be a Sister of Mercy; and if you are under this roof, that is your aim, to deny thyself. If you are incapable of doing that, don't worry. We will make sure you do." She smiled a bright, sunshine smile, but her eyes remained dark and hooded.

In the spirit of defiance, Sarah made the first move by clutching her tiny empty bag she'd sewn herself at age 13 and dumped it into Sister Marguerite's bag. "Fine," she said. "I don't need anything anyway." The other Sisters watching and listening quietly missed Sarah's sarcasm and nodded their approvals.

"Thank you, Sisters. That will be all. Lord, may you have mercy on our souls. In the name of heaven, protect these girls from themselves until they have seen the way. Amen."

Frankie got his first letter from his Missus when Mary got back from her trip.

"Isn't it great news, Frankie? You and Elizabeth are finally going to have a baby!" She smiled, showing him her crooked stained teeth,

but her eyes were black stones of coal, incapable of holding anything like love or warmth for him. She reminded him of her icy daughter.

"Yes, t'is," he said, starting at the words, 'with child.'

"Will you be dropping over for a cup of tea on the weekend?"

He didn't have much to say to the woman on any occasion, but suddenly, he could barely speak. A hitch seemed caught in his chest. He was afraid to breathe. A child. His child. Could it be? He and his Missus had tried so often. But somehow, it didn't add up. He hadn't touched her for too many months. It was as if a fishhook had slid into his chest muscle, sending sharp pain through his heart. Had the little whore been with another man? He felt the red flushing to his face in anger. Waiting for the old woman to leave his front porch wasn't enough. He forced himself to nod in her direction.

'Perhaps', was the only word he could manage. He wasn't much of a letter writer, but somehow he'd have to find a way. He had a few questions for his wife.

Mary turned and left him with his fate. He watched her saunter away, shawl and long skirt blowing in the northeastern wind.

Frankie hadn't gone for tea and Mary hadn't reminded him. Several weeks had gone by and he'd gotten more letters from his Missus. Each one sickened him even further. Before learning she was pregnant, he'd struggled with what to say to her in person. She always wanted to talk and he had nothing to say. And now, all he wanted to do was bash her face in. At the best of times, writing on paper for him was an embarrassing, exposed outlay of words that didn't sound right. Many times, he'd tried but in the end, it only garnered crumpled pages of clutter, which he threw in the woodstove fire. Finally, he decided to write exactly what he thought.

Jack held Sarah's letter in his hand with care. He knew the girls would be so thrilled to hear from Sarry. "Thanks, Mary. So kind of you to help us out, too. We really miss having Sarry, I mean, Sarah

around." He smiled. "Sorry, the girls call her that all the time. I guess I got used to it."

"Jack, honey, that is fine. Whatever you all have to do to get through this difficult time, you do it. You hear me?" Mary patted him on the back while he stared at the letter. "Guess I'll have to learn to read, won't I?"

"Oh, sweetheart, here, let me help you with that." Mary's heart melted as she realized she was intruding on her daughter's privacy but she couldn't bear leaving Jack to fend for himself. "Here, let me read it for you."

"Dear Jack, Maddy and Ellen,

When you receive this letter, it means Momma is home safe and sound. I am safe and sound, too, at my new home in St. John's. It's different here and there are many new sisters I have met. Not real sisters like you two girls, but Sisters of God who are teaching me new things and helping me. I hope you are good girls for your Daddy. I love you all and miss you very much.

Please write soon, love Sarry xoxoxo

PS—Jack, thank you for your kind words. I think about them often. Sarah."

Mary smiled for Jack, though she was saddened for her daughter. Jack was a lovely man, but her life was much too complicated for anyone right now. She handed him the letter and then realized there were two more sheets: drawings with the words, *I hope you are a big girl today* on both sheets.

"That's sweet," said Mary.

Jack nodded his agreement and took the papers. He hesitated for a minute, opened his mouth as if to say something but then changed his mind.

"What is it, Jack?"

"Well, Mary. I was never one for book learning because we had to work, but I have always loved stories and would love to know how to read them to my girls."

"Jack, I would love to help you and your girls learn to read stories."

"Really? You wouldn't mind?" Jack turned a slight pink in the cheek. "I feel a bit funny about it being a grown man and all."

"No, b'y, don't be so foolish. I'd be happy to help. Like you said, you had to work," said Mary, content to help a family who'd lost so much. "I'm sure Kate would be proud of you."

"Yes, ma'am."

"Jack, please call me Mary, for Heaven sakes, how long have you known me?"

"Sorry, Mary. Well you practically raised me. Maybe I should call you Momma."

"Get out," she said, laughing and forcing him to take the letters.

"I'll do that."

Elizabeth held the long-awaited letter in her hand as if it contained her entire future happiness. Sister Jane had secretly dropped off the letter to Elizabeth while they were washing the old wooden floors in the chapel.

"Why don't you read it out loud?" Sarah said, her face smiling but inside she barely contained her anxiety. What had Frankie written? She couldn't bear the suspense.

"What about the floors? Sarah, you know what will happen if Mother Martin walks in here."

"Lizzy, I was joking. You can't read it out loud here."

"Fine, then. In any case, it's been a month or more since we've been here and she hasn't ever walked into the chapel once unless it's prayer time or the mass or meditation." Elizabeth casually walked to the door and glanced down the hall.

"Nobody around," she said before she sat on one of the back pews and tore open her husband's first letter to her about their new child.

Sarah stood very still and dug down into her body for breaths as full as she could muster to calm the pounding sledgehammer in her chest. She didn't want to know what was written in that letter, but she needed to know. She wanted to bust open the hard wooden doors that imprisoned her here and to run away to a warm, forgiving place with hot chocolate and soft blankets and tasty chicken and potatoes with gravy. She wanted to leap through string-bean green fields with wildflowers blooming as pretty as tip-toeing ballerinas on elegant stems swaying in the breeze and the sun blessing their health with golden love. She longed to find a hearth and cling to the very flame, until it burned her flesh. If she could only remove the unwanted future she carried inside her very being. Instead, she couldn't tear herself away from her enemy's words. What would he say about his very own child, their child?

Elizabeth started reading it, aloud.

"Dear Lizzy, I am no writer. Nor am I..." Elizabeth stopped. She started shaking and put her hand to her mouth. "Oh my God."

"What is it? What? Did someone die?"

"No," was Elizabeth's breathy answer. Then she turned and ran.

Sarah ran after her. "Lizzy, come back!" She grabbed her grey habit before she made it out the side door and pulled her to the floor.

"Ow, no!" Elizabeth fell in a pile on the floor with Sarah and gave up, sobbing out of control.

Sarah grabbed the letter and read.

"Dear Lizzy,

I am no writer. Nor am I stupid.

If you are pregnant, there is no way it's mine. The last time we bed together was too long ago. Did you take me for a fool?

I will not have my woman sleeping with another man. Who is he so I can strangle him with my bare hands?

You expect me to raise another man's child? You are a two-faced whore! Don't even bother coming home if you know what's good for you.

Frankie."

* * *

Chapter 13

"I can't believe him." Sarah sat there slowly shaking her head.

"What kind of husband is this?" Elizabeth held up the letter, unaware of the tears running down her face. "He has no trust or faith in me. None."

Sarah reached over and grabbed the paper from her sister's hands, crumpled it into a ball and threw it into their sopping bucket of dirty water.

"Sarah!" Elizabeth eyelids burned scarlet around her two narrow slits. Then she fished the dripping note from the water, delicately trying to shake as many drops off it, without tearing more. She looked up at Sarah. "What if I tell him that it's your baby, but swear him to secrecy?"

"No way," said Sarah.

"But he thinks I've been with another man."

"I don't care," said Sarah. "I don't want him to know, and I definitely do not want him to look after my baby, especially not after reading that letter." Sarah folded her arms.

"Sarah, he's not really like that, he's just a bit upset." Elizabeth's voice grew louder.

"Yes, Lizzy, your Frankie is like that. It's here in black and white," said Sarah, pointing to the letter, "and you still deny it."

Elizabeth's mouth fell open but no sounds came out.

Sarah turned her back on her sister. Sarah realized at this point there was no way she could ever tell her sister the real truth. She wouldn't be able to take it. The truth about her husband would destroy her and their relationship as sisters. She'd think her sister

was making up horrid stories out of vengeance. She'd seen it in writing that he was a bastard and was still defending him.

"My heavens, Sarah, I know he sounds angry but it's because he thinks I've been with another man. I know my own husband. He would never hurt a child."

"Fine, Lizzy. So he's miscalculated the months. Then ask Momma to talk to him. And anyway, he doesn't want children. He couldn't care less. All he minds is drinking and gambling. What kind of father is that?"

"Sarah Lynn Marsh, how dare you." Elizabeth's voice might have been a raw whisper, but it was angry enough to be a shout. "How dare you judge *my* husband?"

"I'm speaking the truth, Lizzy, and you know it." Sarah had her hands on her hips now. "Why would he want to look after some other man's child?"

"He doesn't know that, remember?" Elizabeth paced back and forth across the dirty chapel floorboards that creaked in time with her strides.

"Right. All the more reason why you can't tell him. He's already wondering about the timing and is infuriated. Imagine if he found out it really was from another man? Look, Lizzy, if you're going to take my baby into your home, I need to know she will be wanted and well cared for by *both* parents. Frankie *must* believe that this baby is yours and his no matter what."

Sarah genuinely wondered how he really felt. At least, this baby was his own flesh and blood. How quickly would that change his mind, she wondered? Or would it at all? No, she thought. They must stick to the plan.

"He is family," Elizabeth said slowly, "and so is this baby. He is my husband. He needs to support me and this baby. I can't force him but what's he going to do, say, 'Sorry, Ed, bye, but I can't look after that child?'"

Inside, Sarah knew this to be true and honestly had not thought about that. "Well, hang onto that letter then. If Momma can't convince him, she can threaten to show it to Daddy who would tear him apart for doubting your virtue."

"You have some nerve tearing apart my Frankie. You didn't even have the decency to tell me who the real father was."

"Lizzy, don't start."

Elizabeth turned toward the opening door.

"Sisters, what's going on here?" Sister Jane rushed in, whispering.

Elizabeth smiled at Sister Jane. "Oh it's gossip, dear Sister. We're so sorry…"

"Shhh, we don't have time," she said, handing them their damp cloths. "I came to warn you. Mother Martin is on her way. She must have heard your raised voices. I'm going to slip out the side door. Quick!"

All three young women scurried off, one slipped through the eastside door, the other two dropped to their knees facing opposite directions and worked, as if scrubbing every bit of sin from the rustic, ancient boards underneath them.

"Sisters, please rise."

"Yes, Mother Martin." They stood, heads bowed.

"You do remember our rule of silence while working, do you not?"

Neither spoke.

"I thought I heard arguing in here. May I ask what was going on, please?"

"Mother Martin, it was my fault," said Elizabeth.

Sarah stared in disbelief as her sister confessed.

"I…uh, distracted Sister Sarah," said Elizabeth, staring at her feet. "I'm deeply sorry to have disturbed you."

"No, Mother Martin. Lizzy is so used to being the big sister. It was me who raised my voice."

"Enough. Both of you. How do you expect to hear God in your hearts if you keep nattering on the way you do? Finish your cleaning and see me in my office. I reserve special assignments for my difficult learners like you. I'll be in the chapel later, and so help me, Heavens, this place better sparkle." She steeled her jaw shut and turned.

"Yes, Mother Martin."

Many of the men were sleeping except the skeleton shift of soldiers on night watch. They, too, nodded off from time to time. Escorting allied boats exhausted the men as they made their way week after week across the Atlantic Ocean like tiny spiders sputtering over white-topped waves in a never-ending lake.

Rocking regularly in a sea-drawn rhythm, the *SS Rose Castle* cradled its sailors with loyal sternness and strength as the nighttime hours slipped by. Unaware of any danger, the sleepers dreamt of times when the war would be over and they could take their hard-earned money and slip out to the clubs and buy their buddies a drink. They dreamt of loud music and dancing with the ladies. They moaned over soft skin and luscious breasts miraculously squashed up against them in heated stages of undress. They longed for cold beer that sloshed on the floor and sprayed in their faces as their buddies cheered. They cringed at the loss of their companions in the U-Boat bombings around the unblemished shores of this British colony so close to Canada. They prayed they would not be next; that somehow their very body heat would freeze long enough to evade the sub radars, and warm up again to keep them alive. Awake, they

prayed for safety. Asleep, they dreamt they prayed for safety. With no guarantees, the Germans continued trying to ruin their lives. They'd make the Germans pay. Somehow, they'd pay. But for now, the innocent sailors in their late teens and early twenties, simply slept.

A sluggish capsule, invisible to all the crowd, tread water about 18 nautical miles off the eastern coast. The German Captain touched the middle of his forehead with his right hand, as if saluting the barren island known as the enemy. His hand came off his forehead and descended in an arc in front of him until his arm was straight. The tips of his fingers pointed toward the throbbing pinprick light on the screen in front of him. His second in command had known what to do before the captain asked him. He told the technician: Fire! A rugged hand with the middle finger stained orange from tobacco pressed the flashing red button and lifted off the torpedo. There was no way to stop it now except with mass explosion. The *Rose Castle* shone brightly in Conception Bay's rippling waters. The captain of U-Boat-518 was finally smiling; they had been after this one for a while. An explosion blew the sitting duck into wretched pieces. Slivers of hull and stern mingled with torn arms and legs. The innocent sailors in their late teens and early twenties never awoke, and neither did the handsome Captain Murphy.

"Come in, please!"

Elizabeth and Sarah entered Mother Martin's office for the first time.

"Please sit."

"Mother Martin," Elizabeth started to speak but instead began to sob.

Sarah handed Mother Martin the letter from Frankie.

"I'm sorry, Mother Martin," said Sarah. "but it's very nasty and not what we expected."

Mother Martin's face absorbed the profanity without reaction. "Sister Elizabeth, he is one angry young man, your husband Frankie. Is this normally how he sounds?"

"Oh no, Mother Martin, I don't know what to make of it," she said, distraught and embarrassed. Sarah looked away, her face indifferent, with Mother Martin watching closely.

"Well, clearly, you must convince him that this baby is yours and his or the child could be in danger."

"But Mother Martin, I…"

"Sister Elizabeth, listen to me." Mother Martin's eyes bore through her. Elizabeth dropped her own stare.

"If this child is to be with you and this Frankie of yours, you need to do whatever you can to make sure of its safety. You must convince him immediately that he has miscalculated. Men can get violent in these kinds of situations. Besides, if you don't, we will have to give it away for adoption."

"No," Sarah cried. "You can't. Please."

"I won't if Sister Elizabeth is successful."

Sarah stood up. "This is so unfair." And she got up to leave.

"No, Sarah, come back. I can ask Momma to talk him." But Sarah ignored her sister and let herself out of the office.

"Let her go, Sister Elizabeth. She's angry. Write a letter to your mother today and see what she can do. Go."

By the time Sister Elizabeth left, Mother Martin realized she had forgotten to give the Marsh sisters their punishment for being difficult. Her hand reached up and smoothed the top of her veil. She was fortunate to be wearing it. Otherwise, everyone would see all the grey hairs these two were giving her.

"Dear Momma,

I wish you were here. We miss you so much. The convent is not what it appears to be from the outside and yet the Sisters are very generous and kind to us.

I received a very upsetting letter from Frankie. I can't even repeat what he has written but he believes I must have fallen with another man if I am pregnant as he is convinced he remembers the last time we were together.

As difficult as this is to write to you, Momma, I must do it. You must convince him he is wrong. Mother Martin insists that he accept that the baby is his, as he did not react well to the possibility of raising another man's child. He may only be jealous, thinking I've been with someone else, but we fear there is no guarantee that he will still take care of the child. Momma, please convince Frankie the baby is ours and see if that helps him come around. Please tell him as soon as you can.

Thank you, Momma, and God Bless.

Your loving daughter,

Elizabeth."

"Sister Sarah, there's a telegram for you and your sister from Fox Harbour." Sister Rebecca handed her the short sheet of paper.

U-BOAT HIT ROSE CASTLE STOP CPT MURPHY IS GONE STOP SERVICE IN ST JOHNS NEXT WEEK AT BASILICA STOP PLS GO FULL STOP

Sarah crumbled into a puddle of grey wool on the floor and dropped the note. Elizabeth and other Sisters ran to her and helped her to a nearby bench. "It's okay, Sarah, it's okay. You'll be fine." Elizabeth figured she must be extra sensitive to any sudden or alarming news and resolved to prevent her from receiving any more during the pregnancy. The other sisters stepped in and helped Sarah so Elizabeth, too, could read the news. Her hand started shaking and

the tears fell, wetting Captain Murphy's name. She went into a state of shock.

"Sister Elizabeth, Sarah is on her…oh no. Somebody come help, please," said Sister Rebecca. "Sister Elizabeth is also overcome."

"Jack, come on in, b'y."

"Jesus, Ed." Jack stuck out his hand, slapped Ed in the arm and near hugged him in one fast motion. Jack being a big man, Ed could do nothing but go with it. "That's a crying shame about Captain Murphy. I still can't believe it."

"Yes, b'y, it's somethin', isn't' it?"

"Are ya keeping up okay?"

"Oh yeah, not too bad. Mary is keeping me busy with chores, you know."

Jack smiled and leaned down to take his boots off.

"No, no, leave them on," said Ed. "Don't worry, there are worse things than having your boots on. Here, have a drink with me." Ed unscrewed the bottle of black rum and started to pour Jack a drink.

"No thanks, b'y. I've given it up." Jack had his hand up.

"You never."

"I did. Mind you, I don't have much time these days but even so," said Jack. "I had a nasty spell the last time and haven't touched it since. I'll have a cup of tea, though, when I starts my lesson."

"Your lesson?"

Mary grabbed the kettle and poured up hers and Jack's tea. "That's right, Ed. You can join us if you want."

"For what?"

"I'm going to teach Jack how to read to his girls." She handed Jack a steaming cup of tea and turned to Ed.

"Oh no, I'm not goin' at that stuff."

"Well, the invitation is open, Ed," she said on her way to the dining room with Jack following. "You never know. You might want to read to your grandchildren someday."

Ed grunted and took a big swig of his drink. To anyone else, he was dismissing the thought as quickly as it came. Mary knew he was pondering the truth of it, though. She eyed him quietly as he tried to cover up his embarrassment about reading.

"No rush for that," he said under his breath, running his thick hands through his white hair.

Mary stayed quiet and joined Jack at the dining room table.

"Mother Martin, the two girls have fallen ill with grieving since they got the news." Sister Rebecca handed her the rumpled telegram and waited.

"I'm sure, that's the third or fourth encounter they've had with U-boats, isn't it?" asked Mother Martin.

"Yes, Mother Martin," said Sister Rebecca. "Very sad."

"So it finally caught up with them. It'll be a blessing when this terrible war is over, Heaven help us."

"Indeed, Mother Martin," said the younger sister, blessing herself in response. "The girls knew him quite well. He was a friend of their father's Mr. Edward Marsh. He wishes for them to attend the funeral service if possible on his behalf to pay his respects."

"We'll have a memorial service here in the convent," said Mother Martin. "No need to be out in public blubbering all over the place."

"But, Mother Martin, to respect their father's wishes…"

"Dear Sister Rebecca, I'm sure he won't have a problem with a whole convent of Sisters praying for the soul of his dear Captain to protect his own daughters from public embarrassment."

"Yes, Mother Martin, I didn't mean to…"

"Never mind. Start the preparations. We'll proceed tomorrow night at 8:30 PM in place of our night prayers."

Sister Rebecca nodded and left immediately, leaving Mother Martin examining the telegram.

"How interesting would it be if he were the father?" Then she hurried off to her office.

Mary read her daughter's letter anticipating an uplifting review of convent life. She was immediately infuriated with both Frankie's lack of trust in his own wife and her Elizabeth's poor calculation of months.

"Goodness! Can't they get it together?" she asked aloud. Shaking her head, she dropped the letter on the dining room table, grabbed her shawl and ran off to speak to Frankie directly. He was going to get a piece of her mind. She stopped abruptly, returned to the table and grabbed the letter. She stuffed it in her pocket. The last thing she needed right now was one of the neighbours to wander in and read the next chapter in her family's drama. She started out the door, not looking up, when she literally ran headlong into Frankie's chest.

"Francis John Healey. My son, I needs a word with you. Get inside," said Mary, turning on her heel and walking back into her own kitchen.

Chapter 14

The soft linger of the sopranos could be heard at the opening of night prayers. The Sisters performed Schubert's Requiem in G minor, then waited for Mother Martin to begin.

"Dear Sisters, let us pray." All veils bowed.

"In honour of the heroic Captain Pierce Murphy and his brave crew aboard the *SS Rose Castle*, we wish to dedicate our solemn prayers and voices so that their memory be forever forged in our minds and that their bravery be forever exalted and remembered. And in special attendance, we would like to reference, dear Lord, the two daughters of Mr. Edward Marsh and dear friends of the deceased Captain Murphy. It is with solemn regret and reverence that we honour, Sister Elizabeth and Sister Sarah, on behalf of their dear father. We cannot always explain the loss of a dear friend so suddenly, especially one so dedicated to his work, his country, his men and his family and friends. Someday, the Lord promises that all will be made well once we reach the Kingdom of God. We must put our faith in the Lord, so that our heroes, like Captain Murphy, are brought to His Kingdom where he will live in perfect peace, harmony and safety, forever after. Amen."

"Amen."

Tears poured from Sarah and Elizabeth. Each of them had a Sister beside them for strength but they leaned against each other effortlessly.

"Let us say the Lord's Prayer," said Mother Martin. "Our Father who art in Heaven, hallowed be Thy name…"

"My girl tells me you think she's been with another man." Mary's hands were on her hips.

"Now Mary, take it easy."

"I will *not* take it easy until you tell me what is going on, Francis John Healey. Why would my daughter even think about goin with someone else?"

"Well, I don't like to speak about this stuff with women, but you're asking me. She couldn't be pregnant," he said, hesitating and looking at the wild woman facing him. "That is, uh, I don't know how it's possible, if you get my meaning."

Mary took a deep breath seeing the trouble ahead for her and her girls.

"Yes, Frankie, I was asking, but maybe you mixed up the months." She glared at him. "Isn't that possible?"

"Well," he paused, "I guess it is, but…"

"No '*but*', Frankie," she said. "Since when do men pay that close attention to this kind of women's business anyway?"

"Since I noticed I wasn't gettin' any, that's when," he said, raising his voice, but his mouth didn't get time to shut. Mary slapped him hard. Slack-jawed, he reached for his face.

"Now, my son, you mind yourself," she said not blinking. Her black eyes stilled him. "Don't you dare let me catch you talking about Elizabeth like that again."

"Mary."

"I don't care what you have to say about it, Francis. You don't want me to share any of your talk with Ed now, do ya?"

"Oh Jesus no, Mary. Look, I'm sorry. I must be wrong about Elizabeth's timing. You gotta believe me. I'll love the child like me own."

Frankie was rattled. Jesus, what had he gotten himself into? What a mess. He was shaking his head and looking down, contrite, as he listened.

"That's better, Frankie, much better. The next thing for you to do is write her a nice letter to patch it all up."

Frankie just nodded.

"Good man, Frankie, good man." Mary was nodding and patting him on the right shoulder, her hand rough and small.

"Well, I have to get to work now, Mary."

Mary waved him off. He had some nerve, that young fella, she thought to herself. He'd never have written it if he thought Ed would ever see it.

"Please God," she said aloud, "may that day never come."

"Well, hello, little ladies, come on in." Mary greeted the Davis girls at the door.

Jack was beaming behind them, all three in their Sunday best.

"You all look so handsome," said Mary. "Ed, come have a look! Aren't they gorgeous?"

"Yes, come on in, leave your shoes on," said Ed, smiling, catching Ellen and swinging her up high. The squeals of half delight and half fear of being dropped rang through the kitchen.

"Yes, we saw you in Mass but didn't get a chance to say hi," said Jack, "so here we are. It was Maddy's idea to come say hi to Sarry's momma and daddy, wasn't it, Maddy?"

She just nodded her head.

"Bless her heart," said Mary.

"When is Sarry coming home?" asked Ellen in an angry voice and crossed her arms.

"Ellen." said Jack. "Can I hear a better tone than that please?"

"No." She crossed her arms and turned the other way.

"Ellen." Jack got up to get her and she ran off to the back room. He threw his hands up. "Maddy, go with your sister to Sarry's room for a few minutes. I give up," he said. "They keep asking when she's coming back." He shrugged his shoulders.

"Yes, b'y, I know it's hard," said Mary. "How are they doin' about Kate and all? Must be hard."

"They're okay," he said. "Not as bad as you think, though. I mean, she had been sick since they were born so they didn't know any different.'

"True, true, poor thing," said Mary, nodding her head.

Jack paused briefly. "To be honest, Mary, Sarry is the closest they've ever had to uh…an attentive mother…figure."

Mary looked to see if Ed was listening. He looked back under gruff eyebrows, shrugging his shoulders.

"Let me get you a cup of tea, Jack."

"Thanks, Mary. Any reading we can work on?" Jack was smiling now.

"Yes, my dear. Anytime."

"I'm a bit nervous but I need to learn. I want to read to those two characters in there," said Jack, nodding to Maddy, the smiling big sister, and Ellen, the pouting baby sister who were now slinking their way through the kitchen again.

"You'll be just fine. Bring the girls, if you like. Would you girls like to help me teach your Daddy how to read better?"

"Can you teach him how to write letters to Sarry, too?" Asked Maddy.

"I sure can," said Mary. "Let's start tomorrow."

The next day and into November, the Sisters flung themselves back into their routine without interruption. They rose at five for breakfast, did pre-Mass meditation at six, Mass at seven and began chores at eight. Then they ploughed through the usual four packed hours of scrubbing floors, walls, windowsills, toilets, countertops and tables, polishing handles on doors, drawers, cabinets and lamps, plus silverware and brass, and hand washing clothes, sheets, habits and kitchen linens. By noon, they could hardly keep their eyes open long enough to examine their conscience for 15 minutes before having lunch.

Fortunately, they were permitted to have a caffeinated drink of tea or coffee and a few biscuits about halfway through the morning to keep them going until lunch. Sister Rebecca ran the break in the kitchen laying trays of biscuits along the long tables. She said the blessing before they ate and then it was silent while the exhausted Sisters ate and drank. The rigour of this routine quickly pulled Elizabeth and Sarah out of their grief over Captain Murphy, their angst over Frankie, and Sarah's longing for the Davises. There was so little time to obsess.

After lunch, they spent time in the Chapel visiting the Blessed Sacrament with supper at five every evening, spiritual reading at eight pm and night prayers at 8:30. The hardest part was their private time between three and five in the afternoons. For Sarah, they felt like an eternity. She often wrote letters and read as much as she could, including the Bible, to keep occupied. It gave her material for conversations with the others. They lived and breathed in the Word of God. If she didn't read it, she was left out of the conversations. She embraced it and engaged the others when she had the energy.

Elizabeth wrote letters and read, too, but she didn't read much of the Bible and stayed more to herself. She was still very disturbed about Frankie's initial letter. She still didn't have the nerve to write him back but she at least had written to their Momma who could talk to Frankie.

In the meantime, as long as Sarah stuck to the routine as much as possible and didn't cause trouble, she could stay out of Mother Martin's way. It was a good plan. Except it only lasted for so long.

Sarah must have been asleep. She immediately touched the veil covering her head where her fingertips found an unfamiliar bump. She felt a bit dizzy, as if she'd been on a train that had wobbled for hours across old rickety tracks. The thought made her throw up a small bit of spit, nothing more.

Then she remembered...

One morning in early December between Mass and noonday prayers, Sister Ella found Sarah and Elizabeth in a quiet part of the chapel, silent, eyes closed, meditating.

"Sisters, I beg your pardon?" whispered Sister Ella.

Sarah's eyes opened, but she could still visualize the false dark patches behind her eyes, shaped by random blots of light through eyelid skins. She blinked a couple of times and felt Elizabeth look up from her meditation.

Smiling, Sarah and Elizabeth made room for Sister Ella to sit between them.

"Thank you, dears. Sister Sarah, there's something we should talk about."

"Oh?"

"Yes, dear."

Sarah nodded.

"As we get closer to your due date, you need to start staying in your room. The younger Sisters don't know your...condition. True, you've hidden everything well under the habit during the last two months, but if they know you've been to bed with a man, that you've done the act, there will be issues to work through."

Sarah's mouth flew open but nothing came out.

"To them, you have betrayed the Lord," said Sister Ella, speaking quickly. "It's not your fault, dear. They can't help themselves. They haven't yet matured enough as women of the Lord. Someday, after they have spent some time in the communities, they will be ready to understand. Otherwise, they will likely turn from you."

"But the Bible says not to judge others."

"Yes, I know. But it's because you have sinned in the flesh and sin is the enemy here."

"But I have not sinned!"

Sister Ella looked around before continuing.

"Sister Sarah, believe me, I understand, but…"

"But nothing. I didn't do this to myself! I was attacked. He did this to me. Where was the Lord then?"

Mother Martin's voice sliced the air into helpless ribbons that fell to the chilled floor as she approached. "Sister Sarah, you are not to use the Lord's name in vain in this house. Do you hear me?"

"But, Mother Martin this is an important question. How could the Lord…?"

Mother Martin grabbed Sarah by her veils and pulled so hard, Sarah fell to the wooden floor, hitting her head against the wooden bench.

"Enough!"

Slightly dazed, Sarah's hands touched her crown where it burned under the twisted veil. Then she purposefully covered her mouth. If she spoke, she would spit fire at this hateful woman who claimed to represent the Lord.

Mother Martin crossed her arms and spoke in a measured tone.

"Sister Ella, Sister Elizabeth, you may be excused."

Without a word the two women left, skirts sweeping the floors. Elizabeth parted reluctantly, keeping her eye on Sarah as she walked away. Mother Martin stood above Sarah.

"I am getting terribly tired of your nonsense. Maybe a few quiet days of shed treatment will bring you around. I want you in solitary confinement starting tonight so you can think about improving your behaviour. Follow me."

Sarah was almost relieved. Shed treatment sounded ominous but the idea of solitary confinement suddenly seemed to be the ointment she needed to soothe her injured pride, her overburdened life. She pulled herself to her feet and awkwardly followed Mother Martin down a narrow corridor on the East side of the main convent building toward the kitchen. This solitary confinement 'treatment' was new to her; she hadn't yet learned of this from the other Sisters, but how bad could it be? Had none of them been sent there before? Must be some room where she wasn't allowed to leave. This place would be boring but she wouldn't have to do chores; that wouldn't be too bad. The idea of spending quiet time at peace and alone appealed to her entire person.

They rounded a corner at the end of the hall and walked through the business end of the kitchen, Sisters buzzing around without looking up. Clothed in white cotton habits not yet blemished with food, temporary chefs brought in to help out for this day actively scrubbed potatoes, kneaded bread dough and stirred pots of hot bubbling muck. The two grey-clad nuns went through the kitchen and out the door into the very chilly fall air. They crossed the walkway, down a steep hill that forced the two women into a short run, and around a rusted oil tank where they arrived at a shed-like building with a wooden door painted dark green. Solid cement walls surrounded the grounds topped with three garlands of barbed wire running in parallel and bent inward at an angle to snag any climbers from clean escape. Sarah shivered in the cold, her head a jumbled mess of headache, confusion and loathing as she waited for Mother Martin to open the padlocked door.

"What is this?" Sarah asked, not sure if she wanted the answer. Watching Mother Martin struggle with the padlock the size of an

131

iron pulley seized Sarah by the heart. The pit of her stomach fell, as if the floor of a barn loft had dropped to the cold, damp stalls.

The door opened outward.

"This, my dear," said Mother Martin, extending her left hand in welcome, "is your room for the next three days."

The air was damp and smelled of manure and some other rank odour Sarah could not place.

"There are animals here?"

"Not invited ones," said Mother Martin as she entered the darkness.

Sarah cringed, hoping it was too chilly for anything really creepy.

Mother Martin knew instinctively where to find the light, a naked bulb hanging from a bent wire snaking out of the low ceiling to the left of the door, and flicked it on. Sarah stepped inside as her eyes adjusted to the sallow glow. She tried impatiently to make out the rest of the shapes in her new five-foot by 10-foot prison. The simple dirt floor felt lumpy and cold through her thin slip-on shoes. To her left was an old bench no wider than a foot, at the height of Sarah's knees and about four feet long. On one end, it held what looked like an old Bible. Further left in the back corner of this tiny cave sat a tired bucket with a small pile of cloths next to it. To the right, sat a single cot with a ratty old blanket carelessly hanging over its sides. She would sleep here?

Chapter 15

Mother Martin made it back to the main house and sat solemnly on the hard, worn bench out front. She was tired and torn. Sinners were hard work. She wondered how Jesus did it. How did he accept these scorned women who could not fight their temptations and let men ravish them. He had not only forgiven Mary Magdalene, he loved her like family and treated her better, some would argue, than the Pharaohs themselves. This mystery man had had his way with Sarah but she must have done something to spur on this behaviour. It always took two to tango. Maybe there was a look that had slipped out or a random act of enticement that she had later regretted but refused to admit.

Reluctantly, Mother Martin had to admit that this extraordinary child had a backbone, a ramrod attitude to match and a fight in her that seemed too intense for such a pretty little thing. This kid set off Mother Martin's temper like the flare of a match. Frustrating as it was, she knew such fire actually would be an advantage out in the community doing the Lord's work. There had to be a way to tame Sarah enough so she didn't upset the church authorities yet keep the fire-burning determination going in the field; if Mother Martin could harness that energy and re-direct it to the Lord's work, heaven help the sinners who got in the way of that, indeed. But how much work it would be, would it ever happen and would it be worth it?

Mother Martin sighed. Below the steep hill propping up her convent, she eyed a clutter of boats jockeying for position. From a distance, they almost stood still, but she knew the game there. They'd bob and duck in slapping heaves, miraculously staying on top of the sheltered, inner-port upsurges until they managed to hook onto their post.

To make it to profession day and give the vows of poverty, chastity and obedience, Mother Martin would have to stamp the individuality out of Sarah—as much of it as such a will could allow

without breaking. That would be the tricky part but not impossible. She'd done it before; she supposed she could do it again, but it would be so much work. She sighed again, heavily. It tired her out thinking about it. She wasn't as young and full of energy as she used to be. More energy seemed to propel her when angered than when contented. She didn't like that. She prayed fervently to the Lord about it. Such weakness was disgusting. She didn't like this idea of propping herself up like this. How banal and all consuming. And then she would always return to the scene in the Bible where Jesus angrily tore apart the stalls inside the temple. He'd had a noble purpose for his anger, a focus of his destruction that was good, blessed and loving in the name of his Father. Surely, this was no different.

And what about the Lord himself. As loving as He is, He often got angry with His children and doled out punishments to right the wrongs. Not that she saw herself in the same category, Heavens no, but only to serve as an example, a model of superiority for which to strive, of course.

There was no use moaning about her lot in life. Choosing her direction was easy. Staying with her choice would be uncommonly challenging, but she couldn't imagine doing anything else. The work was as exciting as it was exhausting. And then once in a while, one of the young women would appear and challenge the very essence of being a Sister to raise the stakes an inch or so higher.

Sister Sarah was her inch, her itch, her angst and her test. She would embrace the Lord's challenge and find a way to break the girl. It really was the only way.

All the young Sisters still had to learn to be one with God, and to let go of everything else. It was always the hardest development: to become one with God. The novice Sisters talked about it all the time, but until they let go, not just of the past, but of everything, especially their individuality, they'd never know what it felt like.

Ah, the Lord's work was never done, she thought. She would have to work harder on Sarah or the little harlot and her soon-to-be born offspring would go to hell. It was Mother Martin's job on the

Lord's behalf to save the girl. The way of the world was to show no mercy for the unwed teenage girl and her illegitimate child. The only way to save this tainted child was to restore her as a new Sister of Mercy or she would be reviled.

* * *

Chapter 16

Sarah sat up on her elbows trying to focus in the dark. She remembered hearing Mother Martin fumble with the shed latch, the final click of padlock. Feeling groggy, the smell of peat filled her head. She shivered involuntarily, though she wasn't that cold. Her head-to-toe grey woollens were a blessing in this dank place. Dusk was in its latter stages as it was dark on the ground but the sky had progressed to medium grey. Light still poked through thin slits in the outer walls.

She figured it must have been for an hour that she'd slept. She forced her eyes to clear so she could better take in the rough size and shape of the shed but the darkness took its time to evaporate.

She came up on her knees and reached her hands forward gingerly to find her way as plain, rough walls awkwardly came into focus. The numbness in her head as she struggled to her feet had her wondering if this might be one of those 'Old Hag' dreams, pushing her back. Usually the familiar dream held her down until she took a deep breath and pushed herself upright with all her force. Instead, this cold uneven wooden shed surrounded her and wasn't going away. It was real. Her hands touched the wall after only two steps; she mistakenly ran one hand along the board to see how it felt and quickly pulled back--"Ow!"--with several sharp slivers of wood embedded under the skin of her fingers

Sarah shook her head with her eyes closed, but that threw off her balance and she landed sitting on her heels. She was wide-awake now. She couldn't pull the slivers out of her right hand; there wasn't enough light. She'd have to wait until morning.

She stood again, unwilling to sit idle, trapped and helpless. She reached up and grabbed the door handle, pulling and yanking on it with all her strength. Her actions only rattled the padlock that clunked against the shed door, doing nothing else to separate the

hand-built door from the rest of the structure. She checked each of the four walls from a kneeling position--she didn't want to fall again. The shed tormented her; its door and sides rattled enough to seem rickety but stood too strong to break through. No clicks. No cracks. No breaks. No luck. She was trapped. Like an animal.

Mother Martin must have knocked her on the head and then locked her in. Anger and helplessness fought for release. If she weren't pregnant, perhaps anger would have won, but it was no match for her hormones. The tears roared. They spewed out in self-pity and frustration. She stopped for a moment and listened to the darkness, her breath heaving out of her in fast bursts. Night was coming on and while it was quiet, she could hear activity in the distance. Perhaps a kitchen hand or a labourer might wander by.

She thought of Jack and how horrified he would be to see her in this trap. He'd pry that door open with his bare hands, splintering the old wood like tiny twigs. She thought of Maddy and Ellen and their beautiful, lonely faces, and how they lit up when she came to them; oh how they would never comprehend this. She thought of her mother Mary who would be so disappointed in the Church and Convent to see this kind of treatment of her young, pregnant daughter. She thought of her father and how he would pull Mother Martin by the hair and drag her out her to unchain Sarah from her humiliation and mistreatment. Or would he? Maybe he'd drag his 'whore of a daughter' by the hair and drag her out in the middle of the town square, once he'd learned the truth?

She quickly wiped her eyes and tried to calm herself.

"Hello?" she cried in a meek voice. She cleared her throat and tried again. "Hello, I need help in here. Can anyone hear me? Hello?"

Nothing. A few squeaks and bangs of daily routine from afar but no human voice calling back to say: Don't worry, dear. We'll come get you. Don't worry.

Nothing. She tried again and again, louder, too, until her voice was hoarse, and she could yell no longer.

She looked around the shed. There was a small mason jar of water, a dry piece of bread wrapped in cheesecloth and a Bible laid expectantly on an old wooden bench that once had been painted green but had shed broken paint chips onto the damp, dirt floor. The Bible had worn down so much, it had given up on life. The cover had been torn off and in the dampness, the first few pages had curled back toward the spine in scraggy scrolls. She picked up the holy relic and squinted to discover its first straight page was still in Genesis. But the pages were limp and frail and easily torn. So many pages were in pieces that had been shoved into miscellaneous sections of the Book that when Sarah opened it to the random middle, a light flurry of phyllo-pastry pages spilled onto the ground. She urgently swept the Book away onto the dead floor with its departed pages as if it were diseased.

What was she going to do now? Would Elizabeth know where she was? Would Lizzy bother to find her after what she'd said about Frankie?

"Stupid Frankie," she said aloud. "This is Frankie's stupid fucking fault." She sighed. That was the first time she'd ever sworn like that outside her own head, though she'd heard her parents, and uncles, and a bunch of boys down the lane speak it many times. But it felt good to yell at him, even if he couldn't hear her. She only wished someone would hear her.

Mary Marsh stood knee-deep in the thick snow as she piled more chunks of birch onto Ed's outstretched arms. She hurriedly brushed bits of snow off the wood with her gloved hands before adding it to his load.

"Mary, for Christ's sake, woman! It's nearly dark. Put the junks on; never mind the snow!"

"You mind, now Edward James Marsh, son of Elizabeth Mary Marsh, taking the Lord's name in vain! I don't want no snow comin' in this house."

She glared at him.

138

He paid her no mind. No point answering the woman when her mind was made up. Out of patience, he stormed off with what he had and piled it in the wood cupboard next to the stove. A square-shaped opening cut out under the counter between the sink and the stove offered a quiet reserve for the wood to shed snow and moisture before entering the iron box of fiery hell that warmed the house and cooked their food.

Mary stood a little longer, facing the harbour. She wrapped her shawl tighter around her black wool coat. It was a cold December night, make no mistake, and windy, too. She couldn't help but wonder about her girls with Christmas coming on. She had sent them a parcel of jams and a couple of small things for the Lord's birthday. She worried all the time about what might come of all this. She would do anything to protect the new child, but Sarah was her baby, too. She longed to have them both return home, but realized in her heart that maybe it couldn't be.

Mother Martin said Sarah shouldn't come home, if the baby did. Perhaps that was for her own interests. Nuns didn't mess around when it came to grinding down new young women to work in the name of the Lord. They would probably try anything to convince her baby to make those vows. Was that the best plan for her? Couldn't Mary get her daughter back and enjoy her granddaughter, too? As a family, couldn't they work through it? Elizabeth would be the girl's official mother, and Sarah could visit and spend time the same way she did with the Davis girls before she left.

Her daughter certainly needed those Davis girls, too, and they needed her. Mary had been over there nearly everyday trying to help out. Sweet children, they were, but their good Daddy, bless his heart, wasn't a mommy and those girls were too young to look after themselves. Maybe Sarah could cook and clean for him when she got back. It could all work out.

Mary had been keeping this bloody family together for how long? Surely, she could make sense of this. She wanted all her babies home with her. That's it, she thought. When the spring came and she returned to pick them up, they would all come with her and that was that.

"Mary, are you comin' in, or wha?!"

Mary sighed and turned toward the house. She still loved Ed, mind, but he was as crooked as sin. It was time she made his supper.

Bells rang, announcing evening Vespers. Sisters advanced solemnly in two parallel rows toward the chapel, their black leather-covered Mission Prayer Books in hand, some of them open wide with a rainbow-coloured bookmark ribbon hanging freely from the top of the spine. The chains of Sisters moved quietly past the two bell ringers without looking and entered the chapel, one Sister at a time.

Elizabeth held her Prayer Book in her right hand and Sarah's in her left, thinking she'd see her younger sister in Chapel and prevent any trouble, but she feared she had been too late for that. She hadn't seen Sarah all evening after quietly searching. What was more disturbing was the fact that everyone she'd talked to knew nothing about Sarah's whereabouts. It didn't make sense. There were only so many places she could be. She chewed on her bottom lip as she thought about the possibilities. Maybe after Chapel she could ask around some more. She and Sarah might not be getting along the best right now but Elizabeth did not like this situation at all. The tiny hairs on her arms stood up slightly when she thought too hard about it.

She caught Sister Jane's raised eyebrow before sitting in the same pew. Elizabeth was no longer the only one wondering what had happened to Sarah. Sister Jane shrugged her shoulders so faintly; it looked like she was just taking a deep chest breath. Elizabeth closed her eyes, pretending to pray and was suddenly in the centre of a merry-go-round, like she'd read about in stories. The staked animals like bobbing sea horses swelled on their ascent and shrank on their descent, throbbing and spinning, as tiny multiple Sarahs sat on each one, hanging on with only one hand, as if unable to locate the other. Elizabeth's longing to reach out and help her sister overtook her perception of reality as she touched the veil of the Sister in front of her. The Sister froze, not sure if it really was someone behind her or

divine intervention. No one around them made a sound. Elizabeth opened her eyes and her hand recoiled, protecting it under her layers of cloth, hugging Sarah's Prayer Book beneath her robes. Sister Jane to her right wordlessly patted Elizabeth's knee. Then all the Sisters rose to their feet to begin Prayers.

Sarah wanted to pace so badly to think through her stress and calm herself but she honestly didn't have the energy. How could she be so tired? She had tried reading the Bible. Self-preservation alone would have been motivation enough but she couldn't focus on the tiny print. She was convinced that Mother Martin would return and start quizzing her about the Bible, chastising her for not memorizing passages and perhaps continue to put her to the test until she was satisfied. Perhaps only then would she let Sarah out to see the other Sisters, especially her own blood sister.

Poor Elizabeth had to be worried sick about her. Who in their right mind would harm a pregnant girl? But what if no one ever knew? What if this was the beginning of never going back to the convent ever again? What if this was Mother Martin's way of getting rid of troublesome teen mothers or young girls who misbehaved and were not worthy of the Lord? Sarah got up on her knees and prayed to calm herself. Then unable to hold herself back, she suddenly started digging with her bare hands near the entrance of the shed. She dug her fingers into the solid gritty ground tearing at her fingernails and the tips of her fingers.

Chilly, but frantic, her fingers pushed into the tight earth and worked to pry it open, if for nothing else but to make holes where there weren't any. Simply displacing rocky soil from one area of the shed to another gave her such a satisfaction, she couldn't stop herself.

Then it came to her. The sides of the shed dug into the ground. If she cleared enough soil out from under the door, she might be able to create a tunnel, no matter how small. It would be something.

Digging on the side closest to the lock, she clawed into the ground. Now that the shed was darker, the soil grew blacker and became invisible to her open eyeballs. She blinked as if in disbelief. How had she gotten here to this point in her life? The injustice mocked her; impatience pushed her harder. She longed for the brightness of snow as she dug deeper, cutting and scraping her skin on sharp slate slices of stone embedded in the sour soil. Wiping her cheeks and forehead with the back of her hand, brought particles of the smothering smell of dirt down her lungs, forcing her to cough. Alternating her hands between digging and warming up in her grey woollens, she **plodded** on into the night. She had been digging for hours in the pitch-blackness when she heard something.

She froze.

Something was moving.

Something was making its way around the shed. She could sense it like U-boat radar, flashing its red-dot light on a dark panel, showing a foreign ship intruding on territory as it idled hundreds of feet into the deep.

She felt the brush of fur. She stood back quickly, knocking against one of the side walls and screaming a terror she'd never before felt, before flopping back to the cold, lonely earth. Panting, sweating and speechless, she flopped her hand around until she found the Bible. She couldn't see them but she could hear the pages crinkling and imagined the loose ones flying out of the Book, fleeing the fright and landing out of order.

She held the Book above her head, ready to strike the beast and save herself. Even carpenter bugs at home threw her into a frenzy. Anything bigger than that could send her into a helpless mental state of no return. She heard the sound again and aimed at its source with all her might. She landed the great Book on something and winced. She must have deadened the creature's movement. She whimpered at the realization that it now lay prostrate somewhere close beside her as she smelled fresh feces. She wanted it out of her personal space, out of the shed. To do that, she'd have to 'sweep' it out through the hole she'd just dug. There was no way her tunnel could be big

enough yet to push a whole rat through. She couldn't see the size of the thing but she was not ready to push a dead oversized animal through a too-tiny hole. She shivered.

She had to maintain her momentum and get it out of the shed before she lost her nerve; she had to do this while her adrenaline still pumped. There was only enough room in here for one animal, she decided.

She clutched the good Book again and, imagining where her prey might have stopped, she gingerly edged the tip of the Book toward the invisible thing, praying it was rolling away from her. In quick, robotic sweeping attempts, she urgently ushered the small body forward, feeling its weight through the Book, stopping her movements as abruptly as she started them, until she felt certain it had moved a few inches.

She took a few deep breaths. Her eyes were wet and sore from crying. Still, she couldn't stop a few snivels from escaping as she tried to shove the body through her newly-built tunnel. Then with her hand wrapped in her wool dress, she pushed her hand against the deadweight and through the tunnel until her arm was buried, and until she felt the body pop out the other side. Then, she sat back in relief and threw the Book at the other side of the shed.

Sweat dripped down her neck into her rigid collar. She smelled animal feces again and needed to vomit. She spewed it out into the dark wall of nothing and used her grimy sleeve to wipe her mouth. She'd not eaten a thing since her captivity, and had drunk only enough water to wet her lips a few times. She had no interest in eating in a dungeon like this; somehow it would be like letting the Mother Superior win. She sat shivering with edginess, her bloody and cold fingers tingling with the feeling of pins and needles as she waited for dawn.

At just after midnight, Sister Jane could no longer listen to Elizabeth's concerns. Instead, the kind Sister had succumbed to the draw of her uncomfortable bed, unable to fight off the exhaustion of

the convent's daily drudgery. Elizabeth rocked herself back and forth in her harsh, lumpy bed, praying for sleep and failing wretchedly.

Maybe Sister Marg was right, thought Elizabeth. Maybe Sarah was in confinement. After Chapel, Sister Marguerite had mentioned in her cheerful, but macabre way that dear Sister Sarah might be in solitaire for bad behaviour.

"Solitaire?"

"Yes, dear Sister. Mother Martin likes to teach reluctant learners a lesson by secluding them in a room by themselves for a few nights," said Sister Marg. "She finds it sorts them out sometimes. Although with your sister, I don't know." Sister Marg chuckled to herself. "Mother Martin has her work cut out for her."

"But that sounds horrible," said Elizabeth. "And she's pregnant!"

"Oh, goodness, don't worry, dear," Sister Marg's clown smile broke wide again. "She'll be fine. Just a little bit of a lumpy spot to sleep in, but all in all, it does clear the mind."

"Can I go see her?"

"Oh no, not in solitaire." Sister Marg shook her head, grinning wildly still. "Why isn't that the point, my dear, to not have anyone there?"

"Where is it?" Elizabeth crossed her arms impatiently.

"Oh out by the kitchen somewhere." Sister Marg walked away as if looking for someone who had called her name but Elizabeth had heard nothing.

Now that she was in bed, revisiting the conversation, Elizabeth shook her head.

"The kitchen?" She wondered aloud. "What kind of solitaire was by the kitchen, the busiest room in any house?" That woman was creepy; and Elizabeth never knew what to believe. Standing next to the strange lady's towering height felt like standing beside a clock

tower waiting for the gongs to go off. So what happened when the gongs went off? Elizabeth had no interest in knowing the answer.

Wide awake, she followed the carved swirl of painted wood along the ceiling borders, wondering about Sarah and how they had gone wrong and trying to figure out if she really should be pushing to find out who the father was.

What if she didn't want to know?

What if it were someone horrific-looking boy like Thomas over in Jerseyside? His lower lip bulged and was often damp with spit. His eyes were big and nosy and ran all over every girl's body without shame. Elizabeth cringed at the thought of him even unzipping his pants. She pushed him out of her mind. Or Jake Foley? He and his buddies were a bunch of loudmouth bums with no jobs and no respect. But it couldn't be. When would Sarah have been alone with anyone like that?

Maybe it wasn't someone horrible; maybe it was a handsome guy like Jack Davis Junior. That would be worse. No, it couldn't be. He was a good man, and he had daughters. After something like Sarah had been through, the monster would never be handsome again, whoever he was.

What about some of the older men? Maybe she was thinking all wrong, assuming that he was of their generation. What if it were someone of Daddy's generation?

"Dear Jesus," she muttered under her breath and made the sign of the cross.

What if it were someone who sinned beyond just that one night? What if he already had a girl, or worse, what if he were married and with little children of his own? Oh my, how wicked. Maybe it was better for her not to know who this monster was, just accept that this happened and move on. She struggled to block out the tragedy, but she couldn't will it away. She kept visualizing with increasing horror every possible male in the community, one after the other, on top of her beautiful little sister. Elizabeth couldn't stop herself, especially tonight with Sarah hidden away somewhere all night. Poor Sarah.

How had she been sleeping at night, Elizabeth wondered. Maybe if she hadn't been so focused on her need for Sarah to confide in her about the father, Elizabeth could have spent more energy on helping Sarah get through this awful time in her life. Sarah had been looking tired this last week or so and getting bags under her bright blue eyes. Maybe she hadn't been sleeping, and no wonder. Poor dear Sarah. Time to reach out to her little sister and stand by her, not pry at her for information.

Chapter 17

Leaning half asleep against the shed wall closest to the door, Sarah sat quietly, trying to adjust to the early grey light coming in the high window. She lowered her head and looked through the tiny tunnel, but all she saw was dead dirt.

"Please, can someone help, please?"

Sarah heard some clicking and then footsteps coming toward the front door. She stilled her breath and waited.

"Now Sister Sarah, dear. There's no need to…" Mother Martin stopped speaking. Sarah wondered if the woman's loss of words might be because of the kill outside the shed. Now Sarah really wanted to see.

"Oh!" said a voice that sounded like Sister Ella. Sarah felt warmed inside, knowing she'd see the kind Sister Ella in a moment.

"Dear God in Heaven above," said Mother Martin as she turned the latch, opened the door and flicked on the light. Looking over the state of the shed, shaking her head in disgust, she saw Sarah's veil on the other side of the shed and then met girl's eyes with a horrified look. She was shivering. The place smelled of excrement and pungent meat. A small trench-like scoop of dirt welcomed visitors at the entrance.

Sarah's eyes adjusted to the wall of grey light coming through the door. She looked past the women in the direction of her kill. It looked very asleep, but she knew it wasn't. The rat's chest didn't rise or fall. She let out a weak scowl of revulsion. She'd seen plenty of shrews and field mice but they were minions compared to this catch. Cringing, she looked up at Mother Martin's disgusted face. Mother Martin's hand adjusted her own veil.

"Sister Ella, go get a cloth and pail of water to clean up Sister Sarah." Unruffled, Mother Martin watched as Sarah's torn and bloody hands reached toward Sister Ella's clean, white hands for help. "You have permission, Sister Ella, to bring some ointment for her hands once you've cleaned them up." Mother Martin cleared her throat.

Sister Ella nodded her relief and turned to leave when Sarah spoke in an even, quiet, eerie voice.

"When can I get something to eat and drink, please?"

Sister Ella was afraid to look at Mother Martin but knew they could all be in trouble if anyone found out they'd starved a pregnant girl in an outdoor shed overnight in December, even if it were by accident.

"Sister Ella," said Mother Martin, sighing. "On your way back, tell the kitchen to bring Sarah a decent meal, including meat and hot tea. Tell them it's urgent. If they quibble about the meat, tell them the order came directly from me."

"Yes, Mother Martin," said Sister Ella as she slipped outside the shed, taking care not to step into Sarah's dirt tunnel or clang the flimsy door on her way out.

"I'll go get Brother Randall to take care of that…thing." Mother Martin waved one hand in the air at nothing in particular and turned to leave Sarah's temporary prison. She stopped briefly before leaving and noticed the Bible sitting off to the side. She spoke without looking at Sarah.

"I'm sorry we missed your dinner."

"When can I leave?"

"Not until you've spent another two nights out here."

"I don't know what you want from me."

"Answers."

Silence.

"So you have nothing to say, nothing to tell me?"

"About what?"

"Tell me what happened to you. Clear your involvement in this mess by telling me who supposedly attacked you." Mother Martin stood waiting, her hands closed together. She looked down at the floor, as if easing the pressure might allow Sarah to confide.

"You don't want to help me. Why would you take me in if this is what you do to young girls?"

"I only punish disobedient and insolent girls, Sister Sarah."

"What is insolent?"

Mother Martin's lips formed a smile, her eyes narrowed in judgment. "Rude, disrespectful in action or word."

"I'm only that way when I'm forced to be," said Sarah, summoning all her remaining strength to look Mother Martin straight in the eye.

"Then perhaps you will end up in confinement again." Mother Martin walked nonchalantly to the empty hard bench and sat. She crossed her legs under her skirts and brought her hands together. "Sarah, I took you in because that is the right thing to do in this situation. Otherwise, Fox Harbour would have eaten you alive and you know it."

Sarah's head lowered in shame.

"And we are fine to take you on at the convent. But we have rules. Also, there are other factors you must consider. The Dominion and the Church have laws that don't allow women pregnant out of wedlock to do as they please."

"Laws? But he attacked me," said Sarah.

"So you say. Sarah, maybe you misunderstood. Perhaps if we knew who he was, we could evaluate the situation a little better, perhaps discover it was an accident. We could work to convince him to marry you and it would all work out."

Sarah shook her head and couldn't speak.

"Well, wouldn't you prefer that to living in secret your whole life? Think of your child."

"All I have thought about is this child, there's no way I could marry him because he's..."

The door creaked open shutting down the conversation. Sister Ella had returned with towels, cloths, a bucket hanging off one arm and a scrub brush tucked under the other.

Mother Martin stood. "Think about what I've said, Sister Sarah. I will return after dinner to resume our chat." She left Sister Ella alone with her prisoner.

"Come, dear Sister Sarah. You don't want your sister Elizabeth to see you this way or she'll be worried," said Sister Ella, reaching over and wiping Sarah's motionless face with a warm cloth. Then Sister Ella moved to Sarah's hands and fingernails, reached for a pot of warm water from the cook and placed it beside her. "Here," she said, set your fingers in here to rest a few minutes. Sarah robotically placed all fingers and thumbs underwater and leaned her head against the wooden slats in the rough wall.

Sister Ella kept looking at Sister Sarah's eyes as if looking to see if her charge was coming around. Sarah fell back into her trance; it was as if her soul had evaporated and nothing was left but a shell, just for getting by. She had nothing left.

"How are you feeling, Sister Sarah?"

"Fine."

"Are your fingers sore?"

"A bit."

"What did you do to them, dear Sarah?" Sister Ella must have been worried. Sarah couldn't recall the last time someone called her by name, other than Lizzy.

"Nothing much. Just tried to clear a path," said Sarah. "I don't like being locked in." She looked directly into Sister Ella's eyes for the first time that morning. "I don't like it one bit. Nor does my baby." Sarah rubbed her abdomen coyly.

"Of course not," said Sister Ella. "No one likes being trapped."

Sister Sarah said nothing, only letting her head tip slowly side to side, communicating a long, drawn-out no.

Sister Ella kept working. She scrubbed Sarah as best she could manage with a cloth, warm water, soap, fresh grey woollens and a pleasant smile. But Sarah's spirit had moved on to an alternate universe. Her eyes looked upward, although the rest of her face looked frozen. Then she touched her abdomen and said, "I think I need to go to bed...the child..." Sarah felt a wave of nausea that raced up her insides to the base of her throat, only it didn't stop there. Panic ceased her heart as a blinking sensation flashed to the centre of her head, making everything go dark at once.

"Take a little, Sarah, come on," said a voice, holding a soup ladle full of cooled-off chicken broth up to Sarah's lips. She shook her head but they insisted. "Look, it's not about you anymore. You have to think of her," she said. Sarah paused and then gave in, parking her stubbornness momentarily. She sat up abruptly when she realized it was Elizabeth.

"You're here," said Sarah, looking around at the same sullen shed walls, however, no longer sitting on the bulging dirt floor. Beneath her lay a thick bundle of quilts and a thin-rag pillow on top of a small cot.

"Yes, it's only because you're pregnant that Mother Martin agreed to let me stay with you to bring you around," she paused briefly, "and agreed to bring you a better cot with more padding and

blankets. Sister Ella convinced her, as she was worried about the baby."

"Maybe this is the exact thing we need to do," said Sarah, staring off at nothing in particular.

"I can't understand how Mother Martin can get away with this," said Elizabeth, absently blowing on the soup once more. "You're still in a friggin' shed, Sarah! If Daddy saw this, he'd be so livid."

"Just leave me here. If the baby dies, it is God's will."

Elizabeth dropped the ladle to the ground, spilling soup on her skirt. "No way, Sarah, you are not going to destroy this baby just because it's not convenient. How could you even think of that?" Elizabeth urgently wiped away more broth than had spilled. "God's will," she muttered.

"How could I think it? Lizzy, how could I not? It would solve everything. Look at me, Lizzy. Look at me. I'm in a mess in a shed. Why should I care anymore?" Tears started pouring. "If I give birth, I lose the baby. If I don't give birth, I lose the baby. If I give it to you, I lose the baby. Don't you get it?" She leaned abruptly against the back wall and crossed her arms.

"Well," said Elizabeth, "there's one problem it wouldn't solve— your relationship with this family." Elizabeth's angry eyes stabbed Sarah's broken heart. "If you somehow lose that child," said Lizzy, "you lose this family." She dropped the ladle into the bucket with a cold splash, as if she cared not where it landed. "You could stay here instead," said Lizzy and she walked out.

Sarah listened to her sister's footsteps walk away, out of the shed, out of her world, out of her life, leaving her with no one to turn to. The helplessness overwhelmed her already weak heart. She couldn't tell any of her family. They wouldn't want to hear it. They would not believe her or they'd think she did something wrong to bring it on. Then some quiet night when they least expected it, Frankie would sneak into her room and hurt her badly, or worse, do it to her again what he'd already done: damaged her soul. Then what, she wondered? It didn't make sense. She either had to get rid of this

baby or run away with it or both. But where would she go? All of a sudden, becoming a maid for some Canadian folks on the mainland in a fancy mansion in Toronto sounded really good. But what would she have to tolerate in the convent to get there? And if she lost the baby, Elizabeth would never forgive her and possibly turn her Momma against her. Maybe adoption would be the best thing for this child after all. Then at least the poor thing would be safe from this mess and all the mixed up people. But it would be such a shame that she wouldn't know her real family. Sarah leaned her elbows on her knees and held her head in her hands, incapable of saving herself from her suddenly destroyed life, when she heard someone coming. She lifted her head.

Mother Martin brought her a large tin of warm tea with goat's milk and offered it to her at her cot. Gingerly, Sarah accepted the drink from her enemy, realizing she needed something warm in her stomach, baby or not.

"Well, I'm glad to see you're coming around. Can we pray together, Sarah?"

Sarah looked up in disbelief and distrust.

"Let us pray." They bowed their heads in a unique display of solidarity.

"Lord, let us pray for forgiveness for our deepest sins and for answers to questions and solutions to struggles. May you give us the strength we need to help those in desperate circumstances, even when they may not wish to be helped. Amen."

Sarah stayed silent.

Mother Martin lifted the hood from her head and unbuttoned her cape. She offered the cape to Sarah for warmth. Sarah shook her head.

"I'll lay it here on the bench for now," said Mother Martin. "Depending how our discussion goes, perhaps I'll leave it with you."

Sarah wasn't ready for any of this. Kindness? Consideration? Something was up. She expected a trick, a catch, something to crack open the tension in her body. She fought to keep her guard up and only waited for Mother Martin to make her motives known; then she could get back to considering her fate. Sarah coughed, as if she were starting to catch a cold. Perhaps she could guilt Mother Martin into letting her back into the convent. Mother Martin stayed silent until the coughing stopped and looked unaffected by it.

"There," said Mother Martin, "now back to our conversation. Let's talk about your dilemma, Sister Sarah."

"You just want to destroy me, don't you?"

"I want you to behave the way a young girl should behave, yes. Destroy? That's a little harsh."

"Harsh?" Sarah almost laughed but the sound she emitted was thin. "I'm trapped in a cold, wooden shed where people keep pigs and you think 'destroy' is a little harsh?"

"And furthermore, I cannot stand your attitude and your stubbornness and various other aspects of your brazen personality." Mother Martin got up to pace across the lumpy earth floor as she spoke. "For example, you speak to me like you have options. You have no options, dear. You are at the mercy of society or me. That's it, really. And as much as you may dislike me, I can assure you I would be kinder than society."

Sarah hated being trapped like this and forced to tolerate this women's tormenting, especially in a stupid shed being treated like an animal, but her enemy was right about one thing: Sarah had very few options; and now she realized it was worse than that. She had two: it was Mother Martin or the highly-religious, judgmental and small-minded community of Fox Harbour. And as despicable as this woman was, the people there, she knew, could be crueler. She took deep breaths to try and wait it out—see if she could learn the Mother Superior's hidden motives.

"When this happens to girls your age, there are very few pleasant options. Usually, it ruins your life. Once they know what has

happened to you, you will be scorned, judged, literally, some will spit on you in the street. Young men will take advantage of you, if they ever catch you alone. People will be disgusted with your parents unless they disown you and kick you out on the street. The gossip mills will recreate you until you've become unrecognizable and that will be the version they see forever."

Sarah looked at the rough shed walls, silently acknowledging the unfair truths she heard.

"And you'll be talked about like a young harlot."

"I'm not a harlot!"

"Ah, ah, ah," sang Mother Martin. "It won't matter what you are, Sarah, only what they think of you. You won't have any say in it, you see. In fact, you won't have to do a thing. It will all just magically take care of itself."

Mother Martin had a permanent smug expression pasted to her face as she wandered back and forth within the confining walls of Sarah's prison.

"Now, if you could marry this impulsive man, that would be easier on everyone than the child going to Elizabeth, I'm sure you know."

"There's no way I can marry him."

"So he's already married then."

Sarah's face burned, exposing herself.

"I wondered that," she said, her hand reaching up to her strong chin and rubbing it a few times as if it helped her think.

"No, no, no."

"Well, that explains why you can't marry him, doesn't it?"

"I didn't say anything about that," cried Sarah. "He might not be married."

"I'm sorry. I'm not convinced."

"Why would I expect you to believe anything I say?"

"That's right, Sarah, why would you?"

"You're infuriating."

"Oh good. I'm making progress then."

Exasperated, Sarah smacked at the wooden slats beside her, serving only to hurt her own hands. Tears welled and threatened to escape.

"Sarah, you could put an end to all of your pain really quickly by telling us who it is. Think about *this*; he could do it again."

The thought of that frightened Sarah to the core. She'd obsessed about it many times. But what could she do? She was helpless to stop him.

"I can't help that—he's a moron. He'll do what he pleases."

"You're right. And let's assume you are also right about him attacking you. Well, by not acting, you would be committing a sin of omission. And, he could do it to someone even younger perhaps." Mother Martin eyed Sarah while she reacted.

Suddenly she thought of Maddy and she put her hand up to her mouth. She felt she would get sick, but the urge faded.

"Yes, so you know what I'm suggesting is true. Then what? He brutally rapes another young girl and gets her pregnant. And where do you think they'll come to be rescued then, Sarah? Yes, right here. Do you really want that on your conscience, dear?"

"I can't tell you. Other people will be hurt by it."

"As if *you* could be anything close to a martyr! So you're protecting his lovely wife and perhaps kids, are you? Would they do this for you, do you think? Should they find out, do you think this lovely wife will go to such lengths to protect you?"

"But this wasn't my fault!"

"Yes, and I'm sure she'll take that into consideration."

"You don't know anything."

"Actually, dear," she said, looking arrogantly in Sarah's direction, "I know more than you think. I'll assume that if you're a typical Catholic outport family, and this is uncomfortable women's stuff, your father Edward doesn't know a thing about this."

Sarah looked away longing to hide her transparent skin in her sleeve, her hands, anything that would hide her thoughts and emotions.

"In fact, not only does he not know who the father is, he doesn't know you're pregnant, does he? That means he doesn't know that his precious little girl has been supposedly raped, violated against her will, exposed..."

"Stop it! Stop!" Sarah covered her ears. "Why are you doing this to me?" Tears rolled down her cheeks in frustration and embarrassment. She could not contain her discomfort at the thought of her father knowing she'd been violated and then made pregnant.

"And knowing men of his...ilk...he will despise the child, won't he? And, you."

Sarah was sobbing now.

"Your father will never find out from me, as long as you tell me who this lecherous attacker is. Otherwise, I have to assume you are protecting your secret lover and you really are to blame for getting your stupid self pregnant."

"No, no, no," Sarah was crying, shaking her head.

"As a matter of fact, I spoke to your sister Elizabeth and she is prepared to do the same."

"What? Do what?" Panic flew to her face.

"Why, tell your father, of course."

"She would never."

"Really? She left here pretty angry." Mother Martin lifted her eyebrows and continued. "She looked ready to do just about anything to make sure she gets your baby."

Sarah shuddered.

"Your sister could certainly look like the hero by agreeing to take the bastard child from the whore and save its soul."

"Stop! Stop! I can't take it anymore. Stop!"

She could lose everything, no matter what she did. She was in a losing game. She could not handle living if her father knew. He couldn't know. He couldn't.

Mother Martin grabbed her cape from the bench, put it over her shoulders and started to leave.

"Wait," said Sarah, desperately clutching at the side frames of her small cot as if to lift herself out of her state. "Where are you going?"

"Clearly, you're not prepared to tell me whose child you're carrying so I've got to follow through on my promise. I'll be sending a letter to your father tonight."

"No, you can't please, Mother Martin, please. You don't understand. It's an impossible situation."

"So it's your father then, is it?"

"What? How could you ask such a thing? No, Daddy would never..." Sarah was near the edge. She felt the bile rise and out it came all over her skirts.

Mother Martin sighed.

Sarah wiped the vomit from her wet mouth.

"I'll send Ella to clean you up."

"Wait," said Sarah weakly. "He's dead."

"I'm sorry?"

"The father." She looked up at Mother Martin with empty eyes. "He's dead. It was Captain Murphy."

Chapter 18

"Sister, Sister, Sister, whatever will we do with you, poor child." Sister Ella feverishly wiped Sarah's clothes to remove any remaining mess then suddenly stopped. "We need to get you out of those clothes," she said. "Come on, up you come."

"This is ridiculous," Sister Ella said under her breath, shaking her head in disgust.

Sarah let out a small near-giggle.

"Shh," said Sister Ella. "I may end up in here with you tonight if they think I'm entertaining you. At least now, you'll be in clean clothes."

"Yes, Sister. I don't want you to get in trouble for me."

"Just keep your pretty mouth quiet, you hear me?" Sarah nodded agreeably.

"Good. Stand up straighter so I can get these clothes off you."

"Oh, that feels so good to get these clothes off! Sister Ella, you are a sweet woman, thank you."

"Now lie back down. You need to take advantage of this time to rest. Perhaps what I'll do is talk to Mother Martin about letting you out for your last day and night, what do you think?"

"Oh, Sister, you would do that for me?"

"Sister Sarah, come now, you'll embarrass me. Get back in bed. You've got one more night in here and then you're back with us, so be good."

Sister Ella collected her things; her shiny, silver pail of water swayed unsteadily as she reached for Sarah's soiled clothes, slopping

warm soapy water in dark patches on the earth. She balled up the clothes in a wad and tucked it under her arm, and then with her free hand she grabbed her ointment, threw it into her nursing kit and slipped quietly out the door.

Sarah felt energized now that she had had a few moments to stand up, stretch, wiggle around and put on fresh clothes. It made her feel good. What gave her strength was knowing she had someone who genuinely wished to help her. That made everything all right. For a fleeting moment, she had considered making a dash for the door, but Sister Ella had been too kind to her; and where would it get her.

She was still pregnant. No, she needed a plan. She wanted to go home where she belonged and she wanted to take her baby with her.

She still wasn't convinced that Mother Martin bought her story about Captain Murphy. It was an awful thing to shame an innocent dead man's name but what else could she do? She was trapped. And as long as that knowledge stayed with Mother Martin, her mother and Elizabeth then the supposed illegitimate child could not harm his public reputation or his family. That's how it would have to be. In the meantime, she had to work out a plan.

Mother Martin knelt in prayer in the Chapel. She preferred saying the Rosary in her pre-breakfast private time at 4:30 AM and left the other improvised and tailored prayer for later, but today she was struggling. She didn't get up until well after 6 o'clock and barely made 7 AM Mass, the first time in at least three years. All she could do this morning was apologize to God and ask His forgiveness as she couldn't concentrate on remembering the words to anything: prayers she'd memorized long before becoming a novice Sister of Mercy.

Interactions with Sarah sent Mother Martin's mind to her own pain, a deep thick grip in the pit of her abdomen. It was a layer of sediment she hadn't scratched in a couple of decades, making it very difficult for her to be objective with Sarah.

Mother Martin had been so focused on not letting another rapist get away with violating another young girl, but now he was dead?

And married? And her father's friend? She had gone through so much trouble to protect him, and yet she would be the one judged and ostracized from her family, community and for her entire life, if it got out. Getting raped was bad enough, but then by a married man in the same community – it would be difficult to be in a situation worse than that but Mother Martin knew it did get worse than that.

So often, these young girls were so dramatic about these things and all the people they must protect. Or they were completely oblivious to the shame and pain they were causing their Catholic families. She had assumed Sarah was stubbornly protecting some secret dim-witted boyfriend who didn't understand when to stop and whom her father would squish like a bug the moment he learned the creepy insect had crawled over his golden-haired daughter. Instead, she was trying to protect a family.

He has destroyed her. She can't change that. Had she stubbornly insisted on hiding him to avoid shame on his family? Good Lord, this child was so stubborn, but in some ways, she was probably doing the right thing.

Mother Martin sighed. How unfair, and yet, the way of this world. This unwed mother turned out to be a lot more work than the Mother Superior had anticipated, but they were a decent family and wasn't it the Lord who had given her this challenge? She got up from her kneeling position and left the chapel. She knew what she had to do.

Sarah woke up in a knot of blankets with her head jammed up against one wall. She stared up at the ceiling and wondered what was to come next. She wondered if Mother Martin was still going to write to her father. That meant the letter would arrive in about a week or so, in time for Christmas. Then she thought, wait a second; Daddy wouldn't be picking up the mail. Momma always got it and read the letters. Then Sarah began to smile; Mother Martin could send all the letters she wanted to her Daddy and he would only get the ones that Momma wanted him to get. She was still glad she had told Mother Martin about Captain Murphy; at least it might ease up

the constant pressure. She felt relieved at this small realization, and then hungry.

Instinctively, she put her hand on her stomach. She froze. Did she feel something move ever so slightly? She immediately sat upright, not removing her hand. It moved again.

Heavens, she could not contain her surprise, her excitement as she sat there, alone, yet no longer alone, holding the top of her baby's energy. She needed to find the strength to go on, not to fight, but to find. She needed to find a way to protect and provide for this baby; and somehow she knew the answer was coming from the most unlikely place.

"That's it, little one; it's you and me against the world."

"Good morning, Rosie." Mother Martin picked up a welcome steaming tin of black coffee from the corner counter. Rosie nodded in Mother's direction as she expertly rolled a large body of white dough that was not getting away from her anytime soon.

"Hot enough?" she asked without looking up. The kitchen staff usually had Mother Martin's coffee ready after her early morning Chapel ritual.

"Surprisingly, yes," said Mother Martin after a tentative sip. "I'm late. Thought that might mess you up a bit."

Rosie smiled quietly and pounded the dough.

"No, Mother. No messing up in here," she shouted.

At that, Shirley waved from the back.

"No time for that," said Rosie as she continued her workout. Roll, pound, pound, roll, pound, pound.

"Very good, ladies. I'll leave you be," said Mother Martin. "Did Randall stop in for a tea on his way out yesterday?"

"Oh indeed he did. We wouldn't let him go without a cup of tea, sure. And, we set him up with a few biscuits, too, mind."

"Ah, very good. Much appreciated. I'll be on my way then. I've got a pile of letters to write. Bless you all."

"Yes, Mother, may the Lord bless you, too." Roll, pound, pound, roll, pound, pound.

Mary cleared a spot for Jack to sit at the dining room table where she had papers all laid out, two cups of tea and a plate of raisin buns.

"How are those lovely girls of yours?"

"Oh as beautiful as ever and full of beans," said Jack smiling. "They're with Aunt Marg this afternoon."

"That's sweet," she said. "Now, into the business of reading. You do have some reading from back in school, I believe."

"Some, Mary. I wouldn't get too excited but yes, I got up to grade five."

"Beautiful. Here, let's look at one of the lovely letters I received from Sarah." She unfolded the paper gently looking quickly at Jack's cheeks flush slightly. "You can help me read it."

Jack nodded.

"Dear Momma,

Thank you for the box of goodies for Christmas. We are getting tired of the same old biscuits here. Everyone takes turns helping the baker but none of us are very good.

I'm learning so much more about God and the Bible than I've ever known. All we do is pray or go to Chapel, it seems. We go to Chapel so much, I might never have to go again, if I ever come home."

Jack stopped his slow, deliberate reading of the letter. "If I ever come home? Is she not coming back, Mary?"

Mary cleared her throat, removed her glasses and turned to him.

"Well, you do know that she's considering being a nun."

"Yes, but...," he shook his head. "Not that it's a bad thing, mind. I had a feeling she wasn't into it or maybe hadn't decided yet, is all."

Inwardly Mary smiled.

"She is quite young and is probably still deciding, Jack, yes, but I am not sure if we can count on her being back in Fox Harbour anytime soon. We'll just have to see, honey."

"Hmm." Jack rubbed his face, thinking about what he'd just heard.

"Is everything okay?" asked Mary. "Can we continue?"

"Oh, yeah, yeah, sorry, yes, everything is fine. Go ahead."

But Mary knew she'd lost his concentration. He was nursing a disappointment and needed to be dismissed. She finished up and let him go, sighing as she watched him walk back down the lane.

Mary went back to the table to go through the rest of her letters and eagerly sought out Mother Martin's but was taken aback when she noticed the convent envelope was addressed to Ed. Mary swallowed a surge of bile and fright on seeing his name on this correspondence as he knew nothing about Sarah's condition, but after a few seconds her eyes narrowed. She soon had a slightly different perspective on this Mother Superior as she carefully opened the letter.

"Dear Mr. Edward Marsh,

I trust you and Mary are in good health and eagerly awaiting news of your daughters. They are both doing well considering the circumstances. Elizabeth is falling into the routine easier than Sarah and therefore adapting quite well. There are a couple of

developments that have troubled all of us, which I must share with you. I have had to discipline Sarah as she has not always fully cooperated with us during her stay. I can imagine that might disappoint you, however she has gone through a traumatic experience so it is understandable she may encounter some issues with authority.

As you must know by now, Sarah is with child and up until today had refused to reveal the father. I have since learned that the father of her baby was married. This was why she chose so sternly to not tell us his identity; I imagine she was trying to protect the family. She tells me he was a friend of yours, Captain Murphy who was killed recently on the *SS Rose Castle*? If he really is the father, I can see why she went through so much trouble to keep it secret but I'm not sure if I believe her. If this is true, we must move on and not dwell on the past.

I have watched Sarah's behaviour, interactions and focus and do not feel she has what it takes to become a full-fledged Sister of Mercy, however we are happy to keep her here until the spring when the baby comes. Should she require our help in getting employment in Upper Canada, we can certainly offer that.

All the best to you and yours this holiday season,
Mother Anne Martin, Mother Superior
Motherhouse
Mercy Convent
170 Military Rd., St. John's
Newfoundland."

"That wretched woman! And she calls herself a woman of God. Unbelievable," Mary shook her head in disgust as this breach in confidentiality. "You would think you could trust a woman like her!"

"And Captain Murphy," Mary said it again and again aloud. "No way, no way." Mary was shaking her head, incapable of accepting that he, one of the most upstanding men they knew, could be capable of doing such horror to their little girl. Whatever will become of all this? She threw the letter on the pile. She had to make supper. She suddenly stopped and turned back to the letters. She paused to look

at the sheet of paper, a piece of damning evidence that could set Ed off into a blood-curdling frenzy if he saw it. She swiftly snapped it up, lifted the stove cover and threw it into the fire, watching it melt in the orange jagged heat. She still didn't believe it. Ed wouldn't either, but he'd know Sarah was with child and that was enough. Mary closed the stove on Mother Martin's words.

Sarah was back in the convent. Her last night in confinement had been uneventful and with Sister Ella sneaking supplies in to her, she was able to manage fine. Mother Martin had not come back. Now that Sarah had told her who the father was, it was as if she had given up the fight. Probably not entirely but the break was welcome.

Sister Ella helped Sarah get set up in a different room away from the dorms so she could stay removed from the other Sisters as her condition grew more obvious. Now she would have lots of time to read, write letters, plan her future, and rest for the baby.

Sarah asked Sister Ella to send for Elizabeth to come see her. They needed to talk.

"I am sure Sister Elizabeth will eventually come here as she will be sharing this room with you."

"She will?"

"Yes, she insisted. But also we thought she could keep an eye on you, too. Make sure you're okay and bring you food and water."

"She insisted? You're sure about that, Sister Ella?"

"I am very sure," said Elizabeth who walked in and gave Sarah a long, warm hug.

Sarah couldn't make eye contact with her, especially with Sister Ella still in the room.

"I'm so sorry," said Sarah, when they were alone again. "I was so upset. I would never hurt this baby, ever. I hope you know that."

"I know. You were trapped in a stinky old shed. It was sinful of that woman to do that to you. Let's forget about it." Lizzy smiled. "Plus, I need to apologize, too," she said.

"Why?"

Mother Martin told me why you refused to reveal who the father of your baby was.

"She did?" Sarah looked down at the safest place she could, at her hands, fumbling nervously.

"He's a married man and you felt you had to protect that family from being destroyed. Sarah, I feel terrible about pushing you all this time, when here you were, trying to prevent shaming an innocent family. I have decided we're not going to ask again. I'm leaving it alone."

"Oh." Sarah realized she might as well tell Lizzy the same lie about Captain Murphy. What did she have to lose?

"And Momma talked to Frankie and told him to smarten up and that he'd better not dare accuse her daughter of adultery again or she'd have Daddy 'sort him out!'"

Sarah took a deep breath.

"What is it?" asked Elizabeth

"Nothing, just the idea of Daddy knowing and 'sorting out Frankie' scares me."

"Me, too. Best if he doesn't."

"Yes, especially since it was one of his friends." Sarah waited for Elizabeth's reaction. She needed Mother Martin to believe it. Maybe by Lizzy knowing, Captain Murphy could 'become' the father.

"One of Daddy's friends?"

"Captain Murphy."

"No, Sarah!" Lizzy's hands covered her open mouth in disbelief. "It can't be! I can't fathom it."

"I know." Sarah hung her head, avoiding eye contact. "Now that he's dead, somehow, it's seems easier to admit."

"Sarah." Lizzy reached out and hugged her like they used to hug. Sarah prayed for Lizzy to accept this as truth and silently begged the Lord and Captain Murphy for forgiveness.

"I still want it kept secret."

"Yes, yes," said Lizzy, backing into the chair next to the bed. "Don't worry."

"I mean it, Lizzy. That includes Frankie."

"Why would I tell him, Sarah? I want him to believe the baby is his!"

"I know, Lizzy, it's just...in case you changed your mind. Promise me you'll talk to me first, if you are tempted to tell Frankie the truth.

"Sure, sure. I won't tell him. I promise."

Chapter 19

Everything was quiet and still when Sarah awoke, but she was disturbed. She worried what might happen to Lizzy if Frankie really believed he didn't get her pregnant. Sarah realized he couldn't do too much damage with her Momma and Daddy down the lane but she didn't trust him; and now that he'd gotten away with this, maybe he'd try again with someone else? What if he did that to the new baby when she was older? Sarah prayed that wouldn't happen, but vowed she would stick around for her child to make sure she was safe. In that moment, Sarah knew her fate. She was going home to protect her daughter-to-be.

She wondered what he would think if he knew it was his child with her? She wasn't sure. Perhaps somehow, it would be like admitting that her violation turned out to be a good thing after all. She sighed deeply then caught herself in mid-breath. She immediately sat up in bed. Was that smoke?

She sniffed again. Her sense of smell since getting pregnant had become uncanny, so sharp she could barely tolerate certain rooms, people, places with the distinct smells they brought to her newly-sensitive nose. Now, she could smell smoke. Dear God. She leaped out of bed, grabbed the curtains at the window and looked outside. She couldn't see anything, but when she lifted the small arm of wood that covered the bottom part of the window, her worst fear made her gasp. Something was definitely on fire.

"Lizzy, get up, quick! Fire! Fire!"

In that moment, they heard the clanging of bells and the air raid sirens going off.

Lizzy sat straight up in bed.

"Oh Dear Lord, have we been hit? Is it a bomb?"

"Heavens above, Lizzy, I hadn't even thought of that! I just know there's a fire somewhere."

Sister Jane ran up the hallway. "Come on, Sisters, there's a fire! Up, let's go!"

Sisters scurried out to the halls and down to the main entrance of the convent. Sarah followed quickly behind with Lizzy beside her. Mother Martin was already there.

"It's not here but it's not far," she said with an air of authority and urgency. "Everyone! Please grab whatever towels, blankets and pillows that you can carry and be down here in the next two to three minutes. Wherever this fire is, they are going to need our help, especially if anyone is hurt."

The front door flew open and banged against the wall as Brother Randall arrived panting with urgency. The Sisters froze in their tracks.

"It's the Knights of Columbus hostel just up the road. Could be a lot of soldiers injured. Hurry! They're taking them a block west of the fire. Get there as soon as you can, Sisters!" And he was off again, the door clunking against the same wall in his wake. The women ran off in all directions in search of linens.

"Please, Lizzy, I need to come. How can I stay here?" said Sarah as Lizzy raced around grabbing sheets and towels.

"Fine, come on, take one blanket, that's it, and stay close to me."

Sarah grabbed her own, balled it up and tucked it under her arm. Surely she could help them somehow. She couldn't sit here like a lump and worry about what was happening.

The Sisters trundled to the front entrance armed with whatever they could carry.

"Stay together," Mother Martin said before she turned and led them to the battleground.

The city of St. John's was locked down in customary wartime blackout to protect against enemy attackers from the sky. Sarah knew this to be true simply by peeking out the window at night and seeing nothing but black. She and Lizzy filed into a string of makeshift nurses headed for battle; the Sisters grouped together in twos and threes and though they carried sheets and blankets, they could only carry one arm's worth. Their other arm linked each other together in case an unfortunate Sister slipped on the treacherous and slick layer of ice on the ground under their boots. The moon, a mere sliver, gave them light, though very weak, as they gingerly walked over the icy road and through the near-pitch blackness. In the darkness, they slowly tip-toed their way around the hill from Military Road onto Harvey Road amid short squeals erupting from time to time as a Sister's foot slipped and another Sister or two quickly grabbed her hard to catch her from falling.

In the distance, Sarah could see an orange glow, like a sunset behind a clutch of buildings ahead. If her hand had been free, she would have covered her mouth; instead it hung open, aghast at how a colour so beautifully bright could represent such tragedy. The noise of sirens, screams and shouts shocked her heart. She clutched Lizzy's arm and whispered Hail Marys in her head.

"Careful," called Mother Martin. "We're almost..." she cut her sentence short at the sound of explosions up ahead and the burst of flaming light above the houses in front of them. They jumped back. Mother Martin blessed herself, in spite of blankets hanging off both her arms.

"We need to go around it," she shouted to them. "Let's turn back to Military and turn down so we can go behind it at a safe distance. This way, Sisters!" It was a rare occasion that Sarah was not offended; in fact, she felt mildly relieved with Mother Martin's authority.

In a mild state of shock the crew of helpers walked the couple of minutes back over road they'd already covered and followed Mother Martin down to Merrymeeting Road. Hordes of people gathered on the corner at Parade Street chattering while others ran up and down

the street on a mission carrying pails, some empty, some full of water.

The Sisters made it part way up Parade Street when an officer approached them.

"Ho, there, dear Sisters, this is a danger zone. I need to ask you to turn around and go back where you came from."

"Officer, I am the Mother Superior at the Convent on Military and we're here to help. We have blankets, sheets and arms and legs. How can I direct my Sisters to help, Sir?"

The constable pulled off his scruffy army-green hat and ran his fingers through his hair. Sarah could imagine the steel determination this poor officer faced in Mother Martin's eyes. Sighing, he agreed, pointing to an area behind him.

"All right, Mother. Go over there, then. That's where the injured are at the moment. Warn those young girls about what they might see. Some of those people are pretty burnt up." Mother Martin nodded her head. He placed his hat back on his head and stepped aside to let them through.

The Sisters ran toward the wounded once they realized it was only snow underneath their feet. About thirty-to-forty people lay on the ground some crying and rocking back and forth, more lay there moaning and a couple constantly screamed in pain and fright.

Sarah followed Lizzy closely, vomiting every few minutes not from being pregnant but from the gut-wrenching stench of burnt flesh steaming off the arms, legs and torsos of the fire victims. The Sisters wrapped blankets and linens around people's shoulders to keep them warm from the cold, despite their grotesquely burnt skin. Some of their patients who were scorched horribly rejected the blankets and sheets and screamed at the Sisters to keep away. Several of them died seconds later, the screams barely out of their mouths when the breath fizzled away and with it their cries of horror. Then the Sisters would cover the poor soul's face with a blanket or a sheet.

Sarah continued her attempts to comfort people, in spite of the torrents of wet tears pouring out of both eyes, blurring her sight. Her inability to see people's injuries helped her temporarily cope with the terrifying destruction this fire had done to people's skin and faces. She almost preferred covering the dead to dealing with the living who were much more difficult to help. Suddenly, they realized because so many of the last-minute patients had died, the Sisters had run out of coverings for the dead.

After vomiting a number of times, Sarah reached for Lizzy's arm.

"I can't anymore, Lizzy," said Sarah breathlessly before she passed out.

Elizabeth tugged desperately on the Constable's arm.

"Sir, my sister, I must get her back to the convent!" She pointed to the frail girl in a pile on the snow."

"I'm sorry, Sister, I warned your Superior Mother that it would not be pretty out here. We've got every strong man doing what he can to save these people and put out this fire. Now outta my way, please, Sister!"

"Officer, please," she pleaded under her breath. "She's pregnant."

He lifted his eyebrows in shock. "Wha? A nun pregnant? Jesus, Mary and St. Joseph on that now!" He made the sign of the cross, threw up his hands and sighed heavily. He eyed Sarah's forlorn look and shape and signalled to a spry teenage boy from nearby.

"Son, come over here!"

The boy turned and ran back to the officer, cap in hand.

"Yes, sir."

"Please help these two Sisters down the road to their convent, would you? One of them is...erhm...not well."

"No problem, sir!" He donned his cap, leaned down and scooped Sarah up like a rolled blanket.

"And hurry back, son, we've got a disaster to take care of!"

The boy didn't answer. He and Elizabeth were already on their way, her arm through his.

Sarah's head felt like a boulder dug deeply into her pillow, her neck a heavy branch and her body a wad of earth packed tight under a blanket with no shape or strength. Her dry, raw throat prevented her from speaking as Lizzy wiped her face with a cold, damp cloth.

"That's the stupidest thing I've ever done," said Lizzy, wiping harder and harder with each stroke. Sarah's eyes bulged, asking her to ease off.

"Sorry, Sarah. I am so sorry. I should not have allowed you to go. From this point on, you are not to leave your bed, doctor's orders. He was here to see you already, by the way."

Sarah sighed and turned her head to the side to avert her sister's gaze. Great, she thought. Trapped again, this time, it was in her own body.

"Hey, it will be fine. I'll be taking care of you. We'll all be fine," said Lizzy, winking.

Then it hit Sarah: there had been the fire. She lifted her eyebrows and mouthed the word, fire?

"Oh Sarah, honey, it's so awful. About a hundred people or so died. The police are still sorting through all the rubble so there may be more. Such a shame."

Tears ran down Sarah's cheeks. Lizzy wiped them away. Sarah couldn't really speak. Her throat was sore from smoke.

"Get some rest, Sarah, and pray for those poor souls. That's all we can do."

Part 2.

"She sleeps and dreams of fish. Even in sleep, she knows it is not new, this dream in which she swims through watery canyons, through pale reaching reeds, through damp light filtering down from some unknown source—a moon perhaps or a dying sun."

From *Waiting for Time* (The sequel to *Random Passage)*, by: Bernice Morgan, p.25

Chapter 20

A few short weeks later on Christmas Eve, the convent chimed of muted gongs and bright harmonics from the Chapel. Sisters rushed through the halls buzzing in different directions carrying papers, towels, trays of dishes, and bags of laundry. Scents of cinnamon, freshly baked bread and pungent cloves filtered in and out of hallway passages.

"Lizzy, I have to have one of those cinnamon buns. The smell is killing me. Can you ask?"

"I will, in a moment."

She was writing a few more Christmas cards to people home. It had seemed like yesterday since she and Sarah had arrived and yet it was already Christmas. And so much had happened. She would be late with her cards but that was better than not at all. She could always use the excuse that she was with child. It sounded weird in her head but also thrilling. She was so excited about the new baby that to write that passion into her letters was no feat of hypocrisy.

A knock came at the door.

"Come in!"

"Good morning, girls."

"Oh, dear Sister Ella. Do you think we might get to taste one of those delicious-smelling cinnamon buns?"

"Sarah, Sister Ella has a million things to do right now!"

"I'm sorry, Sister Ella. I couldn't help myself."

"Don't worry, dear. I have good news, ladies. Sister Sarah, as long as you wear your cloaks, you will be able to join us for Christmas dinner tonight and in the Chapel for midnight mass."

"That's great, Sister!"

"You can stay with us for the Christmas meal but then you must come back to your room. The Sisters know you are unwell so they will expect it. Okay, I'm off. Lots of chores."

"Ah, Sister?"

"Yes, right, the buns. I'll sneak a couple up here as soon as I can."

Sarah smiled and clapped like a little girl.

Sarah heard church bells gong in the distance, heralding the start of Christmas Morning Mass at the St. John's Basilica Cathedral. She felt the same giddiness she had felt as a small child discovering a beautiful hand-sewn doll under the tree. The bells, the clink of porcelain and glass, the scrape of cutlery, the pop of corks and caps of spirits and wine, holy wine in this place, brought her mind easily into the season. She excitedly breathed in the cinnamon, cloves and ginger from the kitchen, spruce trim from the outside and incense from the Chapel as if they might disappear before her next breath.

Sarah longed desperately to go to Christmas Dinner later in the evening but Mother Martin's rule was clear: no Mass, no Christmas Dinner. The idea of dragging her swelling weight to church, standing, kneeling, standing and walking back to her room sickened her, leaving her slightly exhausted. She would have to pull herself together. She was going to be stuck in this room for the next few months while she waited for her child; she was going to enjoy this nice evening with the Sisters she hadn't seen much of in the last six to eight weeks.

She didn't look that big yet, but she did feel sluggish around the middle. At least, she was in good spirits. Sarah ambled over to the washbasin where Lizzy had brought her lye soap and water. She

dipped the rough cloth into the lukewarm liquid, wrung it out until it was rendered damp and covered a small section of it with a beige bar of soap.

While she scrubbed her face, with her eyes closed, she smiled at the idea of seeing the Sisters she hadn't seen for many weeks. Then without any introduction, thoughts of Mother Martin interrupted her smile and stilled her; while she had seen the Mother Superior on a few choice occasions during her resting period, the older woman had kept her distance. It had surprised Sarah. She'd expected daily episodes of questions and demands, but none of it came.

Eyes still closed, she gingerly dipped her cloth back into the basin and rinsed the cloth clean, the residue cooling on her complexion. She didn't need to see Mother Martin every day to feel chilled by her presence. Sarah still had this woman in her life; they shared the same building compound; her invisible claws controlled everything in Sarah's life and future at the moment. Sarah lifted the cloth and wiped away whatever dirt remained on her face.

Soon, thought Sarah, when she had this baby, she would be as far away as she could possibly get from Mother Martin whether it would be Fox Harbour or Toronto, she wasn't sure; but Sarah knew in her heart that her home would not be in this convent, not in any convent.

She straightened and felt a sudden sense of relief that she'd made a decision: she would leave this convent with her baby and Lizzy, just as the two girls had planned. If she went home with Lizzy, she could see her baby all the time and even be the ever-helpful auntie. Now she had to convince her Momma that Mother Martin's Toronto idea was the worst thing for everybody.

She folded the damp cloth and hung it from the washstand's railing.

"Sarah, are you ready?" Lizzy entered their room and came towards her to grab the dirty water.

"Yeah.," she said, her arms outstretched in her grey woollens. "Can you tell I'm bigger?"

"You can't see anything, truly," said Lizzy. "I know you're six months in but you could be nine months in those capes. They are so awful."

"Great," said Sarah, rolling her eyes.

"The worst part will be over before you know it," said Lizzy. "Then all the Sisters will have seen you and there'll be no surprises when you walk in for dinner."

"No surprises? I'm a whale, Lizzy, look at me!"

"Come on, Sarah, it'll be fine. These girls would never even suspect. They are too holy anyway. Come on, let's try and have a nice dinner." Lizzy took her hand and pulled her towards the door.

"Wait, I haven't even dried my face, Lizzy!" Sarah pulled on her sister's hand, stopping her. She grabbed a bigger dry cloth, wiped her face and gave her hair a tousle, landing it exactly where it had been before she touched it.

"There, I'm ready," she said, grabbing Lizzy's hand again. Lizzy smiled but seemed a little distant.

"Are you ready?"

"Yes, I am. You look great, Sarah, especially for someone who is ill, remember?"

"I have hardly forgotten my illness," said Sarah, rubbing her small round belly discreetly hidden beneath her grey convent woollens. "I wish I could be home with Momma and away from this awful place. I can't wait to get this baby out so we can go home."

Lizzy looked away and busied herself with tying string around a package wrapped in brown paper. "Yes, I long to be home, too," she said in a quiet voice, still looking down.

"What is it, Lizzy?" Sarah searched for her sister's eyes for answers.

"Nothing, I wish I could go home, too, I said." She tightened the final knot hard and then threw the package on the dresser. "Come on, we're going to be late."

Sarah couldn't be home for Christmas for the first time in her life; she was stuck in this sanctimonious trap. Eating a few morsels of Christmas Dinner might be enough to give her a little boost but she wasn't capable of real joy this season. There was too much in jeopardy.

The two sisters walked to Mass hand-in-hand, filing in behind the others, nodding simply as they made random eye contact with various Sisters. No one spoke as they continued down the hallways to the Chapel. Sarah's free hand protected her stomach beneath her cloaks as she waddled slowly next to her sister. When they knelt silently before the service, she prayed not for her soul or for her family; she prayed she wouldn't faint or vomit in front of the others. Though that would only confirm her alleged illness in front of many witnesses, she wanted to hold herself together to have dinner. Mushy peas pudding, savoury breaded dressing and cooked turnip would be a small way to gain back her strength and feel at home. The organ started and the Sisters rose to the occasion.

Sarah felt her cheeks flush with the activity of rising, sitting, rising again and kneeling. Christmas Mass ended softly with an organ hymn that ushered them down the aisles. Elizabeth grasped her hand and kept close to Sarah, careful not to knock against her as other Sisters strolled behind and around them, hoping to get a friendly glimpse of the sick girl who'd been in hiding, convalescing for the last while. As Sisters passed them, they would nod, lay a hand on Sarah's shoulder or make a quick wave of their hand to acknowledge her. She felt them close to her yet the knowledge of her secret condition made her feel so far away. None of them would ever know her true anguish, her real dilemma. None of them, with all their holiness and strength of prayer could ever help her rise from these tarnished embers of hell that still burned her hopes of a happy life with or without her new baby. She was doomed to be miserable if she went home; and without a sense of home, if she ran. Still their

gentle touches pierced her black mood and touched her old self. Despite herself, she smiled vaguely and kept her feet moving forward.

The others scurried off to finish their assigned roles for the day, taking great pains not to work too hard on such a significant day in Jesus' name. Elizabeth's job was to stay with her sister. They returned to their room where Sarah slept fitfully, turning back and forth in sleepy attempts to stave off angry nightmares where her baby suffered horrible deaths and tortures at the hands of a hideous Mother General dressed in black. Elizabeth watched with worried eyes as her sister heaved and rolled her swollen form in the bed. She wiped the drops of sweat that rolled down Sarah's angelic and twisted face and wrung the soaking wet cloth out in a pan beside the bed. She hoped both mother and child would make it through to March when the new baby would be born.

Elizabeth sighed in guilt and pleasure. She could not separate the two inextricably linked emotions when it came to her niece who would become her daughter. As she wiped Sarah's clammy forehead, she longed to know what would become of this blond girl who had been her sister for 15 years. She could not see the light of joy anywhere in Sarah's future, knowing what she knew.

The bells chimed, telling them that dinner was ready. Sarah sat up, shaken.

"It's okay," said Lizzy, cold cloth gone dry and tepid. "You're okay. It's only the bells that dinner is ready."

Sarah looked around the room as if searching for clues to her whereabouts. She turned her body gingerly and moved her legs to the floor.

The two girls stood. Elizabeth reached over to fix Sarah's hair, gently moving it back and away from her face. "Are you ready?" She asked.

Sarah nodded.

Sarah drank in the decorations and the music as they entered the main dining room. Tablecloths of crisp white fabric covered long stretches of tables in the eating room and held shiny silver candleholders supporting creamy candlesticks. Sisters filed into the big hall and one-by-one slipped quietly into empty wooden chairs. Once the first main table was full, they launched into a sweet rendition of Joy to the World as the others, smiling, found their seats. Sarah had been parched for stimulus so long other than her sister's interactions that she relished the harmonious sounds of the spontaneous carol. Mother Martin sat at the head of the table, said grace, and dinner began.

Sarah stole a few glances at Mother Martin whom she hadn't seen for weeks. It was as if the evil woman had forgotten about the girl she loved to torment. As she watched the older woman nodding her head at the cooks and servers and handing around bowls of boiled potatoes and steamed turnip tops, Sarah wondered what had happened to her. What had her childhood been like? Why did a women so hateful want to give her life to God and the caring of others? She thought she caught a flicker of steel-blue eyes and abruptly looked at the nameless faces of the other Sisters. She breathed deeply and took in the aromas around her.

Sarah couldn't eat much, but the smells, the few tastes she swallowed, and the company of the many Sisters around her were enough to buoy her spirits higher than six weeks of her sister's well-meant nurturing. She watched as lean and lanky Sister Marguerite came around with the teapot to refill her teacup.

"Sarah, you look so well. I was so worried about you these past few weeks," she said, pouring hot brown liquid into Sarah's teacup.

Sarah looked all the way up at the clown-like expression on Sister Marguerite's wide mouth. The clown's black eyes sent a chill down her back as Sarah nodded and turned to look anywhere else.

"I'm feeling much better, thanks," she said, watching to see if the other Sisters safely drank the tea from the same pot before she tasted it herself.

Lizzy's eyebrows lifted. Sarah's two eyelids closed in agreement. Sarah knew what she was thinking: Strange woman. Strange and very creepy.

"Excuse me, dear Sisters." Mother Martin's voice sharply sliced the festive air. Please join me in prayer before we finish our tea and head back to our rooms." The Sisters bowed their heads.

"Dear Lord, please accept our thanks and praise for this wonderful meal on Jesus' special day. We thank you for your many fruitful and unexpected blessings, such as Sarah's improved health."

Sarah didn't dare look up but felt her neck burning with rage at the mention of her name. She clamped her mouth shut and held her hands tightly in a gesture of prayer as she waited for the end.

"We thank you, our Lord, in Jesus' name, Amen."

"Amen," said the Sisters as they rose together, shaking hands, some hugging and others removing dishes and cups from the table and marching off to the kitchen. Each year, a team was on duty during the holiday season to do the work while the others enjoyed and gave praise to the Lord.

Sarah got up immediately and grabbed Elizabeth's hand.

"Come on, I want to get out of here," she said.

Lizzy said nothing and followed.

Mother Martin watched the two skulk out, a sly smile on her mouth.

Sarah's will of steel eventually wilted against the strength of this inner being innocently sucking out all precious nutrients from her ill-nourished body. She felt herself become more and more lethargic as her swollen abdomen grew bigger and bigger. As the long winter months slipped by, so did she, a mere vessel, an empty soul carrying a new life that took its toll on her.

"A couple of bits, Sarah, and only then will I leave you alone." Lizzy waited patiently with the spoon in mid-air.

Sarah sighed outwardly, loudly.

"Sarah, eat. You have a child. You may not care about the world and what's in it but there is a baby inside you and I need to make sure it eats."

"That's all you care about, isn't it?" Sarah glared at her as she opened her mouth wide.

Elizabeth turned pale and shoved the food in her sister's mouth.

"Sarah, we're talking about a little baby. And frankly, you're not making it easy to care about much more than that." Elizabeth was frowning as she dug her spoon back into the porridge. "I'm doing the best I can to take care of you but everyday you make it worse and worse. *I* didn't do this to you remember? Open your mouth."

Sarah took the food without a fight. She felt awful but she really didn't care about anything right now. The cold lump of porridge sat on the middle of her tongue, heavy, intrusive, unappealing. She'd never felt this low before; she couldn't help it. It took all her energy to look interested in anything.

"That's the last of the porridge. I'm going to go for a walk; would you like to come with me?

Elizabeth stood and cleared away the dishes. She straightened up her skirts and brushed off any stray bits that might have fallen in her lap.

"Are you sure you don't want to go for a walk?" Elizabeth was waiting for her to respond, though she knew what answer she would get.

"Yeah," said Sarah, looking at the ceiling, her reply barely audible. "I'm sure."

Elizabeth sighed, grabbed her cape and left.

She walked straight down the hall to the side exit into the gardens. Though it was late February and extremely icy in patches, Brother Randall had diligently put salt on all the walking paths, knowing the Sisters would want to take walks during their private time in the afternoons no matter what the weather.

Brother Randall had told Elizabeth that all weather was the Lord's weather and the Sisters had accepted it all equally. "And anyway," he'd said, "if you waited for fine weather in Newfoundland, sure, you'd never go outside now, would you?" Then he laughed and carried on, distributing his well-measured salts across the next shovelled path.

He usually had a way of making Elizabeth smile to herself, even when she wasn't chatting with him. Such a pleasant man; it was a shame he'd never have a wife.

Elizabeth walked down the first path and turned right to make the circumference walk about the grounds. Though the main convent building itself was sizeable, the grounds were triple the area, hosting other smaller buildings, making up an entire compound. Poised on the side of a hill, leaning into a valley in mid-city, this compound was both comfortable and ideally located. It was a 10-minute walk from the downtown to the waterfront going east. Memorial University College was even closer than that to the west. The Sisters rarely went past the convent grounds anyway but it was nice to know they had options, thought Elizabeth. If she were braver, she'd venture out, but anything bigger than Fox Harbour flustered her. Even Argentia where the Base was could put her into a spin of confusion.

She sighed as she rounded the bend and walked slowly along the back of the grounds. Her mind went back to Sarah and how carefree she used to be. Now she wasn't sure what to do with her—this new Sarah, full of woe and misery and self-hate. Elizabeth was quickly running out of ideas. Ever since Christmas, her sister seemed to have deteriorated in multiple ways: her mood, her interest in anything, her energy. What disturbed Elizabeth the most were Sarah's screaming nightmares that interrupted her sleep every night. She no longer seemed to care that she hadn't written home in a couple of months.

Sarah grew more and more lethargic, listless and uninterested. The rounder and bigger her stomach grew, the broader her depression became, cloaking her in a dreary pale cloud of hopelessness.

Letters from Momma and Jack and the girls addressed to Sarah would have sat untouched if Elizabeth hadn't opened them and read them aloud. Sarah had been so excited about Jack's first letter at Christmas, especially since it literally was the first letter he'd ever written in his life. That was the last time Elizabeth had seen any spark from her sister. She still hadn't written him back yet. It was heartbreaking to watch her disappear. Elizabeth had to write an apologetic note that Sarah was unwell but sent her best wishes.

Spring was around the corner and that meant the baby was soon coming; hopefully, things would get better once the baby was here. Elizabeth worried. She didn't want her sister to be away in Toronto somewhere all on her own. She hoped Sarah could still come to Fox Harbour to watch her own child grow up and to be close to the people she loved, but she had a feeling Mother Martin and her own mother were not going to have that.

After Elizabeth left, Sarah broke into tears. She hated life right now. She hated herself. She felt his hands all over her – every night – smothering her, overwhelming her, forcing her, forcing into her... She would wake up in a sweat, out of breath feeling disgusting, vile and unclean. Her hatred grew as she envisioned the spawn of Satan living inside her. She could not wait for the demon to be removed from her body. She tried to turn her hatred inward, to show no mercy, but she couldn't. She'd lift her fist to punch herself in the bulging mound that grew every day, but she couldn't. Something always stopped her, leaving her to feel helpless, alone and at the mercy of an unfair and cruel nature.

In the last month, she had hardly spoken a word to anyone other than Lizzy. And that didn't matter to her. She didn't care anymore. It wasn't that she wanted to die. She didn't. She didn't care enough to live. She had nothing to live for.

Why bother going for walks or eating, for that matter? Lizzy was always forcing food at her. She didn't need that much. Maybe a little bit for the baby, what else did she need? She was a shell. If she couldn't go home after this and she couldn't have her baby, what was the point of it all? The invisible wall around her kept closing in. Her will to feel better diminished more and more each day.

"Lizzy, look! It's there, see it?" Sarah sat up in the near dark. There was only enough moonlight to remove complete blackness.

"What?" Elizabeth sat up stunned, trying to focus her eyes on Sarah, and the thing she was pointing to. "What thing?"

"There, look! See it? Oh no, Lizzy, it's coming this way, wailed Sarah in a frightful moan, her hands out in front of her, pushing back the darkness."

"There's nothing there, Sarah, come on, wake up. You're dreaming."

"My eyes are open, Lizzy! Stop him. Make him stop! He's huuuurrrting me," she screamed.

Elizabeth was shaking her by the shoulders trying to snap her out of it when the door flew open. Sisters Jane and Ella ran in shrouded in white cotton to see what was the commotion.

"She's dreaming again," Elizabeth told them over Sarah's wailing and crying.

"Heavens!" said Sister Ella. "Wait, I know what we'll do. Sister Jane, get the bottle of vinegar in the kitchen, quickly."

The two women tried to calm Sarah down as she called out pleas to help her and save her from the brutality. Sister Ella blushed in the candlelight and was relieved when Sister Jane returned carrying a white bottle. Sister Ella dumped some on a rag and held it up to Sarah's face.

Sarah shook her head and backed away from the rag, suddenly silent. They breathed a collective sigh of relief. Sarah stared at them amazed.

"What's going on?" She said.

Mother Martin appeared in the doorway.

"Yes, Sister Sarah, that's what I'd like to know."

Elizabeth put her hand on Sarah's arm. "Sister Ella is going to look after you for a moment. I'm going to talk to Mother Martin." Sister Ella nodded. Sarah, a little shell-shocked, watched her sister walk away.

"What do you mean medicine?" Mother Martin asked in the dark hallway outside their room.

"Mother Martin, I mean Sarah is quite unwell. She has only about three to four weeks left of her pregnancy. She's hardly eating anything. I'm worried she won't get enough sleep or that she'll start to deteriorate. She has begun to have these nightly dreams that wake her up in a sweat. I am sure a doctor would know what to do but I think she might need some kind of medicine to help her get through this."

"Well, considering the trauma she's been through, I'm surprised they didn't begin earlier." Mother Martin paused briefly. "Is she asleep the whole time, Sister Elizabeth?"

"I'm not sure. I know she wakes up, her eyes are open but she sees things I do not see. She doesn't seem to know I'm there."

"I see. She is an unlikely target but the Lord does work in strange ways. Could it be Him coming to see her?"

Elizabeth hardened a little underneath her polite veneer. She knew fine whether her sister was experiencing pain and anguish or being visited by the Lord. Everything was not about the Lord! They were psychically connected like twins in a way that Mother Martin

could never know or understand. But she also knew she couldn't dismiss the possibility in front of Mother, if they were to get through this mess with her help.

"Mother Martin, I don't know enough about such visitations nor Sarah's nightmares to say. I see how her terror and rejection are so visible in her words and actions during these episodes. She won't say much about them but she would never behave this way were it the loving Father."

Mother Martin nodded. "Right. Tell me, Sister Elizabeth, what does she say during these dreams?"

"I only hear her telling him to stop what he's doing…uhm to not touch her…to get off her."

Elizabeth found it so difficult to utter those vile words. She felt fury and embarrassment rise in her very core. She was going to find this bastard and – she didn't know what she would do to him but she was going to find him.

"Right then. Definitely not The Lord..." Mother Martin cleared her throat. "Fine, please go see Sister Marguerite later this afternoon. I'll talk to Dr. Parsons at the Apothecary down on Hill O'Chips Street. He can recommend something. There's no need for this to continue if the doctor can do something about it."

"Thank you, Mother Martin."

Dr. Parsons brought his black bag of tonics and elixirs to the convent and gave Sarah one of the mysterious liquids to help her sleep calmly. As Mother Martin and Elizabeth saw him to the door, he gave them strict instructions on what to do.

"Remember, only when she really can't sleep or can't calm down do you give her the medicine. It works wonders, but it can be also highly addictive, depending on the patient."

"Thanks, Dr. Parsons. We will take the utmost care with it."

Dr. Parsons' medicine did the trick. In no time, Sarah began sleeping calmly and quietly, much to Elizabeth's relief.

One blustery morning in March at about 5am, Mother Nature defied all potions and decided it was time. After about a month of relative silence, Sarah let out an unrecognizable grunt and said, "the baby!" Elizabeth leapt out of bed.

"Okay, honey, just try to breathe deeply. I'll go get help."

Sister Marguerite came running with bowls of hot water and towels while Sarah set to work trying to breathe through her contractions, Elizabeth by her side. Mother Martin kept her distance, checking in from time to time or getting updates from Sister Ella.

They ushered the Sisters into a sound-safe area of the convent for a special prayer session to help Sister Sarah through her 'difficult time'.

"Our dear Sister Sarah continues to struggle with ill health. Today and tonight seem to be particularly challenging and so we must hold an overnight vigil and pray for her safe delivery into good and stable health for the long term. Let us pray."

Sarah's breathing quickened. Drops of sweat rolled past her ears and downward toward hell. Her hands clawed rigidly at the bed sheets.

"Lizzy, where's Momma?" cried Sarah, her head surging backwards in a wave of violent pain.

The desperation in her voice brought Elizabeth immediately to the bed where she clasped her little sister's pale struggling hand, obsessively smoothing over scars that had endured too much scratching.

"She's home, Sarah, honey. Shhhh, now. It's soon time. Keep breathing nice, long breaths, that's it, my dear." Elizabeth continued

to murmur calm words to Sarah while perpetually looking up at Sister Ella, trying to read between the lines on her face, searching for answers. How soon would the doctor come? How much pain could Sarah endure? How long would this last? How long before they would hold a beautiful child – Elizabeth's niece – her daughter in her own hands, like a gift fallen out of the sky from God? All she had to do was hold out her hands and catch it. She was suddenly awash with guilt. What right did she have to take this child from Sarah – a child herself? Sarah let out another agonizing cry. And the cries kept coming in horrifying waves. Elizabeth pushed everything out of her mind but her sister, and God. They were all in this together. She switched her words to call on the Holy Father, imploring Sarah to do the same.

"Come on, Sarah. We'll call on Him to help us. Our Father, who art in Heaven, hallowed be thy name…"

Sarah clutched her sister's hand, desperately hoping to pull herself out of this pain. She couldn't do this. It wasn't fair! She did not ask for this agony. Her body was out of her control but mind could not logically accept this. She could not endure this pain any longer. Too much, too much. She cried out again and again.

"I can't do this! Make it stop!" Tears streamed. She knew Lizzy was talking to her but her ears rang with numbness, as she tried to fight the searing and ripping of her insides and her very centre. "Make it stop!" Sarah welcomed a cold cloth on her cheeks and forehead, but it did nothing to ease her body from this hell. She began cursing Frankie loudly and intensely, with abandon, ignoring everything else in the room, riding her hate for his violence against her body and her life. Then everything went black.

Frankie was sitting in his kitchen with the radio on. Gerald S. Doyle's nightly news bulletin percolated through his thoughts. With very few phones in the outports and small communities around the coastline, Doyle's show was often a mainline of communications, announcing personal messages and ads to and from people across the island. Frankie usually had it on in the background.

"To Mrs. Angie Brewer, Clattice Harbour, from Dad. Your mother had her hip surgery. She's doing well. Stay tuned for tomorrow night's update."

"To Mr. George Davis, Ship Harbour...."

And Doyle continued his community listings, holding his island listeners captive every night. These tiny communities hung on his every word, even if they didn't know all the names; but every name belonged to a family somewhere. Frankie read the paper and decided to turn in early, until he heard his name...

"...Fox Harbour, from Elizabeth. We now have a beautiful baby girl, Mary-Lynn Healey, born this morning at six pounds, two ounces. Heading home tomorrow."

"Mary-Lynn," he said out loud.

Now everyone knew he was a father. He was a daddy, his own flesh and blood, supposedly. His face flushed ever so slightly at the thought, though he wasn't completely convinced. Maybe once he saw the child, he'd know for sure.

Elizabeth trembled whenever she held this tiny form in her hands. She couldn't believe this beautiful child was now hers and Frankie's. A shot of guilt plunged through the heart. She looked briefly out the train window at the rain. She hoped Sarah would be okay and that she would forgive her. She had to force herself to focus on the good parts: this new life in front of her was the most important thing. She couldn't wait to see Frankie and show him his new daughter. She did worry a bit about how he might react. She prayed he would love Mary-Lynn as his own and without too many questions. Her momma had warned him all right. She prayed that Sarah would be well and would forgive her sister for not saying goodbye. Mother Martin insisted it would be better this way.

Sarah woke up, alone and panicked.

"Lizzy?"

Sister Ella came to her.

"Now dear, get some rest. You've had a long night."

"Where's Lizzy? She's not here? Where is she?" Sarah's voice quickened with each syllable. "Did the baby...?"

"Dear Sarah, the baby is with Elizabeth. Remember; it's her baby now."

"Noooo.... Can't I see her?" Sarah started screaming and droning. An inexplicable deep ache lodged itself in her core, compelling her to cry out for a child she never wanted.

Sister Ella tried to calm her but failed. Sarah started shoving. Sister Ella's hands chased Sarah's, trying to hold her arms until Sister Marguerite and the others came. They jabbed her with a needle. Her arms relaxed and she looked straight at them.

"Is the baby healthy? Is she okay, Sister Ella?"

"Yes, dear Sarah. She's very healthy and energetic. She's lovely."

Sarah smiled and nodded her head, her eyes already closed.

"Now get some rest."

After a few moments of listening to Sarah's breathing, Sister Marguerite got up to leave. "This wild child is not going to let go too easily, is she, Sister Ella?"

Sister Ella slowly shook her head, looking down at Sarah's sleeping form.

Sarah woke up the next day groggy, in pain and upset.

"Sister Ella, I want to go home."

"Dear Sister Sarah, you are home."

"Don't call me Sister Sarah!"

Sister Ella continued preparing her syringe, saying nothing.

"No, I mean..." Sarah started crying. "I mean Fox Harbour. I want to go to Fox Harbour. I want to see my baby. I want to see Elizabeth. She's my sister. I need to see her. I need to warn her..."

Sister Ella gave the injection.

"No, but it makes me so sleepy, Sister."

"Yes, dear Sarah, because you need your rest, honey. You're unwell. You must recover before you can do anything more."

Mother Martin entered the room and put her hand quietly on Sister Ella's shoulder.

"Sarah, dear, you'll soon be well and then we can talk about it. Until you are calm, we can't risk you hurting yourself or someone else."

But Sarah didn't reply. She was already asleep.

"Continue with the medication if she starts acting up. If she's calm, there's no need, understood."

"Yes, Mother Martin."

Chapter 21

Frankie was pulling up in his car when the train from St. John's carrying Mary and Ed's new granddaughter chugged loudly into Main Branch Station. He watched his in-laws standing on the platform in the freezing wind. Brutal March was so unforgiving all over this cursed province, thought Frankie, but here, it was utterly punishing. His eyes followed the trail of snowdrifts flanked against the station their white sharp slopes pointed violently upward with blinding dominance.

Mary's hands covered her mouth, an unusual circumstance, observed Frankie. He supposed she couldn't wait to see the child. He secretly admitted he couldn't wait either.

The train stopped and after an eternal few minutes the conductor opened the door and climbed down the steps, holding out his hand to anyone needing his assistance. And then she appeared carrying her bag and a tightly wrapped bundle no bigger than a loaf of homemade bread in her arms.

Mary ran to her daughter, hugged her gently and picked up her granddaughter.

"She's gorgeous!"

Elizabeth couldn't contain her smile or her emotions as she grasped her blowing hood, snow swirling in a fury about her. She nodded and hugged Frankie. He looked over in his mother-in-law's arms at his new daughter and looked hurriedly around for Sarah, but she wasn't there.

And then he knew.

He had no proof; he just knew.

She was his daughter.

Christ.

His one weak moment, his one stupid mistake suddenly snarled itself into an overgrown thicket of brush, tightened around his throat and sucked him dry of saliva. She was the one who got with child, not Elizabeth. It had to be true. He knew his own child, and knowing the timing of that night and of all three Marsh women taking off for a trip to see an aunt they never see or talk about or talk to. It all made sense now.

"She's grand Elizabeth. She's grand."

"Yes, she is."

"She is grand," said Ed, smiling, despite his usual sour demeanour.

Frankie couldn't take his eyes off the child. Jesus, if Ed knew, he'd go over the edge.

"Thanks, Daddy."

"How's your sister?"

"Oh yes, she's good, Daddy. She's staying in St. John's for a bit. Seems the Sisters might be able to get her a job. She'll write soon, I'm sure."

"Yes, b'y. She gonna be a nun, or wha?"

Mary didn't even look up, like she couldn't take her eyes off the child she'd been waiting to see for so long. She held the child close as if the bitter winds would pick her up and blow her away.

"Maybe," said Elizabeth. "They are surely workin on her."

"Yes, b'y." Ed nodded his head. "Proper thing, if that's what she minds doin."

Frankie had had enough. "Let's get back to the car. It's enough to freeze you out here."

Frankie ran back to his beater to open the door for his new family. Christ, what was he going to do? This was too dangerous.

Somebody might put two and two together. He looked at Elizabeth wondering if she'd figured it out, then in disbelief that she could lie to him like this. She smiled back at him as she climbed into the car with the baby in her arms. She is going to pretend that this is their child for the rest of her life? Jesus. He couldn't decide if he was the luckiest bastard in the world or the stupidest.

Frankie got in the car and pulled out. Maybe he should just cut his losses and leave town. He heard they're always looking for people up in Labrador. He had until the spring thaw to figure out what to do. Until then, he prayed Ed would never find out the truth.

When they got home, Elizabeth set the sleeping baby in her crib and came out to the kitchen. She flopped down on the daybed.

"You look great for someone who just had a baby," Frankie said, unable to stop himself. He was going to enjoy this…watching his transparent wife try to lie through her teeth and come up with answers. Yet, he couldn't let on he knew the truth, or he'd have to explain how. He fell in love with the child the moment he saw her. She was surely his and only he and Sarah knew it. But suddenly the woman he married was now a liar and a cheat.

"Oh, well," she said, smiling. "I don't know about that. I mean, I am exhausted, though, can't you see?" She put the back of her wrist up against her forehead.

"Oh yeah. So how long were you in labour for?"

She crinkled her eyebrows at the question. "Labour, yes, well, about thirty-six hours, I guess."

"Wow, musta hurt like hell, wha?"

She looked up at him.

"What is this? Of course labour hurts, what do you expect?!"

Frankie took a sip of his beer.

"Now, now. Don't get all touchy on me. I'm only saying. That's all."

"Well I'm goin to bed," she said. "I've had a long day."

"Yes, I bet you have," he muttered under his breath. She wasn't going to tell him what he suspected; and he couldn't say he knew it without blowing his cover. He pondered their strange situation and let it go.

Over the next few days, Elizabeth welcomed the stream of visitors coming to get a look at the new child and bring their best wishes and gifts. Mary stayed around to help with the company. Ed stayed out of the way and chatted with the men over a beer and a cigarette. Frankie watched in eerie silence.

Later one night after being home for about a couple of weeks or so, Frankie came home with an attitude lit up from too much beer and rum.

Elizabeth was finishing some mending work, wondering what had happened to him.

"There you are."

He didn't answer.

"Frankie, you're a father now. You can't be out traipsing all over the place with a young daughter at home. I had no idea where you were. What if something happened?"

"You knew I was at the Base, woman."

"Well, that figures."

"What does that mean?"

"I thought things would be different with you now that we have a child."

"Oh yes, now that we have a child. Well, I wonder if it is my child."

"What? Of course it's your child. Why wouldn't it be?"

Elizabeth knew how terrible she was at lying. If her sister or her mother were here, they would know as they could see through her. She prayed Frankie couldn't.

"How do I know it isn't some other skeet's daughter?"

He swayed dangerously on his feet. She froze. She couldn't bring herself to remind him of her mother's warning. Now would not be a good time.

"Are you accusing me of being with another man again?" She asked quietly.

"Were you?" He came closer.

"My God, no! Never." She stood to face him.

"Well I don't remember you crawling all over me with a burning passion back in the summer, or the last three years for that matter!? Then suddenly, you goes away and comes back with a baby?"

"Francis John Healey, don't you dare talk to me like that!"

He leaned off and slapped a hard stinging blow to her face.

Her hand went up as if to cool the heat.

In a cold, quiet voice, he glared at her with hate spitting through his gritted teeth. "Now you listen to me. Don't *you* dare talk to me like that. Get out of my sight, you fucking cunt."

Tears flooded her vision. She ran to the baby's room, bumping into the doorframe. Mary-Lynn was crying with the ruckus. Tears rained. She could hear Frankie falling like a lump on the daybed, then silence. She rocked Mary-Lynn and herself back to comfort.

201

After about a month of regular injections, Sarah floated in a haze. It took her a while but she finally realized she had to stay calm if she was ever going to find out what was going on. Her sister and her baby had to be back in Fox Harbour. She knew that. She could feel it. But she also felt her baby would be in danger. Now that she was a mother, she understood she had to protect this child and save her from that animalistic bastard who was actually the child's father. Lord knows what he would do to a helpless child. Tears rushed to her eyes, but she forced them back. Damn, she should have told Lizzy about him. She was weak but she couldn't stand this anymore. So when Sister Ella came in, she was ready for her.

Sister Ella murmured soft words as she always did to Sarah before her injection. Sarah tried to stay calm and without over thinking she reached up, grabbed the syringe and jabbed it into Sister Ella's neck with a strength she didn't know she had, then pressing the cold metal plunger, she watched the calming liquid disappear through the syringe into her target. She saw Sister Ella's eyes grow giant and round in disbelief.

"Don't worry, Sister Ella. It'll just make you sleepy; and you've been working so hard."

Sarah's body had taken over what needed to be done. Her brain kicked into fight and flight mode as she threw off her bedclothes. Sister Ella stood swaying with her mouth open in horror and pain, her hands framing the needle sticking out of her body but too afraid to pull it out. She couldn't speak or yell while Sarah hurried around the room grabbing whatever she would need to take with her. In a few minutes, she was ready and out the door. She prayed that she hadn't done too much damage to Sister Ella but enough to cause a distraction, so Sarah could get away. She ran to Sister Ella and whispered a hurried apology to her before she snuck out the door. Sister Ella fell to the floor in a writhing clump of white veil and cloth, an expanding bloom of blood at her centre. Sister Marguerite was downstairs reading when she thought she heard a loud thump on the ceiling. She went upstairs to find Sister Ella slipping into shock.

"She...she..."

"It's okay, Sister Ella. You don't have to talk. Save your energy."

Sister Marguerite called out again. "Can someone please come help?!"

"...she...wanted...to save...her baby...," Sister Ella whispered.

Her pulse barely touched the skin under Sister Marguerite's finger, fighting for every beat, like a tired boxer.

"Dear Mother of God Almighty and the Holy Ghost."

She blessed herself and prayed fervently over Sister Ella, praying her soul would not depart for the Holy Land of the Lord – just yet.

Chapter 22

Something was not right.

It had been well over a month at least since a very fragile Elizabeth had brought home Mary's granddaughter. Mary-Lynn was growing into a very healthy child, but her mother hadn't strengthened at all. In fact, she'd gotten worse.

At first, Mary assumed it was the ordeal of Elizabeth leaving Sarah behind and taking the train with a new baby and having to fake it through the initial public scrutiny. Mary knew that would be hard on her at first; Elizabeth was so honest. But it was worse than Mary had expected.

Her daughter cried at every turn. She was like a cat on hot rocks. It was as if she herself had had the baby and all the emotions that came with it.

Everyone else who encountered her daughter's mood would pat Mary's hand and say, "Not to worry, girl. It's the hormones, you know."

She'd nod her head, but she knew better.

Maybe it was about Sarah. This was the first time since Sarah was born that they'd been apart for this long. That could be it but she couldn't say. She knew she needed to find out what was happening. She wasn't about to lose yet another daughter.

Sarah found her way around the front gardens and through the side gate. She knew sometimes it was left open. She was shaking

from the cold and anxiety. What had she done?! She had no choice. They were trying to manage her with drugs and yet her baby was in danger. Once her child was under his roof, there was no telling the horrors of what he might do to her. Oh dear Lord, she had to get to Fox Harbour as fast as she could.

She couldn't believe Elizabeth would leave with her baby without a word or a note – nothing! It had to be Mother Martin's doing, probably telling her it was for the best.

She strained to recall through the haze of delivery – her name was Mary-Lynn. She leaned in behind a bush and vomited. She was not going to let him hurt her baby the way he hurt her. Even if he killed Sarah, saving her child would be worth it. People needed to know how dangerous he was. Oh, how she should have told Elizabeth everything!

Sarah kept running until she was out of breath. Thankful for leaping into her boots before leaving the convent, she wished she'd grabbed more than her first cloak. Though it was mild, snowing light flurries and she still wore the grey woollens, she felt a damp chill beginning at the nape of her neck and crawling silently down her spine. She felt bruised all over, low on energy, but high on adrenaline. A mother's strength to save her child kicked in and kept her moving toward the train station. Hopefully, they would not get word to Fox Harbour of her running away before she reached Mary-Lynn. She hated doing that to Sister Ella. She hoped she was going to be okay. She would write a letter to apologize as soon as she could.

Mother Martin scrambled out of bed upon hearing the commotion and yelling. Still in her nightdress, she ran over to the girl's room. "Sweet Jesus in the Garden and the Blessed Virgin Mary, what happened?"

Sister Marguerite's face was melting with tears when she turned around to face Mother Martin. "She's still with us, Mother Martin,

but quick! Call the doctor! I have been praying for her since the moment I found her."

A few of the other Sisters were arriving at the door.

"Sister Rebecca, call the doctor now!" Mother Martin walked around Sister Marguerite to get a closer look at Sister Ella. Seeing the needle still sticking out of Sister Ella's neck, she dropped to her knees. "Dear God in Heaven. Where's Sarah?"

Sister Marguerite, face ravaged with tears, turned her head, saying nothing.

"Sarah did this?"

"Sarah's gone! We need to help Sister Ella now." Sister Marguerite normally cheery voice boomed across the old room, shocking everyone into silence, then she continued as if nothing changed. "Mother Martin. The needle. Should we take it out? I wasn't sure? Oh, dear Mother, what do we do?" Sister Marguerite continued to rock back and forth holding Sister Ella's hand.

Moaning came lower than a whisper from the curled clump of grey woollens on the floor.

"Sissssss…"

"No, Sister Ella," said Mother Martin, gently laying her hand on the injured woman's abdomen. "Please, the doctor is on his way." She glanced straight at Sister Marguerite and said calmly. "It's got to come out, Sister. Grab that towel on the basin. Now!"

Sister Marguerite scrambled to her feet, letting Sister Ella's hand drop to her side. She pulled on the linen, knocking over the basin and sending the porcelain bowl crashing to the floor. Water spewed across the floorboards as she handed the cloth to Mother Martin.

"Dear Sisters, let us pray to the Lord our God," and as she said this, Mother Martin readied the cloth, extracted the plunged needle from Sister Ella's neck. Blood spurted out as Mother Martin quickly covered the wound with the cloth and pressure.

Sister Marguerite caressed Sister Ella's clammy forehead and through tears said, "Hang in there, Sister, you can be strong and..." Stopping abruptly, as if entered upon by the Holy Ghost itself, she got to her feet again and grabbed another smaller cloth. She wet it in the spilled water, blessed herself and wiped Sister Ella's forehead clean. Then she made a figure of the cross as if the cloth contained holy oil and as if she herself were an ordained priest of the Catholic Church.

"Dear Sister Ella, through this holy anointing," she paused long enough to catch Mother Martin nodding her approval, "may the Lord in his love and mercy help you, with the grace of the Holy Spirit." Sister Marguerite made another watery cross on each of Sister Ella's hands as she said, "May the Lord who frees you from sin save you and raise you up."

Sister Ella's lips motioned open and closed, and even though no sound came, both Mother Martin and Sister Marguerite knew she said, "amen".

They responded, "Amen."

Sister Marguerite grabbed Sister Ella's weak hand again and droned on, rocking back and forth. "Dear Sister Ella, you still have the Lord's work to do. No, no, no, it's not time for you to go yet. Stay, Sister, stay, please, stay, stay, stay..."

Sarah managed to make her way unnoticed down over the hill in time to see a train pulling out. Without thinking, she started running until she tripped over a thick branch sticking out of a hardened bank of icy snow. She fell hard on the frozen ground knocking the wind out of her. Numb with effort to breathe new air again, she fell momentarily silent. Instead of getting up, she lay suddenly still as she felt all her ribs cave in with pain and her heavy muscles settle down in the hopes of a rest. Exhaustion swamped her. She listened with one ear to the train whistle blow while she hugged the cold ground with her other ear. What had she been planning to do? Jump on a moving train? She didn't even know where that train was going.

She refused to cry, fought for calm and heard another whistle – it was more like a horn. She lifted herself up: boats! She struggled against fatigue and gravity as she pulled herself to her feet and then brushed herself off.

"You okay there, Miss?"

Startled, she turned to face a young boy of about 11 or 12 wearing a slightly dirty pumpkin-shaped face housing a big crooked grin with lots of missing teeth.

Uneasy, she slowly started to step back a bit.

"Yes, I'm...oh!"

She fell again only this time backwards into another clump of snow.

"Ooops! Here, let me help you, Miss, for the love of the Lord; please pardon my language."

She tentatively accepted the filthy hand and felt unceremoniously jerked upwards.

"It's no problem, Miss."

At that, still smiling, he removed his hat, as he would do in the presence of a lady. He was tall and built like a rake, but his hand knew a surprising strength from work of a pulling nature, like fishing or net making. His hair curled naturally, and then took off in all directions in a matted knot of comedy she'd never seen before. She started to laugh.

"Miss?"

"Oh, I'm sorry, young man, you are a perfect gentleman but your hair is like a birch broom in the fits! I couldn't help myself."

"Ha ha, oh, yeah that's okay," he said smoothing down one side, causing it to bounce upright again. "It's like that no matter what I do."

"So what do you do? Where do you live?"

"Me? Oh I'm a boat hand, is all. I lives partly here and partly in Fortune and partly, well all over the peninsula, I s'pose."

"I see."

Sarah hated herself for unintentionally sounding like Mother Martin.

"Yeah, I'm on the Clara you know with Captain Noseworthy."

"Oh? And what does he do?"

"He who?"

"Your Captain, uh what's your name anyway?"

"Oh me, I'm Billy. My Captain, well, she's one tough cookie, I tell you, she…."

"She? She's a she?" Sarah's mouth opened

"Oh yeah, yeah, yeah…I'm pretty sure she is, by the Lord. Yes, she is."

"I'd love to meet her. Would you take me to her and her ship, the Clara, you said?"

"Yes, the Clara Murray. Sure, I don't care. I'm goin that way anyway. It's down over that hill. He stopped for an abrupt moment and turned to look at her. You're okay, though, are ya?"

Sarah smoothed her grey woollens with as much finesse as a lady stepping out of her carriage and smiled her warmest. She glanced at the hills behind her flanked with wooden row housing in blood-reds, bruised blues, diseased yellows and greens, intending to stand out in the grave wool-grey fog and drizzle environment of St. John's' gloomy port. How soon would they come looking for her? Would they call police? She had to move faster. She had a baby to rescue.

"I'm fine, dear Billy. Please, show me to your boat."

209

Billy sported his gummy grin and bobbed up and down over snow bank and icy patch, checking here and there, looking back as if mystified she was still behind him.

Sarah followed her unlikely buddy down around the hill as dusk began to settle in. The Clara Murray sounded familiar to her but she couldn't figure out why. Murray was a Fox Harbour name, she knew that much, but surely this wasn't a Fox Harbour boat. And she'd never in all her days ever heard of a woman being in charge of a boat.

"Along here, miss."

"Billy, please call me Sarah."

"Okay, Miss Sarah, sure."

She shrugged her shoulders giving in to his polite manner; she followed his earnest and easy path to a blue and white ship innocently nodding in wait with Clara Murray written on the side. Sarah immediately recognized it as Frank Murray's work. He'd built it and re-built it out of Fox Harbour. She was sure of it.

Billy started to board and she soon followed – her nerves buzzed, her ears sought welcoming sounds and voices, her eyes inadvertently darted ready for physical danger. She felt her body's tendons tighten as she stepped onto the gangway, wishing any other mode of transportation were available.

"Billy," she called in a brisk whisper.

"Yeah?"

He turned the corner and led her down a narrow ship's passageway. All was calm and relatively quiet on board.

"Ever been to Fox Harbour?"

"Oh, God yes. Sure, we're heading out that way tonight!"

He turned around a sharp turn and there was Captain Stella Louise Noseworthy at the wheel, standing stout, her snug midnight

black rubber boots supporting a solid frame. Despite the multiple cloaks haphazardly layered with jagged ends catching in the bitter wind, her shoulders sheltered the top of her very square and set form in an imposing expanse, giving her more physical height than she possessed. She turned toward Billy and Sarah with apparent surprise and delight.

"Billy," she said. "What have we here?"

The drifting boat, the delayed shock of safety and the gratitude of finding a welcome haven overtook Sarah. Her knees buckled and she was down.

"Dear, dear, girl. Hello? Wake up, now, wake up." On her forehead, Sarah felt Captain Stella's cool hand. The older woman then moved to Sarah's wrist to check her pulse. After a few moments, a couple of men arrived with Billy.

One of the men leaned forward and reached for her, but Sarah quickly drew back.

"What? Who are you?" Starting to come to, Sarah had forgotten where she was. She jumped when she saw six curious eyes looking down at her, her hands grabbing her cloak to cover herself in fright.

"It's okay, my darling. You're safe. You got overcome, is all." The Captain smiled, her broad, wrinkled face projecting motherly concern and her coffee-coloured eyes hosted endless curiosity.

"Hi, Miss Sarah, it's me, Billy. We just met. This is Captain Stella Noseworthy."

"Call me Stella, honey. I'm still Captain to you Mr. Billy-boy!"

"Right! And this is me father, Gerald."

"Uh, hello, I, whew, I feel woozy…"

Billy's father picked Sarah up as if she were a tiny leaf and carried her gently to a side bunk down in the hull, with the Captain and Billy following behind them.

"All right, men. This young woman needs rest," said Captain Stella. "Leave her be. We need to get this ship rolling. Cover her in a blanket and batten down the hatches. It's time to set sail."

Chapter 23

Mary poured hot water from the kettle into two cups and set them down on the kitchen table as she watched her oldest daughter walk up the front steps. They'd had a couple of days of good weather with no rain or snow, a near miracle in the month of April. They were usually deprived of the kind of spring her daughters read about in storybooks; the kind of spring that brought beautiful Mayflowers that grew from warm and happy April showers, but today, the sun had started peeking out from behind the clouds.

Mary shook her head at their annual destiny. Newfoundland held its winter grudge against its people, skipping over spring to launch straight into a fast summer of six weeks and no more. March, April and May were a stew of windswept torrents of chilled rain, of temperatures too mild for ice, making ponds dangerously tentative under foot, both human and equestrian. This weather opened its arms to expansive blankets of horizontal snow layered in feet of walls and canals, dumping playful white padding all over the land. The ongoing battle between the Labrador Current flushing down from the North to meet the warmer stream of the Gulf of Mexico rustling up from the South, spewed its debris most noticeably in the eastern spring, arguing like nattering step-sisters until, the barren island was covered in damp chills and temperate varieties of snow and rain.

Today the sun was brave enough to push all the way out into the open, defying all the elements. "Great day on clothes, isn't it?" Mary ran over to greet Elizabeth and her the child.

"Could be but we might have rain later on. I wish I could get my clothes out on the line. I certainly had time. That child's been up since five this morning."

"Ooh, still an early riser, is she?"

Elizabeth fixed their tea and took a sip of hers before sitting down next to the stove.

Mary looked at her daughter once she'd taken a good look at Mary-Lynn. "My God, girl. What happened to your face? "

"Oh it's nothing, Momma. I banged myself. Walked right into the bloody doorframe. Not payin enough attention to where I'm goin, I s'pose."

"How in God's name did you do that? Sure, you're beat up!"

"I'm not beat up, mother. Don't exaggerate."

"No need to get testy, Elizabeth, girl, but you're not yourself these days."

Elizabeth buried her own stare in her teacup. "Never mind about me."

"Well your own mother can't say a word to you without you barking back at her. I never saw the like."

"Sorry, Momma. I didn't mean…"

Tears started dripping into her teacup, making tiny translucent splashes in the warm liquid the colour of brown paper bags.

"Honey, what is wrong? Ever since you've been back you've been…frail, I s'pose."

"Momma."

"I know it was hard for us to leave Sarah at the Convent, Lord knows it still keeps me up half the night but, girl, you've got to get over it or you're not going to be able to look after that baby."

"I know…I'm trying, but I feel horrible about leaving Sarah there. Mother Martin said it would be better this way, but it doesn't feel better."

"Yes, I thought it was for the best, too, until…"

"Until what?"

"Well, look at you." Mary took a deep breath. "He's hitting you, isn't he?"

She couldn't look at her mother.

"That fucker. If he thinks he's going to get away with that, he's got another thing coming."

"Momma, it's not like that."

"Elizabeth Jane Healey, now you listen to me. Don't you go thinking you can pull the wool over your own mother's eyes, cause I can see right through you. We are getting you and this child out of that house and that is that."

Elizabeth started sobbing.

"But, he'll come after us. I don't know what he might do."

"He's not going to do anything. Do as I say and you'll be safe. You hear me?"

"Okay," said Elizabeth, wiping her face and reaching out for her baby. Her mother brought Mary-Lynn to her and put her arms around them both.

"Please God, tell me he hasn't laid a hand on this young one, has he?"

"No, absolutely not. I'd kill him."

"Okay. Good. We can go back to the convent to visit Sarah and clear your mind. Besides," said Mary, looking out her kitchen window, "I have a few things to discuss with our dear Mother Martin. Now you finish your tea, go upstairs and rest. I'll be back. I have business to take care of."

Mary opened the front door and called out to her husband. "Ed! Ed! Come take me to town. I need to take care of some business at Clara's for the baby." Mary grabbed her handbag and walked out to

the porch to meet Ed. They talked briefly in muted voices until they turned and got in the car.

Elizabeth looked down at her baby and wept.

"So why are ya goin' to the shop now, Mary?"

"I've got a few things to pick up for the young one. I'll be no more than a few minutes."

"I can drop down to the Dukes anyway and see if anyone's around."

"All right, but don't go gettin' into the liquor too hard, mind."

"Go on with ya, woman. Sure, t'is not much damage to be done in a few minutes, anyway. Go do your shoppin' and mind out now."

Mary jumped out of the car and walked into Clara's store. The smell of mutton, dough balls and cooked root vegetables snuck through the seams from the house on the other side of the store.

"Hello, Clara. My Heavens, girl, your supper smells some good."

"Thanks, Mary. Yes, girl, I wanted all the cookin' out of the way early on, you know. How is yourself and all the crowd? And that lovely new granddaughter. My, she's some sweet, wha?"

"Oh, Clara, she is the finest kind. I've never been prouder. Listen, honey, is Pat around, I wonder? I had to ask him something?"

"Oh yes, girl. I believe he's in the back havin' a coffee, you know, the usual."

"I'll talk to you on the way out."

Mary made her way to the back of the store. She turned left down a hallway and went to the door on the other end. Pat Maloney was the town constable of the Newfoundland Rangers. His office was adjoined to his wife's store so they'd be within shouting distance of

each other at all times. She knocked on Pat's door and opened it. He was on the phone but waved her in.

"No, Fred, we can't have that now, I'm sure you understand. Let it go, my son, that's all."

He smiled at Mary and gestured for her to sit down. As he listened, he raised his mug up nodding his head at the teapot. She got up and helped herself to a strong cup of tea. By the time she sat down, he was ready for her.

"Mrs. Mary Marsh, why t'is always a pleasure to see you. How ya gettin' on?"

"Good, b'y, Pat, good."

"So what can I do for you today?"

"Pat, I have a problem. That Frankie is beatin' my girl."

"Jaysus, Mary, and she with that new baby, too."

"Yes, Pat, and I'm not havin' none of it. I tell you, none of it."

"No, girl."

"He's goin' to be on his way now to the Base tonight and do his usual nonsense: drinkin' and gamblin' and then he's goin' to drive home. Now, Pat, last time I checked, we're not to drink that much as he'll have tonight and then go speedin' and carousin' in our cars, now isn't that right?"

"Mary, you are correct. Technically, we are not supposed to do that. I often turns a blind eye, mind, but when push comes to shove, yes, my dear, we need to rein those fellas in when we can. Perhaps I could take a little spin out later on and keep an eye on things around the time the Base closes, is that what you're sayin'?"

"It's up to you, Pat, what you do. You're the Constable. I wanted a review of the law for myself, that's all."

"Well, Mary, you did have that right, and in fact, if I do pick up somebody breakin' that law, it's a full night in the drunk tank. So there's your quick review, shall we say?"

He winked at her and stood extending his hand.

"Thank you, Pat. That should give me enough time to pack my poor girl out. We have to go visit Sarah at the Convent in St. John's anyway. Perhaps we'll go there to keep her safe until we know what to do about the situation."

"Don't you worry, Mary. We'll take care of that young lad—keep him busy for a night—and maybe teach him a lesson, too."

Chapter 24

Dr. Parsons knocked earnestly on the *Sisters of Mercy Convent* door on Military Road and promptly entered without waiting for any reply. Sister Jane was still down the lane, struggling to catch up to him.

"Doctor, you've got to come now," she had cried to Dr. Parsons, as evening had been approaching and he was closing up his apothecary for the night.

"Sister Jane, what is it?"

Her chest heaved under her woollens.

"She's been stabbed! Sister Ella! She's been stabbed with a needle!"

Without a word, he grabbed his coat hanging on a wooden rack and his medical bag, solemn and black, sitting on the floor beneath the other coats, and headed to the convent.

He climbed the stairs two at a time until he reached the room where the Sisters huddled around, lining the walls in pairs, some sitting, some standing. All were praying.

Dr. Parsons ran to Mother Martin's side. He lifted her hands and the blood-soaked cloth from Sister Ella's neck to investigate. The bleeding had stopped, thankfully. The doctor gently touched the side of Sister Ella's neck, her head dipped slightly to the side. The skin on her neck felt cool and her pulse was weak. Dr. Parsons looked up at Mother Martin to meet her questioning eyes. He pulled out his stethoscope, plugged his ears and placed the metal disk on Sister Ella's heaving chest while he looked at the floorboards. He heard her pulse coming regularly, though the intensity was thready.

"Looks like the needle hit her carotid artery but she should be fine. I will dress and clean this wound and give her something to ward off infection. In the meantime, we need to get her into a clean nightdress and into a bed. She'll need someone watching her around the clock."

Mother Martin nodded, then shooed most of the young Sisters back to their rooms.

"Dr. Parsons," said Mother Martin. "Sister Rebecca and Sister Marguerite can help you move Sister Ella to the upstairs room. I need to call the Constable. From this moment on, I want you all to treat this room as a crime scene."

"Yes, Mother Martin," said the doctor in unison with the two sisters and without looking up. He had already begun to wipe her skin clean and was digging into his black bag for his dressings when Sister Rebecca returned to his side with a new shift for his patient.

Constable Raymond Hynes walked around the bed and back over to where blood had stained the floor. Mother Martin hovered.

"So Sarah probably came at the individual with…"

"The individual is Sister Ella."

"Yes, of course. So Sarah came at Sister Ella from the bed with the needle to stab her. Do you know why? Was it simply to escape?"

"We are assuming she wanted her baby back; I'm referring to the one she gave up for adoption to her sister."

Constable Hynes dabbed his knife-sharpened pencil point on the end of his tongue.

"Hmmm…a baby, huh? What was in the syringe exactly, Mother Martin?"

"Oh, Constable, um, I think something to make her sleep. Some elixir or tonic."

"I need to know which one exactly."

"I'd have to ask Sister Marguerite. I'm afraid I'm unclear about it."

Constable Hynes looked up at the Mother Superior above his glasses, eyebrows together.

"Mother Martin, if I may, you don't strike me as a woman who is unclear about anything."

"Yes, well it was most unfortunate." Mother Martin sighed loudly. "It was haloperidol. It was meant to calm her, not to hurt her; she can be quite unruly at the best of times."

"Go on."

"Sarah was yet to turn 16 and was violated by a man in her community about a year ago. She got with child, so her mother and her sister brought her here. The sister offered to take the baby and raise it as her own since she is married. We think when Sarah finally had her baby, she changed her mind and wanted it back, but we couldn't have that, you see."

"Yes, I see."

"And I'd hoped Sarah might join us Sisters, but I don't think that's a possibility anymore."

"The Convent, yes." He nodded. "And for how long had she been taking this drug?"

"For about a month. She was very distraught."

"Yes, no wonder, the poor thing. I take it she didn't report the attack to the police."

"Heavens, no! I don't think anyone in the community knows except the three women and the man who did it and from what we understand, he's dead."

"Dead?"

"Yes, on the high seas in battle."

"Ah, I see. Can't be helped, can it? Let me make note of the date, anyway. Any idea when it would have taken place?"

"We worked it out to be between July 8 and 22, which is guesswork, of course."

"That's fine. It gives us a window to investigate. Mother Martin, thanks for being honest with me about all of this despite the sensitive circumstances. You never know; some details may seem unrelated in the beginning but they soon help clarify the picture of a crime when you least expect it."

A crime. Mother Martin sat straight down onto the nearest seat: an old wooden chair that creaked when her weight landed there. How could she have let things go this far? How could she let her pride and her desire to tame this young girl get in the way of the safety of her Sisters? One of her Sisters was stabbed; she could have been murdered! How did she lose control like this?

"Mother Martin? Mother Martin, hello?" The Constable was gently shaking her shoulders.

"Sorry, Constable Hynes."

"Not at all. We'll need to get word to her family first thing in the morning about what's happened. According to what you've said, that's probably where she's gone."

"Right," said Mother Martin, nodding. "I should have foreseen this, Constable."

"I'm not sure how."

"Right from the beginning, I could tell she would be a challenge. She had a stubborn streak that needed to be reined in and I took her on thinking I could manage her."

"Mother Martin, you could not have predicted this outcome. She reacted with emotion and became violent. If it happened, it was in her to do so; you could not have known she'd react this strongly. I

know lots of stubborn louts but none of them would do this. He gestured to the bloody sheet crumpled on the floor. Your poor Sister could have been killed."

"Constable, I want her captured and to pay for what she has committed here."

"We'll do our very best. Let's get the word out. We don't want to miss her return home; after that, who knows where she'll slip off to."

"So Billy, where did you say you met her again?"

Billy scratched his matted head, as was his habit.

"I ran into her up on the hill above the train station. I could see she'd fallen over a stick or something in the snow and thought I should go help her. She's very pretty."

His father slapped him on the head.

"Mind your manners, son."

Billy looked down at his wiry hands in need of a good scrub.

"It's okay, Gerald, we're trying to figure out where this lady came from and how we can help her."

"Yes, Captain."

"Good. Now, Billy. Think hard. Do you remember anything else?"

"Ahh, I don't…oh, she asked if I'd ever been to Fox Harbour."

Captain Stella perked up.

"Fox Harbour? Did she say that's where she's from?"

"No. That was when she passed out."

"Oh brother, and she didn't mention her last name."

"Nope."

"Well, gentlemen, we've got a ship to move out of the harbour. There've been too many U-boat hits for us to mess around with our timing. We've got to get moving. We'll have to wait until she wakes up!"

Frankie was feeling cocky tonight after baggin' three jackpots of nickels on the slots. Revved up by rum and coke, he screeched his tires while pulling out of the Base. Lots of the Yankees did it to show off to the ladies. Well, he was in the mood to show off and he was always in the mood for the ladies. Behind him he saw red and blue wobbling lights pop out of nowhere.

"Oh fuck."

Frankie thought about speeding away from the cop but it was Paddy. He'd never get out of that one, so he pulled over.

He watched Constable Pat drive up, pull in, park and get out. He walked up to the window and leaned over with his flashlight.

"Frankie, my son, how are ya, b'y?"

"Jim-dandy, Paddy, how are *you*?"

"B'y, I'm doin' fine, thanks for askin'. Noticed you were in a hurry."

"No hurry, b'y."

"That so."

"Yes, b'y."

"Seemed to me you were goin' over the speed limit the way you pulled outta the Base, wha?"

"Okay, Paddy, so you got me goin' a bit fast. What do you want me to do?"

"Could you step outside the vehicle, please?"

"Wha? Wha for?"

"Do what you're told, Frankie. I asked you to step outta the vehicle."

"Alright, Paddy, b'y."

"Okay, Frankie. Go walk a nice straight line there for me."

"For the love of the Lord, Paddy. Look, I had a couple okay, but Jesus Christ, b'y, I'm all right to drive. You knows I am."

"Good. Then you won't mind entertainin' me while you walks that straight line, will you now?"

Frankie wondered what friggin' saint decided to possess Paddy this night and started his imaginary line. His first three steps were not bad but on the fourth, he swaggered way off to the left.

"No, now let me try again, look. I'll get it, I'll get it."

Paddy didn't answer. He let Frankie do it, knowing he would wobble again.

"Now Paddy, I'm tellin' you, you don't have to do this. You never do this. Look, I could lose me license and everything, b'y."

"Sorry, Frankie. You might have given that a thought or two before now, wha? Let's do this nice and peacefully, okay? You don't have to lose your license over this if you do what you're told. I really don't want to embarrass anybody by puttin' on the cuffs, right?"

"Cuffs! Jesus, Paddy. No need for cuffs, b'y. No need. Look, can I put me money in the trunk? I got a couple a bags from the Base."

"Yes, b'y. Had a bit o luck, did you?"

"Yes, b'y, but looks like it's run out, though."

"Yes, b'y, looks like it has."

Chapter 25

Mother Martin entered the breakfast room briskly, her face calm, her skirts in a flurry.

The Sisters forgot themselves and all started talking at once. "Mother Martin…Is she…? Did she…? Will she be okay?"

"Sisters, please," said Mother Martin, her hands mid-air, asking for quiet. "Sister Ella is going to be all right."

The room heaved with relief and whispered exclamations of 'Thank the Lord' and 'Oh Lord have mercy'.

Mother Martin continued. "Yes, thanks to the Lord, Sister Ella is going to remain with us as long as we take good care of her and pay attention to the Doctor's every instruction. She will need plenty of liquids, though she is not eager to consume them as she is quite weak, so we'll need to encourage her to drink as much as she can. Sister Marguerite is in charge of assigning shifts morning, noon, and night. I trust you are all up to the task."

"Yes, Mother Martin," they murmured, white veils nodding around the room.

"Very good, then. Let's sit, pray and eat. We'll need our strength in the coming days."

Mother Martin pulled out her chair at the head of the table, sat, and bowed her head.

"Let us pray to our merciful Lord that he may bless and care for the precious soul of our dear Sister Ella. Amen."

"Amen," in chorus from the Sisters.

The Sisters lifted their heads as they all made a sign of the cross. Eyes were wet with tears, cheeks, rock-hard with anger, their faces wrinkled with worry for what was to come.

Mother Martin took a sip of her hot tea and looked up at her silent Sisters.

"Dear Sisters. I know last night was a very difficult night for all of us. Some of you like Sister Marguerite and Sister Rebecca had a trifle more to handle than the rest of the group. I thank you for your calm and decisive action, especially in the close presence of something that could easily have ended in murder."

The Sisters gasped.

Mother Martin paused to make the sign of the cross—others followed her lead.

Her china cup delicately clinked when she returned it to her saucer. "Some of you may be wondering how this could have happened. How could a young woman from the small outport of Fox Harbour possibly appear so innocent when we met her, and then after the wonderful care she received at our hands, how could she, how did she dare attack our dear Sister Ella?"

The Sisters shivered at the horror and shared their disapproval of Sarah's atrocious behaviour.

"Believe me, dear Sisters, I am equally horrified and angry that this has happened; but I cannot say I am surprised."

"Mother Martin…. What are you saying?"

"Now, now, Sisters, all I mean to say is I never once trusted that young–" She paused, "harlot."

Deep gasps filled the room.

"Sister Sarah was incapable of becoming a truly loving Sister as many of you will do."

She noted the barely perceptible nods from around the table; she looked directly at them while they wrung their hands below the tablecloth.

"Look at the temptation Sister Sarah allowed into her life. She not only attacked our dear Sister Ella, she was also carrying an unknown man's child!"

Every Sister's open mouth was covered with both of their hands.

"Yes, isn't it an utter disgrace? She has defiled herself and our Sisterhood by pretending to be one of us and imagining she could be a bride of Christ. And look at what has happened." Mother Martin rose from her seat and stretched out her arms. "It was as if Sister Sarah had been under a spell, as if the devil himself had his very hands upon her, propelling her toward a foul destiny."

The Sisters drew back instinctively, their eyebrows scrunched up, unable to comprehend the depth of wickedness so near their sheltered existence. Tea buns lay untouched on their plates; lukewarm tea cooled in their cups as the Sisters had only Sarah's indiscretions on their minds.

Mother Martin prompted the Lord's Prayer.

The Sisters held blanks stares in disbelief; they bowed their heads and prayed with her, thankful they didn't need to think, unable to process Sarah's bizarre behaviour, relieved they knew the words by rote, and "Hallowed be Thy Name…"

Paddy pulled up to his station and opened the door for his reluctant prisoner. "There you go, Frankie. You knows I hates to do this but it does set the example for the younger crowd, mind."

"Yes, b'y, I'm sure."

Frankie was pissed. This was ridiculous. Paddy never hauled in people like this. There was a layer of dust on the bench in the cell, for crying out loud. What was up with him, Frankie wondered. He

walked in behind the desk and sat in the cell cage while Paddy locked him in. "So, Paddy, how long do I have to stay?"

"Oh, two nights should do it."

"Two nights! Christ man, what's wrong with you?"

"Now, Frankie, you don't want to turn it into three nights, do ya?"

"Three?"

"I'm kidding. One night is all I can do, according to the law."

"Paddy, look, you'll have to tell me missus. She'll wonder what I've gotten up to."

"Yes, I bet she would. Why don't I give her a call?" Pat dialed Mary Marsh's number instead.

"Yes, hello, this is Constable Pat over at the station. Yes, why hello Mary. Nice to find you visiting your daughter. Would you mind telling your dear Elizabeth that her Frankie is in the lock-up here with me?"

"Oh, no, he's fine, tell her. He came tearing outta that Base and had a bit too much of the sauce to be on the roads, you know. So he's goin to be here in the cage overnight, that's all."

"Okay, dear. Yes, you, too."

"Well, Frankie, lad. We're all set. Just you and me, kid."

~~~

"As we forgive those who trespass against us, and lead us not into temptation, but deliver us from evil."

Quietly, the Sisters said, "Amen." They looked around the table from one to the other, searching for some indication as to what they should do next.

Mother Martin lifted her head and took a deep breath.

"We are sending word to Sarah's family in Fox Harbour today to be on the lookout for her, as well as to all the constables across the island. She will continue to be a threat until she is caught and charged. We'll all be grateful, I'm sure, when we know she is found and that she, her family, and anyone she encounters is unharmed. Please join me again in prayer so that these unsuspecting souls may find the Holy Mary's protection until this whole mess is sorted out. Let us pray."

"Let us pray."

---

Captain Stella Noseworthy had come down the Southern Shore without any trouble and was now making her way around the Cape. Nights like these, she loved being on the water. It gave her a sense of power and humility. She was in control of a ship and its men. The wind and the waves boosted her energy as she inhaled the sharp salt air. But she also knew it could all be out of her control in a flick. Another woman was in charge, one that commanded huge respect from her: Mother Nature. Added to the organic dangers were these U-boat attacks of late. Captain Stella shook her head, remembering the poor lost souls from the last few explosions. She knew the threat was real, and she wasn't immune to it, that was for sure. Yet, she wasn't about to be bossed around by a few cocky German guys either.

"Huh!" She said aloud. "Let them try and catch me."

She was going to die sooner or later; if it happened on her ship, then there was no better place. She'd only owned this boat since last week but she'd navigated boats for almost half of her born years. Captain Stella was no rookie. Her nerves never quivered in the face of any risk, and her crew knew it.

"Captain! Captain Stella!"

"Yes, Tom. What is it?"

"Something strange, Captain Stella. We've lost the young woman."

"I beg your pardon, Tom? We've lost her? How is that?"

Suddenly, Gerald arrived out of breath. "Don't know, Captain." Out of respect, Gerald never used her first name.

"Well, gentlemen, she's got to be on the boat somewhere, surely, God."

"Captain, we've only searched the general areas surrounding where we left her. We can expand the search and report back."

"She's probably cowering in a cupboard somewhere, poor scrap. Get Billy to search every small corner of the ship. Get to it."

"Yes, Captain."

---

Mary hung up the phone and nodded to Elizabeth.

"Ed, I think Elizabeth and me best drop into St. John's to check on our girl," said Mary, scooping up teacups and spoons on her way to the kitchen counter. The clink of dishes and the splash of water from the kettle pouring into the sink blocked out the short silence that followed. Ed looked up from his newspaper and eyed his wife.

"Is that fine?"

"I s'pose. What do you want me to say?" He turned a page and occupied his eyes with the obituary columns, his mind wondering what she was hiding.

"Nothin', b'y. Just lettin' you know, that's all. We're going to run over to Elizabeth's for a bit first and get ready."

The two women started hustling about the kitchen. Mary grabbed their things while Elizabeth went to the back room to get the baby.

"Mary." Ed's tone was snipped. He grabbed her arm, firmly. Though he'd never hurt her in all their years together, she could tell he was in no mood for foolishness.

"What?"

"What are you up to?"

"Ed," she said. "Look, it's easier if I take care of this. No need to be draggin' anyone else in."

"Into what? This is our family, Mary. What is goin' on? Is the baby okay?"

"Ed, it's not the baby. I think Frankie is not quite up to bein' a daddy yet, that's all." Mary motioned gently with her head toward the back room. "She needs a break from it, Ed. That's all."

The brightness in her dark eyes told him to trust her. He took a deep breath into his lungs, protected by an expansive chest. For a man of senior years, he was in ready shape from hauling nets, working cod jiggers and setting traps. He was no stranger to working with his hands, his arms, his shoulders and back. Gruff, he muttered his reply and asked if there was anything he could do.

"Yes. Go talk to Pat."

"Clara's Pat?"

By now, Elizabeth was back in the kitchen listening. Mary spoke to both of them.

"Constable Pat said Frankie was in the lockup overnight for drinking too much and driving out of control after the Base last night."

Elizabeth couldn't imagine the sour mood he'd be in after his overnight stay.

"Daddy is goin' to talk to Constable Pat and find out what happened."

Ed struck a match and lit a cigarette, blowing out a stream of smoke before speaking.

"I'll go talk to him later on after I'm done a bit of fishin'."

"Come on, Elizabeth, honey. We should get goin' to pack your things. We can visit with Sarah, she can see the baby and Frankie can cool off at home," said Mary, winking at her eldest.

Elizabeth grabbed her bag and walked out without looking at her father.

On their way down the lane, Mary told her not to worry and that Pat would take care of it.

"I still can't believe I'm goin' back there, Momma, but I do admit, part of me misses it. And I really want to see Sarah. I feel so bad I didn't talk to her before swipin' her baby from her."

"Stop beatin' yourself up, child. You'll soon see Sarah and it'll be fine. Come on."

"What if she wants her baby back, Momma?"

"Well, that can't happen, can it?"

They entered her house, put down the baby and set to work. Mother and daughter pulled together whatever they could into her trunk, a carry-on bag and a baby's carryall bag. Some other stuff they packed into boxes and stored away, should they be needed later on.

"You never know what may come of this. If he goes to jail, well then fine, we don't have to worry, but if something should go wrong, you may still want your things."

"Why would he go to jail?"

"Never mind, child. Let's just get things organized."

"Oh God, Momma, how am I goin' to do this?"

"Hang in there, my girl. You can do this. You do not deserve to be smacked around by somebody the likes of him."

"But I do deserve it, sort of."

"What in heaven's name are you talkin' about?"

"I left Sarah on her own, Momma. She's my younger sister. And maybe he knows the baby is not his. You know how terrible a liar I am."

"I don't care, Elizabeth, you do not deserve to be beaten, girl."

"I'm supposed to protect Sarah but instead I couldn't wait to get her baby home to show Frankie, thinkin' it would fix everything but it didn't; in fact, it made things worse. He seems angry all the time and now has started hittin' me."

"Child, I'm sure Sarah is doin' fine. She has got a stronger backbone than anyone in this family. And we're on our way back to see her tomorrow, so don't go on about that nonsense anymore. After we get Sarah and bring her back, we're goin' to give that Frankie the fright of his life. Come on. We still have work to do."

\*\*\*

# Chapter 26

At 6 AM sharp the next day, Mary heard the crackle of thick new rubber tires riding over lumpy gravel in the driveway, like muted fireworks going off in the distance, breaking the morning stillness.

Constable Pat had pulled up in his civilian car, a dried-mud coloured Chevy, to bring Mary and Elizabeth to the train station. He stood and stretched his back, lifting his arms up higher than his full 5' 8", reaching his fists high into the salt air, and then slowly brought his arms down to his sides again. He rubbed one tired eye, then another, until they burned with irritation. Next to his Chevy, Ed's car had left a patch of dry gravel, having protected the stones from the overnight downpour. The rain had cleared but the moisture remained and the fog was settling its dense mass, plugging the harbour and preventing a clear view.

Pat walked up the steps, unlatched the first wooden door with a metal clink and walked into the porch. Mary had already opened the inside door.

"Mornin', gals."

The women, already dressed in their coats, each nodded briefly in his direction and kept going. They busied themselves stuffing garments into bags, picking up small packages, examining them or smelling them and placing them gently into a basket.

"Cup of tea, Pat?"

"No, girl. Already had one this mornin'. Where's Ed to?"

"He's already gone fishin', Pat."

"Right. Hard-working' man that he is. He knows you're going then?"

"He does, but he doesn't know Frankie's been hitting our girl. He'd kill him if he knew."

"That he would."

"I'd like to keep Ed out of jail, if I could, Pat."

"I understand, Mary."

"Would you be able to tell him for me? At least Frankie would be safe in the cage, and maybe you could talk Ed through it."

"I'll give him a call later on."

"Thanks so much, Pat. He's planning to drop by and see you."

"Anytime, ladies, anytime."

"Grand," said Mary. "I think we're ready."

Later, on the train, Mary-Lynn had finally settled into a snug cocoon in Elizabeth's arms. Elizabeth stroked the baby's warm cheek as her own shoulders and back muscles settled into the soft cushion seat. How did mothers get anything done, she'd wondered many times, looking at Mary-Lynn's innocent face. Every quiet curve of this baby's face fascinated Elizabeth. She struggled to pry her eyes away from the delicately rounded pink cheeks, gentle eyebrow slopes and tiny nose. Sarah's entire being lay etched across it. Elizabeth lowered her head further as she spoke to her mother.

"Do you think Sarah will hate me?"

"She is not going to hate you. Elizabeth, honey, you need to stop this nonsense. Look up, child. Look at me."

Elizabeth dragged her watery eyes away from Mary-Lynn and lifted her own heavy head to look at her mother's red-hot face, sitting across from her.

"Why would she hate you? You're her sister. She has loved you her whole life."

"The last month before Sarah had Mary-Lynn, I went to Mother Martin asking if we could give Sarah something to calm her down. She was having nightmares and I thought if she took something, she might get some relief."

"Nightmares?"

Elizabeth nodded.

"She was reliving the assault." Elizabeth paused.

Mary looked out the window at the passing landscape. Short trees, barren moss and misplaced lichen-covered boulders scattered the land. "You wanted to stop her from reliving it."

"Yes, but they started giving her something that really changed her. She got quiet – really quiet. She fell into a slump. I wasn't sure what to do, so I let the Sisters take care of her and left her there. She could still be there trapped in that awful depression."

Mary took her hand.

"You did what you thought was the best thing for her at the time. You thought it would help her."

Elizabeth's blue eyes welled. She turned her face to the window, seeing her slight reflection. Through the glass, the grey ground spun past in spurts of short, lumpy hills and random boulders, sitting neglected and useless. A couple of tears dropped onto Mary-Lynn's blanket.

"There. Put it out of your mind. You'll see her in about eight hours and she'll welcome you with open arms."

"If Sarah comes to any harm, I'll never forgive myself."

Sarah felt the rocking and the swaying, like she was on a boat. Her head flopped back and forth on the rough canvas pillow, sweat trickling down her neck. She couldn't tell if she were asleep or awake. Then she saw Captain Murphy standing beside her cot, pointing aggressively past her, as if trying to warn her. No sounds came out of his mouth. Suddenly a big blast shot him apart and she sat up, screaming silently, her eyes closed. Her mouth went dry and her head felt dizzy. She opened her eyes to darkness. Captain Murphy was gone, replaced by panic. She suddenly realized how stupid she had been to get on this boat. What if a U-boat blew them up? She'd never get to her baby. She had to get out of here. Now.

She pulled her cape around her, steadied herself and hoisted her tired body onto her feet, not letting go of the sidewalls. The floor of the boat surged in rhythm to the rigorous pull of the North Atlantic. She gulped back urges from her stomach and made her way down the gangway through a door and out into the sea air. Large, black waves with specks of white-sea foam roared angrily at her and smashed on the deck as she clung to one of the handlesoutside the door she'd come through. Wrong way. She needed to be safe. She scrambled back inside, her boots slipping and sliding on the slimy, wet deck, shutting the door before another slapping wave washed the spot where she'd been.

She heaved a sigh of relief, her back and head leaning against the door, her heart banging against her ribcage. She made her way through the gangway in the opposite direction and found a hole leading to another level in the boat. Suddenly, the idea of being hidden appealed to her. She needed to think. She needed to feel safe. Privacy would give her that.

She climbed down to the next level, treading carefully in wet boots and long skirts. She landed into another gangway, much darker than the one above her. She saw this as a good sign. The darker the spot, the easier to hide. As she awkwardly clambered down this blackened passage, she wondered what she might face at home. What would she do once she got there? Would she take Mary-Lynn and run away somewhere? If so, where? Where could she possibly go? Or maybe she could convince Momma to let her stay with them.

But that would be telling Daddy. No, that would never happen. Her chest tightened at the thought. She couldn't think about all this right now. She had to trust her instincts, save her baby and worry about everything else later.

She got to the end of the gangway and found an area filled with wooden crates, barrels and other storage items. Dry and out of the way, she decided the space would do fine. Besides, she was exhausted. She plopped herself down behind one of the bigger crates with a barrel beside it. She nuzzled in between the two and let go of her tears. Her chest rose and fell as she sobbed uncontrollably. She'd lost track of herself. After the tears passed, she felt calmer.

"Miss Sarah," he called gently.

Sarah held her breath.

"Miss Sarah, it's okay. It's Billy. Come on out. Are you okay?"

She sighed. The poor boy had helped her get this far. She didn't want to worry him. She only wanted peace. She crawled out from her hiding place.

"Hi Billy."

His eyes were wide saucers.

"What is it, Billy?"

"Um, nothing, Sarah. We were wondering what happened to you. Are you okay?"

"I had a bad dream that a U-boat hit us and everything blew up and then I remembered I was on a ship on the ocean. I couldn't stay in bed. What if we get attacked, Billy?"

"Oh hush, hush, now. Don't you worry about those U-boats. Captain Stella knows what she's doin."

"So did Captain Murphy."

"Who?"

"Captain Murphy. His ship, the *SS Rose Castle,* was destroyed by the Germans."

"Oh yes, I heard about that one. We best talk to Captain Stella about this. The way she explains it, we're relatively safe because we're bringing supplies between St. John's and other Newfoundland communities. The Germans are after the convoys going to Europe with supplies for the war. I'll get my Dad to help you to your bed, and send for the Captain okay?"

Sarah nodded. She didn't have the energy to speak anymore. Then she thought back to Sister Ella. "Poor Sister Ella," she cried. She started rocking back and forth on the floor making the sign of the cross, over and over again. "My baby," she cried, "and poor Sister Ella."

Billy scampered away as fast as he could.

\*\*\*

# Chapter 27

The St. John's taxi driver pulled into the driveway of the Sisters of Mercy Convent on Military Road and helped the ladies with their bags to the top of the steps. The Marsh women rang the bell, hearing it clang throughout the ancient building. Mary-Lynn stirred in Mary's arms.

Sister Rebecca answered, eyes wide. " Elizabeth!"

"Yes, hello. We're here to visit with Sarah." Elizabeth moved forward to hug Sister Rebecca who quickly stepped out of reach.

"Sarah? Why she's…uh…just a minute." She shut the door leaving them on the stoop.

Through the old wood, they heard her yell, "Sister Marguerite, come quickly! Please get Mother Martin. Tell her the Marshes are here!"

Elizabeth looked at her mother, perplexed.

Sister Rebecca reopened the door.

"Sister Rebecca," said Elizabeth. "What is going on?"

With disdain on her face, Sister Rebecca responded. "Well, you may as well come in and wait. Mother Martin will be down in a moment." She stood back, holding the door, not making any eye contact.

Elizabeth searched the young sister's eyes. "Sister Rebecca, is everything okay?"

"No, Elizabeth. Everything is *not* okay. Please sit. Mother Martin will be with you in a moment."

Captain Stella came to see Sarah in her tiny quarters. Gerald and Billy stood close by while Sarah lay shivering under piles of quilts on a ship's cot.

"Miss Sarah, dear girl, you gave us quite a scare. Are you okay?"

"Yes, Captain Stella. I'm so so sorry. A bad dream gave me such a fright."

"Well, you mustn't run off like that. This is my ship and I need to know where everyone is at all times. This isn't a passenger liner, dear. Is that understood, young lady?"

"Yes, Captain Stella."

"I'll visit you in the pit," said Billy.

"Billy-boy!" Captain Stella frowned on him. "Good God in Heaven. We're not putting her in the pit."

"Oh, sorry, Captain Stella. I was only joking."

"In the meantime, let's put her in my second cabin and lock the door. She'll be more comfortable there and we'll know where to find her."

"Yes, Captain."

Elizabeth was still shaking her head at the ice-cold welcome when Sister Rebecca returned with a police officer.

"What is this?" Asked Mary.

Constable Hynes cleared his throat. "Ladies, I'm Constable Hynes. Please, please sit down. He reached his hand out in invitation to Elizabeth and Mary."

"Mrs. Marsh, I must tell you," he said in a quiet, deliberate voice. "Your daughter has run away."

"Run away?" Mary stood, Elizabeth stood again and soon everyone else joined them.

"Yes and it's much worse than that." He looked down at his small black notepad. "She attacked a Sister with a needle, stabbed her in the neck and left the poor woman bleeding on the floor before fleeing."

"No!" Elizabeth sat. "That's not possible."

Mary opened her mouth but couldn't speak. Mary-Lynn started to squirm in her grandmother's arms. Mary rocked her precious bundle instinctively.

"I'm sorry to say we found Sister Ella writhing on the floor of Sarah's room early this morning with a needle sticking out of the poor woman's neck!"

"How?" Elizabeth could not equate her sister with the actions of this person they were describing. Something was not making sense. None of it made sense.

"And where is Mother Martin," Mary demanded to know.

"Now please," said Hynes, placing his hand gently on her shoulder. "Please stay calm."

"Leave your hands off me," said Mary. A sudden wave overwhelmed her. She sat down again with the weight of it.

Dr. Parsons entered the room. He was shaking his head and then spoke. "Mrs. Marsh, I am truly sorry for this awful dilemma. I was treating Sarah when this dreadful event happened."

Mary didn't speak. She nodded at the doctor.

Mother Martin entered the room, eyes red-rimmed and grey.

"What the hell did you do to my daughter?" Mary pointed her finger at Mother Martin, her hand shaking from a mother's anger that emanated from her core. Mother Martin silently stood her ground.

"After losing the baby, Sarah took it hard, especially when she realized Elizabeth had gone," said Mother Martin.

"Mrs. Marsh," Dr. Parson's began.

"Don't 'Mrs. Marsh' me...I wants her to answer to this," said Mary, pointing viciously at Mother Martin, mere inches from her thin lips.

"You're right to be angry, Mary," said Mother Martin, "except I was only trying to protect her."

"Protect her?" Elizabeth spoke with a harshness her mother never knew she had. She turned to her oldest daughter. Elizabeth laughed a hollow laugh. "All you ever did was try and crush her."

"Elizabeth..."

"Oh no, Momma, you don't understand," said Elizabeth. "She is responsible for this, for all of it." Elizabeth turned to face Mother Martin. "You've done nothing but try and take her down since she's been here!" Tears started down Elizabeth's cheek.

"By the Lord," said Mary. "Nothing better happen to that child after this. Oh, my poor Sarah!" She pulled Elizabeth near her and they both sat on the chairs in the corner, with Mary's arms around her oldest daughter.

"Ladies, we don't want anything to happen to Sarah," said Hynes, "but we still need to bring her to justice."

"Justice?" Mary eyed each of them one by one. "Justice!"

"I have to agree," said Doctor Parsons nodding his head. "Sarah attacked an innocent person."

"No," said Mary. "This is sabotage. Mother Martin, you are trying to destroy this family. Isn't that why you wrote to my husband to tell him about Sarah's condition?"

The Mother Superior took a quick breath and did not look away from Mary's glare. "There was no reason why I would address my letter to anyone but the man of the house."

"That's very convenient. But you knew exactly what you were doing." Mary turned her back on Mother Martin. "Elizabeth said you gave Sarah a drug to calm her. Did that do something to cause her to...?"

"No," said Mother Martin. "She was in control. There was no reason for her to do this other than to escape." Mother Martin sighed loudly. "I don't believe she wanted to harm anyone. Sister Ella simply was the person giving Sarah the needle, but the deed was still done."

Mary put her head in her hands, her fingers clutching her long black and grey strands of hair.

"Ladies, if I may," said the Constable. "Perhaps if the Marshes had a room for some privacy and to take a cup of tea, we could discuss the issues a little later. This is quite a lot to take in."

He looked to Mother Martin.

"Constable, let's find Sarah and make sure no one else gets hurt," said Mother Martin. She pulled off her veil, ran her fingers through short wiry grey hair and faced the Marshes. They all stared at the Mother General's exposed hair. She ignored them. "I did what I had to do to help you and your family, Mary, when you had nowhere else to turn, but I do feel responsible for this mess, I must admit and somehow, I plan to fix it."

Everyone started talking at once.

"Silence," said the unveiled Mother General, her hand a stop sign up in the air. "Enough chattering!"

"All right," said Mary, her face tight and unreadable as she stood up and approached Mother Martin. "Let's find her then. I don't need a room but Elizabeth and the child will have to get settled."

"Right," nodded the Mother General tossing her veil to the side. "Sister Rebecca, find proper accommodation for the baby, please, and bring us a tea tray."

Reluctantly, Sister Rebecca nodded and picked up Elizabeth's bag. She led mother and child up the stairs while Mary stayed with the Constable, Doctor and Mother Martin.

"We sent you a telegram last night, Mary, but since you're here, you wouldn't have gotten it."

"Oh but my husband will. What did it say?"

"To approach Sarah with caution as she can be extremely aggressive, violent and dangerous."

"Gentle. It doesn't even sound like my daughter. Ed won't know what to do with a message like that except laugh at it."

Mother Martin nodded and stayed silent.

"There's nowhere else she would go except probably Elizabeth's house to find the baby," said Mary. "We could send a telegraph to Constable Pat Maloney at the Placentia Branch of the Newfoundland Rangers, and perhaps put a message in Doyle's radio news bulletin on the off chance she gets out into the community. Everyone in Fox Harbour listens to it."

"Good thinking, Mary. Sister Rebecca, let's do that right away please."

The young Sister nodded, careful to avoid looking directly at Mother Martin's bare head.

"Constable, what will happen to my daughter when we find her?"

"I will need to interrogate her, find out what happened from her side; but the evidence is pretty clear."

"You must know, Constable, what a mother would do to protect her child."

"Of course, Mrs. Marsh, but why would she have reason to fear for the child? Mary-Lynn was with her aunt, wasn't she? Is there anyone else, she feels might hurt the child?"

Mary shook her head. "I know, it doesn't make sense. I just know my daughter would not attack anyone." She looked up at the disheveled Mother Superior and crumbled into heavy sobs.

"Mother Martin, I am terribly sorry about dear Sister Ella," Mary said, looking down at her hands. Mother Martin guided Mary back to her chair.

"It was so unexpected, Mary."

"Ladies," said the Constable. "Sister Rebecca has brought us a tray. Let me pour you both a tea."

---

"Now Ed, please, take it easy, buddy."

"I'm going to fucking kill him with my bare hands."

"Ed, now listen. Come over to the station. I have him here and we can talk to him. He's locked up in the cage so you won't be able to get at him and frankly, I think your daughter and your wife want to see him sweat it all out in court and go to jail, so you'd best contain yourself."

"Pat, don't be so foolish. He's not gonna go to jail for slapping his wife a few times, but he needs to know he can't be at that."

"Oh, Ed, I think he got that message, sir."

"I'll be right over."

"Excellent, man."

"Who was that?" Frankie's face drained, already knowing the answer.

"That was Edward Marsh. He knows what you've done to his daughter."

"Wha? How?" Frankie's hands were on his head, but he couldn't stop the drumming of his blood beating against his skull. "How could that be?" he said, not realizing he'd said it aloud.

"Now Frankie, don't be an idiot. It didn't take Mary long to figure it out something was up with her own daughter. Then the girl admitted it to her mother."

"Christ," said Frankie in a whisper. The spit in his mouth evaporated instantly, leaving him clucking his tongue against the dry roof of his mouth. Sarah spilled the beans? He couldn't believe it. It couldn't be. She wouldn't.

"Anyway, Frankie, as you can imagine, Ed would like to have some words with you."

"Jesus, Paddy, you're not going to let him in here, are ya? You'd be an accomplice to murder."

"In that case, you won't mind being in the cage, wha?"

"But Paddy."

"End of conversation, Frankie."

Frankie couldn't stop the shakes. He was frantic. He wasn't even sure a jail cell would keep Ed out. If he had a bottle of poison handy, he'd drink it.

Constable Pat turned on the radio to hear his nightly news and Doyle's news bulletins; then he sat back and put his feet on the desk. He hadn't had this much excitement in years.

---

The ride flew by. Sarah had slept for most of it. Billy had brought food and water to her. She didn't mind being locked in, safe and secure from Mother Martin's grasp.

Sarah longed for the daughter she hardly remembered; the new mother was in such a drugged haze when she delivered her baby. Sarah also really missed Elizabeth. How strange for them to be apart from each other this long.

"Okay, Miss Sarah, you've arrived."

It was Gerald and Billy. They unlocked the door and showed her to the upper deck to say goodbye to the Captain.

"Miss Sarah, I hope you enjoyed your stay on the *Clara Murray*. We wish you well and take good care, dear."

"Yes, Captain, thanks for your hospitality. I owe you so much."

"Not at all. Now, tell me, do you have someone coming to get you?"

"No, I'll make my way."

"You're sure then."

"Yes, ma'am."

"Okay, take good care."

Captain Stella and her crew watched as Sarah walked anxiously down the gangway and scurried into the night.

"Anybody we should call, Captain?"

"Uh, let me think about that."

"Gerald, perhaps we should advise the local authorities? What do you think?"

"Makes sense, Captain. A young girl roaming around like this. Should have thought of that before we let her go, I s'pose. There's bound to be somebody looking for her."

"I'll give my constable friend in the city a quick call."

\*\*\*

# Chapter 28

Headlights panned through the front window of the station. Constable Pat looked out.

"That's Ed."

Frankie had his head in his hands, his body shaking. He could hear the car door slam.

Ed, a man of few words, shook the Constable's hand with an iron grip. "Paddy." Ed pointed at Frankie like he was a leper.

"You! You stinking bastard. Who do you think you are?"

"Now, listen, Ed, this is all a misunderstanding."

"Yes, it is. I never should have let a piece of shit like you marry my daughter. That's the misunderstanding."

"Ed, did ya want a cuppa tea?"

"No, thanks, Paddy. I don't want no fucking cup o tea. I want that in there to be drawn and quartered," he said, staring right at Frankie. "And I'd love to do it meself."

"I tell you what, Ed."

"What, Paddy?"

"I could let him out. I don't have to hold him any longer."

"Paddy, don't." Frankie started pacing. "Look, I'll do anything you want, okay, but you got to protect me from him. He's a friggin' psycho."

Ed started to crack his fingers one at a time, not taking his eyes off Frankie.

Frankie ran his hand through his hair obsessively.

"Right. Well, what do you think, Ed? What should we do with him?"

Frankie thought for the first time in his life that he might actually shit his pants. That's it, thought Frankie. He was getting out of here. He would talk to his buddy, Don, who worked in Wabush and ask him about the jobs. This situation had gotten out of hand and he wanted to be thousands of miles away—as far away as he could possibly get. If he got out of this cell alive, he'd talk to Don and see what he had to do to get out of Fox Harbour.

"Frankie!"

"Yeah?"

"Do I have your word you'll never again lay a hand on Elizabeth?"

Elizabeth? Frankie froze. Relief washed fear through his body like a bitter rinse. He let out a long breath. This wasn't about Sarah.

"You heard me. Are you goin to promise you won't ever go beatin' on my daughter Elizabeth again? If you make that promise, I won't touch you. You have my word."

"Well, b'y, Frankie, that's about as good a deal as I can come up with meself," said Paddy.

They still didn't know about Sarah. Frankie blessed himself. "All right, b'y," he said. "I'll do it. I swear I won't ever hurt her again. But you swear you're not going to touch me?"

"I swear on me mother's grave, with Paddy as me witness."

"Well then, Frankie, you're free to go. Elizabeth is gone to town with the child to get a break."

Constable Pat unlocked the cage and opened the door.

"She's gone to town?" Frankie asked.

"Yes, now Frankie, I have to speak with Ed, so you get on your way, please."

Frankie tentatively got up, limbs like spindles and walked past Constable Pat. He paused in front of Ed, put his head down and skirted around the hulking figure.

"Yes, and you should keep your head down, you idiot."

Frankie was out the door and breathed out hundreds of pounds of fear from his rattled frame. He planned to head home and look up Don's number. That was much too close. If Frankie had opened his mouth to explain, he would have told on himself and probably would have been dead by now.

Sarah made her way immediately to the Healey house to find her baby. She could have stopped at her parents' house, but it looked like nobody was home. There seemed to be a light on at the Healey's. She prayed Frankie was out. This time of night, he would be, but it'd been a while since she'd been home, how could she know? She wondered if she should stay at her parents' place and come back in the morning when it was safer.

But then she thought of little Mary-Lynn. What if he tried to touch *her* or harm *her* in some way? She couldn't handle that. This couldn't wait one more hour, never mind one more day. She'd have to chance running into him. And she had to see Elizabeth. How could she have left her only sister alone with those nuns?

Sarah steeled her resolve, clenched her fists and walked toward the house. She was so petite, there was no way anyone would hear her approach, especially if no one expected her. She wanted to tear him limb from limb, but knew that would not make the pain go away. That pain was secondary to the agony of missing her daughter. It was a foreign feeling so familiar now, she couldn't imagine living without being close to the child.

A dog howled in the distance, putting her on edge. She tiptoed down the walkway and up the steps. Hard to tell if anyone was in the

lit kitchen as she leaned over the railing to look in. She couldn't see; she was too short. So she decided to try the door. It was unlocked and creaked horribly.

Idiot. He still hadn't fixed it.

She looked inside. It was clean, but in slight disarray. The usual stuff had been moved around a bit. Elizabeth's favourite cookbook from the top of the fridge wasn't there. That never moved unless she was using it.

Something wasn't right.

Then she heard a car. She peered around the corner to see through the window without being seen. It was Frankie's car.

Oh God.

Sarah took a deep breath, look frantically around the room. She saw Elizabeth's kitchen knife on the counter and grabbed it. Wasn't quite sure what she would do with it but she felt safer with it in her hand. As the car pulled in, she ducked under the front window and headed upstairs. She'd lie in wait until she figured out what she really wanted to do.

---

Two telegraphs for Constable Pat sat near his desk, the ink still drying, one from Constable Hynes and one from the Convent, but Constable Pat didn't always check his telegraphs when he had people in the station. Instead he offered Ed a seat.

"You're sure now you don't want a cup o tea."

"No, b'y, I'm fine, thanks."

"Okay, I'm going to make one for meself. Sit back and relax, Ed."

The radio rambled on about the railway and some of the changes they had to make for the US Naval Base and what it cost and wasn't it shockin' what it cost, and in another few minutes, they'd hear the news bulletin.

"Ed, I got to say, I am very impressed with you here tonight. I wasn't sure how this was going to go, you know."

Ed nodded. "I still want to string him up. And by The Lord, if he tries it again..."

"Proper thing, Ed."

\*\*\*

# Chapter 29

At Constable Pat's station, the radio started piping the personal announcements.

"To Mr. Mike McDonald, Fortune Bay, from all of us. Happy Birthday, Poppy."

"To Mrs. Mary James, Elliston, from John Raymond. Mom's doing fine. Tell all the crowd."

"I listen to these every night. They're hilarious," said Constable Pat.

"Yes, the Missus has it on, too. Keeps her up to date with the goings on," said Ed.

"Yeah," said Constable Pat, lifting his tea mug to his lips.

"How's Clara?" asked Ed.

"Clara? Yes, b'y, she's grand, you know. Still minding the store."

"To Mrs. Emily Curtis, Bonavista Proper, from Janie. You were right, Mom. Love you." The radio announcer chuckled and stopped abruptly. Sounds of someone entering the studio broke through behind him. "Now, dear listeners. This one might change the tune a bit. Yes, Constable Raymond Hynes of the Newfoundland Rangers here in St. John's handed me this latest one. Thank you, Constable."

He cleared his throat. "This is a special alert to the Avalon Peninsula: A young woman by the name of Sarah Marsh from Fox Harbour, Placentia Bay is at large and could be dangerous."

"What?" Ed and Constable Pat froze and looked down at the radio transmitter.

"Jaysus, Ed. I never checked me Ranger telegraphs! HQ probably put out a warning across the peninsula–"

"Shut up, Paddy. Listen!" Ed stands up and looks at the telegraph machine.

"All constabularies have been alerted through Ranger telegraphs across the island with a description of the young girl. She has blond hair, blue eyes, is about five-foot-two and slim. She will appear friendly on first approach. Special note to the Marsh Family, the Healey Family and others, from Mother Martin of the Sisters of Mercy Convent in St. John's. Sarah Marsh is likely headed home to Fox Harbour. Please exercise extreme caution when approaching her and alert the authorities immediately when you find her. Well, that's it folks. So keep your eyes out for this young Sarah Marsh and we hope she finds her way home safely. We'll provide any updates as soon as they are available. Thank you, Constable Hynes."

"There's no way my daughter is dangerous. What are they gettin' on with?"

"Ed, if she hasn't been picked up yet…"

Constable Pat didn't need to finish. He and Ed scrambled to their feet knowing full well where she would turn up.

---

Elizabeth and Mary paced, wearing out a path in the carpet. Mother Martin left them not long ago to check with the Constable for news. They knew they were close to hearing but could not handle the waiting. Mary worried Frankie was already dead at Paddy's police station. She couldn't care less about that. She only worried that Ed would have done it.

"Oh please God, let Paddy convince Ed to stay calm," she prayed. "And please let Sarah be safe and not attack someone else. What has happened to this family?"

She put her hands to her forehead. It was more than she could bear. "Sister Rebecca, have you got something stronger than tea to drink so I can calm me nerves?"

Innocent eyebrows rose. "I…don't know, Mrs. Marsh. It may be church wine. I'll check."

Mary looked at her daughter. "I don't care what it is. Elizabeth?"

"Maybe a little."

Sister Rebecca nodded, a tiny smile on her lips, and hurried off to find whatever she could.

---

Constable Pat pulled up in the patrol car and killed his headlights. Frankie's car was already in the driveway.

"Now, Ed. I don't have to remind you about not touching Frankie, right? We already cleared this up at the station."

"Not unless it's self-defence."

"Well, I s'pose. Best not to, if you can help it. We have your word?"

"Paddy, as much as I'd love to tear him apart, I want my daughters to be safe. My word is good and you should know it."

"Dandy. And I don't know what kind of state your poor Sarah is goin to be in. We'll have to see about that. Don't go losing your mind, now, if I have to put her in cuffs."

"Paddy! She's a youngster, b'y."

"I know, Ed, but you heard the bulletin. She is to be approached with caution. In police talk, that's code for: we don't know the whole story. So, we need to be careful. I don't want you turning on me or I'll put you in the cage meself."

Ed ran his hands through his cropped white hair.

Constable Pat had no doubt those thick fisherman's paws could do painful damage to a skinny kid like Frankie, or to a chubby, old officer like himself. He shivered and waited in silence.

Ed nodded. A gentleman's contract, as good as his signature.

They got out of the car and quietly walked down the path. Constable Pat had his walkie-talkie turned down low but loud enough to hear the spitting and spewing. He took a moment to look in the car. He'd seen it only 24 hours ago when he picked up Frankie. He silently wondered if the bags of money were still in the trunk.

Lucky frigger, that Frankie. Everything looked the same, an empty pack of Winston's on the back seat, a pile of old rags covered in grease on the front. This old car broke down a lot. He'd seen Frankie pulled off on the roadside many times trying to fix the darn thing.

He motioned to Ed to keep goin. "Let's get in a little closer, Ed."

"Why aren't we bustin' in on them?"

"Not yet. They might have weapons. Frankie might still be afraid you're going to come after him, so he might have a rifle. I don't know about Sarah, only that they said she could be dangerous."

"Come on, Paddy, b'y. That's such foolishness."

"Look, Ed. In the police business, you have to go with what you got. And sometimes people do strange things, even the people we love. So you have to trust me on this one. They said on the radio to exercise extreme caution. That's what we're doing."

Ed shook his head once more, sighed, shrugged his shoulders and then followed Paddy's lead.

---

Sister Rebecca shrugged her shoulders.

"She said she wanted something to drink… she didn't care what it was…um as long as it was stronger than tea…and by that, I think she meant..."

"I know what she meant." Mother Martin took a deep breath. For the first time in a long time, she felt she could probably use a drink herself with the stress of this whole mess. The meeting with Sister Ella's father had been quite difficult. She had hoped he might calm down but Sister Ella was still recovering. Perhaps once she was feeling better, she might be able to ease his mind.

Mother Martin had yet to return her veil to her head. Having her bare head revealed gave her a freedom she had forgotten. "All right, Sister Rebecca. Hang on."

She lifted one side of her skirt and found a long string with several keys on it. She quickly grabbed the one she wanted and walked swiftly over to a locked academic cupboard. She unlocked it to reveal old books, papers, files and a half full bottle of Irish whiskey tucked in behind a couple of huge tomes. She grabbed it by the neck and handed it to a wide-eye Sister Rebecca.

"God rest his soul, Father Ryan left it behind. He liked a bit once in a while. Warned me that I was not to waste a drop, should he ever pass on. Otherwise, I would have gladly poured it down the sink. Now, not a word to the Sisters, mind. I don't want them getting any notions. This is a unique situation, understood?"

"Yes, Mother Martin."

"Take the Marshes into the Great Room and be sure to keep the doors closed. I'll be there shortly."

"Oh, and yes, Sister Rebecca, you may have a small drop, but no more!" Mother Martin had a slight twinkle in her eye.

Sister Rebecca shook her head vigorously. "Oh heavens. Not for me."

Sister Rebecca held the whiskey at arms length in front of her, one hand around its neck, the other supporting the bottom, like it was

the Chalice containing the broken bread from Mass with the actual Body of Christ in it. She couldn't take her eyes off it.

"Go, Sister. They are waiting for you."

She scurried off.

\*\*\*

# Chapter 30

Frankie flicked on the radio. He'd missed the Doyle news bulletins tonight.

"Probably didn't miss much," he muttered to himself.

He opened the fridge. Wasn't much there, only butter, milk, eggs and a bit of bologna left.

"You think she'd keep a bit of food in the house."

He grabbed the chunk of bologna and reached for the kitchen knife, but it wasn't in its usual place. He moved a few of the canisters around but didn't find it.

"For frig sake. What did she do with the friggin' knife?"

He took the bologna and threw it clear across the room.

"What the hell is Missus doing, anyway, going off to town like that without telling me?"

He picked up the stove burner handle, attached it to the circular iron plate and lifted it up from the stove. He laid the iron circle on top of the black ice-cold stove. Inside the opening, he carefully propped a few splits of wood in the form of a small tepee. He walked over to the daybed, grabbed some newspaper and crumpled it into small balls, which he threw in next to his tepee. He lit a match and threw it in. It ignited. Before he closed the top, he reached into his pocket for a cigarette—Winston's with no filter, cheap from the Base—put one in his mouth and leaned toward the stove to light it.

He was waiting patiently for it to light when his face made contact with the cold black iron. He heard a cracking sound as one of his teeth gave way through the middle. The shock of the hit knocked his senses into turmoil. He slid to his knees, looking up to see Sarah

Marsh, a full five feet, two inches in height with the iron frying pan still in her tiny hands over her head.

Frankie slid to the floor, in shock, but was still conscious. He felt thick, metallic liquid slowly seeping inside his mouth. He lifted his head for a second and spit out a macabre puddle of tooth, cigarette and blood. He heard no sounds. Maybe she wasn't really there. Maybe he was dreaming a horrible nightmare, but she still stood there motionless, the frying pan now hanging from her hands. His head, jaw and mouth throbbed. He suddenly remembered his arms and hands. And his legs, too. He tried to lift himself up, but could barely sit.

And then she spoke.

---

"Can you see anything, Paddy?" called Ed.

At 58 years old, Ed's eyes weren't the best and he was too proud to wear glasses. Thought he'd look 'too foolish' with them on.

"All I can see is a bit of smoke coming out of the stove, like someone didn't put the cover back on. Doesn't look like she's fully lit, though."

"Hmm. Anything else?"

"No, b'y. If they're both in there, they must be in that corner nook in the kitchen."

"Yeah, or who knows where. Enough of this. I'm goin in."

"Ed!"

"Paddy, I promised I won't lay a hand on Frankie. And so I won't. But I didn't promise I would stay away from me own daughter."

"Ed, don't!"

---

Captain Stella Noseworthy was almost at Fortune when she heard the alerts go out over the radio across the island.

"Sacred Heart of Mary, she's Miss Sarah! I knew I should have called me buddy earlier. Damnation. God help me if anybody gets hurt on my account. Gerald! Gerald!"

---

Constable Raymond Hynes was finishing the last of his coffee when an urgent call came in.

"Sir, there's a call for you from one of the ships bound for Fortune and I'm…uh…not making this up, sir, the captain sounds like a missus."

Constable Raymond Hynes smiled to himself. Stella.

"Thanks, buddy, patch her through."

"Yes, sir. Go ahead, ma'am, you're on the line."

"That's Captain to you, sir."

"Er..yes, m'..I mean, yes, Captain."

"Dear Captain Stella, are you giving my guy a hard time now?" He was grinning ear to ear.

"Ray, honey, now you knows me. I was born to give men a hard time," she said, laughing from the base of her round belly.

Constable Hynes howled. "Oh boy, Captain Stella, you haven't changed much, have ya?"

"No, b'y."

"I can't believe you're even out on the water with all them U-boats circling like hawks these days. Have you managed to fend off the Germans?"

"Oh yes, honey. I don't mind them. But I have this other problem."

"You all right?"

"Oh I'm fine. The crew was great until we took this little blond one on board with us and gave her a ride home."

"Sarah."

"Yes, honey. Had no idea who she was 'til I heard your alert a few minutes ago."

"So nobody's hurt?"

"Gosh, no. She's a lovely little child. Why would anybody be hurt?"

"Yes, well it would take a lot to scare you, anyway," he said, his grin never leaving his face.

"Now, there was a short time when we couldn't find her. Hid herself in the cupboard scared to death, poor child. She'd had a bad dream and then started to overthink the U-boat situation."

"So where is she now?"

"Fox Harbour. Dropped her off there about an hour ago. Could be more than that. You know me. I lose track of time when I'm out here on the great North Atlantic."

"Yes, Stella. Well thanks for the call. Take care out there."

"Will do, Ray, honey. Will do."

---

"ooohhhhhe hee hee hee…."

Sister Rebecca couldn't stop herself from giggling. On Mary's insistence, she'd taken a couple of disgusting sips of whiskey. She was not the kind to say no to a firm, more senior Mrs. Marsh.

Mary smiled at Sister Rebecca, enjoying the first calm and pleasurable few minutes since finding out her youngest daughter was missing after attacking a nun.

Elizabeth could feel the whiskey, too, but she'd had alcohol before. Growing up, she'd bring beer to her father or her uncle and have a little sip before giving it to them. Despite having had 'practice', the whiskey was potent. She felt awash with warmth. She sat back on a soft armchair and watched the others as if she were outside the room, looking in on them.

Her mother appeared calmer, too. It'd been a stressful couple of days, ever since she confessed how Frankie was treating her. Now that she was away from him, it felt strange. He was going to kill her when he found out. She couldn't go back home to their house. How could she feel safe if he was still there? Maybe she'd have to flee to the mainland with Sarah and take the baby with her. God, she prayed Sarah didn't end up jail. Just when she'd thought Sarah's situation was impossible before.

She couldn't think clearly. She had to get through this night first. They had to find Sarah, make sure she was safe, and then Elizabeth would deal with her own life. She looked over at the sweet bundle in the crib and her heart nearly burst with love. Mary-Lynn wasn't even her own child, but she was her niece, and no matter how this ended, Elizabeth loved the child with all her heart. How could she possibly have taken such a beautiful being from her sister, her best friend, and expect to keep it all to herself. How could she?

She couldn't. Mary-Lynn belonged to both of them. In fact, she belonged to all of them. They were a family, and when all this was over, they would be a family again. She just had to figure out what to do about Frankie.

Sister Rebecca had finally managed to stop giggling. Then she fell asleep.

"Elizabeth." Mother Martin's voice jolted Elizabeth out of her troubled thoughts and into a broiling head-spin, an automatic response to the matriarch, regardless of words.

"Yes?" Elizabeth smoothed her brown hair absent-mindedly, still shocked at Mother Martin's naked head.

"Would you mind taking Sister Rebecca to her room and tucking her in? I'd like to speak with your mother in private, if I may?"

Elizabeth nodded. Her eyes glanced at the baby before she moved toward Sister Rebecca.

"I'll watch her, honey," said Mary.

"Thanks, Momma."

Sister Rebecca's head lolled left and right a few moments before a set of red-veined eyes blinked open.

"There you are, girl, come on." Elizabeth wrapped a thin, limp arm around her own shoulder and helped Sister Rebecca up to bed.

"May I join you, Mary," asked Mother Martin. With her head free of her veil, she felt the weight of her habit and cloak sinking her into unexpected heaviness.

"Please, Mother, yes. I still can't believe that me own daughter stabbed a nun and is on the run and that me husband has learned that his son-in-law was beating his Lizzy....oh, I can't even begin to think about it all."

"Frankie was beating Elizabeth?" Mother Martin took stock of Mary's face, searching for truth.

"I'm afraid so, Mother. He didn't ever believe that Elizabeth had gotten with child through him and so he took it out on her."

"What about the child?"

"Oh thank heavens, no," said Mary, blessing herself. "Only Elizabeth."

"Dear Lord. Here, Mary, let me top you up there."

Mary watched as Mother Martin also poured herself a drink and shot the whole lot down her gullet.

"My heavens..." Mary couldn't help herself. Seeing a nun shoot whiskey was a shock. She didn't even know other women who did that, never mind any Sisters of Mercy.

"These are extraordinary times, my dear Mary." Mother Martin poured herself another shot and chose to sip it gingerly this time, afterwards wiping her pale forehead with the back of her free hand.

"I am so sorry about what's happened to Sarah. I feel like this is entirely my fault."

"No, Mother, look. It happened the way it happened, girl." Mary's hand went to her mouth, realizing her mistake too late.

Mother Martin shook her head and waved off the 'girl' comment. "Don't worry. It came out naturally, that's all." A corner of her thin line of lips turned slightly north.

"I cannot deny I'm in a state about this whole thing but by the Grace of the Lord you took in both my girls and on such a shameful occasion." Mary's head dropped reluctantly. She still believed in the virtue of her youngest daughter despite her innocence being taken so rudely away, but it only seemed right in the face of the Mother General, even an unveiled Mother General, for Mary to show her shame. Mother Martin finished her glass and filled it again. Mary was starting to lose track of the drinks.

Mother Martin blinked and felt the wetness in her eyes, troubled and ashamed that she could no longer trap it in. "I let my own pride and stubbornness get in the way and now I have driven a young girl to do whatever it took to escape and save her own child, hurting one of my dear sisters in the middle of it all. Sister Ella's family is quite upset. I don't know how I'll ever calm them."

Mary's hand covered her face as she lay back in her chair, listening.

"Sarah unleashed such anger in me, such a fury of emotion that I cannot explain, except I have felt this before," she paused to take another swig of Father Ryan's whiskey. "She reminded me of myself."

Mary looked up. There was eeriness to this conversation that frightened her. She looked at Mother Martin's normally stern face, exceptionally exposed by the missing veil, which she refused to wear again.

"Sarah showed such incredible strength in spite of her attack, and yet she continued to be obstinate in protecting his identity. I completely disapproved of what she was doing and yet, I did the very same thing more than three decades ago."

"Are you saying…?"

"And I protect him to this very day," she said, nodding.

"Mother! Why on earth would you do that?"

"I had to, Mary." Tears raced down Mother Martin's furrowed cheeks. "He was the last person anyone would suspect," said Mother Martin. "And he knew it. He knew he'd be safe." She sighed heavily, knowing her words were weighing on Mary as much as herself. "He was our priest."

"Dear Jesus."

Mother Martin nodded her head silently. "He was so close to the family. It was frightening. You can never say a word, Mary."

"Dear God in Heaven." Mary suddenly realized she might know the father of her grandchild. 'He was so close to the family' replayed several times in her mind. Why hadn't she realized this before? She had not believed it was Captain Murphy from the start. Sarah had been too determined to not reveal the father all along, but then suddenly when he died, she readily admitted it. That hadn't sat right with Mother Martin or Mary. She knew her daughter's stubbornness and she knew his virtue. There was no way.

And now, she knew.

"I won't say a word," said Mary, biting her bottom lip and praying she was wrong.

\*\*\*

269

# Chapter 31

"Jesus, Mary and Joseph, God forgive me." Constable Pat picked up his radio.

"Constable Mikey, from Freshwater, come in Freshwater."

Static and sputtering…

"Freshwater here."

"Mikey. Paddy here. B'y, we got a situation, in Fox Harbour, can you come?"

"Yeah, where to."

"Down Marsh's lane at young Healey's. And bring an ambulance!"

"Roger."

"Ok, Mikey. I'm goin in."

"Over and out."

---

Sarah felt strangely calm. Frankie, her nemesis, the sinner who destroyed her peaceful life and cheated on her sister, the bastard who overpowered her and violated her in the most disgusting way was now a red, slimy wreck trying desperately to slink away from her. She probably broke his jaw when the pan hit, as she heard a slight cracking sound.

She stood there, a little numb with power. She'd never experienced anything like it. She, Sarah Lynn Marsh could decide this worthless slug's fate. She could preserve him or destroy him.

The surge of energy felt like a wave of electricity radiating from her whole body.

"Ssssahh."

Frankie tried to talk to her but she could see it hurt him to open his mouth.

"Frankie, you bastard," said Sarah, spitting on him in a harmless but violent spray.

"Wha? Where y..? ow.."

"Where did I come from, Frankie? Is that what you're asking? You know where I'm from, Frankie? Fox Harbour, remember?"

The frustration, laced with pain, boiled on his cheeks. He rolled gingerly over on his back. Then quickly turned on his side again and threw up.

"Uh, you're so disgusting," she said. She threw a dishtowel at him. He held it up to his face. Then the pain was too much for him. Tears started rolling down his broken face. He rocked as he sobbed.

She stood there, intent on not feeling anything, and yet she felt the rise of pity and sadness in her chest. She realized then she could never kill him.

"They sent me away, Frankie," she said, choking on tears. "Because of you and your pathetic behaviour, I was the one shamed. I was the one driven out. I had to be hidden away in a convent, trapped with no life anymore. You didn't have to do anything. You went on your merry way."

She started walking slowly around the other side of him so he instinctively turned with her, afraid to turn his back on her. He nodded his head in pain.

"Yes, you could carry on as if nothing happened, right, Frankie? Well, it isn't as easy as that. You didn't give one shit about me when you did such horrors!" Tears raged on.

There should have been silence, but instead, she heard something.

"Who's here, Frankie? Is it Mikey, your idiotic, asshole pal? Is it, Frankie? Tell me, or I swear, I'll kill you this minute." She grabbed her frying pan and pulled it above her head.

Frankie curled tightly into the fetal position, whimpering and shaking his head.

The door slowly creaked open. Frankie cursed himself inside for not fixing it. He shook his head with all his might. He couldn't squeak a word from the pain, so he waved his hands up from his sides over his head as high as he could get them. But she came up with the frying pan ready to annihilate. Ed bolted through the door to find his little girl. She made contact and he stopped short.

Lightening white pain shot through Ed's right shoulder. Sarah dropped the pan on the floor.

"Daddy! Oh, Daddy! I didn't know! I didn't know." She burst into uncontrollable sobs as she held her father, the two of them trembling.

"Sarah, honey, it's okay." He groaned in agony. "Come here. Come here. You're okay, honey."

She couldn't speak. Shock and pain registered on her face. She was in her Daddy's arms. Sobs from the centre of her lungs were all that came out.

"Oh, dear Merciful God, what a crowd." Constable Pat walked in and was nearly overcome with the sight of Frankie. "Oh my, Frankie. We're getting you an ambulance, son. It's on its way. Ed, are you all right, you stupid fucker?"

"I'm alive, Paddy, but something is all broke up in me shoulder. I can't get up."

"Don't move, Ed, we got the ambulance coming. Stay put. Sarah, honey, are you okay?"

She nodded, eyes blurry with tears.

"Okay, let's go to my patrol car so no one else gets hurt. Police all over the island are looking for you, young lady, but I think it's best if they find you in my custody for now."

She nodded, got up and followed him. As he was putting her in the back seat, the ambulance came with a team of paramedics.

"Foley! Thank God. Over here. Have one of your guys take a look at her to see she's okay. Someone else follow me. Ed and Frankie are in hard shape and are going to need patching up. She used an iron frying pan."

"Ouch."

---

"Constable Hynes, St. John's, HQ, come in."

"Constable Hynes, sir, you've got another call."

"Yes, b'y, patch them in."

"Ray, it's Paddy in Fox Harbour."

"Paddy! Did you find her?"

"Oh yes, we found her. She broke one fellow's jaw and gave her dad a good crack on the shoulder but they'll be fine. She was defending herself. Didn't know who they were until she'd cracked them."

"Oh Blessed Mary."

"She seems fine, too. Ah, not the Blessed Mary, mind. Sarah!"

"Paddy, you're a card!"

"Ha, now I have her in the back seat locked in."

"Yes, well, we'll be leaving it to the Magistrate to decide on the case."

"Right. Perhaps she could stay in Fox Harbour until it's all decided. I could put her under house arrest for now. She won't go very far, Ray, I can promise ya."

"We'll see, Paddy. I'll let you know. We'll be in touch."

"Oh, and, Ray can you get word to Mrs. Mary Marsh at the Convent on Military? She'll be worried sick by now."

"I'm on my way."

---

Mary slouched over an armchair and Mother Martin sprawled herself over a couch like a throw. Both of them were asleep when Elizabeth and Constable Hynes came to update them.

"Oh boy."

"Yes, Constable, I'm afraid they are exhausted and… let's just leave it at that, shall we?"

"Of course, Elizabeth."

Smiling, he picked up the empty bottle of whiskey. "Why don't I get rid of the evidence now?"

"Oh dear, yes, good idea."

Still smiling, Constable Hynes walked off to the kitchen and disposed of the bottle.

Elizabeth gingerly approached the two women. "Momma," she whispered loudly, looking back toward the kitchen. Mary and Mother Martin sat up.

"Ah, Constable Hynes is here with news of Sarah."

Mother Martin stood quickly, against her better judgment. "Oh heavens," she said, as she sank back into the soft couch. "Elizabeth, dear, have Rosie make us some coffee, Lord save us, and make it strong," said Mother Martin, rubbing her temples.

"But, wait. Is Sarah okay?"

"Yes, Elizabeth. Sarah is in safe hands," said Constable Hynes. "She is with Constable Pat until you return home."

"Thank the Lord." The women blessed themselves. Mary couldn't help herself and hugged Mother Martin and then Elizabeth.

"Wonderful, so everyone's fine," said Mother Martin, trying to straighten her robes.

"Elizabeth, would you mind getting that coffee now please?" asked Constable Hynes.

"Yes, of course."

"Thank you." When Elizabeth was out of the room he continued. "Ed got a good crack on the shoulder, broke a few bones."

"How?" Asked Mary, trying to stand but clearly unable to find her land legs.

"I'm afraid, Mrs. Marsh, it was Sarah. She didn't know it was her father coming in the door. She was trying to protect herself and in a state of high anxiety. She'd been in the Healeys' kitchen with Frankie after hurting him, too. For some reason, she had thought he might hurt the child."

Mary put both her hands up to her cheeks, as if to cool them. It confirmed her suspicions. Frankie must be the father. She sighed heavily. "Will he be okay?"

"Once he has his jaw wired."

Both women cringed.

"He should be fine, yes. He's going to need a lot of time to heal."

"Oh my."

"Yes, what is it?" Elizabeth asked, carrying a tray of steaming cups of hot coffee from the kitchen.

"Oh dear girl," said Mother Martin, "perhaps you should sit down. Pass me that tray, Elizabeth. Your mother will fill you in."

"Elizabeth, honey, let's have a coffee."

\* \* \*

# Chapter 32

Constable Pat ushered Sarah and Mary into his tiny police interview room, grabbing an extra two chairs so he and Constable Hynes could join them. He placed notepads and pencils on the table and offered to make tea.

"Yes, please," said Sarah looking down at the empty notepad in front of her. The light blue lines ran horizontally off the page. Those lines held the promise of white spaces between them, white spaces that could save her or sink her, depending on what words filled them in. Never before had she so relished the existence of clean white paper. She longed to create her own story, one that did not include violence, pain and shame, but one that promised warmth, caring and a beautiful baby.

"Sugar, cream in your tea, love?" Sarah shook her head. Constable Pat had been waiting for her answer.

"I'll help you, Pat," said Mary. "I know what she takes in her tea and, b'y, you don't have enough hands for four cups of tea anyway."

"It's a deal, Mary. Can't do anything right without a good cup o tea on hand, wha?"

"No, b'y," she said as they headed out of the room toward his tea table.

Constable Hynes stayed behind with Sarah. He pulled out his chair, scraping it across the old wooden floor. Sarah noticed he didn't make eye contact with her.

"I wasn't going to kill anyone, you know," said Sarah, searching for the Constable's eyes. "I also hadn't intended to hurt anyone." His eyes met hers. "It's not in my nature."

Constable Hynes sighed deeply and nodded. "Maybe you can tell me about what you did intend."

Her momma and Constable Pat entered carrying four cups of steaming tea.

"Here you go, child," said Mary, setting the cup down and seating herself next to Sarah.

"When you say you weren't going kill anyone...?"

Mary's eyes darted up. "Constable, is this the proper way to start this conversation?" Sarah patted her momma's hand with her own tiny hand.

"It's okay, Momma. I started it this way."

Mary sighed deeply, not taking her eyes off Constable Hynes as she sipped her hot tea. Then she nodded.

"I wasn't going to kill Sister Ella or Frankie, just like I wouldn't kill my own Daddy. What happened to them was as much an accident or unlikely situation as me hitting my own father over the head with a frying pan."

"Okay, so what happened?"

Sarah caught her momma staring at her.

Mary moved in close to Sarah's ear. "I am the only one who knows it's Frankie," she whispered. Sarah froze. She blinked her eyes purposefully. "Don't worry, honey," Mary said aloud so everyone could hear her. "Everything will be fine, you'll see. We'll sort this whole mess out." Mary's dark eyes filled with the warmth and kindness only a mother could express. Her eyes still locked with Sarah's.

Sarah sat back in her chair, closed her eyes and fought the tears. Her momma knew. Dear God.

"Go ahead, child. Tell them the truth." Her momma nodded for her to continue.

"I feel terrible about hurting Sister Ella. She was so kind to me," said Sarah, tears starting to roll down her cheeks. "Sister Ella was the person giving me the needles and taking care of me."

"Yes, the needles, I believe, were to help you sleep and keep you calm, right?" said Constable Pat.

"Yes," said Sarah, "I think they also were meant to keep me trapped there until I started to accept the loss of my baby. The needles made me very sleepy. Right after I gave birth, I woke up and found that my sister Elizabeth and my baby were gone. It was heartbreaking and too much to take all at once. So I screamed and cried as soon as I woke up, demanding to know where they were and to go home. They kept giving me needles to make me go back to sleep." Sarah paused to sip some tea. She set the shaky mug down. "Deep down, I started to figure that out. Then I knew I had to escape if I were ever going to save my daughter."

"Don't you mean you had to escape to save yourself?"

"No. I was afraid for my daughter...that Frankie might try to hurt her...the same way he hurt me."

"And how had he hurt you?" asked Constable Hynes, pencil in hand, writing notes in his notepad.

Sarah looked down at the white spaces on the page again. She picked up the pencil and decided to write her story. It's not the one she would have wanted for herself but if she were to take back control of her life, she needed to own what happened to her. She figured she was ready to handle whatever came next as long as she told the truth and as long as it didn't go public. She started to write on the light blue lines in slow, careful penmanship.

The two constables looked to each other. Her momma caught their attention without words and held her hand up to them, as if telling them to let Sarah do this. She wrote a few lines in silence and then spoke softly.

"He was the one who forced himself on me one night..." the two Constables looked up at the same time. Mary looked down. "...and got me with child."

Constable Hynes blew out a breath of air as if he'd been holding it in a really long time. "Yes, Mother Martin had told me you'd been attacked but I didn't realize it had been your sister's husband."

"No one did. I'd refused to tell anyone. But Mother Martin wouldn't give up until I gave her a name. So I told her it was Captain Murphy and since he had died in the war..."

"I see. And you were afraid Frankie might also attack Mary-Lynn."

Sarah nodded, eyes bloodshot and a huge lump caught in her throat.

Constable Pat, took off his cap and ran his fingers through his hair. "Frankie, Frankie, Frankie. That's why he was so scared here in the cage. Ed and I warned him about hitting Elizabeth, but he must have thought it was about your attack, Sarah, because he'd turned white as a ghost."

"Frankie was hitting Lizzy?" Sarah's tear kept rolling. Lizzy was taking a beating from him. Would Lizzy have done that had she known what he'd done to Sarah? She wondered for a fleeting moment if she should risk everything and tell Lizzy the truth.

"Yes, honey," said Mary. "But Ed and Paddy made him promise not to touch her again."

"But when Frankie realized we were talking about Elizabeth, he suddenly seemed highly relieved. It adds up, Ray."

Constable Hynes continued to jot notes.

"How many times did he assault you, Sarah?"

"Once."

"Only once?"

"Once was enough."

"Is there anything you might have done, perhaps mistakenly to encourage him?"

"Constable!"

"I'm sorry, Mrs. Marsh, but these are questions I must ask."

"It's okay, Sarah, go ahead and tell him your answer," said Constable Pat.

"No, nothing. I was asleep on their daybed. It was late one night when he came home very drunk from the Base."

"Is it possible he mistook you for his wife?"

"Constable, why would a wife sleep on the daybed?" Mary's face tightened as she spoke.

"Again, I'm just asking..."

"I don't know if he thought I was Elizabeth, but he certainly knew it was me because at the end, he shoved his belt buckle in my face and threatened me, saying if I said one word about any of this, he'd kill me."

"He said he'd kill you?" Constable Hynes looked at Constable Pat.

"Those were his exact words."

"And there were no witnesses?"

"No. We were alone."

"Did you believe him?"

"Yes, I still do. And I wanted to kill him ever since that night but when I had the chance, I couldn't do it. I hit him with the frying pan because I was alone in that house and I wasn't sure what he would do to me. I also thought he might hurt me for having a child. I was scared."

"Are you planning to press charges against Frankie Healey, Sarah?"

Sarah looked at her Momma. She didn't know what to say. If she did, how would that affect Lizzy? If she didn't, he'd be getting away with it.

"I don't know. I was in shock the night I hit him but I believe I got him pretty hard. I think he's probably been punished enough."

Both Constables nodded their heads.

"He's in hard shape, Sarah, I gotta say," said Constable Pat.

"And if you do press charges, there are a couple of things you should know," said Constable Hynes. "One is that he could also press charges against you and he could have a case. Two, you would have a very weak case as you have no witnesses, no evidence or proof..."

"Proof? What is Mary-Lynn, if she is not proof?" Sarah nearly spit the word proof.

"Your baby is confirmation that you both had sex, but not that you'd been attacked."

"What? You think I agreed with it? I can't believe this. Momma!"

"Constable, what are you saying about my daughter?"

"Mrs. Marsh, Sarah, I am only stating the facts, which are what a magistrate will examine. This is the reality of your situation. That's not the only thing. If you press charges and we go to court, the whole thing would be on public record."

Sarah shook her head furiously. "You've guessed right, Constable. I will not put on public display the fact that my daughter was the product of..."

"Understood." said Constable Hynes. "In that case, if we all work together, we may be able to sort out this mess without seeing the inside of a courtroom. We can tell Frankie that as long as he doesn't

press charges against you, you won't against him. I have a feeling he will agree to that since the punishment for rape is hanging. The only problem is that he's going to need your family's help to get better. He is in awful shape and will need you all to help him get back on his feet to earn a living again."

"What?" Sarah stood, nearly spilling her tea. "You expect me to take care of that bastard after what he did to me?"

"Now Sarah, hang on," said her momma. "Let's hear the Constable out." She grabbed Sarah's wrist firmly.

"No, Sarah," Constable Hynes' voice was calm. "I mean, if you want to stay out of a public courtroom, your family must agree to help Frankie get back on his pay-cheque earning feet so he can support Elizabeth and your daughter."

Sarah took a deep breath. "Why, why, why should he get this royal treatment?"

Constable Pat stepped into the conversation. "Honey, you haven't seen Frankie yet. There's nothing royal about his current state. He's in really bad shape. If ye crowd can get Frankie back into working condition, then the whole family can benefit."

"But then what? He gets better, goes back to work and we pretend like nothing's happened and I have to see him every day of my life?"

"No, he's going to apply for work in Wabush, Labrador once he's well enough to go."

"That's right, honey," said Mary. "He won't be in Fox Harbour very much."

"So they have to pretend to still be married."

"They will still be married. They won't spend much time together, that's all."

"I need to talk to Lizzy first and make sure she's okay with all of this."

"She is. We've already talked to her." Her momma patted Sarah's hand.

"But..." Sarah felt helpless and longed to talk about it with Lizzy but there was no time.

"Do you think you will try to hurt him again?"

"No, but I won't lie to you. The sight of him makes me sick to my stomach."

"Poor child," said Mary, rubbing her back. "Have some tea."

Sarah did as her momma said.

"So you hit Frankie only once with the frying pan?"

"Yes, and then Daddy by accident coming in the door. I thought he might be one of Frankie's friends who would also try to hurt me."

"What about Elizabeth? Did you think she could ever hurt your baby?"

"Oh heavens, no! She would never hurt Mary-Lynn, but she also didn't know what Frankie was truly capable of. She still has no idea that he's the father. I saw that as a dangerous situation. She trusts him but he can't be trusted."

Constable Hynes took a sip of tea and redirected the discussion. "Sarah, can we talk about Sister Ella for a moment?"

She nodded unable to speak again.

"Can you tell me what you thought would happen to Sister Ella when you stabbed her with the needle?"

"Yes, I figured it would make her sleepy like the needle always did to me. If I'd thought it would have hurt her, I would have found another way."

"Right. And, did you have any intentions of seeking revenge of any kind on the sisters or on Mother Martin?"

Sarah couldn't help but hesitate. She looked away, wondering how to answer.

"At that moment, I wanted to escape to save Mary-Lynn. That's all I could think about. The sisters were good to me, especially Sister Ella. Mother Martin was mean and cruel and I wanted revenge on her many times, but not in that moment. That's not how I was raised." She smiled at her momma who smiled back.

"Sister Ella may be a forgiving soul, but her family isn't. They want to press charges and put you in jail for a while."

Sarah's hands went to her face and she started to sob.

"Also, the Magistrate may not be so forgiving, especially also knowing about what you did to Frankie."

Sarah could only nod.

"I'm afraid I have bad news for you, Sarah. I have to charge you with assault and battery, which might turn into attempted murder of Sister Ella.

"Murder?" cried Mary.

"I'll need to bring you to St. John's to be held until we talk to the Magistrate."

"Ray, b'y, seriously?"

Sarah collapsed into her momma's embrace and they both cried.

"I'm sorry, Pat. My hands are tied at the moment until we have a hearing. In meantime, I'd suggest getting Sarah a lawyer."

Constable Hynes stood, shook hands with Constable Pat, and asked Sarah to follow him.

"But can't I put together a few things for her?" asked Mary.

"I'm sorry, Mrs. Marsh. She can't take anything with her where she's going."

"Where is she going?"

"To Her Majesty's Penitentiary."

\*\*\*

# Part 3.

*"To have a secret does not mean one is living a lie."*
From *The Big Why*, by: Michael Winter, p.372

# Chapter 33

Gingerly, Elizabeth held the spoon up to Frankie's dry lips. He smacked it away, launching the gruel all over her apron and dress. She jumped back, looking startled and feeling deflated. At least he was no longer a physical threat to her or the baby. In fact, he had become completely helpless.

"Agh, wadder," he squawked, drool creeping down the side of his chin.

"Water?" She was beginning to understand the garbled sounds he made through his broken, wired jaw. Not able to nod without pain, he stuck his thumb up in the air to acknowledge her success in getting it right, the only thing she'd gotten right all morning.

Sighing, neither in frustration, nor anger, but simple relief, she leaned across him briefly to grab his cup, the one with the now-permanent straw. He grunted with the weight of her against his body. She got up and walked briskly to the sink. She ran the water a tad longer, to enjoy the moment's peace and the soft, fluid motion of liquid freely gliding across her fingers and palm.

Bang, bang, said his small table as his pounding fist told her to hurry up and not take her sweet time getting water. She could read his impatient messages without looking at the freshly scarred flesh across the side of his battered face. The black stitches that held together the flaps of skin to form his face were Xs, stilled, and floating on his pale skin, marks of an aggressive encounter with a beast, a criminal, a cruel warrior.

"Coming," she said, finally filling up the cup and bringing it to him. He grabbed it hastily, splashing some of it on himself. They were both used to that. Ever since his attack, he was sloppy. His

weakened and rubbery arms made his hands, shaky and uncertain. He slopped and splashed everything he held, like a two-year old unable to control himself.

That part wasn't new, she thought, he could never seem to control himself. At least he couldn't go drinkin' and playin' the slot machines at the Base anymore, and then come home out of control.

And then there was Mary-Lynn. The tiny child that lay in her little cot in the corner, not making a sound, but simply listening to the sounds in her life and processing them the way a two-month old does, mysteriously. Who really knew, wondered Elizabeth, what went through their minds when they heard the gripes and bangs and motions of the tormented and pained souls around them? She worried more about the child's heart and emotions than anything else in this world. Already, in her short little life, she had a painful and secret past protected by the women in this family who would do anything to keep it private forever.

Elizabeth knew in her heart that raising Mary-Lynn felt right but she wasn't so sure about raising her as a single mother. Mind you, technically she would still be married to Frankie otherwise the neighbours would talk. She still longed to be a family, but it couldn't work, especially since the attack. He was angry and violent before Sarah hit him, before she crushed his jaw. Now he seethed with venom. Elizabeth felt his eyes bearing into her, his own wife, as if she, too, had held the coal-black, cast-iron frying pan that changed his life forever.

He may never function quite the same again, the doctors said, not because his jaw was broken. No, that happened to men all the time in bar fights and scuffles. No, it was the damage to the nerves in his spine and some parts of his brain function.

"With a bang to the head like Frankie has had," said Dr. Moore, wiping his brow with his pencil still in his hand, "there's no telling what has happened to all the grey matter underneath his skull."

"Like what?" asked Elizabeth, thinking it couldn't really get worst than a broken and shattered jaw on an angry young man who didn't seem to care about anyone but himself.

"It could lead to problems with his arms and legs. There could also be some changes to his personality or perhaps even mental illness, I daresay." He looked at his clipboard steadily on the words 'mental illness.'

"Does that mean he might not be able to work?" Elizabeth couldn't finish the words before the tears rolled their way out to freedom.

"Let me get your mother. Wait here," said the doctor.

Elizabeth dabbed her eyes urgently as if stopping the flow would stop the pain and stop what was happening to her life.

"Here she is Mrs. Marsh," the doctor led Mary into the examination room with Mary-Lynn held snugly in a cotton blanket. Mary reached out with her free hand to her oldest daughter.

"Oh, child, here, here. Come now, have a seat and let's hear what the good doctor has to say."

Elizabeth sat and listened, numb at the thought of her future.

"Mrs. Marsh, thank you. I was telling Elizabeth that because of the damage to your son-in-law's brain from the serious blow he's had, he could have some repercussions."

"Doctor, talk to me in normal language. What in heavens does that mean?"

"Well, it's possible his personality may suffer some changes…"

"That might not hurt him at all," said Mary as serious as the doctor.

"Now, Mary, it means his behaviour might be affected. It's something that you all have to watch, especially Elizabeth."

"Is it safe for her to be near him, then?"

"It is for now until we see any signs of him getting better control over his arms and legs," said the doctor. "For the next few months, he won't be a physical threat to anyone." Dr. Moore looked for Elizabeth's eyes, as he spoke. Word of Frankie's violence must have made its way around the harbour. "But," he said, "I must tell you, he could still sound threatening by his anger and aggression. He's in bad shape. He may…he may never work again."

"Oh doctor, don't tell me that," said Mary.

"Momma, I can't take this," said Elizabeth, bursting into tears.

"It's still a bit early to say but I can't see him coming out of this very soon. Bring him back in about three weeks and we'll take another look at him and see how he's making out."

"Doctor, are you going to explain all that to him, too?" Mary didn't want her daughter to be the messenger.

"Let's do it right now," he said, leading the way with his arm outstretched.

---

Frankie was sitting uncomfortably on an examination bed in another room waiting for the pain to stop turning his stomach. He knew this jaw was only a mess of broken bones, flesh and teeth. He'd lost four in the blow to his head. The teeth were the first things to fall and float in the pool of blood around him when he had slid to the hard wooden floor. He was going to make that little bitch pay supposing it took him his whole life. He figured them cops wouldn't put her in jail since she was a woman and only 16, but it didn't matter to him. Jail wouldn't be enough penance in his mind anyway and he wasn't religious enough to trust it to the Lord when judgment day came. Sure, that was a load, if he'd ever heard one. That's what the old biddies in town would say. No, he wanted the pleasure of taking care of her himself and putting her through the agony she brought to him. Then if he faced the Lord for it or the devil, he didn't care. There could be no hell worst than the one he was in now.

He thought of how much he hated her with every wince, every ache and every stab of lightening sharp pain that seared through his now broken headgear. He wanted to start over, get a new skull, one that was solid rock, and a new jaw that was lined up and in one piece. He wanted his face smooth again, instead of the deep rivets and bruising from the trauma. He wanted a new life away from these women who were torments to him and useless in so many ways.

The only shimmer of light for him was his daughter; his little girl was his shining glory. She was the most beautiful thing he'd ever laid eyes on. She was the reason he lived and fought to get healed. He couldn't wait until his arms were steady and strong enough to hold her. She was two months old and he had barely had the chance to hold his own flesh and blood in his arms. It was Sarah's fault he couldn't snuggle his own daughter. He had so much to repay her, and he was keeping track, too. He counted everything everyday of what she owed him. He counted the hours and days he couldn't work, the hours and days he couldn't hold his daughter. He counted how long it had been since he'd gone to the Base and played the slots or had a few drinks. And he counted the pain. It became his obsession. It kept him going. It kept him from losing his mind as he sat or lay for hours not able to fend for himself or even feed himself.

He jolted upright without thinking when the door suddenly opened, then lay down again quickly. Ahhh! The pain like exploding bullets shot between his ears and down through his neck. His breathing was ragged and quick while he and his audience silently waited for it to subside. He knew it never did fully. There was always an ache he couldn't reach.

"Sorry to startle you, Frankie," said the doctor as he led Mary and Elizabeth into the small room that grew frighteningly claustrophobic in a hurry. "I was telling your wife and your mother-in-law about your condition, sir."

Frankie didn't make eye contact with anyone as his eyes were closed, as if by covering his eyeballs, he might not be able to hear. He concentrated on his breathing and staying calm through the agony.

"Frankie, I'll give you something for the pain but as you probably already know it may not take care of all of it." The doctor cleared his throat. "I'm afraid things may get worse before they get better."

Frankie wished he could close his ears. He let a quiet grunt escape. He couldn't bear to hear it. It couldn't get worse than this, he thought.

"Yes, Frankie, I know it must be difficult," said Dr. Moore.

Frankie's head turned slightly to the right as his eyeballs looked to the side to catch Dr. Moore's look, as if to say you have no fucking idea. He knew it would hurt like hell but he couldn't help himself. That idiot doctor. Yeah, things were a bit difficult right now, he thought bitterly, then closed his eyelids again and resumed his position, panting slightly as he eased through the grip on his neck and jaws. After a week or so, it had only barely subsided. The painkillers deadened the rage against his body but only barely. At least when he sucked a rum hot toddy through his straw right after he'd taken the pills, he could get some relief by transferring the pain to an obsession with a semi-burnt tongue. A change was as good as a rest.

"Frankie you should know you could have some damage done to your brain that may affect how you feel and how you behave and how your arms and legs work."

"What does that mean, doctor?" Mary finally spoke. "You need to spell it out for us, b'y."

"What I mean, Mary, is all of you have to be watching Frankie for any aggressive or unusual behaviour as he'll need treatment right away."

Elizabeth looked briefly at her mother, wondering at what point aggressive meant aggressive.

"Just call my line if he starts acting out, Elizabeth. Can you do that?" He handed her a slip of paper that she stuffed into her baby's blanket and rose to leave.

"When can he work again, is what I'd really like to know, Doctor?"

Dr. Moore looked up at Frankie, a tired look on his face. "As I said, Mary, it's a bit too early to tell, but Frankie, I'm afraid you may never work again. I wish I could do more."

Frankie opened his eyes and stared at the ceiling.

"I'll see you all in three weeks." The doctor nodded and left the room.

"I'll get Ed to help you to the car, Frankie," said Mary.

***

# Chapter 34

Sarah lay stretched in her thin shift on the boney cot for much too long. It had only been about a week that she'd been locked up in here but it felt like an eternity. The guards called the stark collection of six women's cells the Old Women's Department. Most of the women here were old and in their 30s and 40s. She was the youngest at 16. She couldn't believe they each had their own cell. Even when she was at the convent in the fall, all the Sisters had to share rooms. But a solitary cell didn't make up for the conditions here. She had never been so freezing and so hungry for extended periods of time as she had been here. She never thought she would ever long for the convent. That had been hell on earth, but after the past week, Mother Martin's convent felt more like a long lost dream of cotton beds, clean sheets and hot tea. She even missed the old rag pillows. No such thing as any of that at Her Majesty's Penitentiary. And there was none of the friendship or camaraderie either. Here, if the inmates weren't insane, they were calculating murderers.

She sat up and realized with regret, she was going to struggle when they came to get her for laundry duty. It was only 6 AM but already, they'd eaten a breakfast of lukewarm tea and bread rolls dry enough to break your teeth, and they'd returned to their 'rooms'.

The other day at lunch, the one they call Madame had to be put in restraints again. The new inmate called her a whore, so Madame bit the girl's finger off. Madame will bite fingers when people upset her. Sometimes she chomped on them really hard. This time, she'd bitten the digit clear off. It horrified Sarah so much she started biting her own fingernails, as if to ward off any threats from the Madame. Sarah would not open her mouth to speak if she didn't have to but Madame loved to chat over supper. So Sarah talked to her, addressing her as Madame as much as she could possibly tolerate until at the end of the meal she reached her cell and fell exhausted onto her cot.

She missed her family. Quietly, she longed for Jack as much as she missed his girls, maybe more. He was nine or 10 years older than

her, but he did like her, or so she thought. She wished for more from him but she was in no position to long for anyone. She was in prison. She still had no news about what would happen to her.

Her parents couldn't afford a lawyer so when the Mounties sent her to St. John's, they said they'd get her one. He was a bulbous-nosed drunk named Jeffrey Maddox who kept calling her Cindy.

"My name is Sarah," she'd spit at him under gritted teeth during their first meeting.

"Yes, my dear, details, of course. Now, you say that the Sisters at the convent drugged you?"

Sarah sighed heavily and repeated her answers again and again. "Yes, the Sisters drugged me."

"Why in heaven's name would they do that?"

Sarah didn't want to say because she'd just had a baby that was taken away from her and it was a way to tame her until she calmed down so she stretched the truth a little to keep her secret safe.

"I was having nightmares and couldn't sleep."

"Nightmares, yes." The round light bulb nose nodded. "And what were the nightmares of, dear?" He touched the back of his hand against his forehead. He could have really used a drink by now.

"I dreamt that a man was....," she paused for effect, "attacking me."

"Gracious," he looked up from his notes, as if to confirm his worst fears. "Certainly not the kind of attacks I'm thinking of?"

"What kind of attacks are those?"

"Well, um, so,...what kinds of attack are *you* speaking of here?" He licked the sharp end of his pencil again and prepared himself to continue writing.

"Rape."

"Well! I have never in all my born years heard a young woman of your, your, your age say such a word. Heavens."

"Well that's what it was."

Sarah was weary and tired of the nonsense. He could barely remember her name; he had to be drunk. How ever was he going to help her at all and keep her out of this horrible place?

"Yes, attack. I see." He looked up again. "Surely God, you didn't tell the head mother the subject of these dreams!"

"She knew."

"No! How did she know that?"

"She knew I had been attacked."

"Gracious, you've really been attacked? By whom?"

"I can't tell you and I don't intend to tell you. But you must understand what happened with this drug they gave me. I ended up doing some things that were out of character for me."

"Some things out of characters, yes, let me see..." he flipped through a few pages in a folder in front of him on the bare wooden table. "What do I have here? I have an assault charge here possibly attempted murder of a Sister of Mercy, by needle in the neck..."

"I can explain..."

"I'm sure you can," he said under his breath. "Oh, and I also see here you've beaten a man over the head with a...ooh my...cast-iron frying pan, breaking his jaw, and possibly causing brain damage. Oh dear, Sss...Sarah. I don't know what to say. These are pretty serious charges. What do you have to say about these incidents?"

"It was to save my, uh, I mean to protect my family. And maybe it was the drug, too. I would not have done either of these things otherwise. Well I might have wanted to hit Frankie with the frying pan but I would have chickened out, if it hadn't been for..."

297

"So you'd thought about it before you hit this man?" Maddox looked at her expectantly.

"No, no, no, that's not what I mean." It suddenly occurred to Sarah that this lawyer might not be as drunk as she'd thought.

"I see, well, I will see if I can meet with the Doctor..."

"Parsons."

"Yes, Parsons and see what that fella has to say about all this. My dear Sarah, it certainly is quite the tale, I've got to admit. We'll do the best we can but in the meantime, you need to make sure you don't go off telling stories to the rest of the police, mind. We don't want to be getting our stories all mixed up, you know."

"What stories? These aren't stories. I'm telling the truth."

"I'm sorry, my dear, I meant to say, don't talk to the police anymore unless I'm with you. Can you do that?"

"All right." She sat back in her chair, only somewhat relieved that someone was doing something about her case. She did not want to spend the rest of her life in jail. But Sister Ella's family insisted that Sarah be arrested on suspicion of attempted murder, and when that happens, the Mounties put the suspect in jail first and ask questions later.

"You take it easy now and let me do the detective work, okay dear?"

"And when will I be able to see my family?"

"That will depend on when they plan to come visit you. You won't be able to go home just yet, my child, but they can come in any time they wish. You have to get cleared of these crimes first."

"You mean the trial?"

"Oh I don't plan to go to court with you?"

"Excuse me?"

"I don't go to court."

"Aren't you a lawyer? Isn't that what you do?"

"My dear, that is a small part of what I do. I prevent tragedies, save lives, help people get along better and so much more."

"So.."

"...what am I going to do for you as your lawyer? Yes, I plan to get you out of here so you can go home and never think about this mess again. How does that sound?"

"I would really like that." This conversation was making her so tired. She almost longed for her skeleton cot.

"Good. Is there anything I can do for you?"

"Will you be able to send my letters?"

"I certainly will. Hand them to me and I'll see to it that your family gets them."

Jeffrey shoved them in his jacket pocket and gathered his papers together. She was a really pretty girl, he thought to himself. He wondered how much extra work it caused the guards to have an attractive young girl in the Old Women's Department. He worried about this girl's situation as he made his way through the dirty and cold corridors of the HMP. This case was going to be a sticky one. Oh he hoped and he prayed he didn't have to go to court. Trials could be so tedious. He allowed the guard to open doors and then close them loudly behind him.

---

Mother Martin sipped her hot coffee tentatively and then approvingly nodded in Rosie's direction.

"Lovely cup this mornin', Rosie."

Rosie nodded, without saying anything and pounded away at the crest of round, soft dough in her hands.

Roll, pound, pound.

Roll, pound, pound.

She watched the stately head mother stride towards her office, carrying her coffee.

Roll, pound, pound.

Roll, pound, pound.

That woman had lots of nerve, thought Rosie, the way she pranced around and expected everyone to do her bidding, all in the name of the Lord. That Ice Lady was as cold as the ice pick out back in the middle of February. Only the scalding hot coffee in her hand warmed her fingers. Rosie was convinced it would never reach her blue heart of frost.

Roll, pound, pound.

Mother Martin wasn't cruel to her, mind. In fact, she was downright civilized with her. The girls in the kitchen saw it, too.

"I'm tellin' ya, Rosie. You're the only person in this Godforsaken place that Ice Lady likes, I swear," said Margie one day.

"Go on, girl." Rosie kept chopping her carrots in even swipes.

"You are, ain't she, Liz, wha?"

"Indeed she is," said Liz, wrapping food and cleaning counters. "Indeed she is." Liz always said everything twice, no matter what it was.

Nothing on Rosie's face changed with the knowledge. Inside, she was slightly pleased that she impressed the Ice Lady, for it gave her a slight sense of power she did not hold over her own life. Yet, the interest of her boss gave her the shivers. It meant she had to keep up so she didn't lose her favour. Rosie didn't like that part hanging over her head.

Roll, pound, pound.

Roll, pound, pound.

"Liz, hand me that pan over there, would ya?" Rosie called.

"Yes, girl, here ya go now," said Liz. "Yeah, here ya go now."

---

Mother Martin left the kitchen and wandered back to her office to claw through the pile of mail and paperwork waiting for her. Over the last week or so, she'd had great difficulty focusing on anything with poor Sister Ella attacked and this fiasco with Sarah. Deep down she knew she was partly responsible. But hadn't she taken the girl in and done her best?

The problem was that Sarah hit Sister Ella in the neck. If Sarah had aimed for the stomach or arms or something to distract others so she could make her escape, perhaps Sister Ella's family could have accepted that, but the neck? It seemed so…targeted. They demanded that someone pay for the attack on their daughter who was still recovering. It would take another week, at least, before she was back to her old self. Secretly Mother Martin hoped the girl would have to do substantial time in jail. Would do her good. Teach her a lesson.

The head mother shook her head in disgust at how things had gone wrong with Sarah. She should have known from the start that there would be trouble with that girl. She should have known. Instead, she carried on and decided to help them. Lord, Lord, Lord, live and learn. And it was the Lord's work, after all. She couldn't turn them away, could she?

Mother Martin sipped her black coffee and thought the next unwed teen that showed up at the convent with child might have a harder time getting in. She slipped her letter opener in and out of the various envelopes from the pile until one caught her eye.

"Dear Mother Martin,

Allow me to introduce myself: Barrister Jeffrey Maddox from St. John's. I am representing Miss Sarah Marsh and wondered if you had some time to meet with me this week. I have spoken to Miss Marsh

at length about some of the events in question and would like to understand your view and any details you may be able to provide which could shed some light on this most bizarre situation.

Thank you for your time and I hope this letter finds you in good health,

Mr. Jeffrey Maddox."

"Yes, most bizarre, indeed," said Mother Martin out loud to herself. She could hear the drone of the young Sisters next-door practicing hymns for Chapel. She smiled. "Why, I'd be happy to meet with you, Mr. Maddox," she said to the letter, "and share my views...the sooner, the better."

\*\*\*

# Chapter 35

Elizabeth cooed softly to Mary-Lynn, playing with her toes as she deftly changed her soiled cloth diaper. Taking care not to hurt the child with the pins, she paused momentarily before plugging in each one, then smiling broadly and calling to the baby to keep her content.

She was enjoying the quiet. Frankie had finally fallen asleep and the baby was soon going down for her nap. Then Elizabeth might get a chance to write a letter to Sarah or get a cup of tea for herself. Things had been so hectic ever since Frankie's injuries. It still broke Elizabeth's heart to know that her own sister attacked Sister Ella and Frankie. She knew Sarah did not think much of him, especially when she read his nasty letter to Elizabeth last fall, accusing her of being with another man, but Sarah didn't hate him, surely. To clobber her husband in such a manner shocked and saddened Elizabeth. Sarah had thought an intruder was in the house and going to attack her. Frankie hadn't realized she was there until he was lying on the floor in a pool of blood. He could be a real tangle sometimes, thought Elizabeth, but nobody deserved such an awful smash in the face.

Then she heard rumblings in the next room and suddenly knew her window for peace and quiet and cups of tea and letter writing were now over. She had to put her baby down and tend on her broken husband.

---

"Mary, that Frankie is in some awful way," said Ed in a strangely quiet but gruff voice.

Mary stopped stirring her moose stew. "Oh, I know he is."

"I've never seen him so bitter, Mary, but I'm tellin' ya, when he gets healed, he'd better not lay a hand on Elizabeth again."

Mary purposefully went back to her stew, not wanting to betray anything she might be pondering herself. "Hmmm," she said. "Well, I can't say as I blames him for being bitter, wha? I mean, I don't

know how he takes that pain. According to Dr. Moore, it could get a lot worse before it gets better, too, with possible brain damage."

"Brain damage?" Ed scratched his unshaven chin. "It's not like Frankie can handle any more of that!"

"Ed, that's shockin', b'y."

"Mary, you knows I'm carrying on."

She shook her head, letting a tiny smile show.

"So what kind of stuff did the doctor mean? Will he be like a vegetable?"

"Not like that," she said, stirring. "More like he could act up a bit or be aggressive."

"Wha?" Ed stood to his full height, an imposing figure despite his 58 years. "And our little granddaughter over there?" He took a swig of his drink and planked it down on the kitchen table. "I'll be havin' none of that," he said, as he started to leave.

"Ed, b'y, where ya goin'?"

"Goin to get me granddaughter outta there."

"Oh, yeah, and what are ya gonna do with her then?" Mary had her hands on her hips.

"Well, er...bring her here," he shouted with a brusque wave in the air. "Look, Mary, if he lays a hand on that child, I will split him in two. The last thing he'll be worried about is a broken jaw."

"Ed, don't be so foolish, and what about Elizabeth? You can't just barge in and take the baby from her, Lord Jesus, b'y. Have some sense."

Ed crossed his thick, stubborn arms and glared at Mary with more hype than angst.

"If you're in such a rush to go to the rescue, what about our poor Sarah down in that awful prison? Why don't you go rescue *her*?" Mary stirred her stew even harder, even though it needed no more stirring.

Ed sat down again, dropped his hands in his lap and his head hung for a second or two before he spoke. "I know, girl. What are we going to do about that? How do we save her?"

"She's got that lawyer down there but I don't know if he'll be able to help her?"

"I don't know, girl. And anyway, I don't understand why she would attack a nun, of all people!"

"I know, b'y. I don't understand all of it either."

"I mean, what was she thinking?"

Mary's stomach dipped slightly at the thought of the truth coming out through a public trial. She wondered if that was what Mother Martin was up to. Trial or not, Mary would stop anyone and everyone from tearing this family apart, no matter what she had to do.

"Perhaps I could go talk to Father Williams and see if he has any suggestions."

"Yes, that's a good idea."

"And maybe I can send Jack to town to check on Sarah. I could look after the girls and we could get them through the winter if he loses a month of fishin', could we, Ed?"

"Girl, we'll do what we have to. I'll go get him."

---

"Forgive me Father for I have sinned."

"Oh, Mary, how lovely to see you." Father Williams took off his reading glasses, letting them hang on a beaded string around his

neck. He opened his arms to hug her. "I'm sure you haven't sinned, my dear."

"Oh Father, you can't imagine how awful I am," she said, half smiling.

He chuckled deeply from the bottom of his round, sacred belly. "Come, now, Mary. Please sit down and join me for a tea, would ya?"

"Yes, Father, I'd be delighted." Mary sat, folding her skirts neatly under her, with her two hands joined in her lap like a schoolgirl.

The parish priest returned carrying a teapot that he placed on the table. He picked up two cups and saucers from the top of a low cabinet on wheels which also had a creamer, sugar bowl and spoons for when Father had visitors.

"Still two sugars, Mary?"

"Yes, Father. Good of you to remember such silly details."

"Nothin' silly about a good cuppa tea, wha?"

"No, I s'pose you're right, Father."

Father Williams set Mary's teacup on the table with sugar and cream already in it. He poured tea from the teapot filling the two cups, stirring his own with a spoon.

"So how can I help ya today, Mrs. Mary Marsh?"

"Father, we're in a real bind with our Sarah in this prison in St. John's."

A dark shadow flashed across the cherub-skinned holy man. He nodded. "Shockin', isn't it? So what's happening with all this, Mary? What is the real story here?"

Mary looked down at her rough, but clean hands, holding the delicate china teacup, which belonged to the Parish.

"You know I can't lie to a person of the cloth, and especially if it's you, Father."

"Well, I don't know to what I owe this honour but I am not surprised that you would choose always to be forthright with all people, and especially all clergy. It suits your character, Mary."

"Thank you, Father. I feel blessed by your grace."

"Oh come now, Mary, what's going on?"

"I may not be ready to confess everything just yet, Father, if you'll trust me, but we do need your help. Sarah is in grave trouble. She attacked a nun in St. John's and she accidentally beat poor Frankie over the head, as you know."

Father Williams nodded solemnly, as he often did.

"She did those things, Father, though I know it does not sound like her. She wasn't herself, there's no doubt about it. But I'm wondering if it was the drugs they gave her there to help her with her nightmares."

"Was there a doctor in charge?"

"Oh heavens, yes."

"So that's good. It's not like the convent decided to drug up a young girl on their own because they felt like it."

"Oh gracious, no. I don't think they'd ever do that."

Father Williams took a swig of his tea.

"Father, is there anything we can do to save her?"

"I could perhaps speak to Mother Martin and see what the problem might be. Perhaps she'll tell me the doctor's name. I will be in St. John's again next week; I could try her then."

"Father, that is wonderful. God bless you."

"Anytime, Mary, and...come talk to me when you can. I may be able to help. No matter how bad it is, Mary, the Lord will still forgive."

"Dear Father, the Lord is the least of my worries. He understands forgiveness; it's my community who will judge."

\*\*\*

# Chapter 36

Sarah walked until her feet ached, but at least she was not cold. The walking allowed her blood to circulate and warm her extremities. In the yard, the guards paced but did not follow her every step. Back and forth, their pacing created a human barrier between the women and the fence where the men were.

She couldn't see the men, but she could hear them. They shouted obscenities over the fence, knowing they had an audience of women. They had no idea how old and crazy some of these women were, just that they were women, and based on the kinds of comments they'd made, Sarah realized that that was all that mattered. Most of their brutal and raw comments were missed on her. She only understood some of it, so she was able to tune it out after a while.

She thought about how she was becoming someone who was not as affected by words and actions as she would have been less than a year ago. Was she turning hard or simply growing up? Would anyone want her after all this mess was cleared up? Why would they? She wasn't a virgin anymore, though she had no idea what sex was. She could be ruined. No matter what sentence she might get, the reality was that she was already in here in this hell. Even if they found her to be innocent, she had done time in jail. That couldn't be undone. And was it possible that because she was here already she was doomed to stay? What would someone like her get as a sentence? Did it matter what kind of assault she'd committed, for example, or that she'd attacked two people, and if there were other factors? Wouldn't her lawyer be the one to answer those questions? She had to get another lawyer or she was going to end up as the youngest female at Her Majesty's Penitentiary for the longest term: not a title she wanted to earn. She was already the youngest; that was enough. She took a deep breath of cold air that felt good. A guard interrupted her thoughts when he tapped her on the shoulder.

"Someone is here to see you."

"Who is it?"

"A Mr. Davis is his name, Jack Davis."

Sarah nearly felt faint with relief, emotion and panic all at once. "Oh," she said. "Are there, um, is there anyone else with him?"

"No, miss, he is alone, as far as I can tell. Will you be fine with him alone or should we put someone in the room with you?"

"Oh," she nearly cried. "No, he's one of the most upstanding men I know. I just wondered if he had his daughters with him, that's all."

"No, miss, not to my knowledge. We'll still be able to watch you both through the glass, I wondered if…never mind." He was an older man about her father's age. He seemed genuinely concerned about her. "I'm sorry, you remind me of my daughter. I can't imagine her being in a place like this," he said, looking around, making sure no one else was listening.

She nodded and followed him back through the yard to the visitors' room.

Though she had walked all morning, the walk from the yard to the meeting room felt like an eternity, like a journey unto itself. The last time she had seen Jack, she had been in her mother's kitchen after arriving in Fox Harbour drugged and edgy from her escape from the convent and her violent encounters. He had brought his little girls to see her.

The guard unlocked a number of doors and led her through a long corridor. When he opened the final door, Jack stood from where he'd been sitting, knocking the chair over, his hat in his hand. He stood motionless and waited for the guard to close the door, though the other guards weren't far away, and one side of the room was half glass so they could see in. The moment the door closed and he had collected himself, he laid his hat on the table and came to her. He opened his arms and hugged her while she sobbed uncontrollably in his warm embrace. She hadn't cried this much since she'd had the

baby and was overcome by how deep her tears went before they'd surfaced. Her head lay on his shoulder. It took everything she had to move back, but she felt she had to. He moved some of her hair off of her forehead and to the side and then wiped her tears away with his thumbs, though they kept pouring out.

"Jack." Her voice was barely a rasp. He hushed her and held her again.

It pained her so. He had no idea how tainted she was.

They separated and he gestured to the chairs so they could sit across from each other. He held both her hands across the table.

"The girls demanded that I come and get you from St. John's and bring you back home, Sarah." He was smiling broadly now, a permanent dimple in the middle of one cheek.

Her lips formed a smile but her sadness kept the river flowing. "That is sweet," she said. "They'll never forgive me, will they?"

"You'll never forgive you, will you?" said Jack, as if wise to all her secrets.

She looked him in the eyes, trying to understand how he might know more than what she thought, but his eyes looked innocent to her, boyish, as they had always been.

"Jack," she said, turning away from him, as she felt another wave of tears.

"Sarah, it doesn't matter to me what you did," his hand held her chin for a few moments. "I'm here because I want you to come home. I need to know how I can help."

She put her forehead in both her hands, surveying the grain of the wooden table between them. "I don't know, Jack. I would love for you to help but...I don't know where to start."

"Why don't you tell me how you got into this mess?"

Sarah smiled at his earnestness. She knew he was dying to help but what could he do? She couldn't possibly tell him the truth.

"Being here is a huge help. But there is something."

"Really?"

She was nodding her head. One of the guards looked over at her, through the glass, as if reading her thoughts.

"Do you think you could bring me some books from the university library to read, maybe from the law section?"

He smiled back.

"It would mean a lot, um, more reading than you're used to."

"Well, your momma has been teaching me how to improve my reading so this might be my chance to show my stuff."

"She has?" Sarah was smiling, too. "She didn't tell me that."

"You Marsh girls seem to like your secrets, wha?" His eyes twinkled. "I'll try my best. That's about all I have to offer you."

"How long are you in town for?"

"I can stay for a while. I've arranged for your Momma to take the girls. So don't worry about that. Let's say a month."

"A month?" Her jaw flew open in shock and pleasure. "Does that mean you're coming back to see me again before you go back home?"

He grinned. "Everyday, if they'll let me."

"Oh boy!" Sarah threw her arms in the air. The guards took an immediate interest, stretching their necks to catch the scene, making sure they weren't missing something important. Sarah dropped her arms quickly, slightly embarrassed.

"Okay," she whispered conspiratorially. "What I'd like to read about are the laws of assault charges and attempted murder. Anything you can find that I could read would be a help."

"I will see what I can find."

"That's great." Sarah looked around at the guards, as if worried they might catch some tidbit of information that could incarcerate her for eternity. "I am stuck with this Mr. Maddox man as a lawyer and I'm sure he does grand work but I don't think he's used to...this kind of situation I'm in, so I want to be as prepared as I can be. If I need something legal to happen, I can ask him but I need to know what to ask."

"I always knew you were a smart one, Sarry," said Jack, full of pride and concern.

Sarah looked down at his baseball glove hands that spent more time on a boat untying knots in ropes and hauling nets than scanning through books, especially law books, which will likely be challenging for both of them to understand.

"Okay," he nodded, all business-like. "Assaults. Attempted murder. Got it."

Sarah took a deep breath and let it out. "Jack, honey, I have no idea if either of us, including my lawyer, will understand what you are able to find but we at least have to try."

"Look, Sarah, I can sit in my kitchen and worry about you and listen to my girls go on and on about why Sarry isn't coming home, or I can actually do something about it. So don't worry about this. I'm volunteering, ya hear me?" He squeezed her hand tightly.

Sarah was quiet for a moment. "How is Elizabeth?"

Jack sighed. "Elizabeth seems to be doing well. She's certainly got her hands full with the baby and Frankie."

Sarah cleared her throat. Her voice was a scared whisper. "How is he?"

Jack looked away briefly. "He's not good, girl."

Sarah's face blanked like a stone. She wasn't sure what to do with the mixed torrent of emotions roiling around in her chest. She wanted him to burn in hell, but the worse he was, the worse it would be for her. She didn't remember much about how it felt to hit him. It was as if her arms and body lifted the pan and slammed. Her heart and mind at the time were equally driven to save Mary-Lynn.

Jack was tapping her gently on the wrist, "Sarah? Sarah?"

She shook her head. "Sorry, I..."

"It's okay, I get it. I think I get more than you give me credit for." He looked straight into her eyes. She felt a surge in the base of her stomach, wiping away the fear, cold, hunger and anger of the last few weeks. It frightened her in many other ways. She was immediately brought back to that night when Frankie was on top of her, his hand over her mouth, his rancid rum breath heating her face, forcing his way into her...

"Sarah, are you okay?" Jack put his hand on her right cheek. She backed away from him like his hand had burned her face. She was holding the burning spot where he'd touched her. "I'm sorry, honey, I didn't mean...You looked like you saw a ghost."

She suddenly had a flash of panic. What if all men did what Frankie did? What if they pretended to be friendly at first and then attacked like he did? How did she know any different? She had no experience with them. She was shaking her head in disbelief that Jack, her Jack could do such a thing to her.

"Okay, okay, you didn't see a ghost, but something is scaring you and I'm telling you right now, I'm not gonna let it hurt you again, okay?" Jack's voice, gentle, caring, masculine, concerned finally broke through.

"I...need to go lie down," said Sarah, her head whirling with trauma. It had been days since she'd felt that night all over again. She carried the anger and thought about Frankie as a monster always, but somehow she had separated him into one box in her mind and the

night of the attack into another box. It had been too painful to carry both boxes around all the time. There wasn't room in her head. Suddenly, today, Jack opened all the boxes releasing their toxic contents, spilling their corrosive and contagious materials all over her brain, rendering her unfocused and unable to concentrate on what he was saying. She now wanted to run and hide under covers. Her cold, empty, naked cell called her.

"But wait, Sarah." Jack's hand was outstretched, wanting her to stay. Jack called after her again. "I'll look up that stuff for you, Sarah. Take care." She didn't turn around. She kept going. The heavy door with bars clanged after her, leaving him alone, cold, empty.

\* \* \*

# Chapter 37

Barrister Jeffrey Maddox removed his handkerchief from his breast pocket, gave it a great shake and wiped his brow. Though it was still only early June, Jeffrey always felt the heat from the inside out. In fact, he could help the city of St. John's warm up, some days, he thought, feeling better with less sweat on his brow. It didn't help that nuns always made him nervous. A head mother would be the epitome of nun-hood. He wanted to sit, as his short legs were fatigued from his walk up the steep hills of Church and Cathedral. Bloody religion, he thought. It was everywhere. But he was too addled to sit. He needed to move about, pace or...

"Good morning, Mr. Maddox," said Mother Martin, her hand outstretched like a businessman. He shook it, feeling a force of judgment crawling up his arm from the somewhat wrinkled but very firm small hand with squared nails and long fingers. "Come follow me so we can speak in private."

"After you, Mother Martin," said Jeffrey as he stepped briefly aside and allowed her to lead the way. He looked around at the old but well-scrubbed wooden walls and ceilings with their high arches in the main foyer. "You keep a fine place here, Mother Martin."

"Thank you, kindly, Mr. Maddox." She led him to the Great Room where the door was padded on the inside with burgundy leather to keep highly confidential conversations muffled and discreet. Jeffrey walked in wondering what could possibly warrant such confidentiality in a convent when everything was supposedly about God and religion. Weren't secret rooms for places that had secrets?

"Please, sir, have a seat." She directed him to a soft armchair of dark leather.

"Well, thank you, Mother Martin." He sat and pulled his briefcase out and absentmindedly pulled out his handkerchief again, not noticing a couple of envelopes had spilled out onto the floor.

"You've lost some of your letters," she said, handing him the two she could reach. "Ah," she said. "They are from our dear Sarah."

"Yes, yes, oops, I will put those in my briefcase for safe keeping, thank you." He grabbed them as quickly as he could have without looking too hasty or rude.

"So how is our dear Sarah doing?"

"As best can be expected, under the circumstances." Jeffrey adjusted his glasses and continued. "Mother Martin, if I may, I have asked to meet with you to understand your version of events and perhaps also to understand what may have prompted your sudden interest in pressing charges against our dear Sarah," he said, putting emphasis on 'dear'.

"Dear Mr. Maddox," said Mother Martin with mirrored emphasis on 'dear'. "I am happy to share with you that I didn't take sudden interest in the matter long after the incident, as your comment so implies. I was immediately horrified the moment I arrived at the room where we kept Sarah and found her gone, but a needle sticking out of my dear Sister Ella. That is when I took sudden interest in this matter."

"Of course, you did. Dear me," he said, wanting to soften her a little, also taking in her sudden release of details. "But when did you decide you would press charges? Was that right away or at a later time, was really my question, Mother Martin."

She eyed him sharply, slits narrowed. She had underestimated this bubbling idiot who didn't seem to know up from down. She adjusted the long white folds of her skirts in a smooth and fluid movement.

"Right. I decided to press charges likely when I found myself seated in this very room across from Sister Ella's mother and father, trying to explain why a teenager under my care attacked another Sister of Mercy." As she spoke, Mother Martin leaned her head and

body forward towards Jeffrey as if slowly moving until she arrived at ideal striking distance. Instinctively, he recoiled delicately until his flabby chin brought up against his chest.

Loudly, he cleared his throat, and the venomous religious woman moved back to her original sitting position and he rolled his head to relax the tension in his neck. "That makes perfect sense. How else could you respond? Perfectly understandable. Now, how is it that Sarah got on these drugs? She hardly strikes me as the kind of child to really want to or be drawn to drug taking. How do you explain this?"

"Sarah was in a bad way with nightmares and feeling unwell so we decided to, or rather the good Doctor Parsons decided to give her a drug to calm her and keep her safe."

"Yes, I see, so the Doctor could be to blame then?"

"No, not Doctor Parsons. Heavens, Mr. Maddox, he's been coming to treat patients here at the convent for as long as I can remember. How could you even suggest it?"

"Mother Martin, my job is to question and suggest until I find out what is the truth that will set my client free."

"Nothing will set your client free, Mr. Maddox, even if she doesn't go to jail. Sarah's conscience is taxed rather heavily. I don't know if she'll ever know freedom, to be honest."

"I am more worried about the jail part of freedom, personally."

"Of course you are. You want to go to trial and win. That's how you make your money, isn't it?"

"No, actually. I do not want to go to trial, Mother Martin." Again, he adjusted his glasses.

She lifted her eyebrows. "Mr. Maddox?"

"Yes, I cannot stand trial, ha ha," he chuckled to himself at his own joke. Mother Martin showed no sign of humour in her whole demeanour. "Ahem, yes, what I mean is that I do not like going to

trial. I prefer to settle issues amicably outside of any courts and judges. I find this method to be more, let's say, community-oriented."

"But don't you make less money that way, Mr. Maddox?" She was now perplexed yet intrigued.

"You are correct, Mother Martin, but again, I do not enjoy trials."

He watched her face turn from mild dislike to slight appreciation.

"Trials are horrible exposures of individuals' lives," he said, knowing perfectly well what he was doing. "Lawyers dig out every possible private detail about the people on both sides, things they'd forgotten about themselves from decades and decades ago." Jeffrey waved his arms slightly dramatically. "Then," he said, "suddenly the poor individuals are stricken with embarrassing revelations for all the public to hear and see. And this includes anyone and everyone who is involved, even those who aren't on trial. It's a terrible, terrible business."

He looked up from his notes again to see Mother Martin and made eye contact with her. "But of course, I can't imagine you having anything of such a nature to hide, Mother Martin. That would be most unfortunate for the kind of business you're in, would it not?" His head cocked to the side.

She eyed him carefully, trying to assess him. There was no malicious sneer on his face or devilish gleam in his eyes; he was intrinsic about his approach. And yet…

Jeffrey knew that part of his lawyerly duties was the game, his face and the drama, he thought to himself, just enough to quietly extract the details, response or conclusions he needed. His game face was often pure innocence and honesty. When that failed, he used apparent bumbling stupidity. Usually one or the other worked well enough, depending on his audience.

"Mr. Maddox, are you threatening me?" Mother Martin crossed her arms.

"Oh no, not at all," he said, smiling. "I want to make sure people understand what I am up to and why I work the way I do. Look, here's what I'd like to know. What could we do to help the Gaultons feel that justice has been done? That's the real question here, isn't it?"

"Mr. Maddox, their daughter was attacked!"

"Yes, Mother Martin, I know but nothing will change that. When Sarah rots in jail for a decade for something that was highly unusual for her character while under the influence of drugs...”

Mother Martin opened her mouth to speak but he kept talking. "As I understand it, the doctor authorized the convent to administer this drug, correct?"

"Yes, haloperidol, I believe, but..."

"Right and this medication is normally used to calm people, is it, Mother Martin?"

"That's right. I believe the doctor said they use it in treating people with mental illness especially. It calms any hallucinations or other mental disturbances."

"And do you think it's possible that this batch somehow went wrong? Any ideas? Would the good doctor have any suggestions?"

Jeffrey's face was earnest and clear; she could hardly think he was up to anything.

"No, I don't think there was anything wrong with the drug."

"But she was taking it for a long period of time, yes?"

He lifted his eyebrows expectantly.

"I wouldn't say 'long', necessarily, maybe a month?"

"A month? Oh my, but of course she and her family did agree to this drug, I mean, you had their permission, correct?"

Mother Martin breathed deeply. Jeffrey paused for added effect.

"Look, Mother Martin, you don't have to decide right now," he said, "but we can do a number of things: start a scholarship in Sister Ella's name, perhaps one that allows young men to study more about medications such as these, perhaps even..."

"Perhaps we could consider naming one of our halls or special rooms in her honour here at the convent," she suggested wryly.

"Beautiful idea, yes!"

"Mr. Maddox, she's not dead. That would seem an odd thing to do."

"Of course, of course, but I am confident you now understand that there are other ways to fix one tragedy in one family, and it's not by perpetrating another tragedy in another family."

"Don't patronize me, Mr. Maddox. I have fixed, prevented and undone many tragedies for many families in this province in my 35 years of the Lord's work. You won't fool me with your lawyer tricks." She paused briefly. "However, I will consider our conversation carefully. You should consider all the facts carefully, too, and not just the ones our dear Sarah chooses to tell you."

"I will take that into advisement, Mother Martin. Thank you for your time today." He stood and reached out to shake her hand. She reluctantly gave him her hand, while never breaking eye contact.

"Oh, one final thing. Do you think I could see Sister Ella for a few moments? See how she's doing?" Jeffrey gave her his best smile.

"Not a chance."

"Right, then. Thanks again."

She was an astonishing lady, he thought. Too bad she was dedicated to God. Nuns still made him nervous but he did feel himself flush a little. He needed a drink in the worst way.

\*\*\*

# Chapter 38

Barrister Jeffrey Maddox slid onto the quiet wooden bar stool in Murphy's Public House on Water Street and saluted his favourite bartender in mock reverence.

"Sheriff, how are ya, sir?" The bartender called.

"Ah, Boss, I'm grand. Muckin' along, ya know," said Jeffrey.

"Glad to see ya back. Same as usual?"

"Indeed, Boss. Always the same."

Boss placed an overflowing pint of ale in front of his best-dressed patron, flicked his bar towel and leaned on the bar. He waited until the Sheriff had a sip.

"So what's been happening in the grand court of law?"

"Ha. Boss, you knows I don't go to court."

"You need to come here more often, then, doncha? We hardly sees ya anymore."

"I know, b'y. I'll try my best, wha?"

"I heard you're busy with a particular case up at the convent with that nun attack, wha?"

"Yes, now what do you know about all that, Boss?"

"Oh nothin' much, only Rosie my sister works in the kitchen there, right?"

"She does now, does she?"

"Yes sir. I imagine you probably wants to have a talk with her, I s'pose, would ya?"

"Boss, you are full of surprises, aren't ya, sir!"

"Is that a yes?"

"My sonny boy, you'd better believe it. When can I talk to her?"

"Well she lives in the apartment upstairs when she's not at the convent. I'll run up and see if she's got a few minutes."

"Wonderful stuff." Jeffrey took another healthy swig of his ale and calmly waited to meet Rosie. A few minutes later, Boss returned, smiling.

"You're in luck, Sheriff. She is up putting the kettle on. You'll have to finish that later," said Boss, nodding to the ale. "She's a bit fussy about the drink, ya know."

Jeffrey looked around him and pointed toward the bar. "But, doesn't she live...?"

"Yeah, I know, b'y," said Boss. "I'll never understand women. Go on up, luh." Boss pointed up the staircase to the side of the bar.

"I'm off." Jeffrey took one last swig of ale and grabbed his briefcase. By the time he got to the top of the staircase, he could hear Rosie puttering around the kitchen.

"Ah, it's the Sheriff, come in."

"Rosie, please call me Jeffrey."

"Okay Jeffrey, how would you like to try the world's finest cup of tea?" Rosie wore a cotton housedress with a red cardigan. She poured the steaming liquid into two mismatched cups, laid them on a wooden tray with a layer of fabric under the cups.

"My, that's an offer I must accept," said Jeffrey. "To what do I owe this wonderful pleasure?"

"You're a friend of my brother's but a decent kind of friend, not those rough and ready fellas he usually has around down there; so I s'pose you can have one of my world-class cups of tea." She smiled as she turned. Her soft curly hair had started to go grey in streaks that became her rounded cheeks, making her look younger than her age.

"Sugar?"

"Yes, Dear? Oh, I mean, yes, my dear!" Jeffrey covered his mouth with the tips of his fingers in mock fright at his own slip of the tongue.

She eyed him carefully then handed him his cup of hot tea and waited while she sipped her own.

"Rosie, I don't know how much you know but..."

"People like me always knows too much, I'll tell you that," she said, adding a single, definitive nod at the end of her sentence.

Jeffrey sat up in his chair and leaned forward, sipping earnestly. "If I may," he said, "this is the world's greatest cup of tea." He winked and told her to continue.

"I know about the situation. I work at the convent in the kitchen. There's not a lot gets by me."

"I can believe that. The reason I'm inquiring is that I am Sarah Marsh's lawyer. So, what can you tell me about what happened to her, Rosie?"

"You understand that Mother Martin is still my employer, right?"

Jeffrey nodded. "I do," he said, "but you strikes me as the kind of lady who would not want to send a young lady to prison, and certainly not when she's been in a difficult situation, especially a young thing like Sarah who's meant no harm to anybody in her life."

Rosie looked down at her tea. "I remember Sarah. Lovely girl." She sipped her tea. "She and her sister Elizabeth showed up one night with their momma. The two girls were there to consider

becoming nuns but I wasn't convinced. At first, I'd thought maybe they didn't want to be home anymore or were bored of the outports. We've seen that at the convent before. Girls come and go all the time. But I had a feeling with these two that they weren't really into giving their lives up to God."

Jeffrey decided to not pull out his notebook. Something told him he'd get more if he simply sat, drank tea and listened.

"So, I didn't think too much about it, but then Sarah got ill, or so we were all told. And I remember the girl going into solitaire for a few nights...it must have been some time in late October or early November. Sister Ella, God love her, had gone out to the shed to tend to her."

"Shed?" Jeffrey's eyes widened.

"Yes, that's where the Ice Lady put her. Ice Lady, that's what the help calls the head mother."

"In an outdoor shed for a few days? Surely not overnight, though?"

"Oh yes, overnight." She sipped her tea without looking at him.

"My Lord above. For the whole night?" Jeffrey ran his chubby fingers through the small sprinkle of hair left on his head.

"For nearly three nights, honey."

"That's outrageous, my glory."

"I'm not there to judge, mind, but it does seem a bit much, doesn't it? Still, I knows Sister Ella really helped the young Sarah out during that time. Sarah owed a lot to that woman. They seemed close to me. I can't see how she could have attacked that Sister unless she really felt she had to. That's why I, for one, believe it might have had something to do with those drugs they were giving her."

"Yes, yes," said Jeffrey nodding his head. "But with the drugs, surely she had a say in the matter."

"You don't have a say in very much under the Ice Lady."

"Yes, the Ice Lady," said Jeffrey, mostly to himself, nodding. "And what about the doctor, is he any good?"

"Yes, he's a good doctor. Dr. Parsons. He runs the apothecary on Hill O' Chips. I stand by him, Jeffrey. He wouldn't do a thing to hurt anybody."

"And the constable?"

"Oh yes, Constable Raymond, sorry I forget his last name, but he was there, too. That's how it went."

"Does anyone else know about the shed?"

"You mean so Mother Martin doesn't pin it on me?"

"That's a very important reason for me."

Rosie gave him a small smile and took another sip of her tea. "Lots of us know about the shed but no one outside the convent, including the doctor and the constable, I suspect. But didn't Sarah tell you about it?"

"Not yet. That girl is traumatized. She's gone through a lot in the last eight months or so. We hadn't had a chance to get to that part yet."

"Right." Rosie nodded before she continued. "There's one other thing. Mother Martin insisted that Maggie be the one to look after the Marsh girls' room, clean it and make sure no one else went in there. After Sarah got sick, or I should say one night, the Sisters were all led into a room to pray for her, or maybe it was the Chapel, as she was supposedly taking a turn for the worst."

"Maggie was on stand-by to deal with the room. I was in the kitchen finishing up some loose ends when Maggie came running to me in a panic about the room clean-up and how she was gonna need more help than she'd realized."

"And?" Jeffrey could barely contain himself.

"When I saw the sheets and I won't get into it, I knew Sarah had had a baby."

"No." Jeffrey sat back in his seat in shock.

"Oh yes, I wouldn't mistake that for anything else. I helped Maggie as it was quite the job and then we had to help Elizabeth get ready to leave early the next morning with the child, um, without anyone else knowing." Rosie blessed herself.

"Oh dear merciful." Jeffrey laid his cup down and suddenly longed for his leftover ale sitting on the Boss' bar.

"Why would her own sister take off with Sarah's child?"

"That's a very good question." She stood and walked to her small window that looked out to a very dark backyard. "Jeffrey, I see a lot of strange things and I try not to judge but I have a feeling it was probably better for the married sister to come home with a child than the 15-year-old unwed sister."

"Right, right, right." Jeffrey's nodded his head.

"All Maggie and I could figure out was perhaps she changed her mind and decided to take her baby back. Add a drug of some kind and any resistance at all from Sister Ella and you've got a recipe for disaster. I'm not a mother and never will have children of me own but you can't put anything in the way of a mother and her child. Sir, that's a force of nature that no one's gonna stop."

"Oh my, Rosie. This is not what I expected to hear tonight, I must say. You have been so helpful."

"I hope somehow my sharing this with you will help the poor girl. Will it?"

"I daresay it will, my dear. Would it be okay to join you for tea again sometime?" Jeffrey felt his neck flush.

"Uh, yes," said Rosie. "That would be lovely. Drop in with Jonny first and he'll come up and see if I'm free."

"Jonny? Oh, right, Boss. Yes, I'll do that. Thanks again, Rosie. You're a charm."

"Nice meeting you, Jeffrey. Go back to your beer, now. I'm sure Jonny has it waiting for ya."

He waved to her as he clomped down the musty stairs back to his stool. He was nearly numb with shock and riveted with excitement. He now had something to hold over the head mother. He knew there was a reason nuns made him nervous. Imagine putting a pregnant girl in a bloody shed overnight in the middle of November!

"Oh Sarah, dear," he said aloud. "We might actually have a plan now, you poor thing."

\*\*\*

# Chapter 39

Frankie couldn't grit his teeth without pain but some actions were worth the strife. He banged his shaky fist on the table beside him. Not being able to properly speak wound him up worse than Elizabeth's stupidity. He could hardly tolerate her anymore with her cooing the baby like a lunatic all day long and almost always getting his food wrong. His food, what a joke! It was liquid all the time. He could not wait to eat solid food again. He longed for moose steak and kidney pie. He dreamed of fish and chips with salt and vinegar. Right now, he could have none of it unless he had Elizabeth mash it into a drinkable concoction that he sucked through a straw. Christ, even the sucking hurt. And he was still on the painkillers. It had only been a week or two but he wasn't sure how much longer he could take it.

He was a man of freedom. This business of having Elizabeth do everything for him and having such control over him was sickening. It was humiliating. And he had Sarah to thank for all of it. He was glad she was in prison. He hoped she was thrown in there for a few decades. Might teach her a lesson. She'll learn a thing or two in there about how to take it. Ha, he thought. He was merely a grope compared to what she'd eventually face in Her Majesty's Penitentiary. He'd heard the stories. She wouldn't last. Even better would be for her to get out. Then he could have her all to himself.

He swallowed the liquid food. It wasn't disgusting but there was so little taste left, he may as well have eaten wet sawdust. He flicked the glass to the side when he was done.

He couldn't worry about Sarah in prison. He had to worry about his own situation. Ms. Elizabeth here spilled the beans that he'd slapped her around a bit, and now Ed, her old man, knew and said he wouldn't kill Frankie as long as he behaved. Christ.

This town, this life, this marriage was getting too crowded. He was trapped. Only Mary-Lynn and her sweet face gave him comfort, these days. Her tiny fingers and toes had more power over him than Elizabeth's entire being. He was more impressed with the newborn's impact than any grown adult around him. Some days, he thought about telling Ed to go ahead and knock him out for good and be done with it. Then he thought of Mary-Lynn and realized he couldn't do away with himself; he couldn't miss out on seeing her grow. And then there was Sarah. He didn't want to leave the earth yet, not without making her pay. That just wouldn't do.

---

Mother Martin was thrown off by the lawyer. He had interesting suggestions but she couldn't exactly ignore Sister Ella's family. A knock on her door pulled her reluctantly out of her thoughts.

"Yes?"

Sister Jane poked her head in around the door. "I'm sorry to disturb you, Mother Martin. It's Father Williams. He's at the front door to see you."

"Father Williams?" Mother Martin caught her breath. She hadn't spoken to him or seen him for quite some time. "What a surprise."

"Yes, Mother Martin, I've let him in. He's waiting for you in the Great Room."

"Thank you, Sister Jane. I'll be right down."

Hmp. She seemed to have more visitors in the last week than she'd had all year. She pulled herself together and made her way down the staircase to the Great Room.

"Father Williams." Mother Martin had her arms extended. "What brings you here so unexpectedly?" She asked quietly.

"Mother Martin, you haven't changed a bit, I see. Thank you for seeing me on short notice. I have something important to discuss with you."

330

"By all means. Please, sit down. Sister Jane, thank you. Please leave the tea and biscuits. We'll help ourselves."

Father Williams smiled, his hands folded, as if in prayer, and watched Sister Jane close the heavy, padded door behind her.

"It's about Sarah Marsh."

"Ah yes." Mother Martin stood and walked across the room to pour the tea. "My visitors all seem to be about her these days."

"Oh?"

"Her lawyer came by asking why I was pressing charges."

"Why are you?"

"You used to be smoother than that, Jerome."

He smiled. "Yes, the older I get, the less time I wish to waste, it seems."

"Still two sugars?"

"Yes, thank you." He reached out for the teacup and tasted the hot liquid. "Lovely. Why are you pressing charges, Anne? Was it the medication that was off?"

He hadn't called her Anne in almost two decades. No one called her that anymore. It was a way to grab her attention, a shortcut.

"No, it was a syringe in the neck. The neck, Jerome. Perhaps if it had been anywhere else, I might not have..."

"You might not have...?"

"I mean the family might not have been so shocked had the needle been in their daughter's arm, for example."

"Yes, the neck provides a powerful picture for the mind, doesn't it? How does Sister Ella feel?"

"Oh she's coming along. Dr. Parson's has recommended another week of bed rest, but she's doing well."

"I'm glad to hear, but how does she feel about pressing charges? Is she, too, insisting?"

Mother Martin glared at him. Her eyes narrowed. He could always read her so well, she lamented. "We've told her not to worry about it and that everything is taken care of. She needs to get well, Jerome, not worry about legalities."

"What is it, Anne? What do you have against this child?"

"She's infuriating for starters, but this has nothing to do with the charges."

"Sarah? Oh, please. Are we talking about the same girl?"

"I'm not sure you know her the way I do."

"You're right, I don't. So this is vengeance. You're on a mission long after the logic has passed."

"You were always the logical one, Jerome." Mother Martin rose again from her chair.

"Would you permit me to see Sister Ella for a moment?"

"No, Jerome, I'm afraid that would not be appropriate. If there's nothing else, I do need to get back to work."

"What would it take, Anne, to call off your pride?" Father Williams rose, too, before opening the soundproof door on the Great Room.

"I would have to think about Mr. and Mrs. Gaulton -- it is they who wish to see her brought to justice. Good day, Father Williams. Sister Jane will see you out."

---

Jack Davis Junior had no idea how to find what Sarah needed. He'd never finished school past grade five and it was so long ago. Mary had kindly offered to teach him to improve his reading and he had done well, but to find legal stuff? He wasn't sure he was the right guy to do this. No, he knew he wasn't the right guy, but he was the only guy, and he'd rather it be him than someone else helping Sarah. So, with that in mind, he was going to figure it out.

He arrived at the university after only a brisk walk from his boarding house downtown. Young men dressed in clothes Jack would never dream of wearing were buzzing around the campus with purpose in their step and books under their arms. What were they going to do with all them books, Jack wondered. How were they going to feed their families on books? Unless they all wanted to be schoolteachers. It mystified him, but he put those thoughts aside for the time being. He had a special purpose of his own today, and yet he was severely uncertain about how to get what he needed, and if it would be the right thing. What if he couldn't locate the material because he couldn't read some important information to lead him there?

For the first time in his life, he wished he'd stayed in school. He'd left to help his dad with the fishing as soon as he was old enough. So at 10 years old, he started working for a living to help feed the rest of the family. The way he grew up, that was more important than books. Since he'd never needed it in all his years fishing, he never went back and at a few points along the way when he'd thought about it, he'd already gotten too old it seemed.

It had struck him as silly to go back to a schoolhouse with eight, nine, 10 and 11-year-old kids when he was in his mid-twenties. Now that he was in his mid-thirties with two little girls, it was too foolish to talk about. He was keen on reading stories to the girls but by the time he learned, they would probably know how to read the stories to him. He'd have to make an extra effort this year. On top of that, losing all of June from fishing because he was here in town was gonna hurt. Mind you, Ed and Mary agreed to get them through the winter as he was helping their youngest daughter. Still, he didn't like owing anybody. And he wasn't sure how he was gonna hold up his

end of the bargain if it meant wandering through a maze of books and papers at a university. What did he get himself into? What if everything he did here didn't change a thing and Sarah still went to jail? Fear clutched him in the guts.

He opened the main door, following a couple of younger fellas in shirts and ties. Once inside the quiet hum of the building in the main lobby, he suddenly felt conscious of what he was wearing, something that rarely occurred to him in his normal day-to-day, unless he had to don protective equipment of some kind, or waterproof gear for the job, or if he were in church. He briefly looked down at his old blue flannel shirt with the sleeves rolled up, a white t-shirt underneath, dark blue work pants on bottom and his steel-toed boots on his feet. He'd try and remember to walk quietly in here, if he could.

For a place that was supposed to have a whole bunch of books, he couldn't see that many. There were a few sets of shelves in the back behind a couple of desks and to the side there were more desks but where the heck were all the books? And which desk should he go to? He didn't know. He realized quickly he was going to have to swallow his pride and ask one of these ladies at the desks where to go and what to do. He sighed from the depths of his chest and strode to the nearest one. A woman with hair in a tight bun and thick, round glasses smiled at him, pretending not to notice his boots, he was sure.

"Yes, sir, can I help you?"

"Yes, I don't know much about, um, books..." Jack immediately regretted his opening remarks, wishing he could start over. "I mean..."

"That's okay, honey," she said, a smirk on her face. "Half the youngsters in here don't know about books either. They only pretends they do. What do ya need?"

"I need to know what kinds of books would have information about assault and attempted murder..."

Her eyebrows perked up. "Assault and attempted murder, hey?" She was still smirking.

"Oh my, that didn't sound right," said Jack, feeling hot under his flannel shirt.

"Don't worry about it. So what kind of assault?"

"Well, hitting a man over the head with an iron frying pan, for example."

"Blessed Lord, what have you gotten yourself into, b'y?"

"No, no, it's my girl..." Jack hesitated. "She's in prison right now and I'm trying to get her out."

"Your girl did this? Okay, honey, why don't you start at the beginning," she said. "Have a seat over here. Let me go get my tea, for the love of the Lord. Did you want one?"

Hesitant, he nodded. "I may as well get into this and get 'er done. Yes, girl, I'll have a tea." He sat down, quietly relieved that someone was going to take care of him, so he could take care of Sarah.

\*\*\*

# Chapter 40

Sarah was getting ready for the lunch call when a guard came to her cell and said she had a visitor. She could have her lunch after the visitor had left.

"Who is it?"

"I believe it's your lawyer Mr. Maddox, miss."

Her heart sank. She knew this wasn't good if she didn't want to meet with her own lawyer but this was her life right now. She didn't speak and followed the guard to the visitors' meeting room. He opened the door to her chubby, forgetful Mr. Maddox.

"Sarah, come on in, girl."

He remembered her name. That was progress.

"I brought you some biscuits from Rosie."

She looked abruptly up at him. She only knew one Rosie. It couldn't be the same one. She took the package from him, holding it gently, as if it contained raw goose eggs not to be broken. Jeffrey could tell by her shocked reaction she knew who Rosie was and what it might mean, unless the poor child was simply starving and couldn't believe she had fresh buns to eat.

"Go on, don't wait, child. You must be starving."

She opened the paper on the buns and saw her immediate thoughts confirmed. There was no mistaking Rosie's buns. They were the best buns she'd every eaten, especially compared to when the Sisters all took turns baking. "You were at the convent?"

"I was, but that's not where I got the buns."

Sarah scrunched her lips and cheeks into at twist as she tried to process his information.

"I met with Mother Martin and had a grand chat. I'll fill you in soon, but first I want you to eat something before you disappear into thin air. Here, I've also brought you some goat's milk." He handed her a glass bottle half full of milk. She reached for it like it was the Holy Grail, the answer to all life's meaning.

Once she's stuffed a couple of buns in her mouth and gulped the milk, she sat down sedated and was ready to hear everything. She examined him a little more closely. What was different about him or had she judged him too harshly the first time? She felt numb with confusion. Maybe today he wasn't drunk?

"Good, that must be better, hey?" He was smiling, his fat nose pink but not as shiny as last time.

She nodded silently.

"I spoke with Mother Martin and she is only pressing charges because the family wants justice, at least that's what she's telling me. I suspect there's more to it and you probably know what that is, dear Sarah."

Sarah looked away. How much would she have to tell him, she wondered?

"Sarah, if you want me to help you, you need to tell me about everything, including the shed."

She swung her head back to him as if on a swivel.

"And the baby..."

She coughed an immediate dry and prolonged cough. He offered her the last of the milk. After she drank it, he continued.

"How am I going to help you if you keep secrets? This is assault and possibly attempted murder. This could mean jail for many years, my dear. You do not want to mess around with charges of this nature."

She blinked but didn't answer.

"And if we mess around with a magistrate then the real facts come out...? Not good."

Sarah nodded imperceptibly.

"Good, so I met with Rosie at her apartment. As you know, she works in the kitchen at the convent. She has shared some interesting information with me. So we know you had the baby and Elizabeth took it home and that's when you needed to be sedated and the attacks happened, right?"

Tears were taking over her face and her vision. Mr. Maddox was a blurry blob in front of her who kept throwing the truth at her in messy splotches, making her heart pound horribly loud.

"The shed incident will be seen by any Magistrate as cruelty," he continued, "which  am sure Mother Martin would not want on her public record, so I'm planning to use that as a way of convincing her not to continue pressing charges."

"The shed was so humiliating and uncomfortable."

Jeffrey was shaking his head in disbelief.

Sarah took a deep breath. Seeing Mr. Maddox's reaction confirmed for her that Mother Martin had acted like an outlaw with her this fall. She'd known it in her heart, and yet, she still doubted her own instincts. Not anymore. She was done with secrecy, or at least the secrets that could help her keep the critical ones intact.

"Yes. She locked me inside an outdoor shed for nearly three nights in November with the cold, the rats and no dinner the first night."

"Gentle Jesus." Jeffrey was not a religious man, but without thinking, he made the sign of the cross. He was both horrified and now firmly convinced that his ever-present anxiety around nuns had been warranted. They were an abnormal source of evil, he patted her hand and murmured comforts to her as she told him her story.

"I killed a rat in the darkness with an old bible she'd left close by."

Jeffrey could hardly respond. Finally, he spoke. "What in heaven's name did you do to make her put you in the shed?" He was shaking his head in a constant motion, unable to accept how this could happen.

"I used the Lord's name in vain."

"That's it?" Jeffrey's hands were in the air, imploring her to explain further.

"Well, I wasn't very polite about it. They wanted to isolate me because I had sinned, and the other Sisters wouldn't accept me anymore if I were with child and had sinned, as they'd put it."

"So you did have the baby."

She looked down at her hands, ashamed, though it hadn't been her fault. She didn't have to say anything. Her silence told him he was right. She was relieved to tell him without having to actually say the words out loud.

"Go on, child," he patted her hand again.

"But I tried to tell them I hadn't sinned. I said the Lord hadn't been there for me when I was..." she faltered. "The Lord hadn't been there for me when I was attacked."

"But you were attacked," repeated Jeffrey, his mind reeling with all of the pieces of this puzzle floating around in there, looking to come together and form a picture. "So it wasn't only in the nightmares."

"That's right. When I suggested that the Lord didn't save me or protect me from my attack, and why should I respect him in return, it set her off like I'd never seen her. She'd slapped me before for not addressing her properly and that kind of stuff, which was a shock, but I guess blaming the Lord was not acceptable. That shed was the

last straw for me. It was the worst thing that ever happened to me...other than the attack."

"Dear child, you have given me enough ammunition to blow this prison out of the water." Instinctively, he looked to his left to catch the guard looking his way. Then the guard nonchalantly went back to his watch. "I can't make promises, but if what you're saying is true, there's no reason you should even be in this jail, you poor thing!"

"Mr. Maddox, no one in Fox Harbour can know about this baby. People must believe that this child is Elizabeth's and Frankie's baby or she'll be marked for life."

"I completely understand, my dear, but I'm sure at the very least you'll be pressing charges against your attacker, so I'll get that paperwork going right away."

"No," said Sarah, grabbing his pudgy pink fingers hard. "That is not going to happen."

"But child."

"No. I cannot expose Mary-Lynn's horrible past just to satisfy my own urges for revenge or justice. I won't do it. I couldn't do it. You need to help me get out of here so I can go home to my 'niece'." She gave him a knowing look.

"I see." Jeffrey sighed, gathering his papers into his briefcase. "Well it is your decision but if I could change your mind in any way."

"He said he'd kill me if I ever told anyone. I believed him but because of....for now, we are all safe, but that won't last forever. Now that Mary-Lynn has been born, I'm afraid for her safety because of what he said. I cannot let anything happen to her. I'm sure you understand that."

"My, Sarah, you have certainly come a long way in the last year, and only 16." He looked down. "I understand. I promise I won't pursue that part of the case unless you change your mind."

"Thank you."

"Well, go on now. I've held you up from lunch for too long. And here. Take the rest of them buns."

She left through the steel door and he was left holding his heavy and newly filled head in his hands with the weight of it all.

---

Mary was pouring hot water into a cup when the knock came at the door.

"Come in, Father, come in," she called.

"Mornin', Mary, how'd ya know it was me?" Father Williams removed his hat and boots and came into the kitchen.

"Sure you're the only one in the Harbour who knocks, Father. Who else could it be?"

"I s'pose," he said. "Yes, I can't help it."

"Have a seat. Tea?"

"Please. Where's Ed?"

"He's comin'. He's out in the store clearin' away some of the mess. He'll be in shortly."

"Oh very good."

"I hope you have some good news for me?"

"Yes and no."

"I don't like that answer, Father. What's the situation?"

"There's a part of this puzzle, Mary, that I am missing and I'm sure you know what it is."

Mary stared down at her own tea.

"Mother Martin's reason she said was to give the Gaultons justice for their assaulted daughter."

"By putting mine in jail?"

"I tried to appeal to her compassionate side. She's a hard woman but she might consider it."

"Father, we've got to convince her."

"Mary, Mary, look what I found." Maddy Davis ran into the house, with shoes on and was oblivious to Father Williams. She had something delicate in the palm of her hand.

"What is it, child?" Mary came to her and cradled her own hand under the little soft hand.

"It's a caterpillar, look!" She was grinning ear to ear. "He has so many legs, look!"

Father Williams smiled. "Hello, Maddy."

"Hello, Father, look what I have?"

"Me no cattie piller," said a forlorn Ellen out in the porch.

"Maddy, did you let Ellen hold the caterpillar, too? I hope you know this creature belongs to everyone." She nodded and walked towards her sister, holding out the squirmy bug. Ellen cupped her two hands together ready for it to walk to her. Then the two went outside again fluttering with chat and giggles.

Mary turned back to her kitchen, with Father Williams eying her. "Where's Jack?" He asked.

"In town. He's gone to see Sarah."

"Ah, yes. Are they a pair then?"

"Oh, no, Father. His wife is not in the ground a year yet and Sarah's so young." Mary kept her back turned to him, tending to her cooking at the stove. "No, he's helping out. Sarah spent a lot of time

with those young ones when their mother was sick. She helped them through a really tough time. They ask for her all the time."

"I see. Well, Mary, thanks for the tea. I do need to be going. I will follow up my conversation with Mother Martin with a letter and will let you know if I have any news. Don't worry too much now. The Lord will see us through this patch, don't you worry."

He started out the door, when Mary stopped him.

"Father?"

"Yes, Mary."

"What if Mother Martin had a past that..." Something flickered across the priest's eyes.

"Yes, Mary?"

"If there is a court case, I know for certain there are some things she wouldn't want to come out in public."

"I imagine you're right, Mary, although I've known her a long time. I don't think there's much to expose." His eyes narrowed so slightly, Mary almost missed it. It was like a clench. She couldn't remember ever seeing such a thing in Father.

"Oh?" Mary's sensed the dear Father might know more than she had thought but the feeling seized her in the chest as she weighed her words. "How long have you known her?"

"Why since she was a girl, Mary. I was her parish priest for a good 15 years before I came here. I am fairly certain there is nothing. Let me take care of this, Mary."

Mary swallowed hard. Suddenly her mind registered confusion, shock and fear. Before she could say anything more, she heard her priest speak.

"Good day, Mary," then he left her in a state.

---

Mary watched Father Williams leave through the back door and down over the side steps. Frantically, she thought back to the confessional conversation she'd had with the Mother. She was pretty sure Mother Martin had said her parish priest had raped her. Father Williams? No, she couldn't believe such a horrific thing. Maybe Mother Martin had lied, maybe she'd dramatized the whole thing under the influence. She figured the poor nun hardly took a drink. But thinking about Father's reaction, a man she'd know for almost 30 years, suddenly rattled her spine.

Reluctantly, she was starting to see the clergy as keepers of secrets, bad secrets. How many more of them did they garner? How many had they buried over the centuries? What was it about sin? Wasn't the Almighty forgiving of sin as long as people who sinned were contrite and wanting penance? Or were the secrets too dark to shine any light on them? Would they destroy families, communities and small worlds the way that Mary-Lynn's secret origins would?

Before this entire mess began, Mary assumed sisters and brothers and priests were all as pure as the driven snow and had nothing to hide. Then they found out about Father Pomeroy who was now on the Burin Peninsula serving a parish down there. No one really had any proof but there were rumours that he had handled a few of the altar boys in a terrible way. Mary could not understand why a grown man would want to touch children in the wrong places, but a man of the cloth? It was incomprehensible. It couldn't be true and yet, it must have been close to the truth. They sent him off and then they got Father Williams who was not anything like that. You could trust him with anyone at anytime. He'd never touch a child like that. Maybe he and Mother Martin considered getting married before they both changed their minds and joined the church and gave their bodies to God. Or maybe only one of them changed their minds. Oh now, Mary, she thought to herself. Your mind is gone right off the rails with speculation. She had to stop herself or she'd have the whole world in some kind of conspicuous relationship they shouldn't be in. Time to get the laundry going and hung out to dry before the day was gone.

\*\*\*

344

# Chapter 41

Frankie was finally able to move his head from side to side with not too much pain, only a dull throb at the back of his skull. Minor compared to what he'd already been through. He still drank all his food. The only drink he was allowed was a rum toddy once in a while because of all the painkillers. At least he got his sip of rum. It was better than nothing.

He'd been sleeping on the daybed since the attack. Propped up on pillows that never seemed to be in the right formation for him, he tried hourly to find the right position to ease off the torrent of pain shooting through his head, jaw and body. He would fall into fitful naps during the day and remain wide-awake for entire nights. The nights he was awake, he counted a lot of stabs of pain and a lot of dots on the ceiling.

He'd heard through Elizabeth that Jack Davis was gone into town to help Sarah. Frankie couldn't imagine what Jack was gonna do for her. He wondered if she'd managed to get a lawyer yet. He wanted to press charges but the convent was pressing charges, so he didn't need to do anything. Let them do all that crap. He was too tired and too busy trying to get better.

He sighed as he tried to turn over on his side, gingerly lifting his own shattered head with his shaky arms. Goddamn, this was frustrating. Finally on his side, he tried to relax and forget the pain. He imagined himself playing the slot machines and drinking up a storm and having a real good party at the Base, eventually lulling himself to sleep.

In her room, Elizabeth couldn't tell if he'd fallen asleep. She'd caught herself listening for his every sound. Even though she knew he couldn't get off the daybed and hurt her, she lived in fear everyday and every night. Finally admitting it to herself, she decided

she had to do something about it. This situation was no longer about her. She had a child to consider. She now knew she had to get out and get away from Frankie. But would she ever feel entirely safe? She pondered that thought. No, she would only ever feel safe if he were gone, as in, dead. The realization struck her hard. He was in bad shape, as the doctor had said but he was going to live. She knew in her heart that this fact disappointed her. She felt horribly guilty for even thinking it. She made the sign of the cross and decided she should say a few Hail Marys to clear her conscience. She couldn't be thinking about that stuff. She needed a solution, but it needed to be the right solution. The last thing this family needed was someone else heading to jail.

---

"Hello, Frankie, and how are you feeling?" Doctor Moore looked him in the eye, despite the angst surrounding Frankie's taut body.

"Cou' be bedder," he managed, his jaw still wired tight.

"Good, good. We'll be able to take this wiring out very soon then. You've done a great job, Elizabeth."

"Thanks," she said, without catching eye contact with Frankie.

"Have you been sleeping, Frankie?"

"So' of."

"Sort of, okay, and what about pain on a scale from one to 10 where 10 is awful?"

"Eight."

"That's progress. Last time it was 12, you said, wasn't it?" Doctor Moore smiled. He was the only one in the room smiling.

"Right, well that means we can ease off on the painkillers a little, Elizabeth. We don't want Frankie getting addicted to those things, now do we?"

"No." Frankie was sitting up, his legs dangling from the examination table. "Need pi's."

"He said he needs the pills," said Elizabeth.

"Frankie, if you don't start easing off them when your pain goes down, when will you ease off?"

"Too mush pain."

"Doctor, I agree with him. He is still in too much pain."

The doctor paused, glanced at Elizabeth, and then, turned back to Frankie.

"Okay, then, Frankie, Elizabeth has a good handle on your situation. We'll keep the same and perhaps add a few extras for night time?"

Frankie couldn't nod. That would hurt more. So he grunted.

"Yeh."

"Elizabeth, could I see you outside for a moment please?"

She stood and followed the doctor outside, Mary-Lynn squirming in her arms.

"How has his mood been, Elizabeth?"

"His mood is always the same: terrible but I think it's the pain. Doctor, he is in a lot of pain."

"I see. Perhaps I'll prescribe a sedative for him, then. They are addictive like the painkillers so you will need to monitor that, too."

"I will keep him out of trouble, Doctor, don't worry." She nodded and left the doctor with his clip pad to make notes.

Yes, she would take care of it.

---

"Mornin, child, hand me my lovely granddaughter," said Mary. "Ah, there you are, little one. Look at you. Aren't you the sweetest thing God ever put guts into?"

"Momma, good Lord."

"You leave me alone, now. I am her nanny and I'm going to enjoy every bit of it that I can. You'll have to pour your own cup of tea, girl. Or better yet, why don't you go for a nice walk to Clara's or down the lane? Would do ya good."

"Maybe after my tea." Elizabeth filled two cups of tea and set them on the table before she sat down.

"Yes, girl. After tea, you go for a walk and I'll go check on Frankie for you? How is he?"

"Not good. And he's as crooked as sin."

"Nothing's changed then?"

"Not much. The doctor says he has concerns about it but he gave us some medicine for Frankie to sleep better at night." Elizabeth focused her attention on her teacup.

"Yes, this is going to take some time, isn't it? Why don't you stay with us for a little bit and see how it goes?"

"Who's going to look after Frankie?"

"What about his crowd?"

"I thought of that but he'll be livid if I send one of his sisters over to mind him."

"Too bad about him. That's the way it's gotta be, child. You need a break, you hear me?"

Elizabeth nodded, though she wasn't looking forward to approaching her sister-in-law, or any of his family. They made Frankie appear downright pleasant. "Okay, I'll talk to her later on this week. I'll need to work up to that."

348

Mary laughed. "That's a girl. Ooh, her poppy is going to be so happy." She nuzzled her nose into Mary-Lynn's fresh face, making the child laugh out loud. "Go on, Elizabeth, honey, go get some air."

"Yes, Momma." Elizabeth took a last gulp of hot tea and set her cup down. She knew there was no point arguing with her mother. She left the house, her shawl over her arm in case the wind picked up and marched down the lane toward Clara's. Elizabeth had made up her mind that she would make things better. Perhaps she would see if Clara had some honey to help Frankie better swallow his painkillers, anything that would make him a little better to deal with. She sighed heavily at the thought of the long road to recovery ahead of them. No one, not even the doctor could tell them how long it would be. Would Mary-Lynn be two or three when the lion finally woke up and walked away from this trauma fully healed or would it be sooner? Elizabeth shuddered at the thought of taking care of a mean grump and yet in some ways it was better to have him contained.

She walked into the shop and smiled at Clara.

"Elizabeth, honey, you poor child. How are you doing?"

"Oh, we're managing, Ms. Clara."

"Yes, dear, bless your heart. What can I get you today?"

"I wondered if you might have something to help Frankie with all his painkillers, maybe something to make it easier to swallow like honey?"

"What a sweet soul you are! Let me have a look, dear." Clara walked around the corner to a side shelf and looked up a rung or two. "Well, yes, this is right what you need, love. A small pot of honey. Beautiful stuff."

"How much is it?"

"Don't worry about it. You tell your Momma to send me some of her lovely tea buns and that'll make it even, okay? You've been through enough."

"Ms. Clara, that is kind of you." Elizabeth bowed her head, cheeks flushed.

"Not at all, honey. Ha ha, get it? Take your honey, honey." Clara grinned with joy.

"Thanks a million," said Elizabeth. "You have helped me so much." Elizabeth turned and left the shop with her new purchase. She tucked the small jar into the side pocket of her skirt and sauntered back up the hill, not in a rush to see Frankie but always eager to see her baby.

As she passed her Momma's house, she noticed Mary-Lynn with Ed, bouncing up and down on his knee. Surprised she called out to her Daddy.

"Oh, where's Momma?"

"She's up checking on Frankie, girl."

Elizabeth nodded and made her way to her house to see how her Momma made out. As she came closer, she could hear her Momma's tempered yet steely voice raised ever so slightly. She recognized that tone of anger and venom. It was so controlled it was eerie.

"My son, you may be in an awful way, but let me tell you this: I knows."

Elizabeth's eyes narrowed slightly as she listened to her Momma, peering quietly in through her own window. What was she up to now, giving him another talking to? Frankie tried to look anywhere but in the old woman's eyes but there was no hiding from her. She was in his face.

"I knows what you did to Sarah. I know you're the father." Elizabeth's throat constricted in time with Frankie's eyes gone wide. Her hand went to her own throat, trying to suppress a horrific cough. She ran down the steps around her house and up over the hill before she slumped in behind an old rock. The cough escape until she couldn't breathe and then she threw up into the hay, unable to stomach what she'd heard. Frankie? Frankie? Him? The father?

Suddenly her mind spun with pieces of truth and fiction, circling, rattling against each other until she realized the only truth that mattered. Frankie was Mary-Lynn's real father. She'd never felt so physically upset in her life yet her eyes were dried up with fright at the knowledge. How could she have let this happen to her dear young sister? How could he have done this to Sarah? To her, his wife? What a horror? She felt faint and lay down on the hay.

"Elizabeth, honey, wake up!" Mary slapped her daughter's face, trying to revive her. Ed held Mary-Lynn who wouldn't stop crying at the bottom of the hill.

"Is she all right, Mary?"

"Yes, b'y, I think she's a bit overcome, that's all. The poor girl needs a rest. Come on, honey," said Mary, as she pulled Elizabeth to a seating position. "Let's get you to bed. Ed, can you help?" Mary took the child and Ed helped Elizabeth down the hill to her own house and up the stairs. Mary followed with the child. Ed laid her in her own bed and took Mary-Lynn and laid her beside her momma.

"Hi, baby, it's momma, it's okay," said Elizabeth, calming the child. She suddenly looked straight ahead at a random spot on the white wall of her bedroom as her parents watched her calm her baby, Sarah's baby, Frankie's baby. Oh my God, she thought. This was too much. She stared at that spot for a very long time until she heard her own Momma call her name.

"Elizabeth, honey, are you okay?"

"Honey! Momma," said Elizabeth. "Where's the honey I bought?" She patted her pocket and found it intact. "Oh here it is. Ms. Clara thought it would help Frankie swallow his pills easier. She'd like some of your tea buns for payment. Is that okay?"

Mary looked at Ed, then looked back at her dazed daughter. "Sure, girl, I can do that. You get some rest now, okay? I'll take Mary-Lynn for a bit."

Elizabeth nodded. Good, she thought. She needed Mary-Lynn away from here. She had things to do. "Good, Momma. Take good care of her."

---

Barrister Jeffrey Maddox was brimming with excitement about his case for Miss Sarah. At every turn, he was discovering layers to be peeled away that revealed yet another underneath. The excitement of discovery was the heartbeat of his work. Perhaps he should consider being a private investigator where he could do this stuff all the time. But then he knew he'd have to get a gun and he didn't like that idea too much. No, he would stick with his lawyer's affairs.

He was on his way to meet with Constable Raymond to discuss the night of the convent attack. Supposedly, this gentleman could share his notes and observations to help Jeffrey with his next step. He was willing to bet a lot of bucks that the Constable had no idea about this awful shed business. Jeffrey wouldn't be getting into it unless he had to. He would find out what the officer knew. He needed someone to show him some proof of what happened that night and he would be off to the races. While he was waiting for the Constable, Jeffrey casually wondered if you reached out and grabbed a syringe from somebody, and you stabbed it towards that someone, how likely was it you'd hit the neck? And if you didn't hit the neck, what would you hit? He marvelled at the kinds of things that occupied his mind and that this really was his job.

"Mr. Maddox, good to see you."

Constable Raymond offered his hand to the seated lawyer. Jeffrey got to his feet and grabbed a strong, firm handshake. "Thanks, yes, good to meet you."

"Follow me." The Constable led him behind the reception counter, through a long narrow corridor and around a corner into a tiny office choked with files and papers.

"Yes, this is where it all happens, Mr. Maddox, please take a seat."

Jeffrey sat, laid down his briefcase and faced Constable Raymond. "What the heck happened that night, Constable?"

The Constable smiled. "Yes, it was quite the night. Mother Martin called us in because Sarah Marsh had allegedly stabbed Sister Ella Gaulton with a syringe containing a potent drug."

'"A potent drug that Sister Ella had been administering regularly to Sarah for a month," interrupted Jeffrey quickly.

"Indeed it was," said the Constable slowly. "Fortunately, Sister Ella will recover from her injuries. I've got it all in my police report. I can share a copy with you."

"You are spectacular, sir. What else do you have?"

"There isn't much else, Mr. Maddox."

"I see."

"Other than the notes from my interview with Sister Ella, which might be of interest."

"Do tell."

"Mother Martin and Sister Ella's parents are rather keen on pressing charges against Sarah, but Sister Ella is not."

"Why not?"

"She doesn't think it's warranted. She believes Sarah is a victim, too. She was attacked, raped, forced to have a child away from home, drugged, trapped in this convent and under considerable strain for one so young."

"I couldn't agree more. Constable, isn't it possible the Magistrate might consider her case an exception? Perhaps even let her out on temporary leave while awaiting trial?" Jeffrey did not allow the Constable a chance to speak. "In fact, with your report, couldn't she be released from jail, provided she doesn't leave town and all those other requirements jail people make us follow. Is that correct?"

"Now, Counsellor, I wouldn't rush to judgment. The Mounties will want to have their say. And there's still Mother Martin and the family. I'm not sure how a Magistrate will go up against a head mother."

"Agreed, Mother Martin is keen. It would be nice if she changed her mind about it."

"It certainly would be."

"But isn't it Sister Ella's decision in the end, Constable?"

"It is. Without her, there is no case."

"Well, it was nice chatting with you, Constable, and thank you, I truly look forward to reading your report."

Jeffrey stood. "By the way, I assume that Sarah's shed treatment is accounted for in detail in your report?"

"Shed treatment?" Constable Raymond's eyebrows came together in a sudden collision.

"Ah," said Jeffrey, "Perhaps I'll stay a little longer and fill you in."

\*\*\*

# Chapter 42

Elizabeth rose gingerly from her bed. She felt wiped out, but steady in her purpose. She'd waved off her parents and the baby and pulled herself up on her feet. She could hear the growls from the kitchen. She was not quite ready to answer Frankie's pathetic grunts. She needed paper and pen first. She grabbed a few pages, a pen, walked calmly to the kitchen, sat down and made eye contact with Frankie like she'd never done before. It quieted him momentarily. She could feel his curiosity breathing down her neck as she wrote. Soon his patience wore thin again and he grumbled his disapproval. She finished writing, walked over to him, pushed her right hand solidly against his chest forcing him down on the bed, knocking his injured neck, head and jaw against the pillow and waited for him to calm down. She looked at him dead centre in the eye and said, "You are a bastard. I know what you did. You'll never do anything like that again."

Tears ran down his cheeks from the pain. He shook his head, though that, too, pained him.

"Don't worry," she said. "I'll let you go and you'll be fine, as long as you sign this." She produced the page she had been quietly preparing.

Frankie could see the murder in Elizabeth's eyes, in her control, in the firm hold she had on his chest. Damn, he hated being an invalid. His eyes reluctantly began to read the words on the page.

"I, Francis John Healey, of Fox Harbour, Newfoundland, confess that I raped Sarah Lynn Marsh at the age of 15 in July 1942 and got her pregnant against her will. I am very sorry for my crime."

Signed, Frankie Healey."

"Naa, naa, Ellthe…" Frankie shook his head, trying to get the words out. He couldn't sign his own death sentence, even if it was true. Hanging was how the Magistrates handled rape. He couldn't, he couldn't, ow, she pushed harder on his chest.

"kahy," he nodded. He sighed heavily.

She lifted her hand, held him up as gingerly as she could and put the pen in his hand. She laid the paper on his tray so he could scribble. It wouldn't be his usual signature but they'd know it was his, based on his condition. As soon as he was done, she grabbed the paper, pushed him back on the bed with a thump and walked over to the kitchen counter.

As she prepared his medicine with honey and tea, she felt an odd calm come over her, like a quiet but present tumble. She took a deep breath, turned to face her monster and brought him his drink.

Frankie took it to his lips and eagerly drank it in. Looking forward to his medicine became a ritual that helped him coast a little, but this time it tasted bitter, more so than usual.

"Doctor Moore gave you extra, remember? So you don't feel as much pain." She stared at him as he drank the rest of the tea. He caught her glare. Realization hit him, but it was too late. He slowly put down the mug. She didn't smile but he knew she had won.

"Don't worry, Frankie," she said. "You won't feel a thing, honey."

He slowly sank back into his bed and resigned himself to his fate. Next, he watched her as she made a cup of tea for herself with the rest of his painkillers. Finally, after writing a quick note, she took her tea to her bedroom. She reread her note to Sarah and her family before she drank.

"Dear Sarah,

I am so sorry to learn that my Frankie was the one who hurt you. I understand why you didn't tell me. You had no choice. I forgive you completely. I hope you forgive me for leaving you at the convent, for

taking your baby and for leaving you behind. There was no other way.

Momma and Daddy, I'm sorry, too. Take good care of Mary-Lynn. I love you all.

Elizabeth."

---

Jack was starting to get tired. He'd never seen so much paper in his life, but they were making progress. Fortunately, because it was June and most of the students had gone home for the summer, the librarian was able to spend a lot of time with him and get him started on his project. It took him another four hours to pull together the pile of materials and books for Sarah before the call to close the library came.

His heart was racing as he thought about why he was doing this. He still couldn't believe where he was, what he was doing and why. A year ago, he was saddled with a very sick wife who'd been ill for almost seven years. It felt like more than that. They'd only been together for eight years. Now, here he was in the city scouring law books for a sixteen-year-old girl who he would die for and who his kids loved.

Assault was the threat and the ability to hurt somebody, but battery was the actual physical attack on someone, Jack read. So, if Sarah swung the frying pan at Frankie wanting to hit him and missed, it would have been an assault, but it was battery because she'd made contact. He sighed. When she attacked the sister with a needle, it was more like battery; as she was successful. That sounded right to him, but not good for Sarah. Then he read that aggravated assault was a stronger attack with a deadly weapon. Did an iron-cast frying pan or a syringe count as a deadly weapon? He made note of all this in his head and closed the books. He was tired. He might not be a huge reader but he was pretty good at remembering stuff.

---

Back at the Old Women's Department, Sarah nodded, listening to Jack's every word, amazed at the level of detail he was able to retain without writing anything down. "You have such a memory, better than anybody I know."

"You don't know that many people, Sarah," said Jack, chuckling to himself.

She smiled, too. It made her day to see him. She looked forward to it more than her meals, which she always needed so badly.

"So how did you find the stuff?"

"Oh, I sweet-talked a nice librarian into helping me. She knew I was a fish out of water. Spotted me from a mile away."

Sarah laughed again. "I really appreciate you doing this."

Jack always ignored her on this point. "How is it going with the lawyer guy? Is he coming around at all?"

"Actually," said Sarah, slowly nodding her head. "He's not doing too badly. He has found out a bunch of things he thinks will help. He may even be able to get me out on a temporary leave."

"Really?" Jack's eyes opened wide.

"Don't get too excited," said Jeffrey Maddox as the door popped open and in he walked, "at least not until it's official."

"Mr. Maddox," said Sarah. "This is Jack Davis."

"Jack, t'is a pleasure. May I join you two?"

Jack grabbed another chair from against the wall and pulled it forward.

"The paperwork is in, Sarah, dear. It may take a week but it's in motion. Once I explained your experience in the shed and your treatment at the hands of the convent, Constable Raymond was a little more open to handing his report directly to the Mounties himself, asking for a temporary leave and possible dismissal. That

means you may be out of this place by Friday. Let's say a prayer or two, okay?"

"Possible dismissal?"

"Constable Raymond discovered that your dear Sister Ella refuses to press charges much to Mother Martin's dismay." Jeffrey grinned proudly.

"That is so wonderful." Tears came so fast; she hardly had time to wipe them.

"So you may be off the hook for the Sister Ella case and hopefully Frankie won't press charges like he said. Now we will simply need to find a way home for you."

"I can take care of that, Mr. Maddox," said Jack. Sarah nodded.

"Great, then it's all settled. I'm off. I'll see you in the morning, Sarah. Hopefully, by then I can confirm everything. By for now!" Off he went, clanging the door loudly behind him.

"He doesn't seem so bad," said Jack.

She nodded again. "Are you sure I can come with you?"

"Your Momma and Daddy and I have already taken care of it."

---

Mary buzzed around her kitchen, singing to herself and to Mary-Lynn when Ed walked in more quietly, more slowly than he'd ever done in all the years she'd known him. The weight of his boots carried heft and hurt, his shoulders sagged and he wouldn't look at her.

"Ed." Mary's heart froze as she quickly wiped her hands in her tea towel. "Ed, what is it? You're scarin me."

He kept shaking his head.

"Speak! Is it the baby? What?" Mary ran up to him, grabbed him by the collar and forced him to look at her.

"She's gone, Mary. She said she knows what Frankie did to Sarah."

Mary stared at him in disbelief.

"She's gone, Mary, and she took Frankie with her." Ed stood perfectly still while Mary cried out and punched Ed's broad chest with her fists until she slid down to the floor, clinging to his knees and the hope that he might be wrong about her beautiful oldest daughter.

---

Jeffrey, Jack and Sarah stood together at the train station, the wind whipping past them, despite the sun glaring down at them.

"Beautiful day to be heading home, dear Sarah," said Jeffrey. "Now remember, you aren't out of the woods entirely but I have to say, based on Constable Raymond's reaction to the facts, I don't believe there's a Magistrate who will charge you any jail time past what you've already served. They might ask for a fine, but somehow we'll find a way to deal with that, won't we, girl?"

"Thank you so much, Jeffrey," said Sarah. She hugged him, causing him to flush.

"Oh my, yes, well, all the best." He pulled out his handkerchief, wiped his forehead and waved them off.

Jack gave Sarah his arm and they boarded the train for home.

---

"Mary, I'm so sorry, honey, I wish there was something I could do," said Constable Pat. "But this is too much to hide. The medical examiner is already on his way and we've called it in."

"I can't bear to have my girl seen as a murderer! She's not, I tell you! Ed, do something." Mary cried into her apron again.

"I know, but Mary, we've two bodies, honey." Constable Pat hung his head a moment, sighed deeply and placed his hand on Mary's shoulder. "Mary, here's what we'll do. I knows it's not ideal but hear me out. It was a double suicide. He couldn't bear his pain anymore and she couldn't live without him--a true love story. Finally, Elizabeth asked Sarah in her note to look after Mary-Lynn."

He looked at Ed and Mary and waited. They were very quiet for a moment. Then Mary nodded quickly and burst into tears. Pat looked at Ed for confirmation and when he nodded back, the Constable knew what he had to do.

---

Ed stood at Placentia Station waiting for Sarah's train. His heart was heavy with her pain, her trauma, his and Mary's loss and now he'd have to bestow more pain and trauma on his young Sarah. He prayed she would be strong and not blame herself the way Elizabeth had done. He hoped Sarah could break the cycle. Somehow, he knew she would. She'd been so strong up to now. He decided he would make sure she held up. Jack would help her, too. He could count on Jack.

The train rolled up and took its time coming to a full stop. Ed took a deep breath and walked to the main train car to greet his only living daughter.

\*\*\*

*The End.*

# ACKNOWLEDGEMENTS

This book was born on Labour Day Weekend in 2009; my midwife was the 3-Day Novel Contest, without which I could not have coerced myself into writing those first 25,300 words in 72 hours. Then, thanks to The Northshore Wordsmiths, my writing critique group who helped workshop numerous pages, namely Norma and Jim Shephard, Diana Walsh, Sylvia Mertins and Anne Gwaza who remain my dear friends, and who continue to be supportive. Without them, this book would still be buried on my hard drive.

In particular, my writers' group helped me tighten my submission to the Humber School for Writers where I was accepted in the Creative Writing program and subsequently worked with my mentor, Joseph Kertes, Dean, School of Creative and Performing Arts at Humber College and Founder of the School for Writers. The insight, encouragement and guidance I received from Joe helped shape this work and to him I am grateful.

To my dear friends who read early drafts on my urging, and who propped me up with loving praise, despite the disastrous state of those drafts, I thank them, in particular: Michelle Porteous and her Book Club, Teala Wilson, Sylvie Chamberland, Lynda Nixon, Ella Heneghan, Lynnann Anstey, Joni (Aylward) Dibbet, Dawn (Meadus) Chafe and Mary Nardi.

To my sisters: Cindy Maloney, Stephanie Kelly and Suzanne Smith, who also read early drafts but more importantly whose loving support keeps me going and whose sisterly sarcasm and sense of humour keep me real. To my mom and brother who inspire my creativity, I thank them for being blissfully unaware of their character and charm. (Well, I suspect Joe is aware of his charm!)

Finally, I thank Tara Wyatt, Collections Librarian at Hamilton Public Library, and published romance author, for reviewing my work with eagle eyes and for inspiring me with her own publishing success.

Made in the USA
Charleston, SC
11 February 2016